Africa in Stereo

Africa in Stereo

MODERNISM, MUSIC, AND PAN-AFRICAN
SOLIDARITY

Tsitsi Ella Jaji

OXFORD
UNIVERSITY PRESS

OXFORD
UNIVERSITY PRESS

Oxford University Press is a department of the University of Oxford.
It furthers the University's objective of excellence in research, scholarship,
and education by publishing worldwide.

Oxford New York
Auckland Cape Town Dar es Salaam Hong Kong Karachi
Kuala Lumpur Madrid Melbourne Mexico City Nairobi
New Delhi Shanghai Taipei Toronto

With offices in
Argentina Austria Brazil Chile Czech Republic France Greece
Guatemala Hungary Italy Japan Poland Portugal Singapore
South Korea Switzerland Thailand Turkey Ukraine Vietnam

Oxford is a registered trademark of Oxford University Press
in the UK and certain other countries.

Published in the United States of America by
Oxford University Press
198 Madison Avenue, New York, NY 10016

© Oxford University Press 2014

Library of Congress Cataloging-in-Publication Data
Jaji, Tsitsi.
Africa in stereo : modernism, music, and pan-African solidarity / Tsitsi Ella Jaji.
pages cm
Includes bibliographical references and index.
ISBN 978-0-19-993637-3 (cloth : acid-free paper)—ISBN 978-0-19-993639-7
(pbk. : acid-free paper) 1. African literature—History and criticism. 2. Modernism (Literature)—
Africa. 3. Music in literature. 4. Music in motion pictures. 5. Comparative literature—
African and American. 6. Comparative literature—American and African. 7. Music—Social
aspects—Africa. I. Title.
PL8010.J335 2014
809'896—dc23
2013014042

For my parents, Gail Louise Jaji and Lazarus Musekiwa Jaji.

{CONTENTS}

{ACKNOWLEDGMENTS}

Africa in Stereo began its life as a dissertation at Cornell University, and I had extraordinarily generous and astute teachers there. I thank my dissertation committee chair, Natalie Melas, who guided me with critical insight and wry humor, choreographing the shifting rhythms of the writing process with a rare combination of compassion and high standards. During my first semester at Cornell, Anne Adams introduced me to Senghor's poem "À New York." That poem inspired my dissertation, just as Anne's intellectual generosity and hospitality continue to inspire me. Jacques Coursil has been a treasured model of how to pursue literature, music, and philosophy in harmony. I thank him, too, for the prodigious gift of his library when he departed Ithaca. Grant Farred joined the committee in my final year, and I remain grateful for his guidance and the example of his elegant work on vernacular intellectuals. In addition, I thank Hortense Spillers, Barry Maxwell, Steve Pond, Steve Donatelli, Brett deBary, Pete Wetherbee, Paul Sawyer, and three extraordinary undergraduate mentors, Ama Ata Aidoo, Médoune Gueye, and Sanford Margolis. I am endlessly grateful for the generosity of Frances Walker in supporting my studies at Oberlin College and Conservatory. I offer sincere thanks to my editor, Brendan O'Neill, and his team; Brent Edwards, Jayna Brown, Suzanne Gauch; and my anonymous readers for their invaluable counsel.

The intellectual camaraderie of my colleagues at the University of Pennsylvania has made working there a joy. I am deeply grateful to Thadious Davis for her countless kindnesses, and most especially for reading my manuscript early in its post-dissertation metamorphosis. I thank many who commented on parts of this in various Penn workshops and seminars: Herman Beavers, Guy Ramsey, Ania Loomba, Suvir Kaul, Rita Barnard, Carol Muller, Lydie Moudileno, Salamishah Tillet, Chi-ming Yang, Tamara Walker, Josephine Park, Bob Perelman, David Kazanjian, David Eng, Bob Vitalis, Cheikh Babou, Max Cavitch, Deb Thomas, John Jackson, the Race and Empire faculty group, Africana Studies, and Latitudes reading group. My gratitude also goes to those at Rutgers, Yale, the University of Rochester, Bryn Mawr, Arcadia, Case Western Reserve, Wesleyan, the University of London Institute in Paris, Temple, Princeton, the University of Minnesota, and Harvard's W. E. B. Du Bois Institute for the opportunity to share work as it progressed. And I thank my students, who have inspired me and taught me much, particularly my advisees Khwezi Mkhize, Jennifer Kyker, Petal Samuels, Danielle Bainbridge, and

my research assistant, Nadia Laher. Versions of material from chapters 2 and 4 have appeared elsewhere, in *Safundi* 13.3-4 (2012) and in *Popular Culture in Africa* (Routledge, 2013), edited by Stephanie Newell and Ono Okome.

Numerous grants supported this project. I am grateful to the Mellon Foundation, Cornell's Society for the Humanities, the TIAA-CREF Foundation's Ruth Simms Hamilton Fellowship, the Telluride Association, the Penn Humanities Forum, the Trustees' Council of Penn Women, and the Radcliffe Institute for Advanced Studies at Harvard for supporting this work. I also thank the Centre for African Studies at the University of Cape Town, the West African Research Centre in Dakar, and the Du Bois Centre for Panafrican Culture in Accra for their welcome. In particular, I am grateful to Kofi Anyidoho, Kwadwo Opoku-Agyemang, and Michel de Breteuil for granting me interviews. Finally, I acknowledge the stellar librarians and archivists across three continents who solved many quandaries.

A shout out to some cherished fellow travelers: Sze Wei Ang and Shital Pravinchandra, my cohort-mates at Cornell; the Society for the Humanities fellows of 2007–08; my Dissisters: Danielle Heard, Corinna Lee, and Krupa Shandilya; writing comrades Shirleen Robinson, Doreen Lee, Anna Parkinson, Sheetal Majithia, Aaron Moore, Francesca Brittan, Mukti Lakhi Mangharam, Mary Ebeling, Rachel Ellis Neyra, Linda Kim, and Todd Shepherd. Among the many friends who sweetened this journey, I thank Elinore and Anna Morris, Alicia Swords, Joie Taylor, Safaa Fathy, Arshiya Lokhandwala, Les Goodson, Mme Ndiaye and family, Waggie Cornelius and family, Lindsey Green-Simms, Siphiwe Ndlovu, Hélène Javot, Chido Makunike, Kylie Thomas, Akin Adesokan, Ogaga Ifowodo, Marie-Martine Shannon, Cathy Elliott, Sylvia Berry and Dale Munschy, Malcolm Bilson, Joanne Scanlon, Chiwoniso Kaitano-Price, Jim Littrell, all the folks at St. Mary's, Micky Casad, Rea Tajiri, Erica Cho, Tim Portlock, Tanji Gilliam, Samantha and Ira Karmasine, Senyo Dey, Anthony Reed, Amelia Glaser, the Çolakoğlu family, Jane Rhodes, Lynn Hudson, Lydia Diamond, Daisy Hay, Katherine Ibbett, Tamar Diesendruck, and others whose kindness, though unmentioned, I honor.

To my family I say *kutenda kwakitsi kuri mumwoyo.* The Jaji clan (Maduve Number One, Babamunini, the Mwashitas, the Chigwidas, and many cousin-brothers and sisters) prayed and cheered me on from afar even as it remained a mystery how one person could possibly need so much education; and the Hoover clan (Aunt Barb, Uncle Larry, Uncle Jim, Aunt Janey, Uncle Ed, and my cousins) buoyed me with their steady encouragement, advice, proofreading(!), and love. Thanks to my brother and oldest friend, Tafi, for always believing in me, and to Dee, Briana, Jaylen, and T. J. for brightening many holidays. I bless the memory of my grandparents and loved ones who have gone before.

I cannot imagine a more supportive companion along this (or any) journey than my beloved Franklin David Cason, Jr. I thank him for talking through ideas, reading drafts, dispelling doubts, and continually renewing the joy we find in each other. Finally, words seem insufficient to thank my parents for the gift of their example as thinkers, teachers, and outrageously humane individuals. In their unconditional love, they have taught me the true meaning of my name: *Tsitsi dzinondishamisa, amazing grace.*

{ ABOUT THE COMPANION WEBSITE }

www.oup.com/us/africainstereo

Oxford has created a password-protected website to accompany Africa in
Stereo, and the reader is encouraged to take full advantage of it. The website
includes clips of several pieces of recorded music and films referred to in the
text, as well as additional illustrations, background information, and links
to related materials on other sites. It can be accessed at www.oup.com/us/
africainstereo using the username Music 3 and the password Book 3234.

Africa in Stereo

Stereomodernism

AMPLIFYING THE BLACK ATLANTIC

Two weeks before my fourth birthday, Zimbabwe gained independence after a long and bloody struggle against first British colonialism and then the racist Ian Smith regime. I remember my father and brother going to Rufaro Stadium in Mbare for the independence festivities in April 1980. My brother shared with my grandfather the name *Tafirenyika*—meaning "we have died for our country" in Shona—and it seemed fitting that he, the youngest member of our family, should witness the fruition of the costly war for independence. I later learned that Robert Nesta Marley had performed that night, celebrating the new nation by singing "Zimbabwe," a song that had been an anthem of global solidarity with the fight against the Rhodesian Front and its allies.[1] My own memories of those celebrations are vicarious, and in fact it is another Bob Marley song, "Buffalo Soldier," that I remember most vividly as the first tune I learned from the radio.[2]

Cowritten by Marley and Noel "King Sporty" Williams, "Buffalo Soldier" was posthumously released in 1983, and went on to become one of Marley's best-known anthems. Returning to these lyrics years later, I am struck by the ways in which it maps the routes of a pan-African imaginary, inscribing both an attachment to the continent and what Nahum Chandler has called the "originary displacement" of the Middle Passage, as well as intra-American migrations: "There was a buffalo soldier in the heart of America/Stolen from Africa, brought to America...Driven from the mainland to the heart of the Caribbean."[3] Marley's lyric incisively "analyze[s] the stench" of the trans-Atlantic slave trade's dehumanizing terrors. Yet, his song commemorates the African American regiments recruited in the wake of the American Civil War to fight

[1] For more on Marley's performance, see Grant Farred, *What's My Name?: Black Vernacular Intellectuals* (Minneapolis: U Minnesota P, 2003), 216–22.

[2] Bob Marley and N. G. Williams, "Buffalo Soldier" on Bob Marley and the Wailers album *Confrontation*. Tuff Gong Studios/Island Records, 1983.

[3] Nahum Chandler, "Originary Displacement" in *Boundary 2* 27.3 (Fall 2000): 249–86.

Native Americans defending their land, while leaving the complicity of these troops in U.S. imperialism and genocide unmentioned. Linking the forced labor of slavery—"fighting on arrival, fighting for survival"—to the Buffalo soldiering of these troops indexed, but stopped short of a full accounting for the continuing structures of coercion and ambivalences of national belonging for African Americans in the nineteenth century. Yet these complexities were largely opaque to many Zimbabwe Broadcasting Corporation radio listeners. What came across the airwaves loud and clear was that the "dreadlock rasta[s]" fighting for survival shared with us a legacy of resistance—*Chimurenga* in the Shona language—that had yielded our independence.[4] How "Buffalo Soldier" enabled Zimbabweans to imagine and enact a sense of solidarity with black diasporic subjects in the Caribbean and the U.S. lies at the heart of *Africa in Stereo's* project. But so, too, do the ways in which listening "remotely" over the radio and at a geographic remove left some complexities opaque, mistranslated, even untranslatable. It was this song's musical elements—the danceability of the rock-steady beat, the interludes of vocalized "woo, woo, woo" syllables, and the pentatonic melodic contour of the chorus—that sustained such durable structures of feeling.

My interest in how such music shaped a collective Zimbabwean interest in diasporic culture was buttressed by my experiences upon moving to the U.S. to study piano performance near my mother's mid-Western roots in the Rust Belt of Ohio. There I learned to negotiate a new set of local identity politics as a biracial student. At Oberlin, as I was welcomed into the African American community black music came to hold particular importance. I forged lasting relationships while learning to play gospel piano in my first job as a church musician, accompanying a group of phenomenally talented black conservatory students in performances of "Lift Ev'ry Voice and Sing" during Black History Month, and jamming with friends in jazz, blues, and reggae bands. These musical experiences shaped the questions *Africa in Stereo* seeks to answer, which is why I have chosen to begin by discussing when and where I enter.

This book offers an account of the ways in which black diasporic music travels and circulates in cultural texts of continental Africa. I am interested in the symbolic roles of diasporic music in pan-African writing and film, and in how music informed what it meant to be "modern" in the context of globally interconnected, mutable, and mutually constituted black identities. Concentrating

[4] *Chimurenga* also refers to specific historical periods of resistance to colonial aggression. The first *Chimurenga* was lead by two spirit mediums, Ambuya Nehanda and Sekuru Kaguvi at the end of the nineteenth century. The second *Chimurenga* refers to the liberation struggle leading to independence. Members of Robert Mugabe's ZANU-PF party have referred to various actions (nationalizing commercial farms, for example) taken since 2000 as the third *Chimurenga*. However, when used as cover for generalized terror against political opponents, this is a gross distortion of the word's meaning.

on a particular axis of exchange, between U.S. African American music and Ghanaian, Senegalese, and South African cultural production, I demonstrate how these locations are both exemplary and exceptional within what has come to be known as the Black Atlantic.

Africa in Stereo pursues three intersecting lines of inquiry—namely solidarity, modernism, and media—which I exposit briefly here and return to in more detail below. The most central of the three questions concerns transnational black solidarity expressed in numerous cultural forms animated by a range of pan-African discourses. I use "pan-African" advisedly, revisiting a distinction George Shepperson drew between what he called small "p" and capital "P" p/Pan-Africanisms.[5] Small "p" pan-Africanism designates an eclectic set of ephemeral cultural movements and currents throughout the twentieth century ranging from popular to elite forms in contradistinction to the more formal organizations comprising capital "P" Pan-Africanism. Writing in 1962, Shepperson saw capital "P" Pan-Africanism as designating the series of international gatherings from the protomovement's London conference of 1900 organized by H. Sylvester Williams, to the five congresses between 1918 and 1945 in Europe (in which W. E. B. Du Bois played prominent roles), as well as subsequent gatherings on the African continent in Tanzania, Ghana, and beyond.[6] The distinction between these two forms was never absolute, and this book traces how the informal and formal registers of transnational black solidarity have variously reinforced, cross-fertilized, and interfered with each other. In an era in which the language and efficacy of pan-Africanism seem attenuated, and even dated, it is my hope that revisiting the history of these forms of solidarity from a fresh perspective will uncover and renew the latent political energies of pan-Africanist performance.

A second, related question concerns how artists address the experience of being "modern" in Africa over the course of the long twentieth century. In other words, *Africa in Stereo* asks how being modern has shaped African modernism in writing, film, and other media. The historical scope of the book—from the 1880s to the present—reflects my understanding of modernity in Africa as a long decolonizing process, and coincides with a period when black diasporic music has circulated widely on the continent. I contend that new perspectives on transnational black solidarity from the vantage point of the continent as elaborated in this book are crucial to understanding

[5] George Shepperson, "Pan-Africanism and 'Pan-Africanism': Some Historical Notes," in *Phylon* 23.4 (4th quarter, 1962): 346.

[6] This line Pan-Africanism has also given rise to the series of All-African People's Congresses initiated by Kwame Nkrumah and to international diplomatic projects, such as the OAU, now the African Union. Further, the inclusion of the diaspora as a 6th region within the AU indicates the extent to which Pan-African geographic imaginaries continue to reflect Pan-African discourse within Back-to-Africa visions of nineteenth-century thinkers, such as Edward W. Blyden, Africanus Horton, Martin Delaney, and others.

particularized, local forms of African modernism. In other words, *contra* the Hertskovitsian tradition that traced African cultural retentions in the New World as a unidirectional and finite process, the Afromodern experience is collaboratively, coevally, and continually forged. I am also primarily interested in the kinds of cultural productions—texts, performances, films, and so on—generated in response to a self-conscious experience of being modern, rather than the structural and historical processes of change associated with modernization. Thus, while the "modern" operates through polysemy in this study, my attention leans toward aesthetic projects that could be called modernist, and specifically to transnational black cultural currents that shape local artistic production in what I call *stereomodernism*, as discussed below.

A third major line of thought seeks to historicize the relationship between pan-African solidarity and modernism by tracing how the media of transmission—print, recording, and live performance—have enabled music to do cultural work in giving rise to conceptual frameworks for articulating and promoting solidarity. Put more directly, I am interested not merely in musical performances, but also in recordings, transcriptions, literary and filmic representations in music, and in how recordings and discourses of music circulate among media forms and genres that occupy different statuses within a single medium. In recent years, a rich body of scholarship and autobiographies of musicians, such as Hugh Masekela, Miriam Makeba, E. T. Mensah, Guy Warren, Orchestra Baobab, and others, has emerged, and in *Africa in Stereo* I concentrate my account on music's impact upon other fields of cultural action rather than on specific musicians.[7] I consider the way music travels, as well as the way black music has come to be a privileged *figure* of transnational black sensibilities and modernist expression in three local African contexts, Ghana, Senegal, and South Africa. Why these locations matter is worth reflecting on more fully before I elaborate further on the interrelated rubrics of solidarity, modernity, and media.

Which Africa . . .

Some sites are more "pan-African" than others, and I focus in this study on Ghana, Senegal, and South Africa because throughout the twentieth century there have been numerous significant African American cultural exchanges with these three countries rooted in p/Pan-Africanism. As such, these three countries have produced potent iconographies of *"Africa"* writ *large* that far

[7] For similar reasons, I do not discuss the wide range of literary works Michael Titlestad has already addressed in his magnificent study *Making the Changes: Jazz in South African Literature and Reportage* (Amsterdam: Brill, 2005). My interest in media leads me to focus on newspapers, magazines, films, and websites that flourished alongside the genres he addresses.

exceed their territorial reach. One could certainly argue that a number of other African countries have also figured centrally in pan-African imaginaries—Guinea's early rejection of French colonial domination, Nigeria's prodigious literary and musical production, Tanzania's welcome to expatriated radical black American activists, and Ethiopia's centrality in Ras Tafarian cosmology are but a few salient examples. However, I trust that the sites I have chosen to focus on will prove indicative of potential lines of interdisciplinary research that other scholars may choose to take up elsewhere.[8]

Why Ghana? When Ghana became the first sub-Saharan British colony to gain independence in 1957, the black star at the center of its new flag adopted a symbol of black unity that Marcus Garvey's Universal Negro Improvement Association had first popularized. Under its first president, Kwame Nkrumah, Ghana issued calls to the black diaspora to "return" to participate in building the new nation in the name of pan-African unity. Shirley and W. E. B. Du Bois were but the best known of those who took up the invitation, and Ghana has remained an important "gateway to Africa" for many in the diaspora. In more recent years, the numerous architectural structures still standing that were used in the trans-Atlantic slave trade have also made Ghana an important site of pilgrimage.

And why Senegal? As with the iconic Nkrumah, Senegal's involvement with the diaspora has been similarly shaped by the influence of its first president, Léopold Sédar Senghor. Senghor's poetry and formulation of Négritude advocated both rootedness and openness (*enracinement et ouverture*), reflecting many ties to the Anglophone world of African Americans, as well as to fellow Francophone artists. Senghor's outsized influence shaped Négritude as cultural policy as well as expression, and the state-sponsored 1966 World Festival of Negro Arts (also known as *le Festival Mondial des Arts Nègres*, FESMAN) provided the first occasion for many black artists across the globe to participate in cultural pan-Africanism on such a grand scale. The fact that large-scale, state-supported arts festivals have been mounted at irregular intervals throughout postcolonial Africa shows how durable a format such festivals have proven to be. These festivals (and their place within Senegal's history in particular) are significant because they have had a remarkable capacity to generate counterdiscourses to top-down statist prescriptions of accepted forms of pan-Africanism.

[8] This book follows on the heels of several important musicological studies. Gary Stewart's *Rumba on the River: A History of the Popular Music of the Two Congos* (New York: Verso, 2003) demonstrates the influence of Caribbean musics in West and Central Africa, for example, and Carol Muller and Sathima Bea Benjamin detail how South African musicians in exile interacted with U.S., British, and European players from the 1950s onward in *Musical Echoes: South African Women Thinking in Jazz*, (Durham: Duke UP, 2011) . Another important work in this vein is Robin D. G. Kelley's *Africa Speaks, America Answers: Modern Jazz in Revolutionary Times* (Cambridge: Harvard UP, 2012).

Meanwhile, South Africa's struggle against de facto and de jure apartheid has motivated transnational black solidarity since the very first Pan-African Conference, where delegates from across the world gathered in London in 1900.[9] The petition to Queen Victoria drafted there began by asking her to intervene in "[t]he degrading and illegal compound system of native labor in vogue in Kimberley [in South Africa] and Rhodesia."[10] Alongside (and often within) the long anti-apartheid struggle, South Africans consumed African American cultural products enthusiastically, and this is particularly striking for the reception of jazz by black South Africans. However, South Africa also had powerful symbolic resonance abroad: when cultural pan-Africanism's energies began to recede in the global north and the more public expressions of the Black Arts era (such as adopting African names and fashions, for example) fell out of fashion, anti-apartheid solidarity motivated calls for divestment and sustained organizations such as TransAfrica. Thus, the reciprocal nature of transnational black solidarities is particularly clear in South Africa, and its status as a favored (if reluctant) destination for immigration from other African nations makes it a particularly provocative site for considering pan-African rhetoric and practice in the early twenty-first century.

What emerges through the case studies of *Africa in Stereo* is a perspective on diaspora that includes and inscribes Africa as a constitutive locus rather than viewing it as a "source" for diasporic populations and practices but not an active participant. I want to put pressure on binary conceptions of Africa and diaspora as opposite sides of the Atlantic, and—although my focus on African sites may appear to reinforce precisely this binary—I hope the case studies will reveal intimacies, collaborations, and contentions that clearly demonstrate how deeply entangled these cultures are. As Deborah A. Thomas and Kamari M. Clarke put it, diaspora can be thought of "as a process that generates subjects through negotiations arising from particular structural and historical conditions that change over time."[11] The exchanges between African Americans, Ghanaians, Senegalese, and South Africans, give insight into specific instances of what that process can look like, but they also evidence the nature of diaspora as a process that generates raced subjects keenly aware of both the possibilities and the limits of solidarity. Having noted that I understand diaspora as *process*, or as Brent Hayes Edwards puts it, *practice*, for the purposes of clarity I use "(the African) diaspora" in what, in an American academic context, is the familiar usage, designating black populations descended from Africans transported to the Americas and other parts of the global North

[9] Pan-Africanism's trace in South Africa lives on in the Pan Africanist Congress, an political party founded by Robert Sobukwe which remains active to this day.

[10] J. R. Hooker, "The Pan-African Conference 1900," in *Transition* 46 (1974), 20–24.

[11] Clarke and Thomas, "Introduction: Globalization and the Transformations of Race," in *Globalization and Race,* ed. Clarke and Thomas (Durham: Duke UP, 2006), 12–13.

during the trans-Atlantic slave trade and, to a lesser extent, in the migration from former colonies in the Caribbean, Asia, and Africa to Europe. This usage of diaspora marks my sense of important continuities between U.S. African American music and these other locations, including the fact that this music has always been defined by multiple waves of movement, migration, and immigration. What I am proposing is that, when considering the cultural productions of the diaspora, Africa should be understood as a constitutive component of that diaspora, rather than as a point of origin now removed from the contemporary diaspora.

To return to our opening broadcast, it is of signal importance that U.S. African American history should figure so large in Marley's "Buffalo Soldier," for the song exemplifies ways in which African America has long been paradigmatic of black diasporic experience in many fields of representation. Scholars have long noted the centrality (or in the more strident terms of Jacqueline Nassy Brown, the hegemony) of African America within the continuum of black diasporic experiences.[12] However, there is much work to be done on the particularities of the reception of African American cultural production in Africa, as the histories of Ghana, Senegal, and South Africa make clear. The chapters ahead trace how collaborative musical practices—congregational singing, jazz, soul music, blues, and avant-garde collective improvisation—served African writers and filmmakers as studies in, of, and for collaborative political and imaginative practice. Within a pan-African imaginary, this music appealed as a modernist expression already shaped by resistance and the signifyin(g) practices of blue notes, melismas, and improvisational riffs, a point I will return to below. Examining how these forms came to exert such influence in Africa not only helps to historicize the popularity of hybrid musical forms like Baaba Maal's Afropop, the Soweto Gospel Choir's songs, and Reggie Rockstone's hip-life, but also elucidates the work that music has done in the public and creative spheres. It is this broader cultural impact that is my primary interest. In short, the musical forms discussed in *Africa in Stereo* have been important at key historical moments, revealing how, beyond a mere pleasure principle, music has quite literally *rehearsed* transnational black solidarity emerging simultaneously in literature, film, and other cultural domains.

Solidarity: Thinking in Stereo . . .

Paul Gilroy's articulation of *The Black Atlantic* as a (perhaps *the*) privileged locus for thinking about "modernity and double consciousness" has served as both inspiration and provocation for this book. Twenty years on, the

[12] Jacqueline Nassy Brown, "Black Liverpool, Black America and the Gendering of Diasporic Space," in *Cultural Anthropology* 13.3 (1998): 291–325.

geographical frame of reference Gilroy explored so fruitfully in his 1993 text (building on a concept also articulated by Winston James and others) and the keen attention he pays to music have clearly enriched understandings of trans-Atlantic black cultural exchanges and diasporic processes. However, his claims have been contested from their first appearance and subsequent studies have continued to add nuance, texture, and contrapuntal voices to the Black Atlantic.[13] Where *The Black Atlantic* focused largely on the global North, I draw attention to African participation in the "counter-culture of modernity." Furthermore, pan-Africanism has been portrayed as a largely male-dominated tradition; however, I have tried throughout the book to recover overlooked archives of women's voices, and where this has not proved possible, to think carefully about how and why pan-Africanism is gendered.

I take as my point of departure Gilroy's suggestive description of the Black Atlantic as "the stereophonic, bilingual, or bifocal cultural forms originated by, but no longer the exclusive property of, blacks dispersed within the structures of feeling, producing, communicating, and remembering."[14] Extending this stereophonic framework to Africa, I am not only interested in the metaphorical sense of the stereo as a technological device for creating surround sound effects, but also how the Black Atlantic musics that might play on such a stereo emerge as significant conduits of transnational black solidarity.

One might well question the contemporary relevance of pan-Africanist solidarity. Certainly a compelling narrative about pan-Africanism holds that it was most effective in the simultaneous struggles against colonialism, apartheid, and legally sanctioned racist discrimination in the twentieth century. Once they were officially dismantled—and despite a growing realization that these systems have simply morphed into new forms of multinational capitalist exploitation, imperialism, and corruption—the political energy that these forms of solidarity fueled appeared to dissipate. Hence, to speak of pan-Africanism as an ongoing project now seems outmoded. Yet it is precisely because the challenges of new forms of exploitation are so acute and pervasive that renewed perspectives on liberation movements and solidarity are so urgently needed. If we understood more fully the history of small "p" pan-Africanism that unfolded in those cultural arenas easily dismissed as mere "leisure," we would recognize its entelechy, a renewable energy waiting to be tapped by social movements new and old confronting the confounding political quandaries of our day.

[13] There is a rich body of work on transnational black cultural traffic (to borrow the elegant formulation from the title of a collection edited by Harry Elam and Kennell Jackson) exemplified by the work of Brent Hayes Edwards, Jayna Brown, Michelle Stephens, Alex Weheliye, and Petrine Archer-Straw. See Edwards, *The Practice of Diaspora*, Brown, *Babylon Girls*, Stephens, *Black Empire*, Weheliye, *Phonographies*, and Archer-Straw, *Negrophilia*.

[14] Paul Gilroy, *The Black Atlantic: Modernity and Double Consciousness* (Cambridge, MA: Harvard UP, 1993), 3.

This demands that we ask some tough questions: Just what kind of solidarity can be generated by music? Or literature? Film? Magazines? Internet sites?[15] And what are the limits of solidarity? How does one address the danger in calling the consumption and recycling of cultural exports from the world's (and history's) most dominant capitalist power, the U.S., a form of solidarity? And how is this solidarity distinct from essentialist notions of black identity, given that any collectivity based on race risks scapegoating those judged to pollute the imagined purity of the group. When diaspora-continental relations are anchored in the notion of Mother Africa or even the Middle Passage as a site of origin to which all journeys aim to return, we are in dangerous waters, because when origins are singular there is little room for deviation, wandering, or detours on the way back "home."

We need, then, a model of solidarity that is neither rigid nor bound by orthodoxies, one which could bear witness to difference and respond to it in joyful creativity, one which values individual listening as much as enunciation as (pro)active dimensions of expressivity. The Martinican linguist and recording artist, Jacques Coursil, in fact argues for the acknowledgment of plural listening experiences rather than a single listening collectivity:

> La nécessaire singularité du parlant s'oppose à la possible pluralité des entendants. Cette pluralité des entendants (dont le parlant fait partie) définit l'espace du dialogue. Notons que l'écoute peut être plurielle mais non pas collective. En effet, pour un même groupe, une même salle de classe, une nation toute entière écoutant un même programme de radio, l'entendant est solitaire. Chaque participant, chaque élève de la classe, chaque auditeur entend ce qu'il entend strictement individuellement. Cette individualité de la fonction est liée à l'autonomie physique des sujets: je peux avoir mal entendu, mais personne ne peut entendre pour moi ni par moi. En clair, les entendants sont indépendants. [The necessary singularity of the speaker contrasts with the possible plurality of the hearers. This plurality of hearers (among whom the speaker is included) defines the space of dialogue. Let us note that listening can be plural but not collective. In fact, for the same group, the same classroom, the same entire nation listening to the same radio program, the hearer is solitary. Each participant, each student of the class, each listener hears what he or she hears strictly as an individual. This individuality of the faculty is tied to the physical autonomy of the subjects.

[15] The virtuosic use of social networking sites in the Arab Spring (2010-12) offered a bold answer to at least to the question of internet sites. Nonetheless, we should recall that many of the movements in the Arab Spring unfolded on African soil, in historically pan-African sites: Egypt's Gamal Nasser was a leading figure in early capital "P" Pan-African organizations, for example, and Tunisia's Carthage Film Festival to small "p" pan-African gatherings. So too, of course, was Colonel Muammar Al-Qaddafi support (and funding) of the African Union.

I may have misheard, but no-one can hear for me nor through me. Clearly, hearers are independent.][16]

Coursil astutely points out that scenes of listening allow for a plurality of reception, and an ensemble of responses, which are free and innumerable. Édouard Glissant would call such a scene a veritable *chaos-monde*, a "totality composed of individuals and communities."[17] Glissant suggests that the complexity of such *chaos-monde* can be deciphered through the analytic of what he calls *echo-monde*: "In Relation analytic thought is led to construct unities whose interdependent variances jointly piece together the interactive totality. These unities are not models but revealing *echos-monde*. Thought makes music."[18] Responding to Glissant's elegant formulation, *Africa in Stereo* is structured around individual case studies which, taken together, are indeed a set of interdependent variances pieced together into an interactive totality.

Along with many in the "born-free" generation of Zimbabwe, I have witnessed not only the joys of national liberation but also the many disappointments of the post-colonial condition. Given this perspective, I want to avoid a naïve vision of the relationships between nationalism, pan-Africanism, and human rights. Undoubtedly, Western human rights discourse too often deserves criticism for its indebtedness to imperialist logics: it would be better to clean house at home before imposing "order" in less geopolitically powerful sovereign countries. On the other hand, as Albert Memmi presciently warned in 1957, a newly independent leader may well

> be nationalistic but not, of course, internationalistic. Naturally, by so doing, he runs the risk of falling into exclusionism and chauvinism, of sticking to the most narrow principles, and of setting national solidarity against human solidarity—and even ethnic solidarity against national solidarity.[19]

In searching for a durable articulation of human rights and human solidarity, I have found the imaginative scope of Raoul Vaneigem's *A Declaration of the Rights of Human Beings: On the Sovereignty of Life as Surpassing the Rights of Man* compelling.[20] Vaneigem, an oft-overlooked member of the Situationist International, proposes an ambitious and poetic model of human rights that goes beyond the conceptualization of rights rooted in the Enlightenment. His insistence on the importance of individual pleasure and creativity seems wholly consistent with Glissant's theory of Relation as granting the right of opacity

[16] Jacques Coursil, *La Fonction Muette du Langage: Essai de linguistique générale contemporaine* (Pétit-Bourg, Guadeloupe: Ibis Rouge, 2000), 69.

[17] Edouard Glissant, *Poetics of Relation*, trans. Betsy Wing (Ann Arbor: U Michigan P, 1997), 94.

[18] Ibid., 92–93.

[19] Albert Memmi, *The Colonizer and The Colonized*, trans. Howard Greenfeld (Boston: Beacon Press, 1965), 135.

[20] Raoul Vaneigem, *A Declaration of the Rights of Human Beings: On the Sovereignty of Life as Surpassing the Rights of Man*, trans. Liz Heron (London: Pluto Press, 2003).

and leaving room for *errance* (wandering). In tracing the relation between individual delight and the possibility of solidarity, Vaneigem writes: "[d]elight in the self is not a withdrawal but an opening, through which pleasure taken in one's own company is discovered and refined through society with others."[21] He goes further to warn that:

> The ties of solidarity are a hindrance unless they are willingly bound by the affinities which animate a common desire for pleasure, independence and individual creativity. Wherever the will to live abolishes the will to power, those who come together save themselves most surely from the ways of thinking that have turned groupings, associations, collectivities and other fellowships into hotbeds of resentment, hatred and bogus attachment.[22]

I write with the conviction that pan-Africanism is no bogus attachment, but rather a form of solidarity whose history the stories presented here show in new density. Solidarity in the face of racism is but one of the grounds for affiliation, but it is by no means a stale one. The evidence against the notion of a postracial age mounts daily; by any measure, black and brown life has always been and continues to be more imperiled than white life. The racial disparities in incarceration, graduation, and life expectancy rates in the United States; the ongoing humanitarian crisis in Haiti; the deaths of thousands of innocents who have perished in drone attacks in the "war on terror" in Asia and Africa; and the uncountable people in the global South crushed by the consequences of late capitalism all make this clear. Yet the histories of solidarity among parallel struggles for freedom reveal that the difficult and urgent work of collaborating across difference has often gained momentum through the pleasures of music. *Africa in Stereo* is about serious play.

Dubbing Stereo in for Solidarity

The etymological root of the word *stereo* is the Greek word στερεός, meaning "solid." Its first use in English, judging from the Oxford English Dictionary's entries, was in the word "stereometry," recorded in a 1570 mathematics textbook, where it is defined as the discipline of measuring solids. In this sense, the implication of solid as a body with volume offers a slightly different inflection from the notion of solid as firm, hard, or durable. The links between the wide range of terms—stereophonic, stereotypic, stereoscopic and more—also suggest ways that stereo might be thought of as an effect, that which creates the impression of being surrounded by the contours of a voluminous, extensive three-dimensional body.

[21] Ibid., 49.
[22] Ibid., 55.

Stereo as a prefix flags fundamentally illusionary devices. In audio engineering, a stereophonic system creates the illusion of being surrounded by a three-dimensional shell of sound. In printing, a stereotype was historically a print made using a solid plate cast from a papier-mâché or plaster mold taken from the surface of the original typesetting form. It thus produced a series of increasingly distorted copies of an original solid object—from original, to papier-mâché or plaster cast, to solid metal plate, to impress—used to render an impression of that original object. And it is this series of distortions that, by the early twentieth century, embedded another kind of faulty repetition in the term's meaning. A stereotype in current usage signifies, according to the OED, "A preconceived and oversimplified idea of the characteristics which typify a person, situation, etc.; an attitude based on such a preconception. Also, a person who appears to conform closely to the idea of a type." This usage indexes the danger in illusions of fixity, which I try to attend to as closely as to the possibilities of solidarity. Finally, the stereoscope is an optical device that reproduces the phenomenon of seeing a three-dimensional object by juxtaposing two slightly different images which the eye and mind interpret as detailing the relief of the extrapolated third "true" image. In each of these three cases, depth is not actual so much as a produced effect or impression. "Stereo" in these technologies refers to tools for experiencing the phenomenon of solidity. And stereo as a metaphor indicates a means of experiencing solidarity, the choice to work en bloc.

A stereophonic sound system operates on the principle of minute temporal delays in the signal received by each ear, mimicking the way that in an acoustic space sound from any given direction arrives at one side of our heads milliseconds before it reaches the other side, and with slightly different amplitudes. This enables a stereo effect to be achieved with only two channels. The metaphor of a stereo effect achieved through slight difference refracts Brent Edwards's interpretation of décalage as an illustration of how "diaspora" articulates the body of global black presence, both connecting (just as joints are the connections between bones) and giving expression to (in a more familiar sense of articulation) "difference within unity." As he describes it, the

> black diasporic décalage among African Americans and Africans...is the kernel of precisely that which cannot be transferred or exchanged, the received biases that refuse to pass over when one crosses the water. It is a changing core of difference; it is the work of "differences within unity," an unidentifiable point that is incessantly touched and fingered and pressed.[23]

Décalage, in Edwards's usage, neatly amplifies stereomodernism because stereo effects in a sound system are precisely those effects achieved through subtle

[23] Brent Hayes Edwards, *The Practice of Diaspora: Literature, Translation and the Rise of Black Internationalism* (Cambridge, MA: Harvard UP, 2003), 14.

phase shifts between separate signals. The experience of surround sound, as we have already seen, is achieved by the maintenance of slight temporal differences which the ear interprets psycho-acoustically as information about spatial orientation.[24]

The notion of stereomodern listening as a creative, relational practice generating its own spatial orientation also has much in common with what the French economist and philosopher, Jacques Attali has called composition. Composition is the last of his five schema for how music works in the world, the others being listening, sacrificing, representing, repeating. Counterintuitively, Attali proposes that composing is a fundamentally collaborative and active practice, not a solitary, contemplative one. Composition is not so much the production of new music as a "new way of making music." As he puts it:

> We are all condemned to silence—unless we create our own relation with the world and try to tie other people into the meaning we thus create. That is what composing is. Doing solely for the sake of doing, without trying to artificially recreate the old codes in order to reinsert communication into them. Inventing new codes, inventing the message at the same time as the language…. Composition thus appears as the negation of the division of roles and labor as constructed by the old codes. Therefore, in the final analysis, to listen to music in the network of composition is to rewrite it: "to put music into operation, to draw it toward an unknown praxis," as Roland Barthes writes in a fine text on Beethoven. The listener is the operator.[25]

What is so exciting about Attali's insight is the value he places on creativity as production distributed across an audience: "In composition, to produce is first of all to take pleasure in the production of differences."[26] His vision of this open process, in which listening is not simply passive, but an active and necessary participation, matches the concept of stereomodernism I am working out here, and it is an imagination that has real, material consequences.

[24] Panning (a verb contracting the original sense of a *panoramic* array of visual or sonic images) is perhaps the best example of a stereo effect of this sort. "Panning" is a term borrowed from psychoacoustics and stereophonic recording, and refers to the use of spatial audio to "recreate or synthesize spatial attributes when reproducing audio over loudspeakers or headphones" (http://lib.tkk.fi/Diss/2001/isbn9512255324/). Most spatialization effects depend on subtle temporal inconsistencies between the audio signals sent to each of the two ears to create an interaural temporal difference, which the hearing subject registers and interprets as a spatial difference between the audio source and the subject.

[25] Jacques Attali, *Noise: The Political Economy of Music*, trans. Brian Massumi (Minneapolis: U Minnesota P, 1985), 134–35.

[26] Ibid., 142.

THE "MODERN" IN STEREOMODERNISM

What it means to be "modern" is a vexed question in Africa, but rather than revisiting the hackneyed oppositions between purportedly stable categories of the modern (implying Westernized, colonialized, urban, literate, and so on) and the traditional (implying local, vernacular, rural, oral) I am interested in how these categories are always already blurred through movements of bodies, ideas, texts, and cultural scripts. As numerous scholars have shown, schematic polarized notions of tradition and modernity are not only outdated and reductive, but also often inaccurate. For example, the work of Kofi Anyidoho, Catherine Cole, John Collins, Stephanie Newell, Kwabena Nketia, Kwesi Yankah, and others on popular culture and folklore demonstrate how oral literature continues to be a vibrant part of urban, mediatized, modern Ghanaian life. Thinking through Africa's place in the Black Atlantic necessarily muddles these polarities into an even headier mix, and by following the bacchanal currents that music stirs up, a new optic on the modern emerges. Neither peripheral nor alternative, the forms of modernism examined here are collaboratively worked out among black subjects on the African continent and abroad, subjects who share interrelated legacies of exclusion from the supposed *ur*-modernity of the West, as well as virtuosic repertoires of (re)-invented traditions that mark their modernist cultural productions. Following on from my discussion of "stereo" and solidarity, *Africa in Stereo* offers a new term, *stereomodernism*, as a useful heuristic for analyzing texts and cultural practices that are both political and expressive, activated by black music and operative within the logic of pan-African solidarity.

Over the last century, Africans have inserted themselves into a coeval global field of cultural action as an intentional challenge to the othering function of time as space that Johannes Fabian outlined some thirty years ago.[27] Rejecting crude racist philosophies that have left Africa in the dark since the "Enlightenment," black people across the globe have viewed artistic excellence on a global stage as a crucial tactic to demand the end of their modern subjection and the recognition of their modern subjectivity with all of its inherent human rights. In the shared task of a transnational response to racist discourses, African American music mattered to Africans as black music but also as modern music, an expression of the experience born of industrial and financial capitalism, rapid urbanization, and new, postcolonial systems of governance. Many of the African writers, filmmakers, and musicians in this study recognized in African American forms not only artistic merit but also a compelling model of articulating resistance forged in the crucible of slavery and the long struggle for civil and human rights, and so it was specifically the

[27] Johannes Fabian, *Time and Its Other: How Anthropology Makes Its Object* (New York: Columbia UP, 1983).

"counterculture of modernity"[28] as performed in black music that made it so appealing.

The continuum between modernism, modernity, and modernization speaks in disciplinary dialects that can turn what appear to be mere semantic slippages into substantive political and philosophical rifts, and one might say that modernism is as troublesome a category as pan-Africanism. While I find the diverging directions in which Gaonkar, Jameson, Hanchard, and others have pushed this term to be compelling, I use modernism as a simple heuristic device for indexing aesthetic choices that reflect self-conscious performances of "being modern."[29] Throughout the book I analyze stereomodernist texts, performances, images, and events whose grammars and audiences are determined by aspirations to transatlantic black solidarity. However, keeping my use of modernism and modernity intentionally flexible, I recognize that stereomodernism is necessarily informed by the debates over these terms and the politico-aesthetic movements that have traveled under the sign of the modern, as well as the particular ways that race has inflected these movements. Susan Stanford Friedman has usefully parsed current usages, noting that humanists see modernism as an aesthetic response to modernity—an (illusory) break with the past, a willed forgetting of tradition, continuity, order…the poetics of modernity—change—and the aesthetic inscriptions thereof"—while social scientists see modernism as an attempt to manage modernity—"state planning…totalization…centralized system…the Enlightenment's rational schemata. 'Progress'—'science'—'reason'—'Truth.'"[30] Yet ultimately, Friedman suggests, the field of the modern, its experience in modernity, and its cultural and social manifestations in modernism defy definitional struggles, and reveal more in the debates over meaning and scope than any possible resolution could offer, and I find her invitation to confront and maintain the dissonances in what Amiri Baraka calls the BangClash of these "the oppositional meanings of *modern/modernity/modernism*" highly suggestive. So too, are Sanjay Subrahmanyam's insights into the ways that modernity has always historically been a "global and *conjunctural* phenomenon, not a virus that spreads from one place to another."[31] Building on the work of Friedman, Subrahmanyam, and others, I am more interested in how various experiences and responses to modernity in its broadest sense are collaboratively constructed by African artists in dialogue with diasporans. However, the specifics of this particular

[28] Gilroy, *The Black Atlantic*.

[29] Dilip Gaonkar, ed., *Alternative Modernities,* (Durham: Duke UP, 2001); Michael Hanchard, "Afro Modernity: Temporality, Politics, and the African Diaspora" (in *Alternative Modernities*); Frederic Jameson, *A Singular Modernity: Essay on the Ontology of the Present,* (New York: Verso, 2002)

[30] Susan Stanford Friedman, "Definitional Excursions: The Meanings of Modern/Modernity/Modernism," in *Modernism/Modernity* 8:3 (2001): 494.

[31] Sanjay Subrahmanayan, "Hearing Voices: Vignettes of Early Modernity in South Asia, 1400-1750," in *Daedalus* 127.3 (1998): 99–100, (cited in Friedman, 507).

collaboration are far from simple, and stereomodern solidarity is certainly nei-
ther easy, smooth, nor uniformly celebratory.

Simon Gikandi has deftly traced how black subjects have figured in the his-
tory of twentieth-century Euro-American modernism, and throughout this
book much of the instability in meanings and means of modernism can be
traced back to the fault lines of race in that history. Gikandi's account of the
problematic function of race in Euro-American modernism brings into view
the ways that differently located black cultural productions were essential but
by no means fungible components in Western modernism's self-construction,
and in so doing he lays the groundwork for tracing the interrelationships
between these black cultures of modernism. Thus, the stereomodernism I am
calling for should not be taken for a simple, essentialist, or ontologically black
alternative, but rather as the result of political and cultural work necessitated
by precisely the problems he highlights.

Gikandi describes how Euro-American modernism (particularly its primitiv-
ist strand) was transformed from a transgressive, epiphanic cultural movement
grounded in encounters with what was constructed as radical Otherness into
a monumentalization of Western high culture as what he calls museum event,
maneuvered through a set of procedures to manage difference. He recalls that
"almost without exception, notions of primitivism either explore the influence
of African art objects on the works of modern painters and sculptors (which is
often the case in art history) or focus on the African American body as the sup-
plement for the African (which is the case in literary studies)."[32] However, one of
the dangers he highlights in too easy a conflation of race and geography is that

> in focusing on the diasporic black as the stand-in for the African, the critical
> tradition negates the curiously privileged role of the African American—
> in modernism—as an American. [This privilege is] curious because the
> African American body is endowed with the value of a primitivism that is
> more consumable because of its Western familiarity.[33]

Taking Gikandi's insights in a different direction, I would argue that for
both African American performers and their African collaborators, this com-
plicating factor of American-ness is never out of view. For the more politi-
cally committed figures in my book, this factor opens onto sharp critiques and
shared strategies of resistance to varying forms of racism; however, the story
is more complicated than just a series of heroic acts and stances against hege-
mony. The unique status of African Americans inflects in different ways the
logics of uplift in the second chapter, contentions over complicity with Cold

[32] Simon Gikandi, "Africa and the Epiphany of Modernism" in *Geomodernisms: Race, Modernism, Modernity*, ed. Laura Doyle and Laura Winkiel, (Bloomington and Indianapolis: Indiana UP, 2006), 33.
[33] Ibid., 33–34.

War agendas in the third chapter, the enthusiastic adoption of consumerism in the fourth chapter, the reckonings with slavery's meanings and repressions in the fifth chapter, and the appeal to the energies of black avant-garde experimentalism in the sixth chapter.

A final, but crucial, influence on this exposition of stereomodernism is the body of feminist scholarship on gender and sexuality in the Black Atlantic, beginning with the crucial work of d'Almeida, Andrade, Mudimbe-Boyi, Condé, Edwards, Sharpley-Whiting, Wilks, et. al. Michelle Stephens has usefully made explicit the masculinist tradition within diasporic internationalism, thus bringing a gender analytic to bear on what has often been naturalized as a neutral field of action. At the same time, Jacqueline Nassy Brown's work on black women in Liverpool reminds us that an Atlantic framework needs to include not only those who travel, but those who inhabit the contact zones enabling such travel, many of whom are women. Thus, I have tried to think about women whose roles as adjutants to more visible forms of pan-African action open onto a richer texture of cultural activities while pointing to feminist genealogies emerging from archives we have too long mined only for the great male figures that dominate them. In addition, Jayna Brown's capacious account of Afro-diasporic performing women, *Babylon Girls,* has served as a model for tracing transgressive political possibilities open to performers in terms of mobility, visibility, and interpersonal encounters. It is this model that draws my attention to figures like Charlotte Maxeke, Katherine Dunham, Ken Bugul, and Roberta Flack, who participate in stereomodernist moments but refuse to sign on to totalizing political projects that would paper over their own reinscriptions of oppression along the lines of gender, class, and immigration.

Stereomodernist Media

The changing media of musical transmission over the course of the long twentieth century are as key to historicizing cultural links as close readings of particular works. These media forms are as much technologies of solidarity as the music itself. Through them, the essential work of listening brings affiliation, affinity, and negotiated resolution into acoustic liveness, fully resonant (or, equally important, muffled) across geographic, ethnic, linguistic, and technical fissures. My interest in the role of media forms arises most organically out of the fact that across the period covered in *Africa in Stereo* the means of cultural access has often determined the meanings made, audiences reached, and ends music is turned to. However, I am also building on a long tradition of African popular culture scholarship, anchored in Karin Barber's work on pamphlet literature in Nigeria that has enriched studies of media forms as diverse as self-help manuals in Ghana (Newell), cassette tapes in Nigeria (Larkin), political cartoons in Cameroon (Mbembe), and radio programming

in South Africa (Hamm). More broadly, while John Guillory's recent history of the "media concept" is full of brilliant insights on the disciplinary overlaps of media, cultural, and literary studies, its exclusive focus on Europe and the U.S. leaves much room for work on local contexts such as those I trace in *Africa in Stereo*. I agree wholeheartedly with Guillory's call for

> scholars of a traditional art such as literature [to] take equally seriously both the mediation of literature [and other forms like music] by technologies such as print—as they already do in the context of book history—and the long-durational forms of writing, such as genre. No cultural work comes to us except through such multiple categorical mediations, never simply reducible to the effects of technical media. For this reason, a new instauration of the cultural disciplines depends on the integration of the media concept into a general theory of mediation.[34]

The discussion of specific media formats that emerges in *Africa in Stereo* is intended as just such a historicized theory of mediation (and mediatization) in the Black Atlantic, one that will, I hope, speak to other diasporic contexts in scholarship to come.

Theorizing transnational black solidarity in terms of stereo while keeping the Greek root of "solid" resonant enables analyses of intentional collaboration and collective improvisation, but also noise and static, reverberation and echo, feedback and interference—those difficulties as obdurate as solid rock. The recognition that practicing solidarity is hard work offers us an opportunity to consider pan-Africanism not so much as a movement that has or has not succeeded, but as a continuum of achievements and apparent failures that can only be understood in toto. That is, solidarity is necessarily a project that takes up the challenge to work together: it may work, work out, work poorly, work a nerve, and most important, it may just work it (because sometimes we're fabulous like that). And if solidarity itself is hard work, we must remain alert to the difficult formal and political moves in the cultural expressions of such solidarity. What may look like facile essentialism or tired nationalist rhetoric can usefully be read through and against modernist distinctions between high (or difficult) art and the popular (or artless). In other words, in revising our expectations of these texts to allow for the ways solidarity generates difficult and complex aesthetics, we may need to adopt (stereo)modernist reading practices, a rigor that has often been reserved for "high" modernism.

The notion of "stereomodernism" as responding to that which is constitutively modern in African engagements with the black diaspora is amplified by Steve Connor's broad claim that there is a "growing identification of the self

[34] John Guillory, "Genesis of the Media Concept," *Critical Inquiry*, 36.2 (Winter 2010): 361.

and the ear in some areas of characteristically modern experience." Connor proposes that the auditory sense is an attractive theoretical model because it allows for:

> a more fluid, mobile and voluminous conception of space, in which the observer-observed duality and distinctions between separated points and planes dissolved. Most importantly, the singular space of the visual is transformed by the experience of sound to a plural space; one can hear many sounds simultaneously, where it is impossible to see different visual objects at the same time without disposing them in a unified field of vision. Where auditory experience is dominant, we may say, singular, perspectival gives way to plural, permeated space.[35]

However, rather than arguing for the primacy of the auditory sense over the visual, which he notes has increasingly dominated Western epistemologies since the Renaissance, Connor suggests that paying attention to the auditory might allow us to better understand the close, interdependent relationship between sensory modes. His argument is buttressed by taking note of the profound impact of technological mediation upon modern sensory experience:

> The electrodynamic principles of the telephone, phonograph and microphone were the scientific equivalents of the principle of synaesthesia, or the correspondence of the different senses.... Sound is thus oddly positioned with regard to synaesthesia, for it is both one sense among many, and therefore itself subject to conversion into colour, tactility, electric impulse and so on, and also the privileged figure for the process of synaesthetic and electrodynamic exchange itself.[36]

Listening acutely does not diminish the value of the visual or other senses, but rather trains our attention upon the circulation of meanings among the senses, reminding us of how artificial it is to imagine that each sense is autonomous.[37] This sense of listening as opening up other sensory and imaginative channels resonates in stereomodernism as an account of how music activates other

[35] Steven Connor, "The Modern Auditory I," in *Rewriting the Self: Histories from the Renaissance to the Present*, ed. Porter Roy (New York: Routledge, 1997), 204, 207. I find Connor's argument about plurality (and, Jacques Coursil's related comments earlier in this chapter) a compelling contradiction to Derrida's contrasting interpretation in *Margins of Philosophy*, where he writes "at issue is the ear, the distinct differentiated, articulated organ that produces the effect of proximity, of absolute properness, the idealizing erasure of organic difference" (xvii). It seems unclear to me why the immersive experience of sound should suggest an *erasure* of difference, although this is a point probably better considered elsewhere. Derrida's later discussion of the tympanum adds more nuance.

[36] Ibid., 208.

[37] Ibid., 204; 207. Connor notes Frederic Jameson's argument that the autonomized senses echo commodity fetishism, and thus draw attention to the latter and to the alienation of labor. For Connor, however, the acoustic, and its relation to other senses, points to the possibility of a "more polymorphous transformation of value" (220). This seems like a fascinating argument to follow elsewhere.

fields of cultural production. Operating in stereo with other forms of collaboration, musical performance can rehearse and inaugurate solidarity across the representational fields of literature and film, and across more directly politically forums.

Playlist

Each of the chapters takes up a different medium of transmission as its governing metaphor, while the cultural histories presented span across Ghana, Senegal, and South Africa. While the chapters are arranged in chronological order, the period covered in each one overlaps with the surrounding chapters. As a whole their layered temporal boundaries range from the late nineteenth century to the present. My second chapter, "Sight-Reading: Early Black South African Transcriptions of Freedom," examines the uses of notation as a sign of modernity for black South African intellectuals writing in English and vernacular languages at the turn of the twentieth century. Sol Plaatje, John and Nokutela Dube, and Charlotte Maxeke relayed African American musical, religious, and political discourses from their studies and performances in the U.S. to their compatriots in South Africa, embedding transnational ties within the nascent nationalism of the ANC through transcription. The work of transcription was literal—writing across mediums or across an ocean—and specific, rendering oral and aural texts to a written medium. The politics of sound in Solomon Plaatje's thought emerges as I juxtapose his turn to musical notation and the International Phonetic Alphabet to standardize written Setswana with his musical performances in African American churches and citations of song lyrics. Similarly, John and Nokutela Dube's groundbreaking collection, *A Zulu song book* is central to their model of education patterned after Booker Washington's; and Maxeke's adept use of musical citation in her letters to African American colleagues demonstrates how central music was to establishing and maintaining trans-Atlantic relationships.

The third chapter, "Négritude Musicology: Poetry, Performance, and Statecraft in Senegal," integrates a close reading of Léopold Sédar Senghor's writings on jazz (poetry and essays) with a study of the 1966 World Festival of Negro Arts, which Senghor envisioned as an actualization of Négritude and what he called "the black soul." Beginning with his earliest speeches in the 1930s, I show that the recurrent metaphors of jazz in his work rely on musicology and reportage rather than live and recorded performance. Nevertheless, I argue for a major revision of Senghor's legacy as more complex than the traditionalist figure he is sometimes taken for when the transnational dimension of his interest in jazz is overlooked. My analysis of the World Festival of Negro Arts—one of very few extended discussions of this foundational event—shows that while the festival was beset by ideological contradictions as a proxy of

Cold War politics, it was also an important forum for critiques of Négritude by attendees including Katherine Dunham, Langston Hughes, and Hoyt Fuller. These African American perspectives amplify our understanding of the festival's significance and its legacy in relation to later large-scale festivals held in Algeria (1969), Nigeria (1977), and beyond. Here again, reportage becomes an important medium through which Black Atlantic music's significance is worked out.

The fourth chapter, "What Women Want: Selling Hi-Fi in Consumer Magazines and Film" focuses on women as consumers and participants in the leisure world of the L.P., the radio, the magazine, the cinema. The chapter covers two rarely discussed magazines, South Africa's *Zonk!*, which was a contemporary competitor of the well-known *Drum* magazine, and *Bingo*, a Francophone magazine published from 1953 onward. I show how the home listening technologies regularly featured in these magazines gendered domestic space at a critical world-historical moment for nationalist, antiapartheid, and U.S. civil rights movements after the Second World War. Mirroring glossy black American consumer magazines like *Ebony*, illustrated magazines gained popularity in South Africa and Senegal in the 1950s. I trace the centrality of gender in *Zonk!*'s genesis as a live show for (male) South African troops serving in World War II, its expansion into a magazine, and its concurrent transformation into a musical film featuring the ultimate example of product placement, a song entitled "The Girl on the Cover of *Zonk!*" In contrast to the relatively flat portrayals of female agency in films of this era, *Zonk!*'s magazine pages were less smooth, more ambivalent. The largely unmentioned shadow of apartheid also contrasts starkly with the anticipation of independence animating many *Bingo* pages. Despite these contrasts, I argue that in both magazines, projections of glamour and worldliness that exceeded lived experience opened the sheen of modernity to critique as women discovered the gap between the fetishized surfaces of modernity and the corrosive experiences of colonialism, apartheid, and patriarchy.

" 'Soul to Soul': Echolocating Histories of Slavery and Freedom from Ghana," the fifth chapter, considers the "Black Atlantic" as constituted by the historical and memorializing narratives of the Middle Passage. I discuss how Ghanaian poets Kofi Anyidoho and Kwadwo Opoku-Agyemang engage with African American heritage tourism to work through traumatic legacies of slavery from an African perspective. The seven-year sojourn of Kamau Brathwaite in Ghana makes his poetic reflections as a diasporic subject an important point of comparison. I argue that metaphors of echo and other sound effects allow for both ethical relation and disaffection. The vision of diaspora articulated by these three poets is compared with two other bodies of work. The first is the documentary of *Soul to Soul*, a 1971 collaborative performance in Accra by Tina Turner, Roberta Flack, and others; the second is a group of memoirs and drama set in Ghana by Ama Ata Aidoo, Maya Angelou, and Saidiya Hartman.

Documentaries, sound recording, sound reproduction, echo, and commemorative poetry all operate on a continuum that gives rise to a theory of memory and its limits when confronting historical loss.

The sixth chapter, "Pirates Choice: Hacking into (Post-)Pan-African Futures" shows how new technologies have given rise to a set of practices that pirate, informalize, and distribute the sonic archives of transnational black solidarity traced throughout the book. I begin with a discussion of pirated audio technologies and underground listening sessions in two Senegalese films, *Camp de Thiaroye* (1987) by Ousmane Sembene and *Ça Twiste à Popenguine* (1992) by Moussa Sene Absa, where nostalgic evocations of gramophone listening recall the heady political possibilities of earlier moments. These historical fiction films show the roots of a cultural logic of piracy that becomes more apparent in the contemporary digital era. I trace the development of this pirate logic in three recent works by the Ghanaian-British filmmaker John Akomfrah, Senegalese feminist author Ken Bugul, and the South African-based duo known as the Heliocentrics, Neo Muyanga and Ntone Edjabe. Music forges new publics in the Afro-futurism of Akomfrah's 1987 film, *The Last Angel of History,* which traces the "mothership connection" between Africa and experimental diasporic music from Sun Ra to George Clinton. Ken Bugul's 2005 novel *Rue Félix-Faure* is suffused with Billie Holiday's blues and Cesaria Evora's Cape Verdean *mornas,* the soundtrack for the emergence of transnational feminist solidarity. And the Heliocentrics's ongoing internet radio project, the Pan-African Space Station hacks into the future archive of solidarity as an exploration mission that has yet to dock. The epilogue, for its part, will not give up its secrets just yet. Except where indicated otherwise, all translations in the book are my own.

An accompanying website for the book provides additional images, and video and audio files to supplement the examples analyzed in the following pages.

Sight-Reading

EARLY BLACK SOUTH AFRICAN TRANSCRIPTIONS OF FREEDOM

The generation of black South African intellectuals who came of age at the turn of the twentieth century confronted the double challenge of colonized modernity and racial expropriation. They reimagined oral vernacular literary forms and histories in a new medium, the printed page, and often a new language, English.[1] Formal experiments in newspapers, novels, musical scores, transcribed lyrics, letters, and nonfiction inscribed print culture with the aural sensibilities of a self-consciously inventive black modernism. Faced with colonial racism and land expropriation, they saw cultural production as a means to demonstrate their sophistication as grounds for demanding full human rights, but also as a way to raise collective consciousness for concrete political action. In this chapter I argue that they drew on the medium of musical transcription as practice and metaphor to transfer the aural grammars of interpretation in primary oral cultures to a new set of challenges in a world where the written word was increasingly available to their compatriots. They were aware of and inspired by blacks of other nationalities who were confronting the same aesthetic and political urgencies. As early stereomodernists, they drew upon such links in solidarity as they mined African American music for content, methodologies, performance strategies, and citations.

The "civilizing mission" in nineteenth-century propaganda reproduced myths of black primitiveness and claimed to bring not only the light of the gospel but Enlightenment itself. Confronting such hubris, early black nationalists felt that performing as modern political subjects involved not only making claims before the state, but also claims to recognition as cultural producers.

[1] Writing in other parts of Africa, needless to say, had a long history. For a rich consideration of the legacy of scholarship in Timbuktu, see Zola Maseko's 2009 documentary *Manuscripts of Timbuktu* (California News Reel). In South Africa, Arabic script was used to write down Islamic teachings in Afrikaans from the early nineteenth century, and missionaries advocated the printing of African language Bibles and other materials from the same period onward. However, the generation of intellectuals discussed here were innovators across a range of secular genres and print media formats.

Creative and journalistic writing, music, oratory, and drama were marshaled
to carve out an identity that was simultaneously new (the most basic meaning
of "modern") and African (locally rooted), yet internationally race-conscious.
This chapter begins by elaborating on transcription as a medium of stereo-
modernism and then considers transcription in the work of four exemplary
figures: John Langalibalele Dube, Nokutela Dube née Mdima, Charlotte
Manye Maxeke, and Solomon Tshekisho Plaatje.

It has long been recognized that Western musical accomplishment was
a key sign of Victorian savoir-faire for self-consciously modern Africans of
the period. Les Switzer notes that in addition to newspaper reading, "choral
and reading groups, debating societies, sewing and singing groups" were all
practices that signaled elite social status.[2] A broad range of scholarship also
highlights the musical ties established between blacks in the U.S. and in South
Africa in the 1890s and early 1900s.[3] My study shifts the focus to what writ-
ing music itself—as score and as textual referent—meant for a generation of
self-styled modernist South Africans who saw their own aspirations as insepa-
rably linked to international pan-Africanism. This generation placed a pre-
mium on fluid transitions between languages, ethnic identities, media, and
art forms, a value they shared with other global movements of racial uplift.
The aesthetic and political innovations in their modernism were couched in
transcription, a set of writerly practices shuttling between sound and text.
Transcription enabled an ambitious reimagining of the possibilities of citizen-
ship and solidarity, both with other races within South Africa and with anti-
racist and anticolonial movements in other regions. Transcription functioned
in two ways. First, it was as an analog to translation, mediating between the
different sensory grammars of hearing and sight. Second, it was an alternative
to translation, conveying music as a sonic sign unbounded by linguistic speci-
ficity as such, and could readily access common structures of feeling across
diverse communities.

With the rapid development of an incipient nationalist movement, it became
urgent to consolidate a black politicized identity, although the rise of print
media in vernacular languages added a new potential challenge to collabora-
tion across linguistic differences.[4] Several leaders of the South African Native
National Congress (hereafter SANNC) and related political organizations

[2] Les Switzer, *South Africa's Alternative Press: Voices of Protest and Resistance, 1880s–1960s*
(Cambridge UP, 1997), 46.

[3] Veit Erlmann writes on Orpheus MacAdoo and his singers in *African Stars: Studies in Black South
African Performance* (Chicago: U of Chicago P, 1991) and *Music, Modernity and the Global Imagination*
(Cambridge: Cambridge UP, 1999). His examination of self-representational writing among these
musicians has been particularly generative for this study. Other important works on these connec-
tions later in the twentieth century include David Coplan, Chris Ballantine, Michael Titlestadt, Tim
Couzens, and Ntongela Masilela.

[4] Ntongela Masilela has done extensive work to document what he terms the New African move-
ment, a South African counterpart to the New Negro movement in the U.S. His online documentary

founded or edited local-language newspapers. By the early 1900s, Solomon Plaatje's Setswana paper *Koranta ea Becoana*, John Tengo Jabavu's isiXhosa paper *Imvo Zabantsundu*, and John L. Dube's isiZulu paper *Ilanga Lase Natal* were all important for emerging black political agendas, as well as literary expression in the absence of other publishing houses.[5] Similarly, several writers shared a commitment to transcribing oral literary traditions in new literary forms: biographies, poetry, ethnohistorical nonfiction, and historical fiction in both English and vernacular African languages. Early generations of authors included John Knox Bokwe, D. D. T. Jabavu, John Dube, Walter Rubusana, Sam Mqhayi, and others. These moves to celebrate vernacular heritages in print might easily have fractured rather than unified the literate black body politic by sharpening ethnic differences into linguistically isolated or culturally segregated reading publics informed by discreet and distinct discourses.

Under these circumstances, musical references in reviews, letters, and advertising served as a point of convergence, bridging the linguistic differences through a medium that was mutually intelligible. In addition, they documented the shared use of music for raising funds, collocating assemblies, and lifting morale across a range of distinct religious and political associations. Furthermore, the print aesthetic of these early newspapers trained readers to value visual and conceptual polyphony (and even cacophony) as the layouts were densely packed with graphic mastheads, advertisements in multiple fonts, and irregularly sized columns. Both aural and visual registers, then, were presented as spaces where heterogeneous mechanics could serve tolerant movements toward unity and solidarity, the mediums of stereomodernism.

The four figures in this chapter experimented with multiple forms of musical transcription as a means of toggling between aural and scripted texts. Born within a few years of each other and educated on missions, John Langalibalele Dube (1870–1946), Nokutela Dube (1873–1917), Charlotte Manye Maxeke (1872–1939), and Solomon Tshekisho Plaatje (1876–1932) were all accomplished performing musicians, public figures, and writers. John L. Dube is best known as the founding president of the SANNC (renamed in 1923 the African National Congress, hereafter ANC). He made his mark as an educator, a newspaper editor, and the first isiZulu novelist. However, it

history, archived and continually updated at http://pzacad.pitzer.edu/NAM/ is a valuable step in broadening access to this scholarship. While my use of "new African modernism" is informed by his frame, I refer in this chapter to a body of work published between 1899 and 1930, which is a narrower period than his use of New African Movement. This period overlaps with North Atlantic modernism, and South Africans were responding to the same world-historical factors that triggered the aesthetic and political innovations of other modernisms, so these African works demand the same attention and nuance assigned other, equally challenging contemporaneous world literature.

[5] The dates they were first published ranged from 1884 (*Imvo Zabantsundu*) to 1903 (*Ilanga Lase Natal*).

is rarely recalled that he and his wife Nokutela also compiled and arranged the first collection of secular Zulu songs. There is considerably less information available about Nokutela, but much of it concerns her gifts as a pianist, vocalist, and arranger. Charlotte Manye Maxeke made her deepest impact on South African history by facilitating the merger between black South African separatist churches and the U.S.-based African Methodist Episcopal (AME) denomination. Her travels to the United States as a member of a touring choir led to her studying at Wilberforce College. There she established close relationships with African American women, and forged an enduring transnational black feminist connection. Finally, Sol Plaatje authored *Mhudi*, the first novel in English by a black South African, and like Dube he was a prominent political figure and journalist. Yet when publishers rejected his novel he turned, among other things, to performances of Setswana[6] songs in Harlem's Abyssinian Baptist Church and similar venues to raise the money to self-publish *Mhudi* in 1930. A deep involvement in musical performance was a significant common thread among these figures, and it is by no means incidental that their musical commitments were mirrored in other black national and international contexts.

At the turn of the century, blacks around the globe formulated avowedly modern political and aesthetic agendas. In 1900, the Pan African Association was founded at the London Pan African Conference. Five years later, the Niagara Movement was established in Buffalo, New York, with at least one member, W.E.B. Du Bois, who had been at the London conference. In South Africa, the regional political organizations which would eventually join to form a national congress gathered members throughout the decade. As publishing flourished, genres including poetry, sociological works, novels, magazines and newspapers by and about blacks became increasingly available. Live music allowed performances (and disavowals) of new versions of racialized authenticity, as many blacks made claims for recognition as creative, rational, fully human subjects with inalienable civil and human rights on the grounds of musical accomplishment. Choral singing was a particularly important form, with composers of African heritage across the world showing their mettle. To take but a few examples, South African composer John Knox Bokwe, Britain's Samuel Coleridge-Taylor, Henry T. Burleigh in the U.S., and Francis H. Gow, South African by birth and Jamaican by descent all gained recognition, at least in part, because of the prestige that notated choral part singing enjoyed. Choral performance in the Victorian age was a popular outlet for amateur musicians, and there was particular interest among European and

[6] A note on spellings: many of the languages referred to in this chapter did not use what are now the codified orthographies until many years after the events discussed here. In general I have used the contemporary spellings (such as Setswana) when writing in my own voice, but maintained the original spellings (such as Sechuana, and Becoana) when citing other texts in their original.

Euro-American listeners in historically and culturally specific black music, such as African American spirituals and South African part singing. These concurrent musical cultures not only flourished in tandem, but also at times intersected. Connections were often strictly textual, as in newspaper reviews and letters, sometimes in musical notation (manuscript and sol-fa) and occasionally in live performance exchanges on the same stage.

The substance of this story follows the educational and professional trajectories of the Dubes, Manye Maxeke, and Plaatje. However, it also historicizes their work in the context of contemporaneous efforts toward international black solidarity among diasporic blacks from the Caribbean, the U.S., England, as well as (primarily West) Africans during the same period. Forging relationships among these communities often required hard work, a dimension of stereomodernism that entailed bridging physical distance, cultural unfamiliarity, and personal frictions via letters that regularly transcribed ideas across mediums and from language to language. These bonds were consistently motivated by a vision of liberation and race-pride that anticipated full recognition of citizenship rights for all people, regardless of gender, race, or nationality.

A Ghosted Note: John Langalibalele Dube and Nokutela Dube née Mdima

Given the prominence of the ANC in the last century, it is remarkable that the first commercially available biography of the founding president, John Langalibalele Dube, was only published in 2011, Heather Hughes's *The First President: A Life of John Dube*. His life story reads almost like a fable.[7] A young man born of a disinherited aristocratic Zulu lineage is so inspired by his American missionary teacher that he follows this Dr. Wilcox to Oberlin, Ohio as a naïve sixteen-year-old. He struggles to support himself through menial labor, including work at a printing press. Meanwhile, his old mentor discovers he is a gifted public speaker and invites the young man to join him on speaking tours. He returns home, marries the talented Miss Mdima, and soon afterward they journey to the U.S., where he studies at Union Seminary in New York. During his sojourn, he encounters Booker T. Washington, and wins the support of the "Wizard of Tuskegee" for his own industrial school, the Ohlange Institute, which he establishes in 1901. Having realized this dream, he founds a bilingual isiZulu-English newspaper

[7] Heather Hughes, *The First President: A Life of John Dube* (Johannesburg: Jacana Press, 2011). This is not to suggest that Dube was previously completely neglected by scholars. Manning Marable's dissertation on Dube, "African Nationalist: the Life of John Langalibalele Dube" (1976, UMD) is the most complete source. See also R. Hunt Davis, Shula Marks, Heather Hughes, as well as Cherif Keita's film *Oberlin-Inanda: The Life and Times of John L Dube* (2005).

named *Ilanga Lase Natal (The Natal Sun)* two years later. His star continues
to rise, and in 1912 he is elected president of the first nationwide black polit-
ical assembly, the SANNC, and goes on to make several diplomatic tours
on its behalf. Personal differences lead him to abandon national politics,
however, and he turns to preserving the language, culture, and customs of
the Zulu people in modern forms. He authors the first novel in Zulu, *Insila
kaShaka (Jeqe, the Body-Servant of Shaka)*,[8] in addition to a song collection
and a half dozen works of nonfiction. The moral of this fable lies in his nick-
name, Mafukuzela, which means "one who struggles against obstacles with
tireless energy," and indeed right until his final days he advocates education
as the best means to overcome the dire conditions of an unequal society.
This account, however, glosses over the irony of Dube's life. In spite of serv-
ing as the first president of the ANC, by the end of his life a new generation
of young leaders confronting the rise of the National Party looked back and
sometimes judged him as having been too accommodating.

Rather than weighing the relative merits and demerits of his political posi-
tions throughout a long career, I want to turn attention here to Dube's aural
imagination, which is easily overshadowed by his prodigiously diverse set of
other interests. The rhetorical structure of stereomodernism in South Africa
during this period is best understood as encompassing aural reception, spoken
oratory, and sung music. Dube's role in the founding of the SANNC remains
important for this study, for in it we see how central transcriptions of African
American political rhetoric were to a South African context. At its origins,
one key issue that galvanized the consolidation of multiple regional forerun-
ner organizations into creating a national congress was the Act of Union of
1910. Before the Anglo-Boer War, Britain had held control of the Cape Colony,
where a long-established liberal tradition allowed a certain class of black man
voting rights, and Natal, which had always been segregationist. The joining
of the comparatively liberal Cape Colony and the segregationist Natal to two
former Afrikaner republics, The Transvaal and the Orange Free State, jeopar-
dized the class and political status of all nonwhites, but was especially alarm-
ing to elite blacks who recognized that many of their privileges could easily be
stripped away. As a British dominion, the new Union of South Africa was no
longer as beholden to the crown as the colonies had been, and could extract
rapacious profits out of the gold mines of the Rand and diamond mines of
Kimberly to fill its own national and private coffers while expropriating black

[8] John Dube, *Insila kaShaka* (Marianhill: Marianhill Mission Press, 1933). A few years before,
Magema Fuze had inaugurated Zulu literature with a lively chronicle, *Abantu Abamnyama Lapa Bavela
Ngakona* [1922] (*The Black People and Whence They Came* [1979]), but *Insila kaShaka* is the first work
in isiZulu that can properly be called a novel. I count it as a novel in spite of its relative brevity (about
one hundred pages depending on typesetting).

landowners. The Union disallowed African representation in all state institutions, except for in the Cape, where a limited "qualified" nonracial franchise continued.

Dube's strategy developed through his work with other nationalists. It was Dube's cousin, Pixley ka Isaka Seme, who seized upon the momentum of existing black political forums to initiate a concerted protest movement immediately upon his return from legal studies in London.[9] Seme's invitational announcement in 1912 addressed the most influential members of society, the "[c]hiefs of royal blood and gentlemen of our race," calling on them to lead the people toward unity across ethnic and linguistic boundaries. By beginning with this herald, he may have been transposing into his prose the Zulu genre of *izibongo*, praise songs that traditionally vaunted the history, best deeds, and also unfulfilled duties of leaders. However, he also drew from the lexicon of African American progressive discourse when he declared:

> We have discovered that in the land of their birth, Africans are treated as *hewers of wood and drawers of water*. . . . We have called you, therefore, to this conference, so that we can together devise ways and means of forming our national union for the purpose of creating national unity and defending our rights and privileges.[10]

Seme was transcribing from at least two earlier iterations of the African American protest tradition here.

His 1912 speech echoes the diction in the first chapter of W. E. B. Du Bois's *The Souls of Black Folk*, and the phrase "hewers of wood and drawers of water" suggests he may have been familiar with "Of Our Spiritual Strivings."[11] In it, Du Bois had written:

> The double-aimed struggle of the black artisan—on the one hand to escape white contempt for a nation of *mere hewers of wood and drawers of water*, and on the other hand to plough and nail and dig for a poverty-stricken horde—could only result in making him a poor craftsman, for he had but half a heart in either cause.[12]

Citing "hewers of wood and drawers of water" also suggests that Seme had a good ear for what would resonate with African Christians steeped in Old Testament language, and no doubt familiar with the curse on Noah's son,

[9] Seme was an accomplished rhetorician, and as a student at Columbia University in New York, he won the 1906 Curtis Medal for the best oratory by a graduating senior.

[10] Cited in Richard Rive and Tim Couzens, *Seme: The Founder of the ANC* (Trenton: Africa World Press, 1993), 10, my italics.

[11] Seme's colleague Solomon Plaatje also quoted from the writings of Du Bois (in *Native Life in South Africa*), demonstrating that Booker T. Washington was not the only secular African American leader who held sway over South Africans.

[12] W. E. B. Du Bois, *The Souls of Black Folk* (New York: Bantam Classic, 1996), 4.

Ham. Du Bois's chapter hit upon a challenge confronting the SANNC's leadership: men educated in classical liberal arts, law, and medicine and more practically trained preachers and teachers had to strive to build consensus in order to build a movement. Seme belonged to the former category, having attended secondary school in Mount Hermon, Massachusetts, then Columbia University in New York, followed by law school in Britain. Du Bois's distinguished erudition was a model many in Seme's generation aspired to.

For Seme's cousin Dube, however, Du Bois's characterization of manual work did not ring true. Dube had supported himself with manual labor for years during his studies in Ohio at the Oberlin Preparatory School, and then received practical training for the ministry at Union Theological Seminary. Dube gravitated to Booker T. Washington's view that skilled manual labor was the ideal entry point for full economic participation in modern industrialized modes of production. In his first presidential statement to the SANNC, Dube announced that "Booker Washington is to be my guiding star," and adopted Washington's maxim of *"festina lente,"* that is, make haste slowly. Dube first wrote to Washington in late 1897, so it is likely that the American's position during Dube's second stay in the U.S. (1897–99) was the guideline he had in mind rather than the often-extracted speech at the Atlanta Exposition of 1896.[13] Washington's speech before the Union League of Philadelphia in 1899 used similar phraseology to Du Bois's 1903 text, but toward different ends:

> It is said that we will *be hewers of wood and drawers of water*, but we will be more. We will turn the wood into machinery; into implements of agriculture. We will turn the water into steam; into dairy and agricultural products, and thus knit our life about that of the white man in a way to make us realize anew that "God made from one blood all people to dwell and prosper on the face of the earth."[14]

Seme, Du Bois, and Washington agreed on at least one point: blacks should not, and would not be limited to being "hewers of wood and drawers of water." They found a common language to voice their individual visions of black destiny in the biblical phraseology of Joshua 9:23. This practice of transcribing scripture to cast black liberation as a divinely sanctioned destiny was also seen in the frequent South African and African American citations of the psalmist's prophesy: "Princes shall come out of Egypt; Ethiopia shall soon stretch out her hands unto God" (Ps. 68:31 KJV).

[13] For more on Washington's impact in other parts of Africa see Andrew Zimmerman's *Alabama in Africa: Booker T. Washington, the German Empire and the Globalization of the New South* (Princeton: Princeton UP, 2010).

[14] Con. 978 BTW Papers DLC. Published by the Union League Club for distribution to its membership. [See http://teachingamericanhistory.org/library/index.asp?document=936], accessed 7/18/10.

John L. Dube was so inspired by Washington's model of industrial education that he visited Tuskegee and Hampton Institutes during his 1897–99 sojourn in the U.S.—and even gave commencement addresses at both. He corresponded with both Washington and Rev. R. Moton, who succeeded Washington as president of Tuskegee, to solicit support for the Ohlange Institute. Dube's contemporary, Don Davidson Tengo Jabavu, was another early admirer of Washington. Jabavu noted in his 1913 field study of Tuskegee that senior students training as teachers received instruction in "English, Mathematics…, Economics…, Natural Science…, Hygiene, Education, Kindergarten, Music (vocal and instrumental), Public Speaking."[15] The inclusion of music in a curriculum designed for economic self-sufficiency was one aspect of Washington's approach that Dube embraced. In assembling a collection of Zulu songs, *Amagama Abantu* (which will be discussed further below), Dube and his wife clearly intended that they could be used for school music as the title of the last song in the collection—"Umthandazo Wosapho iwaOhlange" (A prayer for the Children at Ohlange)—makes evident.

Dube's embrace of Washington left him out of step with the evolving ideology of the SANNC and more leftist organizations like Kadalie's Industrial and Commercial Workers Union and the South African Communist Party. Likewise, early twentieth-century American race leadership has come to be seen as an opposition of two archetypes, Du Bois versus Washington. Washington's infamous exhortation for blacks to "cast down your buckets where you are" (a soundbyte that edits out not only the fact that this was also what he prescribed to whites, but also the more complex range of opinions he held throughout his career) fell short of the more forceful calls for civil rights that Du Bois and others supported. As a Washingtonite, not only did Dube enthusiastically adopt an industrial educational model that was later seen as insufficiently progressive, he also severed ties somewhat acrimoniously with the national leadership of the SANNC in 1917. Although he maintained an active role in the Natal chapter, his resigning from leadership at this early stage added to the impression that he cultivated an accommodationist relationship with the white South African government. All of this makes him a complicated figure to assimilate into a lineage of national heroes.[16]

[15] D. D. T. Jabavu, *The Black Problem: Papers and Addresses on Various Native Problems* (Lovedale: Lovedale Press, 1920), 34.

[16] Biographical accounts often dwell on the complexity of parsing Dube's ideological position within the context of his times. The official ANC website, for example, contends that "What should be noted is that Dube's strategy and ideology were outflanked by the times. He had not changed from being a radical to being a conservative as Eddie Roux suggests in his debatable book *Time Longer Than Rope*. He died believing in racial equality; demanding justice and striving for African unity. These were revolutionary goals directly challenging the basis of white power and he believed in this to the end of his life. He fought all his life for the unity and liberation of the Africans—a unity and liberation he saw as coming through education, through working with sympathetic whites, through adoption of Christian values and, more importantly, through political organization under the umbrella of the ANC." See http://www.anc.org.za/showpeople.php?p=31 (accessed 7/11/13).

But what of Dube the musician? One indication of the obscurity of Dube's musical output is that the only mention of his musicianship in Carol Muller's indispensable text, *Focus: Music of South Africa* appears in miniscule print in the final lines of the very last paragraph of the notes to the last chapter. She notes that "John Dube, African National Congress founder…was also a composer, though he was better known for his secular works."[17] Like a suspended chord, the comment is left lingering. It is also too rarely noted that his first wife, Nokutela Dube née Mdima, was an important collaborator in musical and educational work. The Dubes' intellectual legacy shows a form of stereomodernism in which musical transcription was key to their individual and cooperative work, as we can see in the three pieces presented here in chronological order: an early essay by Nokutela, the (c.) 1911 *Amagama Abantu* isiZulu songcollection, and John Dube's 1930 novel, *Insila kaShaka*.[18]

Nokutela Dube née Mdima was a teacher, dressmaker, and musician, clearly a highly educated and gifted woman in her own right. Following her marriage, she joined Dube in raising money to found their new school, the Ohlange Institute. It was this endeavor that brought them to the United States on what was John's second extended stay. While John studied theology, eventually being ordained as a Congregationalist minister, Nokutela busied herself with various church women's organizations. When an invitation to contribute to the American mission periodical *Life and Light for Woman* came in 1898, she protested that she "would prefer to tell of my people and their needs."[19] Whether this was sincere or an adoption of the genre's convention of demure self-deprecation, she agreed to write an autobiographical essay. Much of the essay deals with her education, her mission with her husband to a remote Zulu community in the Transvaal, her analysis of Zulu cosmology and its implications for proselytizing. She then seeks to mobilize her audience's shared religious commitment to support the Dubes' mission by arguing they are uniquely suited to convert and educate those whose culture they understand intimately. However, Nokutela reserves her final sentences to note her profound appreciation for music as a practical skill and as a potential tool in furthering Christian evangelism and its attendant initiation into modernity:

> *Music is a great power among our people,* and God has opened the way for me *to learn better how to sing into their hearts* and teach them to sing of Jesus. Two kind ladies in Brooklyn, Miss Granger of the Tompkins Avenue

[17] Carol Muller, *Focus: Music of South Africa,* 2nd ed. (New York: Routledge, 2008, first edition, 2004), 326.

[18] *Insila kaShaka* is an innovative experiment with the historical novel form, ripe for critical attention not just because it is one of the first works of vernacular language fiction published in South Africa, but also because of its formal and narrative style.

[19] Nokutela Dube, "Africa: The Story of My Life" in *Life and Light for Woman*, Vol. 28, Women's Board of Missions (1898), 110.

> Congregational Church, and Mrs. Grindal of the Church of the Good
> Shepherd, are giving me lessons in *singing and piano playing*.[20]

What constituted *better* evangelistic singing was instruction in American key-board and singing styles, and it was these styles that she hoped to carry back across the Atlantic to South Africa. These new vocal techniques and instru-mental (implicitly modern) timbres blended with Nokutela's own musical background, later informing her aural sensibilities as she notated melodies for *A Zulu song book*.

The Dubes were not unusual among *amakholwa*, or mission-educated elite Zulu married couples where both husband and wife were active in the public arena—in print, speech, and song. In fact, the virtues of companionate mar-riage were often strategically contrasted with possible abuses of traditional *lobola* or bride-wealth marriage contracts. The question of how to train appro-priate "helpmates" for male elites spurred lively debate. Indeed, educational and professional opportunities for women were at the crux of public discourse about what becoming "modern" meant for black South Africans. Nor were female composers unheard of: the world-renowned composer and author John Knox Bokwe included a hymn with words and music by Hilda Rubusana in the 1915 edition of *Amaculo ase Lovedale* (Lovedale Music), as well as songs with lyrics by Ester Kale and Letty Evelyna Bokwe. Nonetheless, it is remarkable that the collection of songs, *Amagama Abantu* (*A Zulu song book*), published at Lovedale in the early twentieth century[21] prominently credits two co-authors on its cover: J. L. D. and N. D., their full names appearing on the recto side's compilers' preface. The preface is in the first person plural (which in isiZulu, as in other Southern African languages, could indicate multiple speakers or the "plural of respect") except for a line that appears to be John L. Dube's: "Mina ngi hlele amagama, umkami wa hlela imusic." [I myself arranged the words, and my wife arranged the music].[22] While it might appear that he had usurped the collective speaking role, not only in drafting the preface but also as the discursive partner in the duo, this sentence pointedly recognizes Nokutela's musical work as a form of specialized labor. The Dubes' impulse to preserve vernacular music was in step with parallel interest in folk music in Europe (as with Zoltán Kodály) and even Dvořák's interest in African American song.

The term i*music* was already in widespread use among *amakholwa* by the turn of the century. I*music* included Western hymns, folk ballads, art music, and part songs as well as the aesthetic and social values embedded within

[20] Nokutela Dube, "Africa," 112, my italics.

[21] The exact date of publication is not indicated in the original booklet, but it was advertised for sale in Dube's *Ilanga Lase Natal* in June 1911, indicating it must have appeared around this time.

[22] John L. Dube and Nokutela Dube, *A Zulu song book/; facsimile reprint of Amagama abantu with modernised version edited, translated, and transcribed to staff notation by David Rycroft* (Durban: Killie Campbell Africana Library; Pietermaritzburg: U Natal P, 1996), xiii (hereafter, *A Zulu song book*).

these forms.[23] However, *imusic* was no mere black imitation of the metropole. In fact, it became a medium for cultural self-assertion and race pride. My claim here is that revising the category of *imusic* to serve a new version of African modernism entailed an entire range of cross-disciplinary textual strategies. Transcription of sounded music into sol-fa scores, staff-notated manuscripts, and verbal narratives rehearsed imagined resolutions of the divergences between sound and page, oral and written forms. Not only did these forms involve new scriptive practices, they also encouraged novel ways of reading. Choral part-singing was by far the most popular and accessible music-making activity. Choral singers used notated music as a leadsheet, a guide that accommodated the improvisational aesthetics of precolonial heterophonous Zulu music. The flexible approach to "correct" reading also allowed a wider geographical dissemination, recognizing that aural instruction by a lead singer literate in sol-fa notation might not necessarily lead to note-perfect reproductions of the music as scored. Richard Crawford observes in "Notation: The Great Divide" that a related dynamic applied in home music making in nineteenth-century America.[24] The sol-fa notations in *Amagama Abantu* were clearly "performers' music" and the compilers' preface even includes an exhortation from the Dubes: "Le eyamaZulu. Wemukeleni bantu niwachumise" ["This is music of the Zulu. Accept them and popularize them"].

The Dubes saw no contradiction in calling these "the first secular songs of the Black community which follow [the principles of] European music" and "music of the Zulu."[25] I would argue that this is not merely an example of hybridity writ large, but rather the medium becoming the message. The printed collection was a call to create a new body of modernist Zulu poetic and musical works that skirted the limitations of Christian decorum and accommodated multiple aesthetics. The Dubes conceived of the very act of compiling *Amagama Abantu* as a way "to resuscitate the art of poetic creativity and expertise among our countrymen, and to get them to compose."[26] This new corpus, however, was to conform to ideas of harmonic orthodoxy strongly informed by the Western musical language that Nokutela Dube had earlier called "better singing." The preface notes the challenge of notating the sounds of a modernist Zulu idiom as in the following terms:

We have been beset by difficulty in this work, in two respects: the songs ought to be repeated, and then they should be extended. In some instances the

[23] Erlmann, *African Stars,* 59.

[24] Richard Crawford, "Home Music Making and the Publishing Industry" in *America's Musical Life* (New York: Norton, 2001).

[25] *A Zulu song book,* IsiZulu original in Rycroft's contemporary orthography: "awokuqala amagama abantu ngaphandle kwawenkolo alendelo *imusic* yabeLungu. Le eyamaZulu" (xiii).

[26] *A Zulu song book,* see xiii, trans. "sifisa ukuvusa ubumgoni nobugagu kubantu bakithi, baqambe" (xii).

music would have been the crudest cacophony if sung exactly as composed. Therefore you will notice a difference in some [of our arrangements].[27]

Besikhwelene nengwangqane kulomsebenzi, amazwi emiqana mibili; emelwe kuphindwa, semelwa ukwandisa. Kwezinye izindawo i*music* ibingenza *the crudest cacophony* nxa iculwa njengokwabaqambi. Ngakho nobona umahluko kwamanye.[28] (italics in Rycroft's 1996 edition)

The Dubes' facsimile (using an earlier orthography) differs from Rycroft's version as it does not italicize "music" and "crudest cacophony." I would argue that the uniform typeface smoothes out distinctions between isiZulu and English, suggesting an easy shifting between cultural and linguistic registers consistent with the Dubes' intercultural work throughout their careers.

In his essay "Secrets, lies and transcriptions: revisions on race, black music and culture,"[29] Guthrie Ramsey has pointed to a special function of transcription in late nineteenth-century black society, particularly the impulse to render in strict "scientific" (in the sense of learnèd) Western art music conventions the unruly world of the "folk." Behind this move, which Ramsey sees most clearly in the preface to African American pioneer James Trotter's 1878 study *Music and Some Highly Musical People,* is a "desire to write blackness into the consciousness of both the nation and modernity through the discourse of science"—and indeed Trotter's language makes this desire quite explicit when he states that what distinguishes "relatively, quite a number" of these "highly musical people" is their ability "to originate and scientifically arrange good music."[30] Distinctions between performing, composing, and arranging are de-emphasized by this stress on the scientific.

There is an analogous ambiguity in the Dubes' isiZulu text as to whether they are presenting original musical compositions, harmonized and edited arrangements, or a combination of the two. The isiZulu verb used, *qamba*, is defined as "to compose,"[31] as in the hope that this collection should encourage new creativity, *baqambe. Hlela* on the other hand has a range of idiomatic significations including "adjust, arrange, organize, put in order, flatten, level, smooth, edit." The choice of this verb suggests that the musical notation is not merely a transcription but, in fact, an arrangement. *Amagama Abantu's* project may be read, then, as both a celebration of emerging modern musical forms and a regulating exercise, arranging unruly aesthetic impulses within newly accepted forms.

[27] Ibid., xiii.

[28] Ibid., xii. The Dube's original text reads: "Be si kwelene ne ngwangqane ku lo msebenzi, amazwi emiqana mibili, emelwe ku pindwa, se melwa uku wandisa. Kwe zinye izindawo imusic ibingeza the crudest cacophony nxa iculwa nje ngo kwa baqambi. Ngako no bona umahluko kwa manye."(2).

[29] Guthrie Ramsey, "Secrets, Lies and Transcriptions: Revisions on Race, Black Music and Culture," in *Western Music and Race*, ed. Julie Brown (Cambridge: Cambridge UP, 2007), 24–36.

[30] Ibid., 27.

[31] See http//.isiZulu.net/ (accessed July 18, 2010).

The compilers' preface contends that their very work process exposes *imu-sic*'s potential for cacophony. If *imusic* is the set of Westernized performance practices Erlmann suggests, then it is a Western approach to transcription, a literal note-for-note score of existing songs, that fails to capture the performance practices of repetition and extension considered essential to making pleasing music in a Zulu aesthetic. Only by intervening as an arranger, and supplementing the score with the performance notes, offering a critical translation in effect, can the Dubes make these songs functional for building a renewed musical culture. It is important to note that the scope of arrangement is always provocatively uncertain. It involves assigning notes to respective voice parts at the very least, but also possibly adjusting text to match musical phrasing, rewriting melodic contours, and emending notation in other ways while still maintaining the integrity (another loose term) of an original work. The preface introduces significant instability in notions of a composer's ownership of a work, what inheres in an "original," and when a transcription becomes a new invention. Peter Szendy's reflections on arranging within the Western classical art music tradition are surprisingly apt in this context. He writes:

> [W]hat arrangers are signing is above all a listening. *Their* hearing of a work. They may even be the only listeners in the history of music to *write down* their listenings, rather than *describe* them (as critics do).... the strength of every arrangement [is that] *we are hearing double.* In this oscillating, divided listening, in this listening that lets itself be hollowed out by the endlessly traversed gap between the original version and its deformation in the mirror of the [arranged version].[32]

It is this "divided listening," the willfully exposed gap between original and arrangement that the Dubes recognize as emerging in the work of preparing *Amagama Abantu* for print. And I would argue that this is, for them, a way that they can amplify the potential of these songs in a moment when this repertoire is defined and reoriented by modernity's transitions.

The theoretical implications of transcription become even more striking when the publication history of the collection is factored in. The collection is most readily available in its 1996 edition *A Zulu song book (Amagama Abantu)* published by the Killie Campbell Africana Library (Durban) and University of Natal Press (Pietermaritzburg). The cover announces that the Dubes' work has been "[t]ransliterated, translated and edited by David Rycroft" while the title page specifies further: this is a "Facsimile reprint of *Amagama Abantu* with Modernised version edited, translated, and transcribed to staff notation" by Rycroft. If transcription implies a simple binary relationship between a heard original and a written version, generally assumed to be a faithful copy, the

[32] Peter Szendy, *Listen: A History of Our Ears* (New York: Fordham UP, 2008), 36.

1996 edition destabilizes our certainty of what exactly makes any given version reliable. Rycroft's editorial work adds an introductory essay full of invaluable background information but also offers a list of corrigenda, further implying that the original print may not be an acceptable master copy. The original title page, *Amagama Abantu/awe/Mishado, Imiququmbelo, Utando, Nawe Mikekelo no Kudhlala/aqoqwe ngo J.L.D. no N.D.* is in fact the *third* one we encounter.[33]

The 1996 edition comes complete with a picaresque tale of its publication history. Rycroft's introduction recounts how he came across the score in the library of the University of Zimbabwe while serving as an external examiner in 1979. He then conceived of the project to release "the present modernized and annotated version" which would include an English translation prepared "with assistance" from the late Mr. M. B. Yengwa. Unwittingly, perhaps, this narrative echoes tropes of European ethnographers discovering African and diasporic artifacts, an impression only heightened by the vague and parenthetical reference to Mr. M. B. Yengwa's collaboration. What is more, although there is no way of knowing whether something as mundane as publication cost concerns might be a primary factor, Rycroft mentions that the 1996 edition of *A Zulu song book* was only published with a limited print run of 250 *numbered* copies, and 26 presentation copies. Attention is drawn to the rarity of this artifact by the fact that the copy numbers are handwritten in pencil.[34] Without question, Rycroft has done an invaluable service to music and cultural studies by bringing this collection into the public domain. Nonetheless, his paratextual framework generates a set of questions closely related to the issues of transcription presented here.

The 1996 edition places value on multiple forms of mediation. In the first place, the Zulu text is translated not only into a different language, English, but also into a modern, post-1934 standardized Zulu orthography. Second, Rycroft provides a staff-notation version of the music to supplement the sol-fa version. The mission choral traditions and hymnbooks across South Africa introduced sol-fa notation as part of the overall formation of educated elites, making it a sign for musical modernism (although instrumentalists would have learned staff notation during studies like Nokutela's American keyboard lessons). Sol-fa long remained a favored form of musical notation. However, twentieth-century popular music, such as jazz and other self-consciously modern musical compositional forms have gravitated toward staff notation. The 1996 edition uncovers a tension between accessibility and currency showing that obsolescence is a constitutive problem of the modern. Early

[33] One slight variation worth noting is that the original volume does not introduce Nokutela Dube as "Mrs.," but rather presents her full name as a co-author following alphabetically after John Dube. In so doing, it gives full credit to her creative work in the project rather than framing it through the mediating and enabling position of her husband. In other words, Nokutela Dube did not sign off as her husband's "better half," Mrs. Dube, but as an artist in her own right.

[34] The University of Pennsylvania library copy I used in preparing this book, for example, is number 34.

AMAGAMA ABANTU

Inhlanhla Kwabashadayo

Key of A♭.

[sol-fa notation]

1. Uz' u ba pate ngenhlalo enhle,
 Uz' u ba pate ngenhlalo enhle,
 NjengoAdam be noEva;
 NjengoAdam be noEva.

2. Kwa ti ku njalo kwa fik' inyoka,
 Kwa ti ku njalo kwa fik' inyoka,
 Ya ti kuye, "yidhla lo muti,"
 Ya ti kuye, "yidhla lo muti."

3. Kwanga ku bona ku nge be njalo,
 Kwanga ku bona ku nge be njalo,

Laba abazoshada namhla,
Laba abazoshada namhla.

4. Ba ze ba hlale ngenhlalo enhle,
 Ba ze ba hlale ngenhlalo enhle,
 Njeng' ababus' eParadesi,
 Njeng' ababus' eParadesi.

5. Ba ze ba hlale be nokutula,
 Ba ze ba hlale be nokutula;
 Ba be nokutokoza njalo,
 Ba be nokutokoza njalo.

FIGURE 2.1 *A Zulu song book selection in sol-fa notation—Inhlanhla Kwabashadayo (Good Luck to the Bridal Pair)*

twentieth-century Zulu orthography becomes heterodox, and sol-fa notation provincial, if not marginal. In the shadow of transcription, Marx's maxim holds true: all that is solid melts into air.

While *Amagama Abantu (A Zulu song book)* is the Dubes' most substantive engagement with music (and a historically important text as the only extant manuscript co-authored by Nokutela Dube) the songbook's concerns with transcription also appear in a more figural manner in John Dube's work of fiction, *Insila kaShaka (Jeqe, The Bodyservant of Shaka)*. First published in 1930 by Marianhill Mission Press, Dube's *Insila kaShaka* deserves further scholarly attention. In the context of this study, its significance lies in the remarkably

1. Inhlanhla Kwabashadayo

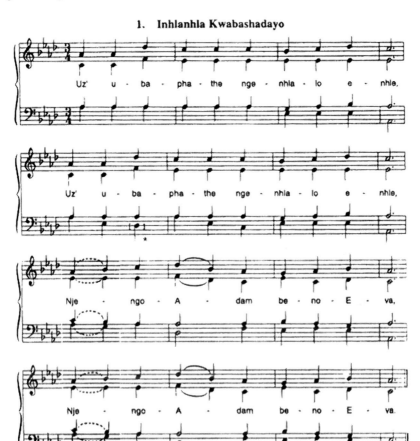

1. Uz' ubaphathe ngenhlalo enhle,
 Uz' ubaphathe ngenhlalo enhle,
 NjengoAdam benoEva;
 NjengoAdam benoEva.

2. Kwathi kunjalo kwafik' inyoka,
 Kwathi kunjalo kwafik' inyoka.
 Yathi kuye, "yidla lomuthi,"
 Yathi kuye, "yidla lomuthi."

3. Kwangakubona kungebenjalo,
 Kwangakubona kungebenjalo,

 Laba abazoshada namhla,
 Laba abazoshada namhla.

4. Baze bahlale ngenhlalo enhle,
 Baze bahlale ngenhlalo enhle.
 Njengababus' ePharadisi,
 Njengababus' ePharadisi.

5. Baze bahlale benokuthula,
 Baze bahlale benokuthula;
 Babenokuthokoza njalo,
 Babenokuthokoza njalo.

* The original has 'C' which is obviously wrong (perhaps misplaced from the next bar).

FIGURE 2.2 *A Zulu song book selection in Rycroft's staff notation—Inhlanhla Kwabashadayo.*

detailed descriptions of singing and other oral performance. *Insila kaShaka* includes eight sets of lyrics and describes songs for children's games, love, war, and hunting as well as *izibongo*. While *izibongo*, often translated as praise songs, are not musical texts, the stylized delivery and pitch specificity of isiZulu marks these as eminently aural texts. These aural texts interrupt the novelistic prose to create a variegated texture whose polyvocality parallels European and American modernist works like Joyce's *Ulysses* or Eliot's *Four Quartets*. I am not arguing that the these texts are commensurate in scale or impact, much less that Dube would have read them. Rather, I would suggest that the habits of reading that scholars of high modernism have cultivated can yield a nuanced reading of the formal elements in Dube's text. In the South African context, Dube was inventing a genre, the Zulu novel, drawing upon oral literature and music, and it was in fact the *izibongo* and games that would have struck his readers as most familiar or canonical. Ironically, it is the novel's prose, the chronological third-person narration, which broke most clearly with vernacular oral literary forms, and so it might be better to think of transcription as not so much carrying the aural into the written, but interrupting the aural with the written.

The novel's plot is a parable of interethnic understanding and alliances. The action centers on a love affair between Zaki, a beautiful Tonga girl, and U-Jeqe, the erstwhile servant and confidante of the late Zulu king, Shaka. Fleeing a death sentence demanded by the custom of burying a body-servant with the deceased king, U-Jeqe receives assistance, cover, and esoteric education from several distant Zulu clans, and Tonga medical and spiritual instruction. When he saves the Swazi kingdom from an outbreak of dysentery he is invited to settle among them, with Zaki, now his Tonga wife, as well as his Zulu parents. Despite his departure from the SANNC leadership, Dube remained committed to the vision of a national unity that could also accommodate ethnic difference. U-Jeqe's household queers the endogamous lineage of Zulu national chauvinism to establish a new model of kinship, one that is heterodox in its domestic cosmopolitanism.[35]

Music's significance in the novel is most clearly seen in two moments. Before his death, Shaka becomes depressed because his subjects are increasingly disgruntled by his incessant warmongering and cattle raids. "[A]ll the best musicians in the land, those who [play] on reeds and flutes and all stringed instruments"[36] are summoned to perform. When his spirits are instantly lifted, it partially dissipates the Zulu capital's generalized terror triggered by Shaka's arbitrary violence during his despondency. The second

[35] I thank my students in Modernism Across Borders (Spring 2011), and particularly Don James McLaughlin, for insightful contributions to this reading of kinship.

[36] *Jeqe, The Bodyservant of King Shaka* (New York: Penguin, 2008; based on 1951 trans. by J. Boxwell, Lovedale Press), 34.

moment that highlights music's centrality is when Jeqe and Zaki first fall in love. Dube writes:

Zaki, overcome by the sweet power of love, composed this song:

> Sweet is the memory
>> Of those happy days,
> When we were gathering shells, Jeqe,
>> On the banks of the Usutu;
> When we were gathering shells, Jeqe,
>> On that lovely riverbank,
>> On the banks of the Usutu.[37]

Dube explicitly refers to the song as a composed piece, marking it as a crafted aesthetic object. Strikingly, the song is composed at the very beginning of Jeqe and Zaki's acquaintance, and while it is Jeqe who has succeeded in a quest to gather shells for Zaki's sisters, he and Zaki have not yet had time to build any memories, sweet or otherwise. This music seems to bend time, becoming a modernist figure of temporal and semantic instability. Indeed, when Jeqe departs to earn bridewealth for their marriage, Zaki takes comfort in the song as a prophetic promissory note that Jeqe will return unharmed in the future. The past evoked in the song extends her love for Jeqe into a temporal vortex: memories of a time before known time, memories of a time as yet to come.

The novel closes with an image of domestic bliss. Jeqe lives to an old age, rearing six children with Zaki, and after his death she maintains his memory through song. The very last lines of the novel show what may be read as a protofeminist impulse, for the last word goes to the heroine, Zaki as she sings her song once more. The verb "qamba" lays stress on the creativity involved in composing a song, and the novel reiterates that this is the song, "igama aliqamba," that she made up early in her love affair with U-Jeqe. Exercising her creativity along the banks of the Usutu river, outside of the sphere of parental and clan oversight, her relation to Jeqe is one that mirrors the collaboration Nokutela and John Dube strove for in their lives and work together.

[37] *Jeqe* (Penguin), 60. IsiZulu original [Dube *Insila kaShaka* (Marianhill: Marianhill Mission Press, 1933), 10]:

"Ngeke zingikhohle,
Lezo zinsuku ezimnandi Jeqe,
Sicosha amagobolondo
Ogwini loSuthu.
Jeqe, zazimanandi lezo zinsuku,
Sicosha amagobolondo,
Ogwini loSuthu"

Charlotte Manye Maxeke: Techniques for Trans-Atlantic Vocal Projection

The Oxford English Dictionary's primary definition of the Latin prefix *trans-* is "across, to, or on the farther side of, beyond, over." Charlotte Makgoma Manye (later Mrs. Maxeke)[38] engaged in multiple exercises in such writing *across* and *beyond* the Atlantic between her South African home and her sojourns in England and the U.S. Her correspondences bolstered material and affective cross-Atlantic solidarity in a network of women who belonged to the African Methodist Episcopal Church. Here I analyze her musical performance, writing, and political work as an integral oeuvre, in which form, in the musical sense, gesture, and transposition are key.[39] This comprehensive account of how consistently Manye Maxeke interwove her public roles reveals an imprint of transnational black feminist solidarity on this period that often goes unrecognized. Manye Maxeke expressed her vision in multiple voices as a world-touring contralto, as a correspondent with African Americans who embraced her during her studies in the U.S., and as an activist for women in the South African prison system. Taken together, these expressive forms reveal the potential of transcription as a strategy Manye Maxeke adopted in writing on and through her body the very correspondence between South African and African American experiences of racial and gender oppression that made transnational black solidarity so necessary. Her methodology was rooted in adapting various aural structures from the stage to the page, and allowed her to attain a unique if ambivalent position of influence within state and religious structures. She first became a pivotal figure connecting blacks in the U.S. and South Africa through her experiences in education, and it is with these I begin.

By the turn of the century, mission schools like the Wesleyan School in Kimberly where Maxeke herself taught had adopted and were reproducing the Victorian ideal of domestic femininity. While most schools admitted students regardless of gender, female students were less likely than their male

[38] I use "Charlotte Manye Maxeke" throughout this essay, although Manye only married in 1903. Likewise, her sister Kate Manye Makanya was still Kate Manye at the time she enters into this story. My use of their combined names makes deference to the value assigned marriage and the position of wife within kinship structures of the period in South Africa while still recognizing their individual identities, and membership in the Manye family.

[39] As with Dube, despite her pioneering role in South Africa's history, Manye has been the subject of only one biography—a pamphlet of barely twenty pages written by future ANC president, Dr. A. B. Xuma. The pamphlet is entitled *Charlotte Manye (Maxeke) Or What An Educated African Girl Can Do* (Johannesburg: Women's Parent Mite Missionary Society of the AME Church, 1930). Other valuable, though brief, discussions are found in Veit Erlmann's work on turn-of-the-century music, and J. Mutero Chirenje and James Campbell's histories of the AME and independent churches, yet these are bounded by scholarly and historical categories, obscuring the full scope of her work.

counterparts to gain family permission to study.[40] A course of study that fitted women to be ideal Christian, literate helpmates for male clergy and skilled workers was crucial then, for women's access to formal education. Beyond the core subjects of reading and math, girls studied dressmaking, domestic science, and sometimes teaching methods. The lively debates over education in South Africa at that time mirrored those among African Americans in the U.S., where the classical schooling offered at Fisk, Hampton, and Wilberforce were counterposed to Tuskegee Institutes' industrial course. However, women students rarely had such options open, and followed a program of study that was a compromise between domestic and academic pursuits. An article in the newspaper, *Imvo Zabantsundu,* which appeared after the release of the Lovedale School Girls' Report of 1889 illustrates the concerns of the day:

> The part Native young women are called upon to play in our economical system is, in importance, second to none. All the domestic arrangements, for weal or for woe, hinge upon them. And great would be the happiness of households if native young women were up to the domestic ropes.[41]

As with discourses of ideal domesticity in other parts of the world, a woman's sphere of influence was confined to the home. Manye Maxeke's own view on "a woman's place," within the conceptual and material Home was a complex one and it informed much of her activism. She had tested conventional domestic boundaries (both household and geopolitical) throughout her life, beginning with her early career in music.

Manye Maxeke made her debut as a solo contralto singer at a Kimberley community concert in September 1890, barely two months after Orpheus McAdoo's ensemble, the Virginia Jubilee Singers, had first arrived in Cape Town.[42] The American group was sensationally popular, inspiring a number of black elite local choirs whose preferences ran toward "modern" forms of leisure to adopt African American spirituals into their repertoire. One such group, the African Jubilee Singers (also known as the South African Choir) soon planned a tour to Britain organized by a set of enterprising impresarios, J. Balmer, Walter Letty, and Paul Xiniwe.[43] Their stated aim was to raise 10,000 pounds for building technical schools in South Africa, a mission clearly

[40] As outlined in more detail below, Manye Maxeke made special mention of this issue in her letters to her supporters in the U.S. when launching her work as a college-educated teacher in the rural Transvaal.

[41] Cited in J. Mutero Chirenje, *Ethiopianism and Afro-Americans in Southern Africa, 1883–1916* (Baton Rouge and London: Louisiana State UP, 1987), 31. Lovedale was, of course, one of the flagship mission schools.

[42] For more on Maxeke's musical career, see Erlmann, African Stars and Music, Modernity and the Global Imagination *(Chicago: U Chicago P, 1991).*

[43] There is some variance in accounts of who was involved. While Erlmann mentions Balmer and Letty, Chirenje counts Xiniwe as a key figure. There also appear to have been additional managers and agents in the overseas venues.

inspired by the Fisk Jubilee Singers' fundraising efforts. However, the shoddy management of the tour suggests that Balmer and his partners were far more interested in their own private profit than altruism.[44] Charlotte Manye and her sister Kate were among the choir's first recruits, and embarked on the first international concert tour in 1891. Many British listeners responded enthusiastically to the choir. Manye Maxeke's biographer Xuma noted that "they had the unique experience of singing before the late Queen Victoria and other members of the Royal Family, who enjoyed their rendering of English songs and still more particularly of the native compositions set to more or less traditional tunes."[45] However, their performances also fueled debate on what authentic South African voices ought to sound like, and as Veit Erlmann points out, some listeners were disappointed by the choir's failure to perform their difference sufficiently.

The audience's disappointment was aural for the concert was not short on visual spectacle: the costuming provided lurid caricature stereotypes contrasting "raw" (as the language of the period put it) and "civilized natives." The choir sang the first half of the program, devoted to "native songs," in purportedly traditional dress, featuring animal skins from a hodgepodge of exotic locales (including a tiger pelt that somehow strayed from orientalized Asia to savage Africa), and other signs of primitiveness. After a quick costume change during the intermission, they performed the second half's program of standard Victorian amateur repertoire pieces in "modern," which is to say English, fashions of the day. The object lesson was to demonstrate how civilization's arts could transform guileless authentic natives into modern sophisticates. In order for this lesson to hold true, the knowledge that the signs of authenticity were a transcription of metropolitan fantasies onto black bodies had to be concealed by the mutual consent of audience and performers, the equivalent of a stage whisper. The audience was to suppress any doubts over how a "native" song came to fall into four-part harmony along the lines of European hymnody, or why Southern Africans were singing of (U.S. Southern) cotton, but rather were to marvel at how wondrously transformed they looked and sounded once the ostensibly improving conventions of Victorian concert performance were transcribed onto *their* bodies. That this was the same decade that blacks in Britain were organizing the international Pan-African Conference only shows how outrageous the reception of these performances was. Back home, South Africans who got wind of the staging arrangements were appalled that leading members of the black elite would appear in clothing that missionaries had convinced them symbolized the "barbarism" from which the *amakholwa* had

[44] See Chirenje, *Ethiopianism*, 39 and Erlmann, *African Stars*, 47. Erlmann details the adventures of the African Jubilee Singers in the second chapter of *African Stars*. He gives a full account of the parallel journeys of Orpheus McAdoo's Jubilee Singers and its various splinter groups and the two African Jubliee Singers' tours.

[45] Xuma, *Charlotte Manye (Maxeke)*, 11.

been rescued. While their anxieties centered on the visual field, British audiences were troubled that the contrast was visible but not audible enough.[46]

Homi Bhabha's analysis of colonial mimicry[47] provides a useful lens for understanding why some found that the singers veered too close to European standards. The African choir's Victorian segment presented the performers as the successful exemplars of the imperial civilizing project, or in Bhabha's terms, as "subject[s] of a difference that is almost the same, but not quite." However, the colonial desire for (and consumption of) such exemplary "natives" was also vulnerable to a menacing instability of (re)presentation, for maintaining whiteness depended on reproducing and marking signal differences. Bhabha analyzes colonial mimicry within the register of scopic desire, but what is striking in Manye Maxeke and her compatriots' performance is that colonial mimicry operates in the aural register. Reactions in the British press were mixed. The weekly magazine *South Africa* judged that the "inevitable European harmonies...suggestive rather of an English tonic sol-fa class than savage strains" detracted from the value of the performance.[48] The choir's mastery of a range of idioms abandoned the function of standard colonial spectacle, to shore up confidence in metropolitan modernity by displaying colonial primitiveness. Instead, the evidence that the imperial "civilizing mission" could produce subjects so adept at maneuvering across languages, cultures, and mediums was deeply troubling for it revealed that a teleological arc from premodern "native" authenticity to a staid Victorian modernity might land in the wrong key, a key not easily distinguished from the familiar (literally, too close to diatonic Western harmonies). The imperial ear, alarmingly, did not, in fact, have a monopoly on perfect pitch.

In the context of these fraught performances, Manye Maxeke developed an ability to rivet an audience's attention while disorganizing and frustrating their scopic and aural desires, and instead projecting before them issues they would rather ignore. If her musical performances simultaneously confused, delighted, and disappointed, her interviews with the British press similarly disarmed her audience. She reinforced their national ego ideal as exemplars of a uniquely British fairness, but used this as a challenge to marshal their support for human rights and educational opportunities for blacks in South Africa:

> Let us be in Africa even as we are in England. Here we are treated as men and women. Yonder we are but as cattle. But in Africa, as in England, we are human.... Help us to found the schools for which we pray, where our people could learn to labour..., give our children free education...shut up the canteens, and take away the drink. These four things we ask from the English. *Do not say us nay.*[49]

[46] Erlmann figs 4.1 and 4.2 (129–30) illustrate this vividly.

[47] Homi K. Bhabha, *The Location of Culture*, (New York: Routledge, 1993), 85–92.

[48] *South Africa*, 4 July 1891: 17, cited in Erlmann, 112.

[49] *The Review of Reviews*, ed. William T. Stead: September 1891 (cited in Erlmann, "Spectatorial Lust" in *Africans on Stage*, 107).

The whole passage lilts metrically and uses such lyrical devices as chiasmus deftly. In particular, the last sentence, with its bold imperative, direct address, alliterating stress on "not" and "nay" and rhyme (say/nay), reveals a sure inner ear for English rhetoric. She would remain committed to this agenda for reform throughout her career, challenging white liberals to ratify the colonial propaganda of a "civilizing mission" by recognizing the emerging modern black middle class and improving access to education. And she continued to use the rhetorical tactic of first lulling her audience into the comfort of familiar concord and then accenting the discord between such relationships and current situations to motivate action. The tensions between consonance and dissonance defined the putatively Western diachronic musical grammar the African choir so provocatively mastered, and also characterized Manye Maxeke's discursive praxes: in this way she transcribed the most fundamental musical structures in her early career into her later textual output.

Poor management and internal strife brought the British tour to a dismal end, and Manye Maxeke was the only member of the original choir to agree to a second tour, this time destined for the U.S. and Canada with a much smaller ensemble of six. This tour was again derailed by the producers' incompetence: when Balmer ran out of money he shamelessly abandoned the group, leaving them stranded and broke in Cleveland, Ohio. This was a turning point in Manye Maxeke's life. Her biographer, Xuma, describes it in characteristically vivid terms. Upon meeting the choir, a "vision at once flamed into [AME Reverend Reverdy C. Ransom]'s mind. He asked them if they did not want an education. They were eager for it"[50] and he soon obtained permission, through rather involved means. Secretary of Missions, Dr. Derrick, unable to obtain official consent from the managers of the tour or her parents,

> "kidnapped" Charlotte, a consenting party, and despatched [sic] her to Wilberforce [University, Xenia Ohio] where she was received temporarily as one of the family in Bishop Arnett's home. Later she was adopted by the Third Episcopal District as their African daughter.[51]

Two things stand out in Xuma's account. First, his tone turns the relatively mundane matter of college registration into a melodrama complete with exaggerated emotion, sudden (presumably divine) inspiration, and international intrigue. Second, his language stresses kinship while casting Manye Maxeke as a perpetual minor, a daughter in need of multiple layers of parenting, and I will return to the question of kinship below.

Wilberforce was the flagship American Methodist Episcopal institution, the first private black university in the U.S., and one that offered a classical

[50] Xuma, *Charlotte Manye (Maxeke)*, 11.
[51] Ibid., 12.

education. Its faculty included internationally prominent black intellectuals, including Charlotte's professor W. E. B. Du Bois, and philologist William Scarborough, both of whom would soon participate in the Pan-African Conference of 1900. Xenia was also home to an unusually large community of college-educated prosperous blacks so that Charlotte not only had much to write home about, but she also transformed Southern African religious history through her letters home.

Writing to her sister, Kate Manye Makanya, Charlotte described the African Methodist Episcopal church in the U.S. and when Kate shared a letter with their uncle Rev. J. M. Mokone, he caught Charlotte's enthusiasm and sought to merge his separatist Ethiopianist church with the U.S. denomination. The letter in question does not survive in manuscript, but rather "has been preserved as a kind of oral tradition within the South African AME Church"[52] and the textual transcriptions of this oral tradition are revealing as we consider Charlotte Manye Maxeke's agency as an educated black woman in her time. Campbell's history of the AME Church is typical of multiple versions of the events that adopt a speculative and wondrous tone oddly out of tune in an otherwise sober account:

> Sometime in 1894, Charlotte Manye wrote to her sister Kate in Johannesburg, apparently on paper *emblazoned* with the letterhead of AME Bishop Henry Turner,...Kate *chanced* to show the letter to Mangena Mokone.... After reading Charlotte's *rapturous descriptions* of Wilberforce, Mokone penned a brief letter to Bishop Turner, dated May 1895. A brief *courtship* ensued.[53]

The two denominations soon forged formal ties. The version L. L. Berry gives in *A Century of Missions of the African Methodist Episcopal Church 1840–1940* is even more striking in tone:

> The counterpart to *the prophecy of Isaiah* as he referred to the introduction and peaceful reign of the Church of Jesus Christ when he said, "*And a little child shall lead them,*" may be applied to this introduction of the Ethiopian Church of South Africa to the African Methodist Episcopal Church, *for it was a native young woman of South Africa*, Catherine [sic] Manye, who first called the attention of the Rev. M. M. Mokone to Bishop H. M. Turner, of Atlanta, Ga., as the representative of *the greatest Negro Church in the world*, known as the African Methodist Episcopal Church.[54]

[52] James Campbell, *Songs of Zion: The African Methodist Episcopal Church in the United States and in South Africa*, (Chapel Hill: U North Carolina P, 1998), 134. Much of what is known of the letter is from an unpublished interview with her sister. The interview by Margaret McCord (1954) was made available to Erlmann, who cites it in *Music, Modernity and the Global Imagination*, 107.

[53] Ibid., 134 (my italics).

[54] Llewelyn L. Berry, *Century of Missions of the African Methodist Episcopal Church, 1840–1940.* (New York: Gutenberg, 1942), 74.

Manye Maxeke's activities were repeatedly described as signs, wonders, and fulfillments of biblical prophecies. These accounts honor Manye Maxeke's remarkable impact on South African history; however they also obscure her agency by emphasizing her youth and ascribing the affective and intellectual labor of her writing to divine intervention in ways that male figures in this story were not described. Such narratives imply a degree of dependency in her interactions with friends and colleagues at Wilberforce that is not consistent with her public speaking record or with the energy and independence she brought to her work establishing schools once she returned to South Africa.

Many accounts of the early days of the AME Church in South Africa imply that after her initial letter, Charlotte receded into relative obscurity.[55] Quite the contrary, the trans-Atlantic correspondence in 1895 did not suddenly exclude Manye Maxeke after the initial letter. According to the entry on Rev. Mokone in *African Who's Who*, "[o]n the 31st May, 1895 Rev. Mokone wrote to Bishop Turner and Miss Charlotte Makhomo [sic] Manye. After this letter a regular correspondence was carried on between Bishop Turner, Rev. Mokone and Miss C. M. Manye."[56] Mweli Skota, editor of the *Who's Who*, not only knew Manye Maxeke, but also relied on her as one of the main contributors to the volume. She would have at the least proofread this entry on her uncle if not penned it, and so it should be taken seriously as a reliable source despite the absence of the letter referenced. A second detail seldom mentioned is that the print matter Bishop Turner mailed to Mokone to familiarize him with the AME Church included music as well as text. When Mokone wrote requesting information on the denomination Turner sent "a Discipline, a hymnal, and other books."[57] Writing in 1922, church historian, Charles S. Smith viewed a hymnal as just one among many books, a form of print culture as legitimate and quotidian as any other textual object. Music was central to the culture of the church, and hymnals were deemed useful, indeed necessary elements for establishing an understanding between the American denomination and its would-be South African affiliates. Uniting South African believers with the AME church in the U.S. was achieved through an exchange of textual and musical print matter.

Manye Maxeke's most important experiences in Xenia came through her ties to the Women's Mite Missionary Society. No mere "ladies' auxiliary," the Society was an international organization that placed AME women at the forefront of the exchanges between African American and South African (not to

[55] Early twentieth-century versions of the establishing of the AME's South African diocese mention material texts exchanged across the Atlantic. Chirenje, for example, provides information on letters Mokone, his assistant Reverend Xaba, and John Tule wrote to Turner, but does not mention Manye Maxeke.

[56] Mweli Skota, ed. *African Who's Who: An Illustrated Classified Register and National Biographical Dictionary of the Africans in the Transvaal*, 15.

[57] Charles Spenser Smith, *A History of the African Methodist Episcopal Church: Being a Volume Supplemental to A History of the African Methodist Episcopal Church* (Philadelphia: A.M.E. Book Concern, 1922), 182. Supplement to Daniel Alexander Payne's earlier edition.

mention West African and West Indian) religious seekers. During her studies, Charlotte received financial support as a "daughter" of the local Xenia chapter. However, she was far more than a charity case: she became an active member and regularly addressed meetings.[58] As she honed her speaking skills, she drew on a rich heritage of female African American religious orators, including Zilpha Elaw, Julia Foote, and Jarena Lee, for whom social justice and personal spiritual fulfillment were inseparable.[59] Charlotte urged her American sisters to support other South Africans wishing to study at Wilberforce, so that they could return to teach at home. Indeed, she was instrumental in facilitating scholarships for a number of young students, including her future husband, Marshall Maxeke.[60]

When Manye Maxeke returned to South Africa, she joined Fannie Jackson Coppin in establishing an AME women's organizational network in South Africa. Jackson Coppin, a pioneering administrator in the Philadelphia schools and former music teacher, had overseen the restructuring of The Women's Mite Missionary Society to make its fundraising activities and internal communication more effective during her tenure at its helm. When her husband, Bishop Levi Coppin, was assigned to oversee the South African district in 1900, she accompanied him. Even after the missionary couple returned to the U.S. in 1904, Manye Maxeke would continue to work through the Society, maintaining ties with American-based branches through her letters, keeping them all apprised of her work as a teacher in the Transvaal. Initially, AME institutions in South Africa relied on financial support from American-based missionary funds, although they would soon show their own initiative in raising funds.[61] So at first Manye Maxeke had to rely on her writing skills as a correspondent to request help from members of the Xenia chapter, as in her letter to the 1903 Convention of the Society.

The gist of her letter was an update of her teaching activities and progress in opening educational opportunities to girls whose parents were skeptical of formal education. Her prose finessed the language of kinship, calling on her American colleagues as mothers while also recognizing

[58] Chirenje, *Ethiopiansim,* 51.

[59] William Andrews's volume *Sisters of the Spirit: Three Black Women's Autobiographies of the Nineteenth Century* (Bloomington: Indiana UP, 1986) remains an invaluable source for information on these women.

[60] According to Skota's *African Who's Who,* Marshall Maxeke was originally inspired to seek education in the U.S. by Orpheus McAdoo's ensemble. His future wife helped him gain admission, and he went on to be ordained in the AME church. He compiled the first AME Church Hymn Book in the Xhosa language, indicating that Charlotte was not the only one transcribing black sounds across the Atlantic.

[61] Bishop Levi J. Coppin records in his *Unwritten History* how South African chapters took extraordinary initiative in mobilizing. "It is a fact that one has pleasure in noting with especial emphasis, that our African women…are really enthusiastic Christian workers. They so soon learn that Christianity is not simply something to believe or recite, but, something to be, and to do" (362).

that the Society was an organization, made up of members, not simply spiritual sisters, daughters, and mothers. This distinction between kinship and member-to-member relations served to highlight the fact that affective connections did not substitute for the constitutional obligation of the organization's members to collaborate. At the same time, addressing "her mothers" in the plural reflected the overlap between Southern African conceptions of extended family, diasporic retentions of similar widespread African cultural values, and the language of Christian fellowship. She wrote:

> Most of the boys and girls sit on the floor and the floor is of mud and clay. As I said when I was there, I need the aid of *my mothers. Let each member of the society*, if possible, adopt a boy or girl to aid him or her with things to put on.... A few pounds will buy the wood and I can get some one to make the benches, so please tell *my mothers* about this.[62]

In order to mobilize her readers' emotions, she emphasized nostalgia particularly effectively by recalling songs they had sung together, songs familiar to them all.

This was an astute choice given that music was a central part of the program for the conference where her letter was to be read. Indeed five hymns and two choir selections were included in the program for the July 2 evening session where her appeal was to be heard. Such gatherings were unimaginable without music, especially congregational singing, which engaged the entire body in vocalizing the unity they had gathered to forge. Charlotte wrote to her fellow believers, explaining:

> I am way out forty miles from the nearest town. I used to sing over there, "Perhaps to-day there's a lonely spot in earth's harvest field so wide," and I think this is the spot. Write to us soon. I have written many letters that were never answered. Pray for us. "God be with you till we meet again."[63]

The first lyrics that she cited were from a mission song "I will go where you want me to go," by Mary Brown (with additional lyrics by Charles Prior), and music by Carrie E. Rounsefell.[64] With music composed in 1894,

[62] Minutes, "Women's Mite Missionary Society, Minutes of the Seventh Annual Convention, Cincinnati" (1903), 47, my italics.

[63] Ibid., 47.

[64] http://www.cyberhymnal.org/htm/i/g/igowhere.html.
Words: Mary Brown, in *Our Best Endeavor* (Silver Burdett & Company: 1892) (verse 1), and Charles E. Prior (verses 2–3). The original title was "Go Stand and Speak," with music by Prior. A new tune for the hymn, by Carrie E. Rounsefell, was composed in 1894 for use in a revival meeting at the Baptist church in Lynn, Massachusetts, and this became the standard tune.

it would have been the latest thing, a most modern gospel song, and Manye Maxeke's choice indexed women's increasing participation in liturgy through new music. Furthermore, it highlighted how music functioned to orient her in a familiar affective and spiritual landscape (one she shared with her American sisters) even as she experienced her location as remote. Lastly, recalling the words of a song she had learned in the United States reinvoked memories of how she had been taken in as a "foreigner," by the Society.

Her signifying on remoteness and loneliness was complicated by the fact that her status as a distinctly modern subject had been ratified by her experiences as a foreigner in Britain, Canada, and the U.S. So for Manye Maxeke becoming "modern" was predicated on the ability to feel alienated from a landscape that lacked the signs of Western modernity. Her citation garbled the lines of the hymn slightly: "Perhaps today there are loving words" came from the second verse, and "In earth's harvest fields so wide" from the third. The sample lines suggest that she quotes from memory, which shows how ingrained congregational singing was in religious practice; however, they also reveal that even the aural mnemonic device of citation was subject to the erosions of time and space. Manye Maxeke's remoteness was wearing away the common musical repertoire she shared with those meeting in Ohio.

That said, there are multiple indications of her letter's effectiveness in tapping a common nerve in the conference minutes. Immediately following its reading, the assembly sang "God be with you till we meet again." This was, of course, a traditional choice for an adjourning song, but in joining to sing the lyric that Manye Maxeke herself had referenced, the trans-Atlantic solidarity between these women literally resounded. It was also noted that hers was "A *very touching* letter" with the full text included in the minutes. Finally, the audit report indicates that $400 was set aside for the work in South Africa ($100 of which was specifically designated for Manye Maxeke). She had struck the right chord.

Although little of her writing or speech texts are extant for the next two decades, reports appeared in newspapers, including *Izwi LaBantu*, the *Christian Express, Imvo Zabantsundu,* and even the Mozambican paper, *O Brado Africano,* covering her activities as an educator, her testimony and organizing in protest of the women's pass laws in 1912, her founding of the Bantu Women's League in 1918, and activism throughout the 1920s advocating for better living and working conditions for black women migrating to urban areas and rights for female prisoners. As with the her address to British audiences in 1891, and her letter to her AME comrades in 1903, these reports show that her speeches balanced tact and direct interpellation in careful counterpoint, but it was the latter that defined her style.

Having seen how central music was for Manye Maxeke's thought, a new reading of her most anthologized writing emerges. Her address to the 1928 Bantu-European Students' Christian Conference in Fort Hare, entitled "Social Conditions Among Bantu Women and Girls," and published in their proceedings in 1930 did not explicitly mention music. However, the anxieties about an urban underground economy driven by beer illegally brewed by women and animated by *marabi*, a popular local jazz form furiously fueled social welfare debates. At issue was the institution and maintenance of bounds between public and private, street and home. Put differently, the topologies of black South African aspiration depended upon maintaining the borders of interior domestic space, and orienting the center of this space around women. In her discussion of how current conditions of urban migration and labor markets in Johannesburg impact family life, Manye Maxeke begins with an analysis of space. It is the Home, she argued, "around which and in which the whole activity of family life circulates," that fundamentally structures a society because of the importance of home training in raising future generations. For Manye Maxeke, this put women on the frontlines of South Africa's unfolding experiment in urban modernity, facing the injurious proto-apartheid laws. As a mother, a woman was her children's "first counselor and teacher; on her rest[ed] the responsibility of implanting in the flexible minds of her young, the right principles and teachings of modern civilization."[65]

Her most trenchant critique of rent regulations that disallowed black women the right to secure lodgings unless accompanied by a man was that they turned domestic space inside out. When women migrated to the cities in search of their missing husbands (mine laborers who fell out of touch with their rural families), they often had difficulty locating these men. The rental laws were such that women were

> forced by circumstances to consort with men in order to provide shelter for their families. Thus we see that the authorities in enforcing the restrictions in regard to accommodation are often doing Bantu society a grievous harm, for they are forcing its womanhood, its wedded womanhood, to the first step on the downward path of sin and crime.[66]

The pass laws meant that this was not mere hand-wringing over decorous morality. When newly arrived women in a society dependent upon strong domestic ties forged in the interior home space were literally turned out of doors by the state, not only their personal lives but an entire economic system and generational structure was being destabilized. And wage labor was

[65] Charlotte Maxeke, "Social Women Among Bantu Women and Girls (1930)" in *Women Writing Southern Africa*, ed. Mary Daymond (New York: Feminist Press, 2003), 196.
[66] Ibid., 197

so unfairly remunerated that even women who managed to locate their husbands were forced to take jobs with no accommodations for their children, who wound up on the streets to "run wild" (197). Running wild, in 1920s South African cities, implied not only possible prostitution, but brewing *skokiaan* in informal speakeasies, or *shebeens,* often with live *marabi* or brass band music playing to attract customers. Ironically, her desire to maintain petit bourgeois decorum and uplift the race echoed many of jazz's detractors among African American elite.

If many of her ideals about a harmonious household were consonant with the cult of domesticity that had accompanied the missionaries' "civilizing project," she was also savvy about her audience, and how to interpellate them most directly by naming the possibility that they might turn a deaf ear. As in earlier declarations she wrote:

> These facts *do not sound very pleasant* I know, but this Conference is, according to my belief, intended to give us all the opportunity of expressing our views, our problems, and of discussing them in an attitude of friendliness and fairmindedness, so that we may perhaps be enabled to see some way out of them.[67]

She understood that coalition building depended as much on congregational listening as on congregational singing, and on being able to listen multiply, anticipating the surround sound of solidarity. By collocating audiences through oratory, press, and public correspondence, Manye Maxeke quite literally, wrote *across* geographic, denominational, cultural, and linguistic gaps that made this feminist chapter in solidarity possible.

Relative Pitch: Sol Plaatje's Polyglot Modernism

Solomon Tshekisho Plaatje, the first black South African to write a novel in English, was also an exceptional linguist and his first career was as a court interpreter. His facility in nine different languages, including Setswana isiXhosa, English, Dutch, and German made him invaluable to African defendants already disadvantaged by the racial prejudices of colonial institutions, even in the supposedly liberal Cape Town courts. Perhaps more than any other of the characters in this chapter, Plaatje heard in stereo, and spoke through the channels of multiple languages in addition to his lively musical imagination. Thanks to his own diaries and the biographic work of Brian Willan and others, we know a fair amount about Plaatje's early education, and his beginnings significantly shaped his later intellectual output. Born on a German (Berliner)

[67] Ibid., 197–98 (my italics).

mission station to a family who had converted a generation earlier, Plaatje moved with his family to Pniel in Griqualand West when still a young boy, and there came under the tutelage of the Westphal family. The Westphals had a keen interest in vernacular African languages and they may well have encouraged the young polyglot's enthusiasm for linguistics.[68] His other talents were soon apparent, and he was given music lessons in piano, violin, and voice. These studies honed his ear and clearly made an indelible impression on Plaatje, for he continued to perform and integrate musical references into his writing throughout his career.

I want to consider here how his labors as interpreter, orator, transcriber, and writer cohere into the work of a specific form of subjectivity structured by active listening. Reading Plaatje's output under the hermeneutical supposition that he had a "good ear" and that this aural faculty (indeed, facility) informed his analytic praxis deepens our insight into how and why music was such an essential reference point for Plaatje and his generation. While aural "texts" are central to Plaatje's work (music, but also speech and sound), the act of listening represents for him an essential interface between the heard and the transcribed and so I begin by parsing Plaatje's own claims about the *work a good ear can do*.

Plaatje's professional life began at eighteen with a rather humble job as a postal messenger. However, by 1898 he had qualified as a court interpreter and moved to Mafikeng to take up a position at the magistrates court. The earliest of his known writings date from this period, but his entrance into the public record came not through his professional life, but rather through musical performance. In 1897, he performed as a member of the Philharmonic Society. The debut performance presented a group of artists including Will Thompson, a pianist who had left Orpheus McAdoo's Virginia Jubilee Singers to settle in Kimberley, and Rev. H. R. Ngcayiya, later one of the first ordained AME clergymen. The Philharmonic Society's program reflected multiple pan-African impulses: a hymn by the early South African convert Ntsikana, John Knox Bokwe's "Kaffir Wedding Song," the minstrel standard "Pickin' on de Harp," and finally "God Save the Queen."[69] While the final song reflected a misplaced faith in the impartial justice administered by the British crown (a faith only dislodged when Britain failed to intervene in the Natives Land Act), the clearest ties evident were the transnational relationships that music had facilitated among blacks throughout that decade. These ties lay the foundations for an increasingly politicized solidarity in later years.

[68] One grandson of Plaatje's teachers, Ernest O. J. Westphal later became a prominent professor of African linguistics, teaching at the University of Witswatersrand, the School of Oriental and African Studies in London, and the University of Cape Town.

[69] Campbell, *Songs of Zion*, 133.

In 1899, just two years before Plaatje launched his newspaper *Koranta ea Becoana,*[70] he began keeping a detailed diary of the Boer War (1899–1902). The priority Plaatje gave to accuracy and exact reproduction in his work as an interpreter transferred to his diary writing—and later to his nonfiction. It is doubtful that he ever envisioned the diary becoming public, yet the detail with which he recorded the sights, sounds, and feelings the battles elicited suggest that he was as interested in accurately recording the sensory experience of witnessing the war as he was in chronicling the events themselves. The terms in which he rendered history immediate and palpable are astonishingly literal in their musical references. His earliest entries represent the battles for control of land as struggles over acoustic space, not just geographic territory. His entry on Sunday October 29, 1899 is a perfect example. Describing one of his first experiences witnessing the war's gunfire, Plaatje writes:

> To give a short account of what I found war to be, I can say: *no music is as thrilling and as immensely captivating as to listen to the firing of guns on our own side.* It is like enjoying supernatural melodies in a paradise to hear one or two shots fired off the armoured train; but *no words can suitably depict the fascination of the music produced by the action of a Maxim,* which to Boer ears, I am sure, is an exasperation which *not only disturbs the ear but also disorganizes the free circulation of the listener's blood.*[71]

The sounds of war are described in terms of the sublime, as "thrilling," "immensely captivating," "like enjoying supernatural melodies in paradise," and producing "fascination." The proximity of his language to Immanuel Kant's notion of the dynamically sublime is not entirely surprising, given that Plaatje's education began on a German mission station. Yet for Plaatje, the music of war, heard in stereo surround sound, is not merely thrilling but also disruptive, pointing to the insufficiency of both language and interpretation. Kant, famously, doubted music's capacity to supercede rational thought (in which logic and *logos,* the word, were almost inseparable).[72] And indeed Plaatje found that the aural experience of this musical gunfire exceeded both his own descriptive capacities to find language "to suitably depict" the sonic effect of the Maxim and the Boer's ability to decipher its source and location.

[70] Les and Donna Switzer, and M. Adhikari, among others, have done fantastic work on the black and alternative press in South Africa. Given my own linguistic limitations, I will not deal with *Koranta* nor Plaatje's path-breaking translations of Shakespeare into Setswana; rather I confine my discussion to his English language publications, and look forward to reading scholarship on Plaatje's Setswana writings.

[71] Solomon Plaatje, *Mafeking Diary: A Black Man's View of a White Man's War,* ed. John Comaroff (London: James Currey and Athens: Ohio UP, 1973), 1, my italics. John Comaroff edited and published the diary in 1973 as *The Boer War Diary of Sol T. Plaatje: An African at Mafeking.* The spelling of Mafeking/Mafikeng has shifted over time. I retain the spelling "Mafeking" from the published version for accuracy in citation, but use the contemporary spelling "Mafikeng" in all other instances.

[72] Immanuel Kant, *Critique of Judgment,* trans. Werner S. Pluhar (Cambridge: Hackett, 1987).

The sublime effect of the music of war is further evoked by the idea that it not only "disturbs the ear" but also "disorganizes the free circulation of the listener's blood," taking the entire body hostage to a single sense. While Plaatje's sympathies lay with the British in the Anglo Boer War (largely because the Cape Colony's British governance was far more liberal toward [primarily educated] blacks than the Boers), he also recorded the sonic confusion that the "melodious tones of big guns" wrought in the British camp as well. Upon hearing gunfire, the Crown's soldiers, he reports, respond to it

> like a gentle subterranean instrument, some thirty fathoms beneath our feet and not as remote as Mafeking; they have listened to it, I am told, with cheerful hearts, for they just mistook it for what it is not. Undoubtedly the enrapturing charm of this delectable music will give place to a most irritating discord when they have discovered that, so far from it being the action of the modern Britsher's workmanship going for the Dutch, it is the "boom" of the State artillerist,[73] giving us thunder and lightning with his guns.[74]

Both the Boers and the Brits lacked a "good ear" for the acoustics of the South African terrain over which they were struggling. When several other indigenous African peoples entered the fray, each seeking to protect their own interests in the eventuality of a new European dominating presence, the "noise" effects that scrambled the signal of Maxim drums were only heightened.

Over the next decade, Plaatje founded and edited the *Koranta ea Becoana* newspaper and its successors, and became involved in politics and (briefly) mine labor recruiting. Given the rich scholarship available on African newspapers, I focus here on other texts. Willan's publication of the *Selected Writings* (1996) includes one of Plaatje's few available pieces outside of the newspapers. This hitherto unpublished manuscript includes an essay, "The Essential Interpreter," probably composed in 1908 or 1909, in which Plaatje describes how even the slightest divergences in grammar and nuance lead to gross miscarriages of justice. The essay is a treatise on the relationship between the oral and aural in testimony, a sophisticated reading of the court as a problem in acoustic design. Justice can only ring forth when the room is sufficiently live for spoken testimony to resonate properly in the reproduction of faithful interpreters.

The essay opens by remarking that only those familiar with "local forensic procedure" will grasp the urgency of the issues he highlights, making oblique reference to the a priori disadvantages of black Southern Africans before the twinned barriers of institutionalized colonial racism and the dearth of

[73] As Comaroff explains in his edition of the *Mafeking Diary*, State artillerist refers to the "Staats Artillerie" who operated the Boer artillery.

[74] Plaatje, *Mafeking Diary*, 22.

Europeans and Africans fluent in each others' languages. Plaatje lays out his observations and concerns as follows:

> I do not mean that interpreters are infallible. I have often noticed during my term that a witness would fail to drive home a point by stopping short of uttering a small suffix which could at once decide the issue, and I have seen, in minor instances, interpreters make use of their own knowledge of the circumstance and add such missing links not expressed by the witness in evidence, and this apparently insignificant addition become the subject on which counsel based their disquisition, and decided a momentous issue.[75]

The role of the interpreter—the real-time parallel to what Benjamin would call "the task of the translator" some thirty years later—is to convey rather than supplement the other's language. Plaatje's own linguistic mastery gave him enough aural acuity that, like a listener with perfect pitch who immediately identifies a slight fault in intonation, the smallest deviations in grammar or lexicography registered with him, and it was from this vantage point that he could critique the practice of intervening rather than merely interpreting.

With the next serious crisis in South Africa, the Native Lands Act of 1913, Plaatje was impelled to write a substantial and impassioned critique of the increasingly institutionalized violence of the newly constituted Union of South Africa. His response, a work of nonfiction that defies genre classification, was published in London 1916 as *Native Life in South Africa*. This text called on sympathetic readers to press for the full recognition of the human rights of those facing racialized and gendered oppression and emphasized the political potential of both men and women.[76] By this time, Plaatje was well known as the editor of a series of black-owned Setswana-language papers,[77] and the book he published in protest of the Native Lands Act was an ambitious and eclectic assemblage. It included personal and critical essays, journalistic accounts of his participation in the SANNC delegation to England to protest the Act,[78]

[75] Solomon Plaatje, *Solomon Plaatje: Selected Writings*, ed. Brian Willan, (Athens, OH: Ohio UP, 1997), 53.

[76] Laura Chrisman has done important work in bringing to the fore Plaatje's profeminist stance in *Mhudi* and other works. Here I add to her analysis of gender, and a more recent work by Peter Limb in the same vein, by illustrating how music, as an often feminized field of action, consistently revealed Plaatje's attention to women's work and rights.

[77] Willan's edited volume includes a photograph (61) showing the eight members of staff for the *Koranta ea Becoana*, where Plaatje held his first editorial position. Although only two members are identified (Plaatje and Silas Molema) there is a woman seated between the two, clearly indicating that the newspaper business was not an exclusively male profession. After editing *Koranta* from 1901–08, Plaatje went on to edit *Tsala ea Batho* from 1910–15.

[78] Plaatje participated in both this and the 1919 delegation to Britain, and then proceeded to Canada and the U.S. (1920–21) where he sought to raise awareness and funds for the cause of embattled black South Africans.

exact reproductions of supplementary documents and articles from newspapers, and implicitly, proposals for what the next steps in self-determination might be.

At the end of the prologue to *Native Life*, Plaatje cites W. E. B. Du Bois's *The Souls of Black Folk*, which may have been a template for both the montagelike genre and the political purpose of Plaatje's work. His citation is an odd choice, so general in its reference that the commonalities in the racial subjugation in their two nations is left implicit, while the pitch of social critique as such is brought to the fore. Plaatje quotes from the ninth chapter, "On the Sons of Master and Man":

> I have not glossed over matters for policy's sake, for I fear we have already gone too far in that sort of thing. On the other hand I have sincerely sought to let no unfair exaggerations creep in. I do not doubt that in some communities conditions are better than those I have indicated; while I am no less certain that in other communities they are far worse.[79]

There is an interesting prefiguration of the rhetoric in Manye Maxeke's 1928 address discussed earlier. Here, however, Du Bois's words serve as an authorizing gesture, making the claim that he adopts a balanced and moderated tone that should have the status of evidence rather than propoganda. Plaatje uses the same approach, finding the strategy of a measured, well-tempered tone more effective than shrill cries of outrage and demands for action. What is important to note is that for both Du Bois and Plaatje this is a rhetorical strategy that allows them to make a trenchant political intervention while anticipating the calumny of their detractors.

It is difficult to know whether Plaatje would have recognized the musical citation that begins "On the Sons of Master and Man," ("I'm a Rolling," which may or may not have been one of the songs made popular by the Virginia Jubilee Singers and other African Americans in South Africa). However, it is striking that he chose one of only two chapters in the *Souls of Black Folk* that begins *and* ends with musical references (the other, of course, being the final chapter "On the Sorrow Songs"). In the ninth chapter, Du Bois's closing citation comes from Alfred Tennyson's long poem "A. H. H. In Memoriam," and reads "That mind and soul according well,/May make one music as before,/But vaster." In *The Souls of Black Folk* and *Native Life*, the authors repeatedly use music as metaphor and metonym for an ideal social harmony accessible only by redressing racial oppression. And among the many discords or incoherencies they point to in the intersections between religious universalism and racial segregation is the fact that what purportedly Christian white supremacists "sing with their lips" they do not "believe in their hearts," much less "show

[79] Plaatje, *Native Life*, 4–5; citing Du Bois, *Souls of Black Folk*, 207.

forth in their lives" to paraphrase the Choristers Prayer.[80] Plaatje begins the first chapter proper of *Native Life,* "A Retrospect" with a familiar biblical quotation, and here again there is a parallel with *Souls of Black Folk,* for the cited passage, "I am black but comely" are the exact same lines from the Song of Solomon, that Du Bois uses as the epigraph for his seventh chapter, "Of the Black Belt." The echoes in rhetoric continue: where Du Bois writes "Out of the North the train thundered, and *we woke to see the crimson soil* of Georgia stretching away bare and monotonous right and left" (140), Plaatje's dawn reflects a loss rather than a discovery of one's land: "*Awaking* on Friday morning, June 20, 1913, the South African Native found himself, not actually a slave, but a pariah in the *land of his birth.*"[81] Even Plaatje's precise language, parsing the difference between the chattel slavery that comrades in the diaspora had survived and the dispossession facing South Africans of color reflects his thoughtful reading of Du Bois. The two men's interactions would continue to be conducted primarily through reading and citing each other's works. When Du Bois convened the Second Pan African Congress in 1921 and Plaatje lacked funds to attend in person, Du Bois read his paper in his absence (curiously, however, attributing it to an anonymous South African). Even more significantly, it was under Du Bois's editorial direction that *The Crisis* republished *Native Life in South Africa* in its fourth edition in 1922.

Music played a uniquely pivotal role as social text in South Africa given that literacy was still the exception rather than the rule for the majority. This becomes clear when Plaatje recounts the interpretation of many black South Africans unable to fully grasp the devastation portended by the Native Areas Act:

> Our people, in fact a number of them, said amongst themselves that *even Dutchmen sing psalms*—all the psalms, including the 24th; and, believing as they did that Dutchmen could have no other religion besides the one recommended in the New Testament and preached by the predikants of the Dutch Reformed Church, were prepared to commend their safety to the influence of that sweet and peaceable religion.[82]

The Christian religion was understood as a shared text, a "sweet and peaceable" common ground, one could even go so far as to say a commonplace book that belonged equally to all denominations and races. And this text was affirmed as creed through singing, not merely preaching. While chanting psalms as such was not a core part of liturgy in most Southern African denominations, hymn singing certainly was. Plaatje emphasizes that music and verbal discourse are congruent and overlapping discursive fields. Segregation opened up a chasm

[80] http://www.rscm-oxford.org.uk/choristers%27%20prayer.htm (accessed 7/10/13).
[81] Plaatje, *Native Life in South Africa* (1916, republished 1987), 6 (my italics).
[82] Ibid.,43.

of mutual unintelligibility generated not only by linguistic difference and illiteracy but also by different assignations of meaning to musical practice. Plaatje refers to singing as a confirmation of discursive faith acts such as reading and preaching. The reference to psalmody shows how black African believers interpreted the aural evidence of religious singing as a sign of religious sincerity and brotherhood in spite of the difficulties in translating spoken and written language. Hitherto, musical authority and textual authority were complementary in civil society, and so the government's move toward increasing control over the movement and labor of black populations in a strictly textual legislated regime was felt as a bewildering and incomprehensible transition.

The fourteenth chapter, "The Kimberley Congress" reported on the crucial SANNC meeting convened in February of 1914 where the plans for the deputation to be sent to London were formalized as part of a multifaceted response to the new land legislation. The very opening of the congress involved collective music-making, with Rev. I. I. Hlangwana of St. Paul's Mission leading the gathering in singing "native hymns." The white religious and business community seemed to embrace the assembly, hosting an evening reception as well as participating in the opening invocation. However, these gestures merely attempted to temper the Congress's plans for action, with one bishop urging them "not to ask for a repeal of the whole Act, but only for relief from the oppressive clauses, and then to wait for the Commission's report in regard to the remainder of the Act."[83] The assembled delegates included South Africans long active in the South African Native Congress (formed in 1898 in the Cape) and other local forerunners of the SANNC, Mahatma Ghandi's Indian Congress (formed in 1894 in Natal), and the African People's Organisation[84] (a largely "coloured" group founded in 1902 by Dr Abdullah Abdurahman). While these groups shared certain common political interests, there was also a history of racial separatism, as some "coloureds" and Indians were willing to accept preferential treatment over "natives." Plaatje's report on an evening's entertainment during the congress indicates just how crucial audience experience—listening, watching, applauding –was in forging (inter)-racial solidarity:

> The coloured people attended in their hundreds, and cheered the musicians of their native brethren who entertained the people who thronged the City Hall till many were refused admission.... The president of [the A.P.O's] Ladies' Guild, Mrs van der Riet, a schoolteacher and musician of long standing, attended and played the accompaniment for the Greenport Choir on

[83] Ibid., 142.

[84] Among the APO's members was Francis Zaccheus Santiago Peregrino, the Gold Coast-born newspaperman whose biography was a veritable map of transnational black solidarity. For more on Peregrino, see Christopher Saunders, "F.Z.S. Peregrino and *The South African Spectator*," *Quarterly Bulletin of the South African Library*, 32 (1978), 81–90.

the pianoforte; Miss M. Ntsiko, who had borne the brunt of the evening's accompaniment, was thus relieved.[85]

Black and "coloured" performers shared the stage, and won the admiration of audiences across these racial, religious, and class differences. In fact, it was these performances that were the essential performative acts of mutual recognition, coalition building, inspiration—in a word, solidarity.

Links of solidarity between political and religious undertakings became tactically crucial after the the historical shock of the Native Lands Act of 1912. Plaatje and other members of the delegation the SANNC dispatched to Britain to protest the land legislation sought the assistance of an international Christian organization called the Brotherhood movement. Like the temperance movement, Abolition and Aboriginal Protection Society and other similar groups, the Brotherhood movement advanced a project of social and moral betterment; however, it also explicitly conceived its agenda as both religious and democratic. The particular strand which the SANNC delegation approached was known as the "Pleasant Sunday Afternoon Brotherhood" (or, as Plaatje refers to it, the P.S.A. Brotherhood). This quaint Victorian name hardly indicated the scope of the movement's activities. Frederick Deland Leete's volume *Christian Brotherhoods* was first published in 1912 at the height of the P.S.A. Brotherhood's prominence, when the organization claimed some five hundred thousand members. Emphasizing the democratic nature of the P.S.A. movement, Leete described it's aims as "nothing less than to teach a 'democratic religion' leading to a 'practical Christianity' full of love and good works, [whose] ultimate aim is a social state which shall bring upon earth the Kingdom of Christ, and whose benefits shall be universally distributed."[86] The membership's vision extended beyond the British Empire, and explicitly sought to address economic injustice by meeting physical needs before spiritual ones. Nevertheless, it was still rooted in a "democratic" solidarity aligned with the British Crown, which was largely imagined as the starting point for bringing about and perfecting the kingdom of heaven on earth.

In one of the most sustained examples of his analysis of music as a political and moralizing tool, Plaatje devotes an entire chapter of *Native Life in South Africa* to the delegation's visit to a single P.S.A. meeting. It is full of lengthy citations, transcribing the exact wording of publicity for the delegation's appeal, descriptions of the movement by members, and even a hymn found in the widely used *Fellowship Hymnal*. William Cross presented the aims of the movement, and Plaatje found his description compelling enough to paraphrase it at length.

[85] Plaatje, *Native Life,* 143.
[86] Frederick Deland Leete, Christian Brotherhoods (Cincinnati: Jennings and Graham, 1912), 272.

There was a great resemblance between Brotherhood and empire. In it all kinds of religion were represented, yet all were united in one great principle.... There was no limit to the empire that was founded upon unity, toleration, justice, and liberty; it surely had no end. Similarly there was no frontier to the kingdom of Brotherhood, and they looked for a kingdom out-spanning far beyond the roll of British drums—the kingdom of Brotherhood—the kingdom of Christ.[87]

The flourish of a drum roll added a particular flair to this vision and indeed the staged elements of the movement appealed to Plaatje's sensibilities. The SANNC's regrettable belief that imperial Britain would intervene rather than allow such a gross injustice as the Native Lands Act to stand was consonant with the Brotherhood's embrace of imperial British values. Plaatje's chapter closes with a debate that he settles almost entirely in musical terms, everything coming down to a hymn.

Transcription—as both accurate notation and as transfer from one version to another—is crucially important in this episode where musical performance takes on real political significance when music projects where speech alone does not carry. News of Plaatje and his comrades' journey had traveled rapidly and readily to the press back home, and white newspapers expressed suspicion about the group's activities. They maintained that the Brotherhood had strayed from its original and proper purpose by interesting itself in the legal affairs of the Union of South Africa. In response, Plaatje described a meeting where he interpreted the chairman's hymn choice as making it pointedly clear that the P.S.A. members stood in solidarity with their black South African brethren. The last hymn sung was not the one programmed, but rather one called on the spot by the chairman. As Plaatje reminded the newspaper critics "the chairman did not run out of the meeting to borrow a book from somewhere containing that song. The song is No. 26 of the [ecumenically popular] *Fellowship Hymnal*—the hymnbook of the P.S.A. and Brotherhoods."[88] In other words, the Brotherhood Song of Liberty expressed the core of the Brotherhood's mission, not a deviation from the group's roots. Plaatje described his fondness for the hymn in multiple musical settings, having relished hearing "the orchestra lead off with the tune of Costa's March of the Israelites" repeatedly, and then savoring the "pleasant variety" when "the grand organ chimed the more familiar tune of 'Jesu, lover of my soul' (Hollingside's)...[a variety in music that] lent extra freshness to the singing."[89] He ended his chapter by reproducing the text of all three verses of the song, whose words are by F. R. Lowell. The first of the quoted verses is as follows:

[87] Ibid., 186.
[88] Ibid., 186.
[89] Ibid.

Men whose boast is that ye
Come of fathers brave and free
If there breathe on earth a slave,
Are ye truly free and brave?
If ye do not feel the chain
When it works a brother's pain,
Are ye not base slaves indeed
Slaves unworthy to be freed?

The tunes to which the lyrics were sung, and their effect upon his sensibility were emphasized, confirming what his other writing makes abundantly clear: that music amplified the message of Liberty, that "They are slaves who fear to speak/For the fallen and the weak."[90] For Plaatje, the pleasure of music could potentially temper (in that original sense of tuning) the just militancy of such words to a tone his audience might be willing to hear.

Music was also important to Plaatje's gender politics. As remarked earlier, the SANNC embraced an officially gender-inclusive agenda from early on, but there were contradictions, such as their failure to support women protesting the Women's Pass Laws of 1913. Nonetheless, one can read Plaatje's inclusion of women as political subjects in his writing as a protofeminist stance. Musical training was a near essential element in the ideal of genteel Victorian femininity, and most of Plaatje's mentions of women at political events center on music. Given that there was music at many of the events Plaatje describes it appears that, as with the concert of songs by Afro-British composer Samuel Coleridge-Taylor performed at the Pan-African Conference of 1900, concert music served an essential function in gathering together and raising the morale of would-be activists. One such example in *Native Life* recalls an "Imperial indoor demonstration," Plaatje attended in Southall, Britain. Members of various colonized nations sent representatives to a cultural, religious, and political gathering sponsored by the P.S.A. Brotherhood. Worth noting in his account is the attention paid to female performance. Plaatje records that a "Ruth Bucknall, the celebrated lyric soprano [contributed] the solos, represent[ing] Australia."[91] Here, as at the opening SANNC ceremonies, musical performance was one of the key ways in which women could come to the forefront in building solidarity and organizing for political or social action.

The value Plaatje placed on women's performance and leadership carried over into his other writing, particularly in his portrayal of women within Barolong society at the beginning of his novel *Mhudi*. Published in 1930 (after over a decade struggling to find a publisher), *Mhudi: An Epic of South African Life a Hundred Years Ago* (1930) portrays a Barolong couple whose trials as

[90] Ibid., 187, (stanza 3, lines 1 and 2).
[91] Ibid., 183.

star-crossed lovers thrust them into the dangers of the Mfecane invasion of the Zulu empire, and drive them toward unlikely allies from other ethnic communities, including an Afrikaaner couple. As the novel opens, Plaatje provides one of several quasi-ethnographic accounts of Barolong life. In describing women's oversight of domestic affairs, Plaatje imagines their potential leadership in spite of some patriarchal cultural elements, writing that "the simple women of the tribes...transacted their onerous duties with the same satisfaction and pride as an English artist would the job of conducting an orchestra" (24). This is a startling metaphor indeed, vividly conjuring aural experience of listening to tremendous diversity that coheres to create a grander, richer whole, far in excess of the sum of its parts. Comparing women to conductors also draws attention to the masculinist traditions of Western art music, where few if any women had been allowed to conduct full orchestras at the time Plattje was writing. One cannot help but imagine how satisfied Plaatje would have been to know that Samuel Coleridge-Taylor's daughter, Avril, would make her conducting debut at the Royal Albert Hall in 1933 just two years after his death, and that she later emigrated to South Africa.[92]

The final text here most literally reflects this chapter's central concern: *transcription*. In 1915, Plaatje was introduced to Daniel Jones, a member of the faculty in the Phonetics Department of University College, London, by a young woman named Mary Werner. He was deeply impressed, upon visiting one of Jones's lectures, by the scene he encountered:

> After some exercises I gave the students a few Sechuana sentences, which Mr. Jones wrote phonetically on the blackboard. The result was to me astonishing. I saw some English ladies, who knew nothing of Sechuana, look at the blackboard and read these phrases aloud without the least trace of European accent...it was as if I [was] hear[ing...Bahurutshe women on the banks of the Marico River.[93]

He contrasted the women's flawless linguistic performance with the embarrassing errors missionaries in South Africa regularly made when attempting to speak Setswana without having mastered the inflections of tone. Congregations were accustomed to "listening to wrong words, some of them obscene, proceeding from the mouth of the preacher in place of those which he has in mind (which have similar conventional spellings but different tones)." In spite of how entertaining these gaffes may have been, he hoped that a modern approach to phonetics would provide a more accurate transcription of these sounds, and that his compatriots "should soon hear no more of such errors." Furthermore,

[92] See the entry for [Gwendolen] Avril Colerdige-Taylor in *The New Grove Dictionary of Women Composers*, ed. Julie Anne Sadie and Rhian Samuel (New York: MacMillan, 1994).

[93] Solomon Plaatje and Daniel Jones, *Sechuana Reader in International Orthography (with English Translations)* (London: U London P: 1916), vii.

he immediately saw the potential that a phonetic notation had for improving the prospects of written literature in Setswana and other tonal African languages, and so launched on a joint book project with Jones: *Sechuana Phonetic Reader* (1916). The accuracy Jones and Plaatje pursued in their transcriptions combined the use of the newly updated International Phonetic Alphabet (revised in 1900) with musical manuscript notation to indicate subtle tonal shifts with intervals ranging from minor seconds[94] to major thirds.[95] While the musical notation was used less than the I.P.A. in their work, Plaatje and Jones included *eleven* musical entries in their introduction, one of which indicated the rhythm rather than the pitch of speech.

It is striking that Plaatje phrases his reaction to the possibilities of phonetic notation in terms of aesthetic enjoyment. He writes in his preface that it has "been [his] pleasure on many occasions to sit and listen to Mr. Jones reading aloud (from phonetic texts) long and difficult Sechuana passages, of which he did not know the meaning, with *a purity of sound and tone more perfect* than I have ever heard from Englishmen in Africa" (my italics).[96] Such praise for sound and tone could easily be speaking to a musical performance, and Plaatje's thrill at the way a notation system could lead to a well-executed interpretation confirms his ongoing search for an effective approach to transcription. He saw that such an expanded notion of transcription could bring sounding, listening, and writing into new relation, ushering in an African modernist culture where the vernacular resources of music and oral literature were available to be inscribed in mediums appropriated from Western modernity, to make something entirely new. Clearly, the value of music within Plaatje's work was diverse, dynamic, and went far beyond mere *divertimenti*.

To conclude, for the figures examined in this chapter, transcription was an important means of inscribing versions of modernity in new print cultures. Lived experiences of travel and reading shaped relationships South Africans forged with African American and other diasporic projects of racial uplift and liberation. However, more than the uniquely African American characteristics of the genres of music they engaged, it was the strategic political use of music that they shared with African Americans. As an analog of translation, a shared text in religious communities, a resource for fundraising, and a purveyor of black modernities outside of colonialism, transcription privileged music in a set of experiments tying aural and written text.

[94] Minor seconds are also called semitones, which are the smallest interval easily notated in Western diatonic music.

[95] Major thirds can be subdivided into four semitones, and are thus wider pitch intervals.

[96] Plaatje and Jones, *Sechuana reader*, ix.

Négritude Musicology

POETRY, PERFORMANCE, AND STATECRAFT IN SENEGAL

Taking the previous chapter's concerns with how to bring music to text in a different direction, this chapter considers the impact of jazz and other Afro-diasporic music in mid-century Senegal. I begin where the last chapter ends, in the 1930s, with Léopold Sédar Senghor's movements between the land of his birth and France, where his most significant encounters with African diaspora writers and musicians began. The *idea* of popular black Atlantic music, and most specifically jazz and the blues, is remarkably central to his formulation of the essential characterstics of *l'âme noire*, the black soul. However, for Senghor, writings *about* music held more sway than live performance, and secondary musical texts, including music criticism, reportage, journalism, and imaginative literature most clearly shaped his ideas about diasporic music, and most especially, jazz. These interlocking textual apparatuses encompassed multiple forms of cultural criticism in an instance of stereomodernism that I call *Négritude musicology*. Senghor draws most heavily on early French musicological texts about jazz (including Goffin, Hodeir, and Vian) and African American literary celebrations (particularly the works of Claude McKay and James Weldon Johnson). Where the Dubes, Manye Maxeke, and Plaatje used music instrumentally to enact a unifying national identity, Senghor saw jazz in a broader context as an example par excellence of Négritude, his theory of black political aesthetics. Négritude, however, was not a uniformly embraced philosophy and while Senghor's wide readings about jazz as an African American popular music inflected his Négritude writings and state policy, there were those among his contemporaries in Senegal and beyond who challenged his views sharply. In this chapter I trace the development of Négritude musicology, and then analyze some of its contestations.

Taking up the three central concerns laid out in the introduction—solidarity, modernism, and media—I show how diasporic accounts of music's cultural and stylistic significance mediated Senghor's embrace of jazz as a sign of Négritude, allowing him to articulate parallels between African vernacular oral art forms and jazz as commensurable modern black forms. Highlighting

common aesthetic characteristics in local Senegalese, more generalized African, and African American jazz musical practices, Senghor argued that these traits demonstrated the modernity of Africa and the legitimacy of musical art as a ground for Négritude's claim to a pan-racial black sensibility that stood in for solidarity. Critics as diverse as Adotevi, Towa, Soyinka, and others have famously questioned Senghorian Négritude's essentializing tendencies and its failures to challenge colonial logic sufficiently, so why return to what is by now an old, and effectively settled matter?[1] Attending to Senghor's ideas about music uncovers his epistemological approach to comparison and evidentiary argument, but also serves as an optic for how his claims about music elicited a set of contesting voices.[2] The value of Négritude lay as much in its provocations as in its proclamations, and struggles over meaning provided occasions for frank exchange necessary to building any solidarity worth its salt.

The Senghorian vision of Négritude was highly determined by an internationalism rooted not only in collective reading and social networks of Paris-based blacks and French enthusiasts of black cultural expression, but also in writings by African Americans who celebrated the seemingly transcendent qualities of jazz. However, the forms of recognition and misrecognition that jazz and other African American music elicited were sites of Relation in the Glissantian sense, moments that exposed stubborn opacities that could not be reduced to a hasty transparency. As Glissant writes in *Traité du Tout-Monde*:

Je réclame pour tous le droit à l'*opacité*, qui n'est pas le renfermement.

C'est pour réagir par là contre tant de réductions à la fausse clarté de modèles universels....

Que l'opacité...ne ferme pas sur l'obscurantisme ni l'apartheid, nous soit une fête, non une terreur. Que le droit à l'opacité, par où se préserverait au mieux le Divers et par où se renforcerait l'acceptation, veille, ô lampes! sur nos poétiques.

[I reclaim for all the right to *opacity*, which is not to shut oneself away.

It is thus in order to react against the endless reduction to a false clarity of universal models....May opacity...not trap us within obscurantism nor apartheid, may it be for us a celebration, not a terror. May the right to opacity, by which the Diverse is best preserved and through which acceptance is reinforced, stand guard to our poetics, O lights!][3]

[1] See Stanslav Adotevi, *Négritude et Négrologues* (Paris: Union Génerale d'Éditions, 1972); Marcien Towa, *Léopold Sédar Sénghor, Négritude ou servitude?* (Yaounde: Éditions CLE, 1971); Soyinka, "The Future of West African Writing," 4:1 in *The Horn* (1960), 10–16 for rejoinders to Négritude.

[2] For a good overview of the current state of Négritude studies, see F. Abiola Irele's *The Négritude Moment: Explorations in Francophone African and Caribbean Literature and Thought* (Trenton: Africa World Press, 2011), and Patrice Nganang's review in *Research in African Literatures* 43.3 (Fall 2012), 131–34.

[3] Glissant, Edouard. *Traité du Tout-Monde (Poétique IV).* (Paris: Gallimard, 1997), 29.

For Senghor, music was the universal language of Négritude. However, its opacity posed a challenge to many of Négritude's more universalizing gestures, and by parsing such gestures carefully and retracing the counterarguments elicited, we gain insight into the dialectical relationship between the forms of cultural opacity Glissant summons in his later writings and the claims to pan-racial understandings Senghor sought to arrive at via jazz. Too hasty a dismissal of Senghorian Négritude would miss the way it contributed to this dialectic.

My argument unfolds via a chronological reading of Senghor's poetry, prose, and speeches where he claims that jazz (often used interchangeably with the blues) was a quintessential example of *l'âme noire*—the black soul onto-logically inseparable from Négritude. Senghor made such claims in academic and political circles that included few sustained personal ties with African Americans, and it was not until the World Festival of Negro Arts (*Festival Mondial des Arts Nègres*, hereafter FESMAN) in 1966 that these claims were tested by artists and academics from across the black world. The second part of the chapter considers how festival delegates, and African Americans in particular, contested Senghor's claims for jazz music. By 1966, I argue, the dominant musical metaphors of transnational solidarity had already shifted to other musical genres. There was less interest in whether Négritude had swing than in the kind of sonic challenge to universalist humanism uttered in Abbey Lincoln's siren call on the *We Insist!—Freedom Now Suite* (1960) album, or the heavy sweat of a collective black body politic summoned together by James Brown's *Live at the Apollo* (1962).

Négritude musicology drew on musical discourse by and about African American cultural workers, where *logos,* as both theoretical language and disciplinary method, was prioritized over material sound. Senghor's interests developed in parallel with a turn to popular and vernacular music in other Afro-diasporic sites—not only among Harlem Renaissance figures (notably Alain Locke, Harry T. Burleigh, Langston Hughes, and others) but also in the journalism, novels, and the magnus opus *La música en Cuba* of Alejo Carpentier.[4] Although Paul Gilroy has drawn attention to how music is freighted with the burden of racial authenticity in the late twentieth-century, writers in the 1920s and 1930s were already making such moves. Nonetheless, Gilroy's lament over the instrumentalization of music as "a cipher for racial authenticity" in *Small Acts* is remarkably resonant with Senghor's apparent stance on music as an index of blackness rather than as sonic pleasure in and for itself:

> Music, which was the centre of black vernacular culture for such a long time, has acquired a new place and a new significance.... Its non-representational

[4] *La música en Cuba* was not published until 1946, but reflected years of archival work, as well as the influence of the Parisian milieu of the primitivist 1920s.

qualities are being pressed into service to do an uncomplicated representational job. They are burdened with the task of conjuring up a utopia of racial authenticity that is everywhere denied but still sought nonetheless.[5]

Senghor's Négritude musicology drew on two sources: African American literary texts and early French musicology and journalism, and the seeming contradictions among these two streams gave rise to a highly complex (and at times, vexed) approach to representing jazz. African American writing about jazz was foremost, and the emblematic uses to which he puts jazz (often letting it stand in for *négro-americains*[6] and even for *l'âme nègre*), as well as examples of anachronism in his references reveal that music was a crucial means of condensing the black diaspora into a stable cultural monad.

Mercer Cook's essay "Afro-Americans in Senghor's Poetry," originally published in a 1976 collection for Senghor's seventieth birthday, outlines many of Senghor's jazz references[7] and building on Cook's work, it becomes clear that Senghor cited Alain Locke's writings about music, and literary representations by Langston Hughes, Claude McKay, and Sterling Brown more often than individual performers, recordings, or live performances. Strikingly, however, all the other musicological sources that Senghor turns to, and all but one of the jazz clubs he refers to, are European. The French music critic, Hughes Panassié is cited more extensively than any (African) American sources, and the prestige that Senghor assigns to jazz music mirrors the enthusiasm with which the metropole embraced visual and musical signs of blackness in the 1920s and 1930s.[8] Paradoxically, then, Senghor's adoption of jazz as a Négritude object par excellence was routed via the colonial metropole, and partially mediated through Paris-based writers responding to European and Euro-American high modernism's craze for all things *nègre*. This is not to diminish the significance of black cultural exchanges in the metropole. It is, by now, well known that Paris was an essential site for the spread of black international thought in the interwar period. Indeed, Senghor's earliest poems citing the blues date from his sojourn as a student in France, when he was first encountering

[5] Paul Gilroy, *Small Acts* (London/New York: Serpent's Tail, 1993), 5.

[6] Senghor's names for diasporans reflect his familiarity with the Nardal sisters. Paulette Nardal's writing in *Revue du Monde Noir* introduced terms that included Afro-Latin and Afro-French in the same period when Césaire, Damas, Senghor, and others were revalorizing *nègre* as a term to celebrate blackness by coining "Négritude." See Brent Hayes Edwards, *The Practice of Diaspora* on Nardal's translation work. See Jennifer Wilks, *Race, Gender and Comparative Black Modernism* and T. Denean Sharpley-Whiting, *Negritude Women*, [sic] for more on the Nardal sisters and their transatlantic work.

[7] Mercer Cook, "Afro-Americans in Senghor's Poetry," in *Critical Perspectives on Léopold Senghor*, edited by Janice Spleth (Washington, DC: Three Continents Press, 1990). Originally published in *Hommage à Léopold Sédar Senghor, homme de culture* (Paris: Présence Africaine, 1976).

[8] Petrine Archer-Straw details this phenomenon elegantly in *Negrophilia: Avant Garde Paris and Black Culture in the 1920s* (London: Thames and Hudson, 2000).

fellow students from other parts of the black world. From these blues poems to comparisons between education policies and jazz aesthetics, from nods to black-cast musical films like *Green Pastures* (1936) to a poem cycle in the 1980s calling for gospel choir accompaniment, African American popular music figured prominently in Senghor's understanding of the creative energy of *l'âme noire*, the black soul, which, he maintained, lay at the foundation of Négritude.

Despite the fact that we remember him as *le poète-président,* Senghor wrote far more prose than the other founders of the literary movement, Aimé Césaire and Léon Damas; his published essays and speeches fill five volumes (over two thousand pages) of *Liberté* in addition to his prolific poetic output. Jazz and related Black Atlantic musical practices were a constant reference point from the time he came to France in the late 1920s onward. However, the limited number of performers mentioned by name and the level of abstraction in his descriptions raise the question of how much Senghor actually listened to the music he so readily cited. Ironically, while Senghor advocated emotion, rhythm, and dance as core aspects of Négritude, he was, according to his biographers, a reserved person far more likely to attend solemn Mass on a Sunday morning than to take in a live music show on a Saturday night.[9] How did the proponent of a form of Négritude that celebrated the (neo-) traditionalist black soul (*âme noir*) sounded on the kora, the balaphon, and the sabar drum become so interested in jazz and other forms of popular music? This chapter poses a cheeky question: does Senghor's Négritude have swing? More to the point, what *did* jazz mean to Senghor? And how might the sometimes pedantic slow drag of the poet-president's theories on jazz as an exemplar of Négritude open up the "pocket," that essential ragged approach to the beat in a jazz ensemble, to think about transnational black solidarity as a dynamic relationship between the popular, the scholarly, and the belletristic?

The question of swing turns on whether Senghor imagined himself as a participant or an observer, a player or an audience member. Performance instructors and ethnomusicologists alike stress that to play jazz one must cultivate a good ear through active listening practices. Indeed, Mark Levine cautions in the introduction to *Jazz Piano,* one of the definitive texts for beginning keyboard improvisers:

> Nobody has ever learned to play jazz from a book only.... Listen to as much live and recorded jazz as you can, transcribe solos and song from records, and, in general, immerse yourself as much as possible in the world of JAZZ.[10]

[9] Numerous biographies mention Senghor's introversion. See, for example, Janet Vaillant, *Black, French, and African: A Life of Léopold Sédar Senghor* (Cambridge, MA: Harvard UP, 1990).
[10] Mark Levine, *Jazz Piano* (Petaluma, CA: Sher Music, 1989), ix.

Paul Berliner strikes a similar note in his magnum opus *Thinking in Jazz*, where he analyzes how jazz musicians develop formidable musical intelligence. Jazz musicians internalize the ins and outs of diatonic theory so thoroughly that they can make decisions based not only on the complex combinatorics of harmonic chord structures but also on a personalized aesthetic and a commitment to honing a shared language with their fellow improvisers. Berliner demonstrates how musicians learn from one another, often in seemingly informal settings that almost always involve listening together, whether to live performers or recordings.[11] While musicians may develop an interest in musicological approaches or written histories that supplement their practical and aural initiation into the history of this art form, listening is the primary mode for learning how and why "It Don't Mean a Thing if it Ain't Got That Swing." Lingering over the poet-president's writings and cultural policy alongside that of his critics elucidates what meaning(s) Senghor made of "ce que les Américains appellent *swing*," as he gingerly puts it in his seminal essay "Ce que l'homme noir apporte[What the Black Man Offers]," and, in the process, opens new insights on the relation of Senghorian Négritude to other pan-African cultural expressions over the course of his long career.

Begin the "Bicephalous" Beguine

To foreground the intersections between artist and statesman, I begin with the speech that launched Senghor's political career. In September of 1937, Léopold Sédar Senghor made his first official speech in Senegal, presenting his vision of an education system adapted to the colonial context in a presentation entitled "Le Problème Culturel en A.O.F." before the Foyer France-Sénégal at the Chamber of Commerce in Dakar's Plateau district. He had published a review of René Maran's *Batouala* in the much-fabled l'*Étudiant noir* in 1935, but this speech, later published in *Liberté I*, marked Senghor's first officially invited address to the Dakar public. He began by confessing (rather disingenuously for Africa's first *agrégé*) that he was going to speak as a peasant from Sine—"*en paysan du Sine*"—and anchored his speech in the boldly twinned traditions "du bonhomme Socrate et de notre sage Kotye Barma" [of the fine fellow Socrates and our sage, Kotye Barma].[12] He would go on to argue that education ought to be adapted to reflect both the values of African civilization and the demands of assimilation imposed by colonialism, and jazz music served as a prototype of the balance to be struck between these two sets of interests.

[11] Paul Berliner, *Thinking in Jazz: The Infinite Art of Improvisation* (Chicago: U Chicago P, 1994).

[12] Léopold Sédar Senghor, "Le Problème Culturel en A.O.F.," in *Liberté I: Négritude et Humanisme* (Paris: Seuil, 1964), 11. An agrégé has passed a highly competitive exam to teach in France.

The first section of his discussion was framed as a debate over the meaning of "culture" between imagined interlocutors whose names marked them as representatives of a range of Senegalese ethnic groups. Beginning in this way reestablished his credibility and connection to local identities after ten years residing in France, but it also highlighted the problematic disparity in rights enjoyed by the African *citizens* from the urban Communes of Dakar, Rufisque, St-Louis, and Gorée and the marginalized African *subjects*, largely rural peasants from places like Sine across French West Africa. What these Africans shared, however, was the dilemma of assimilation:

> Que si nous voulons *survivre*, la nécessité d'une adaptation ne peut nous échapper: d'une *assimiliation*. Notre milieu n'est plus ouest-africain, il est aussi français, il est international; pour tout dire, il est *afro-français* [That if we wish to *survive*, the necessity of an adaptation cannot escape us, nor indeed of an *assimilation*. Our milieu is no longer strictly West African, it is also French, it is international: in sum, it is *Afro-French*].[13]

Senghor stressed the need to maintain an African cultural identity outside of French economic and political domination, a space of alterity, if not resistance. Given that he saw assimilation as inescapable, the question he posed concerned what sort of education would best fit the challenges of the day.

Senghor then turned to a more technical discussion of education and to a topic that might hardly be expected to launch a political career on the world stage: textbook selection. Calling for a bifurcated system that he rather awkwardly named *bicéphalisme* (two-mindedness), he voiced an expectation that the French would continue to expand the right to participate in governance to West Africans.[14] *Bicéphalisme* would encourage young West African urbanites to develop an acquaintance with local cultural and economic imperatives on the one hand and familiarity with the world of the French colonizers on the other, a description consonant with the idea of binaural hearing in stereophonics. While admittedly elitist, his statement that "L'élite est appellée à être exemple et intermédiaire [The elite is called to be an example and an intermediary]" urged his audience to consider what an education for future citizenship would involve.[15] His criticism of one well-known textbook hinged on the need to prepare for wider access to civil rights and responsibilities:

> le fameux *Mamadou et Bineta* fait merveille en brousse. Mais il n'est pas fait pour des élèves de Dakar: il ne leur parle pas de mille choses familières aux citadins.… [J'attends] le *Mamadou et Bineta* du Citoyen, et ce livre du Cours

[13] Senghor, *Liberté I*, 14. Here Senghor adopts Nardal's term, "afro-français."

[14] At the time of Senghor's speech, the French colony of l'Afrique occidentale francaise (French West Africa) encompassed those territories that would become Senegal, Mali, Mauritania, Guinea, Ivory Coast, Niger, Burkina Faso, and Benin.

[15] Senghor, *Liberté I*, 18.

moyen qui groupera les meilleures pages des écrivains coloniaux, noirs comme blancs, et des écrivains métropolitains, les unes éclairant et complétant les autres. [the famous *Mamadou and Bineta* goes over marvellously in the bush. Yet it is not designed for the students of Dakar: it does not speak to them of a thousand things familiar to urbanites.... [I await] the *Mamadou and Bineta* of the Citizen, and that middle school textbook which will gather the best pages of colonial writers, black as well as white, along with metropolitan writers, complementing and shedding light on each other.][16]

According to this prescription of preparatory readings for citizenship, the reader was imagined as a *citadin*, not only an urban resident but also a civic being. It was this urban civic reader, after all, who would most need to maintain his or her bilingualism in the face of the dominance of French language instruction in the high schools, and was in need of a bulwark against the metropolitan cultural wave.

And it was precisely as an urban citizen that Senghor's imagined reader might find a relevant cultural resource in jazz and the other black diaspora expressions to which Senghor turned at the end of his speech. In proto-Négritude[17] terms "Les intellectuels ont mission de restaurer les *valeurs noires* dans leur vérité et leur excellence.... Par les Lettres surtout [Intellectuals have a mission to restore *black values* in their truth and their excellence.... Through Literature above all else]."[18] The forerunners for such a project were all from the diaspora— Haitian literature first of all, but also "négro-américaine, négro-espagnole, négro-portugaise." Yet he immediately undercut this agenda, deeming what he called "notre peuple" [our people] unready to launch a literature using the instrument of the French language, and suggested an intermediary step was necessary in the cultural vindication of "black values." The model for this step was jazz:

Enfin, une telle littérature ne saurait exprimer toute notre âme. Il y a une certaine saveur, une certaine odeur, un certain accent, un certain timbre noir inexprimable à des instruments européens. Les inventeurs du *jazz-hot* l'ont compris, qui emploient la trompette bouchée et autres instruments bizarres à l'homme de la rue. [Finally, such a literature would not know how to express our whole soul. There is a certain flavour, a certain odor, a certain accent, a certain black timbre that cannot be expressed on European instruments. The inventors of hot jazz understood this, and they use the muted

[16] Ibid., 16.
[17] Throughout the speech, Senghor uses a wide range of terms to identify black cultures, including "afro-francais" (18), *"valeurs noirs"* (19), "négro-americaine, négro-espagnole, négro-portugaise" (19); this variable terminology suggests that he was not yet committed to revindication and the more consistent use of the term "nègre," which became characteristic of his later thought.
[18] Senghor, *Liberté I,* 19.

trumpet and other bizarre instruments appropriated from the man in the street.][19]

Jazz, for Senghor, captured something putatively unnameable and inexpressible (*inexprimable*), a "je-ne-sais-quoi" about blackness to which the *agrégé*[20] only gestured in the repeated "certain"; this inexpressible quality exceeded the scope of the linguistic and visual realms, yet engaged a range of other senses (hearing, smelling, tasting). Put differently, language was not up to the task of adequately conveying this supplementary blackness. It was, however, captured and conveyed in the very sound of hot jazz, the timbre of its instruments, rather than in its form, its lyrics, its sociocultural context. How striking that, in a speech so concerned with bilingualism, this supplementary blackness is not mediated by either a European or an African language but rather by *sound* —instrumentation, timbre and accent. Furthermore, it is the timbre of brass instruments, and specifically the declamatory tones of the trumpet, that are referenced here, and that would predominate in Senghor's references to jazz, not the plucked bass, percussive piano, or brushed drum set. This suggests that the function of jazz in Senghor's work was to herald a genius that is specifically *nègre* with fanfare. Négritude musicology was mining jazz for a set of metaphors and shared references that could tune local political challenges to the song of transnational black political solidarity.

Senghor quickly returned, however, to his speech's original theme, and here the traces of another project of bilingualism emerged in his choice of examples. "Le bilinguisme, précisément, permettrait une *expression intégrale* du *Nègre nouveau*—j'emploie le mot à dessein; il doit être restitué dans sa dignité [Bilingualism, precisely, will permit an *integral expression* of the *Nègre nouveau*—I employ the word intentionally: it must be restored to its dignity]."[21] The term "Nègre nouveau" was, of course, a translation of the "New Negro," which Senghor had first encountered among the community of black intellectuals introduced to him by the Nardal sisters and their bilingual French-English journal, *La Revue du Monde Noir*.[22] As Brent Hayes Edwards points out, "More than any other interwar periodical, *La Revue du Monde Noir* systematically strove to practice black internationalism as bilingualism, running English and French in parallel columns throughout every issue."[23] Thus, when Senghor presented bilingualism as a principle to be adopted in French West Africa, both

[19] Ibid.,19.
[20] Senghor was awarded the *agrégé* teaching qualification in 1935, the first black African to receive this French academic degree.
[21] Senghor, *Liberté I*, 19.
[22] Both Edwards (120) and Vaillant (91) describe the Nardal sisters as crucial in introducing Senghor to African American and Caribbean intellectuals in Paris.
[23] Brent Hayes Edwards, *The Practice of Diaspora: Literature, Translation, and the Rise of Black Internationalism* (Cambridge, MA: Harvard UP, 2003), 120.

the conceptual genealogy and the specific references to the New Negro move-
ment attested to the impact the diaspora in black Paris had upon him.

The list of particular writers whose work he saw as models of this "inte-
gral expression" was also telling. If "Un Paul Laurence Dunbar, un Claude
MacKay [*sic*], un Langston Hughes, un Sterling Brown ont fait, du patois
négro-américain, d'un pauvre balbutiement d'esclaves déracinés, une mer-
veille de beauté: *a thing of beauty* [a Paul Laurence Dunbar, a Claude McKay,
a Langston Hughes, a Sterling Brown have made, of Negro American dialect,
of the poor mumblings of deracinated slaves, *a thing of beauty*],"[24] they had
all done so by crafting poetry constituted by its relation to black music, black
speech, but most of all black *sound*. Whether in direct references to jazz music,
or through the influence of these New Negro writers who themselves emu-
lated music, Senghor came to assign a place of privilege to early jazz in his
poetic, as well as prose oeuvre, casting it as a definitive example of Négritude
as "l'ensemble des valeurs du monde noir [the ensemble of values of the black
world]."

Although presumably composed during the same period as his entry into
public service, Senghor's *Poèmes perdus* (or *Lost poems*) were first published in
the 1990 Seuil edition of his complete works. Diaspora-derived music is repeat-
edly associated with the nostalgia, homesickness, melancholia, and alienation
that haunted Senghor's own chosen exile. Senghor returned to Senegal in 1932
and again in 1937, but apart from these visits he was living in France, and the
nostalgia that ran through these poems reflected his own experience of exile's
soleil noir.[25]

In addition to referencing the eponymous poem by one of Senghor's favor-
ite poets, Charles Baudelaire, "Spleen" plays on the two senses of the blues—
a musical form and a melancholic mood. The stereomodernist influence of
Langston Hughes, whose poetry Senghor memorized and recited, is apparent
in the adherence to formal rhyming and rhythmic patterns, in the economy of
diction, and in patterns of "repetition with a difference," which Samuel Floyd
has shown to be a rhetorical signifying practice typical of blues musical forms.[26]
Senghor was well aware of typical twelve-bar blues form (although his analysis
focused more on the poetic than musical aspects of the form). In a 1950 lecture
on "La poésie négro-américaine," he described the standard form of stanzas of

[24] In choosing the English-language phrase "a thing of beauty," Senghor also invoked John Keats's
poem "Endymion," and it's claim for beauty's staying power as a legitimizing gesture, an affirmation of
the lasting aesthetic value of work by Dunbar and the other authors he mentioned.

[25] Vaillant notes: "Apparently Senghor suffered bleak periods throughout his life. He learned to rec-
ognize them and to remember that they would pass." (104). My phrasing here makes a nod not only to
Julia Kristeva's powerful theorization of depression and melancholia, *Le soleil noir* (translated as *Black
Sun*), but also to her thoughtful work on exile and literature in *Strangers to Ourselves*.

[26] See Samuel Floyd, *The Power of Black Music: Interpreting Its History from Africa to the United
States* (New York: Oxford UP, 1996). Floyd expands on Henry Louis Gates's work on "signifyin[g]."

three lines, with an identical or slightly altered repetition of the first, and a third line that closes unexpectedly.[27] Given his clear exposé of blues form, the variations from blues form in "Spleen" may be taken as intentional poetic license. Each stanza is four lines long, and a diegetic stanza alternates with a chorus:

> C'est un blues mélancolique,
> Un blues nostalgique,
> Un blues indolent
> Et lent.[28]

> It's a melancholy blues,
> A nostalgic blues,
> A slow, lazy
> Blues.[29]

In "Spleen" the first two lines of the chorus present a synonymous and rhymed pair (mélancolique/nostalgique), which is elaborated in the final line, "Un blues indolent/et lent." While the line break before "et lent" serves to "worry the line," another practice of embellishment or elaboration typical of Afro-diasporic musical practice. As Stephen Henderson explains in his classic, *Understanding the New Black Poetry*, "worrying the line" is a "folk expression for the device of altering the pitch of a note in a given passage or for other kinds of ornamentation often associated with melismatic singing in the black tradition. A verbal parallel exists in which a word or phrase is broken up to allow for affective of didactic comment."[30]

Another of Senghor's early *Pòemes perdus*, "Émeute à Harlem" was written long before Senghor's first trip to New York (he did not travel there until 1950), and the Harlem imagined here is one he knew only through literature and the acquaintances he made through the Nardals and Louis Achille in Paris. The poem's opening lines suggest a joyous epiphany, whose juxtaposition with the title suggests a more revolutionary-minded lyric speaker than we have encountered so far:

> Et je me suis réveillé un matin
> De mon sommeil opiniâtre et muet,
> Joyeux, aux sons d'un jazz aérien[31]

[27] Senghor, *Liberté I*, 106.

[28] Léopold Sédar Senghor, *Oeuvre Poétique* (Paris: Seiul, 1990), 348.

[29] Léopold Sédar Senghor, *The Collected Poetry*, trans. Melvin Dixon. (Charlottesville: U Virginia P, 1991), 241. (Hereafter cited as Dixon, *Collected Poetry*.) Note, Dixon often departs from Senghor's line-breaks.

[30] Stephen Henderson, *Understanding the New Black Poetry: Black Speech and Black Music as References*. (New York: Morrow, 1973), 41. Cheryl Wall's monograph *Worrying the Line: Black Women Writers, Lineage and Literary Tradition* (Durham: U North Carolina P, 2005) expands upon Henderson's definition.

[31] Senghor, *Oeuvre Poétique*, 351.

> And I awoke one morning
> From my stubborn, mute sleep,
> Joyful for the sounds of jazz in the air[32]

The poem begins in mid-thought, like an anacrusis (upbeat), and the repetitions of nasal [m] and approximant [j] phonemes figure sleep's silent grip on the speaker. In the third line jazz erupts, the first word from outside a standard French lexicon, and awakens the speaker to recognize the "turpitudes/Sous le velours et la soie fine [turpitudes/Below the velvet and fine silk]" of a decadent exterior (presumably that of the capitalist West, although the poem leaves this vague "ils"/"leurs" without specification).[33] At first glance jazz seems entirely abstracted here, a passing reference, whose aerial qualities contrast sharply with the insistence on materiality, and specifically the bodily images that follow (gangrene, saliva, a feverish head, blood). However, the phonetics and rhythmic tension of the line "Joyeux, aux sons d'un jazz aérien [Joyful for the sounds of jazz in the air]" evoke jazz at the level of onomatopoeia. The fricative phonemes—[ʒ], [z] and [s]—mimic the innovation of brushes used on a drum set. By the end of the poem, nauseated by the stench of a gangrened world unmasked, the speaker's head has been converted into "Une usine à révoltes/ Montée par de longs siècles de patience [A factory of revolts/Raised up by long centuries of patience]." He ends calling for "des chocs, des cris, du sang,/Des morts [shocks, and shouts, and blood,/And deaths]" and the return to an iambic rhythm suggests an echo of the third line and a parting evocation of jazz.

The title "Émeute [Uprising]" shares the same etymology as *émotion*, which Senghor (in)famously qualified as *nègre* in the oft-quoted statement: "L'émotion est nègre, comme la raison hellène [Emotion is negro, as reason is Greek]."[34] In light of the poem, Senghor's *émotion* registers not just as the English word "emotion," but as a reaction of protest to oppression privileging action rather than mere analysis. Senghor's statement about emotion and reason comes from his essay "Ce que l'homme noir apporte" [What the black man brings], which he contributed to a section entitled "Vers une harmonie [Towards a harmony]" in the 1939 edited collection *Homme de Couleur*. Senghor's essay proposes that blacks have a unique approach to religion, societal organization, and the arts, and draws on German ethnologist Leo Frobenius' idiosyncratic theory of the ties between plant life and emotional vigor to ground its controversial statement.[35] However, the essay is of particular interest here because it

[32] Dixon, *Collected Poetry,* 244.

[33] Senghor, *Oeuvre Poétique,* 354.

[34] Senghor, *Liberté I,* 24.

[35] Césaire, Damas, and Senghor studied Frobenius's "Qu'est-ce que l'Afrique signifie pour nous?" from the 1936 French translation of Frobenius work, *L'Histoire de la civilization Africaine* well enough that Senghor claimed to know the text by heart.

not only draws from a repertoire of diaspora sources, but also specifies what aspects of jazz Senghor sees in *l'âme nègre* [the black soul]."

"Ce que l'homme noir apporte" quotes French translations of Lewis Alexander, Countee Cullen, Langston Hughes, and Claude McKay, mentioning Jean Toomer and Alain Locke in footnotes as well as Lydia Cabrera's collection, *Contes nègres de Cuba,* (a French translation of a foundational text from the Hispanophone African diaspora), and the film *Verts Pâturages* (a subtitled version of the 1936 classic *Green Pastures*). All but one of the cited poems had been published in Locke's anthology, *The New Negro*, a text so influential that one might claim Locke edited the textbook for Négritude musicology.

In this essay, Senghor is more specific about what aspects of jazz he sees as most crucial. Senghor declares that the "force ordinatrice qui fait le style nègre est le *rythme* [determining force which defines the Negro style is *rhythm*]."[36] He notes in very general terms that the approach to rhythm in music as opposed to the plastic arts is exemplified by the fact that song in *le style nègre* is often accompanied by drums and no other instrumentation. However, it is to African American culture that Senghor turns in articulating what he purports to be the unique aspects of a black approach to rhythm:

> C'est ce que les Américains appellent *swing*. Caractérisé par la syncope, il est loin d'être mécanique. Il est fait de constance et de variété, de tyrannie et de fantaisie, d'attente et de surprise; ce qui explique que le Nègre puisse, pendant des heures, se plaire à la même phrase musicale, car elle n'est pas tout à fait la même. [It is what the Americans call *swing*. Characterized by syncopation, it is far from being mechanical. It is composed of constancy and variety; of tyranny and fantasy; of expectation and surprise; which is what explains how the Negro could, for hours on end, be able to take pleasure in the same musical phrase, for it is not altogether the same.][37]

The example he gives of iterations of the same musical phrase over several hours could not be further from the aesthetics of invention and improvisation key to jazz performance. Senghor's elastic use of the term "rhythm" leads him to examples that might otherwise seem contradictory, rendering the notion that "le Nègre était un être rythmique [the Negro was a rhythmic being]" so broad that it becomes virtually meaningless.

He is on less tenuous ground in his discussion of instrumentation, which he sees as not strictly a musical element, but which leads him to a striking comment on timbre:

> le Nègre a montré les ressources que l'on pouvait tirer de certains instruments ignorés jusque-là ou arbitrairement méprisés et cantonnés dans un

[36] Senghor, *Liberté I*, 36.
[37] Ibid., 37.

rôle subalterne. Tel fut le cas des instruments à percussion, dont le xylo-phone; tel est le cas du saxophone et des cuivres, trompette et trombone. Grâce à la netteté, à la vigueur, à la noblesse de leurs sonorités, ceux-ci étaient tout désignés pour rendre le *style nègre*. Grâce aussi à tous les effets de déli-cate douceur et de mystère qu'en ont tirés, depuis, les meilleurs 'hotistes.' [the Negro has demonstrated the resources upon which one can draw in certain instruments which were hitherto unknown or arbitrarily looked down upon and ghettoized in a subaltern role. Such was the case with percussion instru-ments, such as the xylophone; such is the case with the saxophone and brass instruments like the trumpet and trombone. Thanks to the cleanness, the vigor and the nobility of their sonorities, all these were well-suited to render the Negro style. Thanks also, to all the effects of delicate sweetness and of mystery which, since then, the very best of the hot jazz players, have been able to draw from their instruments.][38]

One of the innovations of the *style nègre* as sound per se, then, is to introduce a specific sonority that hot jazz artists know best how manipulate. Yet what unites these instruments' very different timbres is not merely the "cleanness, the vigor and the nobility" of their timbre, but the conversion of a hierarchizing critique into a positive value, not unlike the transformation of the racist over-tones of the word *nègre* to the "Négritude" that Césaire had first announced four years previously. Senghor's bold claim here is that the reclamation of black dignity has a *sonic* quality.

Senghor's final point about jazz reveals the degree to which the music shapes his poetics rather than merely appearing at intervals as a referent:

Hughes Panassié a mis en pleine lumière les apports nègres dans le *jazz hot*, dont le caractère fondamental est dans l'*interprétation*. ... La valeur de l'interprétation est dans l'intonation, que Panassié définit: 'Non seulement la manière d'attaquer la note, mais encore la manière de la tenir, de l'abandon-ner, bref de lui donner toute son expression.' 'C'est, ajoute-t-il, l'expression, l'accent que l'exécutant imprime à chaque note, dans lequel il fait passer toute sa personnalité.' [Hughes Panassié has brought to light the black con-tributions to *hot jazz*, among which the fundamental characteristic emerges in *interpretation*. ... The value of interpretation lies in its approach to intona-tion, which Panassié defines thus: "Not only the manner of attacking a note, but also the manner of holding and releasing it, in short, in giving it all its expressivity." "It is, he adds, the expressivity, the accent which the performer imprints on each note, in which he transmits his entire personality."] (my italics)[39]

[38] Ibid., 37.
[39] Ibid., 38.

In other words, it is the material sound itself, the timbre, tuning, and articulation of a particular performer's sound rather than what pitches are played that commands Senghor's attention in Panassié's discussion.

The Shadow of a Smile

Sylvie Kandé has argued that jazz allows Senghor to find a resonance between his own alienation as a student from the colonies in Paris, and the originary displacement (to borrow Nahum Chandler's phrase) of the Middle Passage for diaspora blacks:

> Le poète inscrit répétitivement la nostalgie qui embrume son exil à Paris dans le cadre immense et tragique de l'exil collectif des Africains déportés puis mis en esclavage sur un sol étranger, double désastre dont témoigne indirectement le blues. [The poet repeatedly inscribes the nostalgia which fogs his exile in Paris within the immense and tragic framework of the collective exile of those Africans deported and then enslaved on foreign soil, a double disaster to which the blues bears indirect witness.][40]

She draws attention, in particular, to the poems "Joal"[41] and "Ndéssé ou 'Blues.'" While Kandé's interpretation is suggestive, we need to note that Senghor's exile is incommensurable in significant ways with the Middle Passage, and that if slavery figures in these poems at all only a careful reading can discern such references. In "Joal," Senghor's nostalgia is exacerbated by the mythic dimension in his childhood memories of his hometown, Joal. He fears that he will discover that his connection with traditions has eroded during his European sojourn, rendering him an orphan. It is not merely that he remembers, but that these memories open onto a collective identity rooted in an intimate knowledge of the genealogical history of his home. And these memories are anchored in sonic elements:

> Je me rappelle les festins funèbres fumant du sang des troupeaux égorgés
> Du bruit des querelles, des rhapsodies des griots.
> Je me rappelle les voix païennes rythmant le *Tantum Ergo*
> [I remember the funeral feasts blood smoking from the slaughtered beasts
> The noise of quarrels, the rhapsodies of griots
> I remember the pagan voices beating out the *Tantum Ego*][42]

[40] Sylvie Kandé, "Jazz et Littérature francophone" *Mots Pluriels 13* (April, 2000), p. 6.http://www.arts.uwa.edu.au/MotsPluriels/MP1300syk.html (accessed 6/24/11).

[41] "Joal" is analyzed in some detail in Barthélemy Kotchy's monograph, *La Correspondance des Arts dans la Poésie de Senghor.*

[42] Senghor, *Oeuvre Poétique,* 17.

He goes on to mention the choirs that sing at traditional wrestling matches known as *lamb,* and the cry of women in love. Yet these sounds are inaccessible, heard only within his own mind's ear.

> Je me rappelle, je me rappelle . . .
>
> Ma tête rythmant
> Quelle marche lasse le long des jours d'Europe où parfois
> Apparaît un jazz orphelin qui sanglote sanglote sanglote.
> [I remember, I remember . . .
>
> My head pounding
> Some languid march the length of European days or sometimes
> An orphaned bit of jazz which sobbed, sobbed, sobbed.][43]

The repeated phrase, "je me rappelle," running as a leitmotif throughout the poem, is also the rhythm in Senghor's head ["tête rythmant"] against which jazz's orphan sobs strike him as a new cross-rhythm. Why, we might ask, must this rhythm (for certainly the repetition of "sanglote" creates a new rhythm) register as an inconsolable sobbing? Whose loss is it marking? And what is its relation to Senghor's own nostalgic melancholia? I would argue that the triple iteration of "sanglote" against the dual iteration "je me rappelle" with which the stanza begins underscores a difference this poem does not gloss over. While Senghor makes no mention of his own family in these memories, the allusion to rhapsodic griots early in the poem contrasts with the orphan figure of jazz. Jazz, as a third term, external to his childhood memories and Hexagonal French patrimony, allows Senghor to work through his own homesickness. That this encounter with the diaspora is routed through Europe is also significant because it implicates Europe not merely as the site of a second-wave diaspora of colonial subjects migrating to the metropole, but also as originating the very "marche lasse [weary walk]," the long wandering that becomes what Édouard Glissant calls *errancy,* and jazz, as a diaspora music, is evoked as the poem's orphan.

The "Accompanied" Poems

Senghor introduced an important innovation to his poetry with *Hosties Noires* in 1948, annotating selected poems to be accompanied by musical instruments, whether these be koras, tama, or pipe organ.[44] In the *Chants pour*

[43] Ibid., 18.

[44] Although there are numerous recordings of Léopold Senghor reciting his poems, none of the recorded poems with annotations for musical accompaniment include musical tracks in the recitations, to my knowledge. However, in a recording of his poem "Joal" included on *Entretiens avec*

Naett, originally published as a stand-alone volume in 1949, and later renamed "Chants pour Signare" when included in the collection *Nocturnes* (1961), this practice of annotating a musical accompaniment for the poems is extended: in fact, the "Chants de Signare" have no titles, and are thus most easily identified by their musical annotations. Historically, *signares* were women of mixed African and European ancestry who occupied positions of privilege in the Four Communes, particularly Saint Louis, as an intermediary elite between the colonizing French and the rest of the local population. In spite of their ambiguous position they continue to be a celebrated part of Senegalese history and culture, and many events in contemporary Dakar include two or three young women dressed in period costumes, including the pointed cloth hats that have become the trademark of the signares. Senghor's reasons for renaming the collection are unclear, but the decision did reflect his interest in "métissage" (inadequately translated as hybridity) as a way of thinking about cultural exchange. For Senghor, jazz was a musical example of métissage as his ideal metaphor for the relation between French and Senegalese cultures. A perfect example is found in his essay "De la liberté de *l'âme,* ou l'éloge du métissage" [On the liberty of the soul, or in praise of hybridity] published in *Liberté I.* He states:

> Notre vocation de colonisés est de surmonter les contradictions de la conjoncture, l'antinomie artificiellement dressée entre l'Afrique et l'Europe, notre hérédité et notre éducation.... Supériorité, parce que liberté, du *Métis,* qui choisit, où il veut, ce qu'il veut pour faire, des éléments réconciliés, une oeuvre exquise et forte. Mais n'est-ce pas, là, la vocation des élites et des grandes civilisations? ...
>
> Trop assimilés et pas assez assimilés? Tel est exactement notre destin de métis culturels. C'est un rôle ingrat, difficile à tenir, c'est un rôle nécessaire si la conjoncture et l'Union française ont un sens.
>
> [Our calling as colonized people is to overcome the contradictions of conjuncture, the artificially maintained antinomy between Africa and Europe, our heritage and our education.... The appeal of the *hybrid* lies in his freedom, for he chooses where he will, what he will, in order to make an exquisite and compelling work out of the reconciled elements. Yet, is this not the calling of elites and of great civilizations? ...

Patrice Galbeau, 1977 (INA Mémoire Vive, 2006), a soundtrack plays the sound of children's voices, laughter, and other sounds associated with his hometown village in the background. For additional examples of Senghor's recitations, see Léopold Sédar Senghor, *Enregistrements Historiques* (Frémaux et Associés FA5136); Léopold Senghor, Jacques Rabemanjara, Tchicaya U Tam'si, *Négritude & Poésie—Les Grandes Voix Du Sud Vol. 1* (Frémaux et Associés FA5187), and the three-disque RFI set *Léopold Sédar Senghor: Les voix de l'écriture* (ARCL 33; 34 and 35). Interestingly, Langston Hughes also wrote copious musical annotations for his poem cycle *Ask Your Mama,* and recorded himself reciting the poems, but without the accompanying music alluded to in his text. See *Langston Hughes: The Black Verse (12 Moods for Jazz)* on Buddah Records BDS 2005 (1970).

> Too assimilated and not assimilated enough? That is exactly our destiny as cultural hybrids. It is an awkward role, difficult to maintain, yet a necessary role if the present moment and the French Union are to have any meaning.][45]

Clearly, by the mid-twentieth century, Senghor was convinced that creative, active projects drawing from both African and European traditions moved in a necessary political as well as aesthetic direction. Jazz music figures as the emblematic examplar of this cultural *métissage* in his thought.

Chant (*Pour orchestre de jazz*) is an intimate love-poem. It is also the most direct evocation of diaspora and the traumas of the trans-Atlantic slave trade in Senghor's work. First published the year after his marriage to Ginette Eboué, the daughter of the Guyanese governor of Upper Volta (today's Burkina Faso), the poem was likely inspired by his new wife as well as his readings about the New World.[46] The poem's opening line seems at first to be simply a reminiscence of a childhood game, but may also be read as an evocation of the Middle Passage: "*Dans la nuit abyssale* en notre mère, nous jouions aux noyés t'en souvient-il? [Hidden in the abyss of night within our mother do you remember playing as if drowned],"[47] Unhomed by these early games, the poet wanders among various communities:

Aux sables du Levant à la Pointe-du-Sud, chez les Peuples-de-la-Mer-verte
Et chez les Peuples d'Outre-mer.
Et la conque au loin dans tes rêves c'était moi.

....to the eastern sands,
To the southern point, among the People-of-the-Green-Sea
And among the Overseas People. And the distant conch
Sounding in your dreams was I.[48]

The distinctions between various articulated portions of the diaspora peel away in layers just as musics seem to overlay each other in the lines:

Contre l'épaule de la Nuit cubaine, si j'ai pleuré sur tes cheveux fanés!
Prêtresse du Vaudou en l'Île Ensorcelée, mais souviens-toi du victimaire
Aux yeux droits et froids de poignards. Sous l'ombrage lilial d'Amboise,
 poétesse
Tu m'as filé souvent des *blues*. Ah! la voix de lumière et son halo de sang!
Les ombres transparentes des chantres royaux pleuraient au son de la
 trompette.

Upon the shoulders of a Cuban night, [how I wept] on your faded hair!
Voudou Priestess on the Enchanted Island, do you remember your victim

[45] Senghor, *Liberté I*, 103.
[46] They divorced in 1955, and Senghor married Colette Hubert, the French woman from Normandy who became Senegal's first first lady, and with whom he had a son, Philippe-Maguilen Senghor.
[47] Senghor, *Oeuvre Poétique*, 188.
[48] Dixon, *Collected Poetry*, 129.

With eyes straight and cold as daggers? Woman poet, under the
 lily-white rage
Of Amboise, you often played me the blues. Ah! Voice of light
And its halo of blood! The transparent shadows of court singers
Cried at the trumpet's sound.

The explicit moves that allow the poet to shift from "la Nuit cubaine" to the
Haitian "Île Ensorcelée" and then to an unnamed, abstract topos of transparent
shadows are not revealed, but the soundtrack to these moves is prominent: the
blues swell into a trumpet's cry. As in earlier examples and in Senghor's prose,
the power of material sound to effect cultural work, particularly a rapproche-
ment between diaspora and continent is highlighted.

(Autumn) In New York

In the 1956 collection *Éthiopiques,* all the poems include musical annotations,
making this one of the most stereomodernist of all his collections. The tripar-
tite poem "À New York," scored for "un orchestre de jazz: solo de trompette,"
is the most extended poetic expression of Senghor's interest in jazz. In the first
section, the poet reacts to the architecture and population of New York as
first intimidating and impressive, then alienating, efficient, yet lacking human
warmth. The second section focuses on the poet's discovery of Harlem and his
call to New York to listen to its "nocturnal heart." The final section reiterates
this call in more exhortative tones, urging the city to not only open its eyes, but
also its ears to a truth that can only be grasped aurally and inviting the reader
to a rest the poet finds missing in New York's bustle. Each section of the poem
relies on a sonic figure to crystallize its rhetoric, whether in the sirens of the first
section, the trombones of the second, or the saxophone's laughter of the third.
 The first section of the poem begins with an exclamation at the confu-
sion and awe the poet first feels encountering the city: "New York! D'abord
j'ai été confondu par ta beauté" [New York! At first I was bewildered by your
beauty].[49] The tone quickly shifts to critical alienation in the cold and clinical
environment. This contrast between the opening exclamation and the eventual
tone of the first section gives the beginning an offbeat or syncopated feel, a
diegetic rather than rhythmic anacrusis, and thus a translation of poetry into
syncopation. The temporal experience of the visit to New York is brought to
the fore, not merely in the poem's opening, but in the precision of the period
that it takes for the poet to discover a new truth about the city:

Mais quinze jours sur les trottoirs chauves de Manhattan—
C'est au bout de la troisième semaine que vous saisit la fièvre en un

[49] Senghor, *Oeuvre Poétique,* 119, followed by Dixon, *Collected Poetry,* 87.

bond de jaguar
Quinze jours sans un puits ni pâturage, tous les oiseaux de l'air
Tombant soudains et morts sous les hautes cendres des terrasses.[50]

But two weeks on the naked sidewalks of Manhattan—
At the end of the third week the fever
Overtakes you with a jaguar's leap
Two weeks without well water or pasture all birds of the air
Fall suddenly dead under the high sooty terraces[51]

Along with this emphasis on the temporal, New York is reduced to a synec-doche of nylon legs, breasts with neither sweat nor scent, and howling sirens, highlighting a dichotomy between modern urban artifice and idyllic, timeless nature.

However, in the second section Senghor heralds an alternative modernity within New York, contrasting the hard cold lines of the opening with a mil-lenarian vision proclaimed in a biblical lexicon and tone, a prophetic voice that emerges to trouble the modern(ist) version of historical time evoked in the first stanza:

Voici le temps des signes et des comptes
New York! or voici le temps de la manne et de l'hysope.
Il n'est que d'écouter les trombones de Dieu, ton coeur battre au rythme du sang ton sang.[52]

Now is the time for signs and reckoning, New York!
Now is the time of manna and hyssop.
You have only to listen to God's trombones, to your heart
Beating to the rhythm of blood, your blood.[53]

The foregrounding of temporality in shifts between a scriptural, seemingly timeless moment and New York's modern veneer poetically mirror the tension around the beat, or "playing in the pocket," so crucial to swing in jazz. Playing in the pocket allows different members of a rhythm section to play slightly before or slightly after the beat to create a pocket of time between the soundings of the beat to raise the rhythmic tension. "God's trombones"—"les trombones de Dieu"—in the third line also reveal the importance of the Harlem Renaissance to Senghor's literary imaginary, riffing on the title of James Weldon Johnson's collection of

[50] Senghor, *Oeuvre Poétique*, 119.
[51] Dixon, *Collected Poetry*, 87.
[52] Senghor, *Oeuvre Poétique*, 120.
[53] Dixon, *Collected Poetry*, 88.

poetic sermons, *God's Trombones*, first published in 1927.[54] The prophetic tone is continued in the line: "J'ai vu dans Harlem bourdonnant de bruits de couleurs solennelles et d'odeurs flamboyantes" ["I saw Harlem teeming with sounds and ritual colors/And outrageous smells" in Dixon], using a past tense to present the image as a revealed truth (not unlike the tone of the book of Revelation in the Christian Bible). For Senghor, this revelation comes from the nocturnal spaces of Harlem, which sustain mangoes, rivulets of rum, and cotton flowers in the midst of the frosty city so alienating in the first section. Two motifs emerge: the rhythm of blood and the tom-tom. It is striking how these motifs parallel modernist Harlem Renaissance portrayals of Africa. Consider Countee Cullen's "Heritage," which begins famously, "What is Africa to me?" and continues with evocations of the drumbeat of dark "blood damned within." African American literary expression is a crucial intermediary through which music is refracted for Senghor.

The final stanza maintains the prophetic tone elaborated in the second, even proscribing what is required of New York for its "redemption," namely, to let the blood of its black culture enrich the city as a whole. The closing lines present a veritable *ars poetica* statement of Senghor's value for combining artistic media in a unitary cultural expression, perhaps indicating one reason for the prominence of jazz in his poetry, a literary exemplification of this uniting of creative energies:

L'idée liée à l'acte l'oreille au coeur le signe au sens....
Mais il suffit d'ouvrir les yeux à l'arc-en-ciel d'Avril
Et les oreilles, surtout les oreilles à Dieu qui d'un rire de saxophone créa le ciel et la terre en six jours.
Et le septième jour, il dormit du grand sommeil nègre.[55]

Idea links to action, the ear to the heart, sign to meaning . . .

Just open your eyes to the April rainbow
And your ears, especially your ears, to God
Who in one burst of saxophone laughter
Created heaven and earth in six days,
And on the seventh slept a deep Negro sleep.[56]

The final line also exemplifies the strategy of taking an insulting stereotype of black people—here, laziness—and converting it into a positive value—the idea of Sabbath as sacred rest—much as Négritude made a positive value of the often derogatory term, *nègre*, as we have seen elsewhere in Senghor.

[54] Senghor mentions Weldon in his 1950 lecture "La Poésie Négro-Américaine," noting that "Le Négro-américain a la tête épique. *Les Trompettes* [*sic*] *de Dieu* de James Weldon Johnson, poète et diplomate, sont le chef-d'oeuvre du genre et, dans ce recueil, particulièrement les *Sermons en vers*. [The American Negro has an epic imagination. *God's Trombones* by James Weldon Johnson, poet and diplomat, are masterpieces of the genre, and from this collection, especially the *Sermons in Verse*]" (*Liberté I*, 108–9).

[55] Senghor, *Oeuvre Poétique*, 121

[56] Dixon, *Collected Poetry*, 89

The collection *Éthiopiques* closes with a postface "Comme les lamantins vont boire à la source," [As the manatees will drink from the fount] which provides Senghor's most extended discussion in prose of his jazz poetics. Not surprisingly, given that all the poems in this volume begin with instructions for instrumental accompaniment, Senghor declares:

> La grande leçon que j'ai retenue de Marône, la poétesse de mon village, est que la poésie est chant sinon musique—et ce n'est pas là un cliché littéraire. Le poème est comme une partition de jazz, dont l'exécution est aussi importante que le texte. [The great lesson I learned from Marône, the woman poet of my village, is that poetry is song if not music—and that is not just a literary cliché. The poem is like a jazz score or chart, whose performance is as important as the text.][57]

Jazz is not merely an important recurring theme or referent in Senghor's poetry, but indeed its performance practice structures his very understanding of the relation between written and recited poetry. It is clear that while Senghor was concerned with formal questions of prosody such as meter and syllabification, he ultimately envisioned his poems as oral performances. However, the oral performance was a collaboration between reader and writer, just as a live jazz performance involves far more than the harmonic, rhythmic and melodic form of a piece. It is defined by the performer's decisions made in the moment, on the spot, in front of an audience. Senghor wrote that he "persiste à penser que le poème n'est accompli que s'il se fait chant, parole et musique en même temps [continues to think that the poem is not successful unless it works as song, speech and music at the same time]."[58] Just as a jazz chart was only a partial representation of the music, which could only be fully realized through an improvised performance, so the poem on the page was seen as a limited sketch of a collaborative stereomodernist event that Senghor imagined as being best illustrated through music. A fuller picture was projected in grand style in 1966.

La plus belle Africaine: Backstage at the World Festival of Negro Arts[59]

One of Senegal's most significant contributions to cultural pan-Africanism was hosting the Premier Festival Mondial des Arts Nègres (hereafter, FESMAN), held in Dakar from April 1–24, 1966, and began with a colloquium (from

[57] Senghor, *Oeuvre Poétique,* 172.

[58] Ibid., 173.

[59] "La plus belle africaine" was a song by Duke Ellington which he first recorded on the heels of his visit to Dakar, in July 1966, in a live performance at the Juan-les-Pins/Antibes Jazz Festival. The recording was released the following year on the appropriately named Verve album, *Soul Call.*

March 30 to April 8) which featured major artists and scholars discussing
black expressive arts.[60] A coming-of-age party of sorts, the festival gathered
together performing, plastic, and literary artists from thirty-seven nations
on four continents for what would be a new chapter in Négritude musicol-
ogy. The festival was unique as the first "*manifestation pan-nègre*" staged on
the African continent, since previous gatherings—including Henry Sylvester
Williams's Pan-African Conference of 1900, the Pan-African Congresses of the
du Boisian tradition (1919–45), and the 1956 and 1959 Congresses for Writers
and Artists organized by Présence Africaine—had all taken place in Europe
and New York.[61] It was not only a scene of celebration and festivity, but also a
forum for healthy and heated debate about what precisely Négritude meant,
and to whom. As such, it may be read as a referendum on Senghor's version
of Négritude.

The festival was held under the aegis of the Senegalese state, and Senghor, as
head of state, was the sponsoring figurehead of the event, although two other
people, Alioune Diop and Souleymane Sidibé, also played lead roles. Alioune
Diop of Présence Africaine and the Société Africaine de Culture was credited
with initiating the festival,[62] which was, in some senses, a sequel to the 1956
and 1959 conferences. Souleymane Sidibé, Commissaire National du Festival,
bore the responsibility of representing the festival organizers to the public. His
efforts were rewarded after its closure with Senegal's highest honor, a decora-
tion as a Commander of the National Order. However, the festival had mul-
tiple authors and sponsors (whose larger geopolitical manoeuvers reflected the
Cold War tensions of the day). The wide range of filmic, journalistic, and criti-
cal texts it inspired reflected the polyphony and even dissonance of divergent
agendas. Preceding the festival, a Colloquium on the Function and Significance
of Black Art in the Life of the People and For the People (to cite its full title)
gathered scholars of literature, the visual and performing arts, and anthropol-
ogy together. As I discuss in more detail further below, the Colloquium was a
historic opportunity for dialogue, a live forum or agora where actual encoun-
ters between black subjects brought abstracted versions of Négritude into
productive crisis. Attendees debated and performed alternate approaches to
pan-Africanism, laying open before the local as well as international audience

[60] A number of recent works have addressed FESMAN and its relation to other pan-African festi-
vals and Senegalese politics. Among these, see Anthony J. Ratcliff *Liberation at the end of a pen: Writing
Pan-African Politics of Struggle*, diss. U Mass, Amherst, 2009; Elizabeth Harney, *In Senghor's
Shadow: Art, Politics and the Avant-Garde in Senegal, 1960–1995* (Durham: Duke UP, 2004); and Tracy
D. Snipe, *Arts and Politics in Senegal: 1960–1996* (Trenton: Africa World Press: 1998).
[61] The Congress of Black Writers and Artists which the journal *Présence Africaine* convened in
Paris in 1956 and again in Rome in 1959 were important precedents, and Alioune Diop, the editor of the
journal and a key organizer of the congresses, was also an essential figure in bringing FESMAN to life.
[62] Senghor's hommage to Diop appeared in a commemorative edition of the journal *Ethiopiques* 24
(1980) following Diop's death.

tensions between a state-sponsored, top-down approach and more organic approaches to solidarity and identity. Many texts generated by the festival—film, news and magazine reportage, official reports, and memorabilia—were evaluative, adding to the range of views the colloquium elicited.

When preparations first began, Senghor announced that the festival would present "an illustration and no longer a theoretical exposition, it [was to] constitute a definite action, a positive contribution to the construction of a civilization based on universal values."[63] As stated at the first meeting of the planning body responsible for the event, the Association Sénégalaise du Festival Mondial des Arts Nègres:

Cette manifestation se propose comme objectifs
- de parvenir à une meilleure compréhension internationale et interraciale
- d'affirmer la contribution des Artistes et Ecrivains noirs aux grands courants universels de pensée
- de permettre aux artistes noirs de tous les horizons de confronter les résultats de leurs recherches
[This event proposes the following objectives:
- to arrive at a better international and interracial understanding
- to affirm the contribution of black artists and writers to the great universal currents of thought
- to permit black artists from all backgrounds to come face to face with the fruit of their research.][64]

In addition to Senegalese governmental support, UNESCO and France were among the major sponsors of the event. The colloquium was opened, tellingly, by the writer André Malraux, then French Minister of Culture, and his comments situated the festival as an expression of a modernist binarism, pitting a stable and seemingly unchanging "patrimoine artistique de l'Afrique [artistic patrimony of Africa]" against a more dynamic spirit of "création vivante [living creation]." The opposing yet complementary logic of these two elements structured Malraux's entire speech, but was particularly striking in his proposal that Africa had two musics: one born of the despair of plantation slavery in the Americas (spirituals) and the other, jazz, whose rhythm and originality he saw as essential characteristics:

Là l'Afrique a inventé; . . .
En somme, le jazz est parti d'éléments mélodiques européens ou américains, à partir desquels l'Afrique a retrouvé son âme. Plus exactement, a trouvé une âme qu'elle n'avait pas autrefois, car c'est peut-être son âme

[63] "Message From President Senghor to the Senegalese People [First World Festival of Negro Arts]," bilingual official government publication (Dakar, 1963).

[64] Amadou Racine Ndiaye, "Communication du sécrétaire d'état" (Dakar, Feb. 1963).

désespérée qu'expriment les blues, mais ce n'est pas son âme d'autrefois
qu'exprime le jazz, qu'elle a vraiment inventé.

[There, Africa has invented . . .

In sum, jazz took off from European or American melodic elements,
from which point Africa rediscovered its soul. To be exact, discovered a soul
which she did not have in ancient times, for it is perhaps her despairing soul
which expresses itself in the blues, but it is not her ancient soul which jazz
expresses, but one she has truly invented].[65]

The elision of Africa and the black cultures of the United States was wholly
unmarked in his speech, and resulted in the odd implicit suggestion that
Africa had no music of its own to speak of.

Malraux situated his discussion of global black music within a context of a
French censure of American race relations and human rights by associating
one strand of musical creativity (the spirituals) with the specific protests of
enslaved Africans along the banks of the Mississippi. In fact, his comments
that jazz was not so much Africa's rediscovered soul but a discovery of a soul
that she did not possess before further served to distance jazz from the cultural
patrimony of Africa, and rather to situate it on the other side of the dichotomy
he opened with, as a marker of a contemporary and emerging African moder-
nity, its living creation.

Paying careful attention to Malraux's comments should not imply that his
perspective as a guest in Senegal served to define the terms on which jazz
figured in the festival. Rather, his speech demonstrates the degree to which
jazz was already an overdetermined signifier in rhetorics that had little to do
with the music itself, and much to do with the role of the state (and indeed
states) in defining and promoting "Culture." Another telling indicator of the
work jazz was to do at the festival is found in an article by Lamine Diakhaté[66]
included in the official program entitled "Artistes du monde noir." Of the
eleven artists featured, only three were continental Africans: Habib Benglia of
Mali, Facelli Kanté of Guinée, and Miriam Makeba of South Africa. The others
were: Josephine Baker, Marian Anderson, Louis Armstrong, Duke Ellington,
Ella Fitzgerald, Katherine Dunham, Mahalia Jackson, Maria d'Apparecida/
Samba du Brésil. Given that Diakhaté's article was appearing in 1966, it is strik-
ing that the representatives of jazz were Armstrong, Ellington, Fitzgerald, and,
arguably, Josephine Baker, all of whom had been in the international spotlight
for at least three decades. If "jazz" was to occupy pride of place at the festi-
val it was clearly the polished big-band jazz of the Ellington orchestra, who
appeared as representatives of the American delegation to the festival, not the

[65] André Malraux, "Discours de M. André Malraux à l'Ouverture du Colloque" in L'Unité Africaine. Dakar: 196 (7 April, 1966), 1.

[66] Diakhaté was a jazz afficionado whose black cosmpolitanism later bore fruit in his novel Chalys d'Harlem.

bebop sound of Charlie Parker or Dizzy Gillespie, much less the iconoclastic free jazz of the so-called October Revolution of 1964.

Although, as I began by noting, FESMAN provided an important forum for critique as well as celebration of Négritude's principles, it was not the first occasion when skeptics had aired their reservations about Négritude. One of the earliest and best-known critiques of Leopold Senghor's approach was the young Wole Soyinka's declaration that Négritude was an "invalid doctrine." Soyinka's oft-repeated quip at the 1962 African Writers' Conference noted that tigers, rather than announcing their *tigritude,* simply pounce, but he had first articulated the thought in slightly different terms in a 1960 essay:

> The duiker will not paint "duiker" on his beautiful back to proclaim his dui-keritude; you'll know him by his elegant leap. The less self-conscious the African is, and the more innately his individual qualities appear in his writing, the more seriously he will be taken as an artist of exciting dignity.[67]

While it may be true that a duiker need not proclaim its *duikeritude,* its status as a member of the antelope family and its relation to another species, say, the elk, might be more complex than the young Soyinka allowed. In other words, Soyinka's comments do not engage fully with the international scope of the *poète-président*'s vision of *l'âme nègre* [the black soul], nor with the ways that blacks in locales on and beyond the African continent might seek to forge solidarity and build upon differences.

While FESMAN was in fact one of the great successes of Senghorian Négritude, staging *l'âme nègre* [black soul] exposed complex power relations within an international context of decolonization and the Cold War. It also made it clear that in such a context the potential of large-scale, state-sponsored events like the festival to materialize transnational solidarity was limited. FESMAN spawned many international arts festivals, and these, too, might be considered challenges to Négritude as cultural policity. These included the 1969 Algiers Pan-African Festival, which pointedly invited the Maghreb nations that Senghor's festival had excluded and featured far more radical African American participants; the biannual Film and Television Festival of Ouagadougou (FESPACO); the 1977 and 2010 versions of FESMAN (Nigeria's FESTAC and Dakar's FESMAN III, respectively); and Ghana's biannual PANAFEST, to name but a few. These festivals contribute significantly to the

[67] Soyinka's essay, "The Future of West African Writing," which argued that Chinua Achebe rather than Senghor should be seen as initiating truly African literature, originally appeared in the Nigerian literary journal *The Horn* 4:1 (1960), 10–16. *The Horn* was not widely circulated but it has since been cited by scholars, including Bernth Lindfors (see especially "The Early Writings of Wole Soyinka" in *Critical Perspectives on Wole Soyinka,* Lyn Rienner Publications, 1990), Martin Banham, and Obiajuru Maduakor. For a fine contextualization of Soyinka's statement, see Maduakor "Wole Soyinka as Literary Critic" in *Research on Wole Soyinka,* ed. Lindfors and Gibbs (Trenton: Africa World Press, 1993).

tourism and national budgets of developing African nations, and thus the pan-African festival is a cultural medium that concerns Négritude musicology not only in coming to grips with the styles of performance, but also with the context and conditions of possibility for such events. The tensions between national prestige and international goodwill often bound up in funding problems complicate reading such events as expressions of transnational black solidarity; however, it is these very material constraints that reveal the limits of imagined and improvised community. Such limits were reflected in the fact that, with primarily government funding, representatives of the invited nations were unlikely to depart too far or too stridely from their government's agenda or official diplomatic position. As a result, the debates over aesthetics bore the additional weight of displaced political discourses. Therefore, debates about comparative black aesthetics became a sort of referendum on various forms of transnational black solidarity.

The call in Senghor's poetry to hear not only the voice of the West African kora, but also the wawa-muted trumpet enunciating a reclaimed sense of honor and resistance reflected Senghor's pan-African commitments. On the other hand, many African Americans among the festival's interdisciplinary, international, and intergenerational participants questioned the logic of Senghor's Négritude musicology, both at the colloquium and in other informal settings during the festival. William Greaves, the African American filmmaker, produced a film for the United States Information Agency, *The World Festival of Negro Arts,* which not only conveys the energy of the festival and colloquium but also presents its own complex reading of the two events, couched within the Cold War politics that determined its funding. A number of other African American artists in attendance, including Langston Hughes, Duke Ellington, Katherine Dunham, and Hoyt Fuller documented the event. Tellingly, a number of African Americans attending the festival posed their challenges to Senghor's schematic interpretation of jazz as synechdoche for African America and exemplar of Négritude in musicological terms. Thus it is worth lingering here to consider in more detail what we can learn from these African American accounts of the festival, particularly in relation to the Senegalese versions.

As one of the most comprehensive documents of the festival, William Greaves's film, *The World Festival of Negro Arts,*[68] presents a montage of black-and-white shots featuring Ellington, the Alvin Ailey Company, and the Leonard de Paur Chorus among a range of primarily dance performances and footage shot in the art exhibition spaces, colloquium, and informal outdoor spaces of Dakar, with largely nonsynchronized sound. The film Greaves wrote

[68] *World Festival of Negro Arts,* directed by William Greaves, 1966.

and directed was funded by the United States Information Agency, which had originally commissioned a five-minute news clip.[69] The expanded project

> proved the most popular U.S.I.A. film in Africa for the following decade. U.S.I.A. films were prohibited at the time (and until recently) from distribution in the United States. Although such [continent-to-diaspora] links could have been radicalizing for African Americans, this affirmation was more likely to serve a conservative agenda when presented to Africans—in suggesting greater identity with the United States and, by implication, with its Vietnam-era policies.[70]

Both because of its reception in Africa and as a filmic text, the film deserves a fuller analysis than I have space for here, so my comments are confined to the complicated nature of the relationship of jazz and Négritude as Senghor articulated it and Greaves's film as a counterpoint to that vision.

The black-and-white format underscored Greaves's intention to "put together an effective and comprehensive record of the event" to capture the historic nature of an event which his film already laced with nostalgia.[71] The self-conscious making of history was also in continuity with Senegalese publicity produced for the festival. The Senegalese national archives are, rightfully, a source of pride for its citizens and a badge of bureaucratic modernity, and the Festival has two sets of its own files in Dakar. In addition to minutes from meetings at every stage of the planning process, the documentation includes copies of stamps, postcards, programs, posters, commemorative printed fabric bearing the festival logo, and architectural plans that represent at every level of scale the inscription of Négritude into the historical record. If the traditions of African peoples on the continent and in the diaspora were the object of performances, it was the performance of national and transnational modernity that is the object of these acts of documentation. The fact that these plans were realized in the event of the festival and in the construction of infrastructure, including the Théâtre Daniel Sorano and Musée Dynamique (now the seat of the court of appeals in Dakar), vividly demonstrates the power of representation and the scalar imagination.

Greaves's film opens with a shot of Langston Hughes on the beach in Dakar watching fishermen in a pirogue with traditional Senegalese drumming, balafong playing, and unaccompanied choral song as the sound track. A single voice narrates the whole film, beginning with a recitation of Hughes's poem "I've Known Rivers," which the poet himself read in his Colloquium presentation and which Senghor had quoted in his 1939 essay "Ce que l'homme noir

[69] Adam Knee and Charles Musser, "William Greaves: Documentary Film-Making, and the African American Experience," in *Film Quarterly* 4:3 (Spring 1992).

[70] Ibid., 17.

[71] Ibid., 16.

apporte." It is thus an effective text for evoking the link between diasporic blacks and Africa, not only for its content, but also, such uses of the poem were already familiar. The film's narration is remarkable for its prophetic tone, in part an effect of the off-screen, stage-perfect enunciation of Greaves's Actor's Studio-trained voice, but also because of the diction and rhetorical structure of the narration. The poem so aptly captures the agenda of the film that we might not immediately recognize how remarkable it is that a text about Négritude's most important historical event begins not with a poem by Senghor nor, for that matter, with a reading from Césaire or Damas. Instead Hughes is the focus. This reads two ways: first, as an extension of black international literary connections beyond Négritude proper to include the New Negro movement and beyond (just as Senghor had hoped, although to different ends), and second, as an indication that the film was designed to present an American and specifically State Department perspective.

The opening intertitle "World Festival of Negro Arts" is accompanied by an abrupt change in the soundtrack music to a solo trumpet obbligato line against an orchestral and drum ostinato rhythm, whose tension will continue to mount throughout the sequence. The question "Who am I?" is repeated throughout the film, and its response ranges from named individual artists to entire nations or even transnational regional cultures. With the exception of Senghor and Emperor Haile Selassie, the only named individuals are African Americans or other Westerners. Thus, the narration "What is my name? My name is Duke Ellington, Langston Hughes, Marpessa Dawn" accompanies close-ups of each of these artists viewing works in an exhibition space, while the next lines "What is my name? My name is Benin, Ethiopia, Monomatapa" narrate a cut to a Benin brass statuary. Greaves reproduces the long-troubled dynamics in African visual arts between the so-called "primitive" (whose creators remain nameless) and the contemporary (in which circuits of celebrity play an important role). As Sally Price incisively points out in her critique of "Anonymity and Timelessness" in *Primitive Art in Civilized Places*, "many accounts of Primitive Art, both popular and scholarly continue to insist that aesthetic choices are governed exclusively by the tyrannical power of custom."[72] Greaves seems to fall into this pattern. However, both the next frame and the soundtrack behind this sequence offer a complicating factor. "My name is Africa. Gather round me" plays over a cut to Ellington, Hughes, and Dawn bent in conversation and fascination over an example of Ethiopian calligraphy in a cabinet, and then a close-up of Ellington, as the narration continues "Gather round, my writers, musicians, artists, for we have many moments of creativity and history to share. Moments in which we shall tell the world who I am." Strikingly, it is not until close-ups of Hughes, Ellington, and Brazilian

[72] Sally Price, *Primitive Art in Civilized Places*, (Chicago: U Chicago P, 1989), 58.

singer Marpessa Dawn along with shots of ancient African art pieces have been shown that we are introduced to the *poète-président*, with the shot accompanied by Greaves's narration "Let the poet who also bears my name, Leopold Senghor, president of Senegal, let he [*sic*] and his countrymen provide a place at this festival for all who seek to know me." Perhaps more surprising is the close up of flags swinging high above the outdoor musical performance. The long close-up on the American flag that precedes shots of the Senegalese and other flags (although not of the French flag in spite of the significant subsidy the French were providing) is one of the clearest indications that this film was to serve as a tool of U.S. Cold War propaganda.

The images then suddenly appear to become synchronized with the music that has been playing in the soundtrack thus far as the camera pans from Ellington on stage to his trumpet player, orchestra, and then audience. However, viewing these shots closely, it is clear that the trumpeter is playing far more notes and Ellington is swinging bodily to a different rhythmic feel than the Iberian-tinged orchestral music playing in the background. The ostinato rhythm, declarative melodic lines of the trumpet, and antiphonal instrumentation of the music playing behind this scene serve to create a monumental effect, which, I would suggest, is congruent with the history-making impulse discussed above. Nevertheless, by featuring a recognizable jazz ensemble in these opening visual images, Greaves seems to endorse Senghor's often unmediated insertion of jazz as an exemplar for the black creative spirit. This could be read as undoing the kinds of binaries that posit the individual modern artist/creator as the antithesis of traditional/ancient nameless, collective, ethnically determined, implicitly male craftsman and suggesting the need for an alternative modernism to reconcile the two in each discrete historical moment or work.

This is not to suggest that the film reads as mere propaganda nor that it definitively works out the often contradictory agendas on display. Rather, it is to suggest that the presence of Ellington's music in the film complicates the binaries of tradition and modernity upon which discourses of black (particularly African) authenticity so often turn. The fact that Ellington himself rejected the label "jazz" and insisted that all worthwhile music was "beyond category" further complicates my point, although the timbre and soaring melodic contours of the trumpet solo emphasize connections to Senghor's valuation of music. The poem "À New York" (discussed earlier), for example, was explicitly for *solo trompette et orchestre du jazz*, and creative interpretation was the aspect of a jazz approach to text that Senghor drew attention to in the postface to *Ethiopiques*.

As the film continues, dance rather than instrumental music is most prominently featured. Troupes from Ethiopia, Zambia, Brazil, Gabon, and many other nations displayed their national art forms. Francesca Castaldi's 2006 study, *Choreographies of African Identities: Négritude, Dance, and the National*

96 Africa in Stereo

Ballet of Senegal, demonstrates that the world-famous Guinean National Ballet under Keita Fodeba was not an isolated example of national arts policy under Sekou Touré but part of a common regional impulse to use embodied performance as a vehicle of cultural and national pride. An important Cold War counterpoint to Greaves's film, the Soviet newsreel production *African Rhythmus,* includes even more dance footage, and the rich color film brings an immediacy to the events where Greave's black-and-white footage lends an archival feel.[73] The Russian narration guides viewers through numerous Dakar neighborhoods into which the festival's events spilled over in outdoor performances, and emphasizes the event's significance as a "reunification" of peoples severed by colonization. Among the performers featured in *African Rhythmus* but not in Greaves's film are Josephine Baker and Moune de Rivel (who became important to Senegalese and other African readers through her regular advice column in the magazine *Bingo,* discussed more fully in the following chapter). The U.S. sent the Alvin Ailey dance troupe, and Greaves's final shot in the film captures Alvin Ailey himself waving goodbye to the crowd at Dakar's airport, as if to close with an assertion of the continuity in aesthetic vision between African and African American artists.

On reason for the prominence of dance may well have been that the dancer and anthropologist Katherine Dunham played a major role in the earliest planning phases of the festival through her involvement with the *Société Africaine de Culture.* Dunham already had significant connections to Senegal, having been invited by Senghor himself to train the National Ballet of Senegal after he met her in Paris. She was in a unique position, as both an appointee of the head of the Senegalese state and of the U.S. State Department. Her Janus-headed role allowed her to broker between two different agendas, and to speak frankly as a trusted insider to multiple audiences. In Dakar, she replaced Mercer Cook, the American Ambassador to Senegal at the time, as a jury member for the Anglophone literary prize committee.[74] She was also responsible for the "comité d'analyse des spectacles" (a group that included Jean Rouch and Marpessa Dawn, among others)[75] and presented both a regular paper and a retrospective closing address at the Colloquium, before the festival itself was fully underway.

Her address was the first official summation of an African American perspective on the festival and it likely shaped how other festival attendees perceived the event. Earlier that week, in her Colloquium paper, Dunham had stressed her intention to "speak freely, whatever the consequence," even if

[73] A copy of *African Rhythmus* is held in the New York African Film Festival collection, and was screened at the 39th African Literature Association Conference in Charleston, SC on March 21, 2013.

[74] Archives Nationales du Senegal Fonds sur le FESMAN. "Liste des Participants"

[75] "Catherine DUNHAM et le comité d'analyse des spectacles ont porté des appreciations," *Dakar Matin,* May 2, 1966, 3.

what she had to say was "not in absolute conformity with the conclusions of [her]associates on this colloquium."[76] In other words, critique rather than celebration was her priority. The substance of her presentation called for "depth learning" in training African performing artists and urged artists to maintain control of their works (through copyright and fair payment), and her argument drew on jazz as an example—to be avoided:

> As one example, there is scarcely a form of music today to which the New World Negro of African provenience has not contributed. Some of this influence has been through the natural process of diffusion, some through independent invention, but unfortunately much has been pure commercial exploitation. I think of the great wave of American jazz from which the world will never be free, and I think of the limited opportunity for commercial benefit to the creators themselves.[77]

The contrast between the ways in which Dunham and Senghor saw jazz as exemplary of the black condition could not be more marked. For Dunham, the material conditions of the production of the art form were key, where, as we have seen already, for Senghor, jazz seemed to exist as a platonic ideal unrelated to the labor of musicians.

However, the friendship between Dunham and Senghor and her close involvement in the festival preparations reflected their shared sense that what mattered about the Festival Mondial des Arts Nègres was that it was making history:

> the beauty of the city and its people, the combined sophistication and primitiveness of the spectacle of Gorée staged by Jean Mazel to the poetry of an old friend, Jean Brierre; the treasures of the dynamic museum, this gathering together in the colloquium of specialists, friends, and intellectuals from all over the world; the brilliant opening at the Daniel Sorano Theater by the Nigerian players in a remarkable production of Wole Soyinka; and the elegance of the audience of the inauguration itself—these things alone would make this occasion a history-making event.[78]

The elements she noted include evocations of the interpersonal aspects of the festival experience otherwise unlikely to have entered the written historical record—"the beauty of the city and its people"; "this gathering together in the colloquium of specialists, friends and intellectuals from all over the world" and "the elegance of the audience of the inauguration itself." Along with these

[76] *1er Festival mondial des Arts nègres: Dakar, 1-24 avril 1966: Colloque. I, Fonction et signification de l'Art nègre dans la vie du peuple et pour le peuple (30 mars-8 avril)*, Festival mondial des Arts nègres (1966; Dakar), *Présence Africaine*, 1967, 473.

[77] Ibid., 474.

[78] VèVè Clark, and Sarah E. Johnson, eds., *Kaiso! Writings by and about Katherine Dunham* (Madison: U Wisconsin P, 2005), 412.

personal notes, she highlighted the large-scale events in historic, monumental structures, including the spectacle at Gorée and Césaire and Soyinka's plays staged at the newly built state-of-the-art Théâtre Daniel Sorano.

The Gorée spectacle that Dunham refers to was a *son et lumière* show, a series of narrated live tableaux scenes staged on the island of Gorée off the coast of Dakar. The *son et lumière* genre is a uniquely French creation, combining stereophonic sound engineering with dramatic lighting effects in a postdusk evening show. Most often installed at significant historical sites, *son et lumière* shows fully exploit the technologies of visual projection and sonic amplification, producing a monumentalizing effect very much in sync with the dynamics of FESMAN. This effect tends toward the sublime, in terms of both scale and alienation effects. As such, the *son et lumière* show was emblematic of the festival's approach to representing black history and culture as an overwhelming, monadic, and inescapable whole. Under spectacular lighting, and projected through powerful speakers, Négritude seemed greater than the sum of its parts.

The script was by Jean Brierre, a Haitian poet who had emigrated to Senegal. It portrayed Gorée's involvement in the slave trade as well as its subsequent role as one of the four Communes in the colony of French West Africa whose residents were entitled to French citizenship. By definition, a *son et lumière* show is in situ, *on location* and, in the Spectacle Féerique at Gorée, many of the structures on the island, which had historically been used to house kidnapped Africans before they were launched on the long journey to the Americas or to Europe, took on the role of *lieux de mémoire* for the members of the audience.[79] French and Senegalese army servicemen as well as residents of the island participated in the production's cast of over three hundred, and the show was performed nightly throughout the month of April 1966 with recorded soundtracks that ranged from eighteenth-century harpsichord music (reflecting the Orientalist fashion of the time) to African American spirituals. The program notes state that "L'éloignement du navire négrier est évoqué par la 'Marche des galères turques' de Lulli, dont tambourins et hautbois semblent s'évanouir progressivement dans la nuit océane [The slave ship's departure is evoked by the 'March of the Turkish Ceremony' by Lully, whose tambourines and oboes seem to disappear gradually into the night ocean.]"

Even more remarkable, given the importance of metaphors of stereo systems to this study, are the terms in which the program notes discuss the abolition of slavery. The fourth tableau is captioned "Par la stéréophonie parviennent d'Europe, d'Amérique et d'Afrique la clameur et les échos de l'émancipation de l'univers [Through the stereophony linking Europe, America and Africa, come

[79] For more on the concept of "lieux de mémoire" (sites of memory) see Pierre Nora's seminal article, which has appeared in numerous publications, including "Between Memory and History: Les Lieux de Mémoire" in *Representations,* 26 (Spring 1989), 7–24.

the clamor for and echoes of emancipation]."[80] In other words, Brierre imagines the space between Africa and the diaspora as an acoustic space, where the very circulation of sonic traces, the stereophony of the trans-Atlantic triangle, contributes to the amplification of black claims on freedom. A clearer example of stereomodernism as medium becoming message is difficult to imagine.

It is also worth noting that spirituals were chosen to signify the experience of the trans-Atlantic slave trade and its abolition. In a sense, African American music stood in for "diaspora" in spite of the great diversity of destinations and subsequent cultural expressions at which the descendants of those launched from Gorée arrived. The program notes describe the music for the final tableau thusly:

> La sonnerie aux morts précède le panégyrique des héros de la Négritude dont le sacrifice n'a pas été vain. Il nous revient en effet sous forme d'un immense chant d'action de grâces, repris dans toutes les dimensions de la stéréophonie: "God is marvellous"...Dieu est merveilleux. L'enregistrement aussi est merveilleux, réalisé sur le vif par le Back Home Choir dans la Baptist Church de New York, illustration émouvante entre toutes de la contribution de la Négritude à la civilisation de l'universel. [The taps for the dead precedes a panegyric of heroes of Négritude whose sacrifice has not been in vain. It comes back to us in fact in the form of an immense chorus of acts of grace, taken up in all its dimensions by the stereophony: "God is marvelous." The recording is also marvellous, made live by the Back Home Choir in the Baptist Church of New York, a moving illustration of the contribution of Négritude to civilisation and to the universal].[81]

Dunham's discussion of the *son et lumière* show at Gorée gives an indication of just how significant heritage sites associated with the slave trade were for many diasporic Africans, and it is striking that the *son et lumière* was not featured at all in Greaves's documentary. U.S. State Department film editors likely saw any reference to the trans-Atlantic slave trade as working against their aims of promoting a positive and sympathetic image of U.S. race relations and emphasizing a cultural bond between African Americans and continental Africans.

Dunham's address is a study in inscribing the kind of historic solidarity she saw the festival facilitating; she stresses "that no man with an honest mission walks alone."[82] She traced the importance of various diaspora figures in the development of her own thinking, beginning with the leader of the festival's Haitian delegation Dr. Price-Mars. Her discourse made her personal relationships with public touchstone figures of black internationalism public and thus allowed her listeners to participate in networks she had already woven. More than simply doing the

[80] *Spectacle féérique de Gorée*, Program notes, (Paris: A. Rousseau, 1966), 21.
[81] Ibid., 22.
[82] Clark and Johnson, *Kaiso!*, 413.

affective labor of reinforcing intellectual hospitality, she modeled an innovative, living historiography when she singled out her friends and collaborators in the audience:

> I see Louis Achille [a key figure in the group of young black intellectuals Senghor had spent time with germinating "Négritude" in the 1930s] here and am carried back to Martinique where his father took over from Price-Mars and acquainted me with the tiny island and what was left of song, ritual, and dance.... And Gbeho, a musicologist from Ghana, reminded me the other day that his entire company of dancers and musicians sat through matinée and evening shows in London, staying between shows to exchange drum rhythms with our Haitian and Cuban and Brazilian drummers.[83]

One also sees this commitment to entering the workings of diaspora thinking (rather than merely its final declarations and manifestations) into the historical record in her references to discussions sparked by the Colloquium. The two extracts from her address illustrate my point:

> The other day, in a Colloquium discussion the question as to whether the advisability of separating dance and music into sacred and secular as I have done in *Dances of Haiti* was hanging in a state of immobile suspension.[84]
>
> During our very interesting committee sessions it occurred to me that there was among certain of the participants a kind of mistrust, a *méfiance* at the likelihood of a reversal to the traditional, or I should say more specifically, to a nostalgia of the traditional that might serve to inhibit "modernization," and I have put *modernization* in quotes.[85]

In both of these extracts, not only does Dunham give an account of a conversation, a dialogue, but she actually draws attention to the tensions involved. She is confident in what her friend, "psychiatrist Harry Stack Sullivan used to call...the 'diffused optimism' of the Negro race" and in the fact that, for her, contentious discussions mark value and productive criticism, rather than any failure of Négritude or black international solidarity. Dunham's account was largely celebratory and, in mapping out her own development through studies and collaborations with Caribbeans and Africans, minimized a larger-scale African American thread which jazz might have been a part of.

One caveat is that in her role as head of the "comité d'analyse des spectacles," she gave a press conference appraisal of a number of performances, which, although extremely cursory, highlighted Trinidad and Tobago's "Eblouissant ensemble d'orchestre"[86] [Astonishing orchestral ensemble]. This steel-band's

[83] Ibid., 414.
[84] Ibid., 415.
[85] Ibid., 416.
[86] "Catherine DUNHAM et le comité d'analyse des spectacles ont porté des appreciations," *Dakar-Matin*, 2 Mai 1966, 3.

performance of "The Girl from Ipanema" was captured, if only briefly, in William Greaves's documentary. The band's music plays behind footage of smartly dressed dignitaries demonstrating the "elegance of the audience of the inauguration itself" in animated conversation during a cocktail hour, and continues playing as the shot cuts to their onstage performance. The very fact that "The Girl from Ipanema" was the Trinidadian vehicle of success is evidence of multiple waves of diasporic exchange at work. The 1962 bossa nova by Vincius de Moraes and Antonio Carols Jobim "Garota de Ipanema" became well known after the international success of Jewish American jazz saxophonist Stan Getz's collaboration with Brazilians João Gilberto and Astrud Gilberto's 1963 version, on their album *Getz/Gilberto*. As an African American woman commenting on a successful Trinidadian steel band adaptation of a Brazilian song in an African newspaper Dunham magnificently embodied the will to recognize and elaborate upon cultural affinities at work in such pan-African impulses as Négritude.

Another prominent figure at the Colloquium was Langston Hughes, who had deeply influenced Senghor's poetic representations of jazz and blues. His Colloquium presentation, "Black Writers in a Troubled World," was a remarkable articulation[87] of how the African American literary scene had developed since the days of Senghor's enthusiastic readings of New Negro writers. Hughes used the occasion to describe what he saw as generational splits among African American writers, noting his own unease with the "obscene" vision of LeRoi Jones while comparing it to earlier writers' no less sharp critiques of racism. He suggested that some of Jones's strategies reflected his youth, a time when "one's thinking is unclear—and one's ability to analyze this world about one is uncertain" and then proposed that this dilemma might parallel what African writers faced "not in terms of race and color, but I would think, perhaps in terms of folk life or urban thinking, regional tongues or European, tribalism or educated-ism, the basic roots or the new young branches."[88] His paper, as a whole, entertained this larger problematic, teasing out to what degree African and African American literary challenges were comparable.

Hughes's deftly diplomatic presentation did not so much question Négritude as revise it. He stopped short of calling Senghor's set of references (such as in the apparent dismissal of any postwar innovations of musical style) anachronistic, but his critique was implicit when he proposed an African American alternative to Négritude, a word that summed up both the popular black

[87] I use this term in the sense that Brent Hayes Edwards, elaborating Stuart Hall's 1980 essay "Race, Articulation, and Societies Structured in Dominance," employs the term. Edwards writes: "Articulation here functions as a concept-metaphor that allows us to think relations of 'difference within unity,' non-naturalizable relations of linkage between disparate societal elements" (2001: 59).

[88] *Colloque, Présence Africaine*, 507

contemporary music of the day and African American disposition in the sense Bourdieu uses, *soul:*

> Négritude, as I have garnered from Senegal's distinguished poet, Léopold Sédar Senghor, has its roots deep in the beauty of the black people—in what the younger writers and musicians in America call "soul," which I would define in this way: *Soul* is a synthesis of the essence of Negro folk art redistilled—particularly the old music and its flavor, the ancient basic beat out of Africa, the folk rhymes and Ashanti stories—expressed in contemporary ways so definitely and emotionally colored with the old, that it gives a distinctly "Negro" flavor to today's music, painting or writing—or even to merely personal attitudes and daily conversation. *Soul* is contemporary Harlem's *Négritude,* revealing to the Negro people and the world the beauty within themselves.[89]

Hughes's word choice effectively called for a renewal in Négritude musicology, indirectly demonstrating that Senghor's views on jazz were out of date. Beyond the question of diction, his point was that just as the music of the day had changed considerably since the first articulations of Négritude—after all, Motown records had been founded in 1960—so too, *contemporary* folk (or in today's parlance, *vernacular*) cultures must animate any theory of black identity. Also implicit in the word "folk" was a critique of elitism that we also see in Duke Ellington's reflections.

Duke Ellington was perhaps the most high-profile member of the American delegation, and his band's appearance was sponsored by the U.S. State Department. By 1966, the State Department had a decade-long relationship with various jazz artists, who were deployed to counter one of the most damaging critiques of the U.S. circulating in the Cold War context, the shameful history of racial persecution that demonstrated the failures of American democracy. Penny von Eschen's rich work on the Jazz Ambassadors program notes the ironies often revealed in the reactions of performers who were accorded honor and dignity abroad as representatives of a country that still denied them basic civil and human rights.[90] Ellington certainly experienced some of these contradictions. He later published reflections on his experiences at the festival in a chapter of his autobiography, *Music is My Mistress,* entitled "Dakar Journal, 1966." His account highlights a fault line between the official and the informal registers of the festival:

> We get the usual diplomatic applause from the diplomatic corps down front, but the cats in the bleachers really dig it. You can see them rocking back

[89] Ibid., 508.

[90] Penny von Eschen, *Satchmo Blows Up The World: Jazz Ambassadors Play the Cold War* (Cambridge, MA: Harvard UP, 2004).

there while we play. When we are finished, they shout approval and dash for backstage, where they hug and embrace us, some of them with tears in their eyes. It is acceptance at the highest level, and it gives us a once in a lifetime feeling of having truly broken through to our brothers.[91]

For many among both the band and the audience, jazz at FESMAN represented a visceral connection between continent and diaspora that was highly valued and longed for and that exceeded the more academic and state-authored parameters outlined in the opening colloquium.

One of the sharpest critiques of the statist (and specifically U.S.) agenda FESMAN served came from Hoyt W. Fuller, who not only covered the festival for *Ebony* magazine but also wrote more pointedly about it in his 1971 memoir, *Journey to Africa*. Fuller's *Ebony* article largely sought to convey the scope of the festival to a readership that largely had no experience of travel to Africa but also unmasked a number of contradictions that were edited out of other accounts in both literal and figurative acts of diplomacy:

> [T]he absence of the most exciting of America's black intellectuals—people like John O. Killens, LeRoi Jones, Ossie Davis and James Baldwin—genuinely puzzled Africans and Europeans alike. "You sent us Langston Hughes, and we love him," a bi-lingual Senegalese actor complained, "but where are your younger writers?" ... There was nothing but praise for Duke Ellington and his orchestra and the Alvin Ailey Dancers, but many felt [that several other acts featuring black performers of classical music were not appropriate to the festival's stated goals]. Painter Amadou Yoro Ba, a jazz *aficionado*, asked why musicians like Miles Davis and Thelonius Monk did not come to Dakar, and half of Senegal seemed to have assumed that Harry Belafonte should have been present.[92]

Fuller went on to note that, for Senegal, the festival was not merely a celebration of culture but also an effort to "stave off economic collapse" and encourage tourism, particularly among African Americans. These observations seem to have been borne out by more recent pan-African festivals such as PANAFEST[93] in Ghana and the third edition of FESMAN held in 2010 in Senegal. Whether any of these events was an economic success is open to debate, but lies beyond the scope of this study.

[91] Edward Kennedy Ellington, *Music Is My Mistress* (Garden City, NY: Doubleday, 1973), 338.

[92] Hoyt W. Fuller, "World Festival of Negro Arts: Senegal Fete Illustrates Philosophy of 'Negritude,'"[sic] in *Ebony* 21:9 (July 1966), 102.

[93] Since its inception in 1992, the "Pan-African Historical Theatre Festival" has taken place every two years. Originally conceived as a theater festival by Ghanaian pioneering teacher and author Efua Sutherland, the festival has grown into a wide-ranging arts and culture celebration that Caribbean, African American, and Afro-European participants support in growing numbers.

Fuller's account in *Journey to Africa* centered less on the performances themselves and more on the ways U.S. government agents had actively worked to minimize the festival's potential for launching a more political pan-Africanism:

> One of these days, the full, awful story of the American secret service's role in the First World Festival of Negro Arts at Dakar in 1966 will be told, stripping of honor certain esteemed Black Americans who lent their prestige to the effort to hold to the barest minimum the political impact of that unprecedented event. As it was, the American Society of African Culture's relationship with the CIA was revealed following the Festival, throwing into full relief the role of AMSAC and its white "friends" in planning American participation in the Festival. It was a sorry affair.[94]

Fuller's perspective excavates a dimension of the festival apt to be obscured in officially archived documentation of the festival, which was produced and collected by the Senegalese state and by entities sympathetic to Senghor's perspective. As Ann Laura Stoler shows in *Along the Archival Grain: Epistemic Anxieties and Colonial Common Sense,* we can learn as much about the values determining selection and inclusion on the part of documenting officials as we can from the documents themselves.[95] An event like FESMAN, in the longue-durée, becomes part of a national history, even if originally a transnational event, and thus the texts it produces are sorted through selectively by the archival machinery of that state. Looking through the Dakar archives, one will not find Fuller's accounts, and this is only partly because they appeared only in the U.S. press. The textuality of a transnational event, the way in which it generates reportage and memoir among authors of numerous nationalities, poses specific challenges to the scholar interested in tracing diaspora networks, and omissions such as the Fuller accounts indicate how local and transnational interests and historiographical priorities may diverge. I return to this question of archives in more detail in the sixth chapter.

A sideline drama that played out over Soviet participation in the festival adds depth to Fuller's critique. The USSR, not to be excluded from the tremendous opportunity for public diplomacy that the festival offered, sent both their noted poet Yevgeny Yevtushenko and several journalists. However, pointing out that the USSR had little if any black culture to speak of, Senghor asked Yevtushenko to wait until after the festival to read. Langston Hughes's biographer, Arnold Rampersad, points out that Hughes and Greaves, however, seized the opportunity to become well acquainted with Yevtushenko, spending much of their free time on the docked Soviet ship. Rampersad quotes Greaves:

[94] Hoyt Fuller, *Journey to Africa* (Chicago: Third World Press, 1971), 92.

[95] Ann Laura Stoler, *Along the Archival Grain: Epistemic Anxieties and Colonial Common Sense* (Princeton: Princeton UP, 2010).

"We used to ride around in Yevtushenko's limousine," Bill Greaves recalled, "drinking pretty heavily and having a lot of fun." "Whatever the Russians expected in the way of rivalry," U.S. Ambassador Mercer Cook recalled, "never developed. Langston wouldn't allow it. He and Yevtushenko seemed to be arm in arm every time I saw them together."[96]

Furthermore, the Soviet film *African Rhythmus* includes footage of Yevtushenko and Senghor meeting in Senghor's presidential offices, suggesting that shared poetic interests overrode national and geopolitical differences. In other words, as incisive as Fuller's critique may be, the relationship between ideology and personal interaction was a complex one, and while U.S. government funding may well have acted as a censoring mechanism, many of the African American artists who traveled to Dakar were savvy and independent-minded enough to improvise alternatives to the strictures of state policy.

The ideological tenor of Fuller's accounts takes on another dimension when considered in relation to a second text William Greaves composed about his FESMAN experience, an article for the N.A.A.C.P.'s *Crisis* magazine. The article distinguished between those aspects of Négritude that had, since Sartre's *Orphée Noire*, been seen as an antiracist racism and "[t]he Festival's overriding mood...that of interracial harmony."[97] His list of reasons why there had not been more diverse African American participation in the festival did highlight some of the problematic aspects of the State Department's involvement (in selecting artists as well as in appointing as chair of the American organizing committee a white woman, Virginia Inness-Brown, whose race was deemed to demonstrate a lack of interest or commitment for a *pan-African* dimension to the festival). However, the list was also so eclectic as to preclude reading any clear political statement, indicating the diversity of preoccupations for African American artists at the time, which ranged from getting paid (which, as Dunham's presentation underscored not an entirely a-political concern) to getting civil rights. Like the figures discussed above, Greaves also made an indirect point that, while jazz was an important part of the African American cultural storehouse, it was not received as the most dynamic dimension of the diasporic contribution to Négritude in Dakar in 1966. However, unlike Hughes, he argued that the essential element, "soul," should be understood in its universal rather than vernacular sense. His point was about jazz *dance,* but it is no less relevant:

The Alvin Ailey Company was a roaring smash hit, and this is particularly interesting because in outer form there was little in their performance

[96] Arnold Rampersad, *The Life of Langston Hughes: Volume II: 1941–1967, I Dream a World* (New York: Oxford UP, 1988), 401.

[97] William Greaves, "The First World Festival of Negro Arts: An Afro-American View," in *Crisis Magazine* 73:6 (June–July 1966), 312.

reminiscent of the dance of Africa or even American Jazz. They relied on modern dance forms, on excellent, but westernized, choreography to convey their "Négritude."...The Ailey Company, working with non-African styles, demonstrated that Négritude does not necessarily rely on external form to reveal itself, that, it can be a state of consciousness which reflects itself in many ways. Some Afro-Americans call that state "soul."... The Ailey Company was successful partly because of their skill, but also because "soul" veritably cascaded from them out over the footlights.

There is a tendency among some Negro intellectuals to view soul as the private property of the black man—a ludicrous notion. Soul is the necessary ingredient of all great art.[98]

Greaves's priority in the article was to demonstrate that the arts at the festival met this universal criterion for "great art," which, strikingly, coincides with Senghor's oft-repeated assertion that Négritude was a form of humanism and its goal was to ensure that the black contribution to a universal human cultural patrimony was recognized.

While my discussion thus far has focused on African American responses to Senghor's interpretation of jazz, FESMAN also provided an occasion for other voices to join this debate, and the presence of Southern Africans involved in antiapartheid and liberation struggles was a key hallmark of the event. One such attendee at the festival was the South African poet and ANC cadre, Keorapetse "Bra Willie" Kgositsile, who would go on to become his nation's poet laureate exactly fifty years later. Kgositsile had been sent into exile by the ANC leadership in 1962, and was based in the U.S. by the time of the festival, where his studies at Langston Hughes's alma mater, Lincoln University, and involvement with many leading figures of the Black Arts Movement made him a living embodiment of many of the ideals of the 1966 festival. In contrast with the abstracted function of jazz in Senghor's Négritude philosophy, Kgositsile's jazz poetry was often anchored by detailed engagements with specific musicians and recordings, as well as conversations with other writers. Synesthesia in Kgositsile's poetry reflects an intersensory concatenation of the modes of sense perception, particularly vision and hearing, and thus performs a solidarity among the senses that can be read as an aesthetic parallel of the search for solidarity between Black Americans and South Africans in exile. Sound experienced through multiple sensory modalities figures intimacy between the senses, a metaphor for pan-African Relation through embodied experience. Alex Weheliye has shown eloquently the unique ways that black experience leaves its trace in distinctive sensory patterns, taking double consciousness as a paradigm for a feeling of two-ness,

[98] Ibid., 312.

not only in terms of cultural identity, but also in terms of perceptive capacity. He writes:

> In the end, double consciousness does not so much critique as *gift* (poison and bless) the disembodiment of vision and by extension the human in modernity in its excavation and amplification of aural materiality, the "tremulous treble and darkening bass" (*Souls*, 215) veiled by scopic racial formation, as it throws phono-optics into the mix of the phonographic grooves of sonic Afro-modernity.[99]

While Weheliye's observations are largely confined to black diasporic experience, this notion of linking Du Boisian double consciousness with disembodied vision and amplified aural capacity is generative in interpreting Kgositsile's work. For Kgositsile, the disconnection from homeland and the disarticulation of apartheid's extreme segregationist policies, along with his experiences living under U.S. Jim Crow and everyday racism, gives rise to a vision of radical cohesion, a convergence of senses figuring the possibility of a healed and healing Afro-modernity that I have described in more detail elsewhere.[100]

The 1966 Dakar festival led to one of Kgositsile's earliest publications, a set of three poems, alongside French translations by Mauritian poet Edouard Maunick, which appeared in *Présence Africaine* in 1967, prefaced by Maunick's interview of the South African during the 1966 festival.[101] The Sharpeville massacre of 1960, the continuing repressions of the National Party government and the jailing of leaders including Mandela in 1964 lent particular urgency to *Présence Africaine*'s interest in the South African situation. This interview reveals how Kgositsile's very presence was essential to the work he did in linking geographically dispersed black intellectual communities. It is telling that, in spite of differences Kgositsile himself articulated with Senghor's Négritude aesthetic, Maunick would present the poems as "hosties noires," echoing the title of Senghor's 1948 poetry collection in an attempt to bring Francophone and Anglophone African worlds in closer intimacy. While neither the 1967 interview nor the poems address Senghorian Négritude directly, Kgositsile's forthright invocations of black diasporic music's capacity to amplify a rebuke of injustices and to mobilize collective determination to effect change must have registered a distinctively oppositional stance far more abstracted if not missing in Senghor's own approach to music.

Of the three poems published, "Manifesto" makes the most direct reference to black American music and literature. The poem is a song of mourning

[99] Alexander G. Weheliye, *Phonographies: Grooves in Sonic Afro-Modernity* (Durham and London: Duke UP, 2005), 44–45.

[100] Tsitsi Jaji, "Sound Effects: Synaesthesia as Purposeful Distortion in Keorapetse Kgositsile's Poetry" in *Comparative Literature Studies* 46.2 (2009), 287–310.

[101] Edouard J. Maunick, "Une voix vivante de l'Afrique du sud: William Kgositsile" in *Présence Africaine* 62:2 (1967): 177–81.

for Malcolm X (killed in 1965) and Patrice Lumumba (killed in 1961), and a vow to continue resistance alongside Mandela. Kgositsile uses references to black diasporic music to link geographically separate topoi, and historically distinct temporalities, projecting a performance of simultaneity that enacts pan-African solidarity and draws on the past as a resource for present struggles. The poem's first reference to music rewrites the African American spiritual, "Were you there when they crucified my Lord" as "(Were[102] you there when/They killed Lumumba/Were you there when/They killed Brother Malcolm)."[103] This rewording is a significant and productive distortion on two levels. First, the semantic shift from the original line to the references to Lumumba and Malcolm X reroute devotional religious energy toward the political. And second, a musical value is diverted into the poetic text through the transcription of the African American performance practice of "worrying the line," or embellishing a melodic contour through melisma and other musical ornamentation.[104]

Shifting focus from the contemporary to the historical, the poem condemns slavery, announcing an intention "To defy the devils who traded in the human Spirit/For Black cargoes and material superprofits/We emerge to sing a Song of Fire with Rolland."[105] This last line references a poem by Rolland Snellings (later Askia Touré), "The Song of Fire," which draws on a range of religious traditions to indict American imperialism in Vietnam and nuclear proliferation in a chorus of Third-Worldist claims upon transcendent justice. Although dominated by Judeo-Christian eschatological imagery of fire and brimstone, Snellings's poem also invokes the Yoruba war-god Shango, Congolese drumming, Buddhist monastic garb, and a vision of Allah wielding a "flaming sword" of justice. The scope of Kgositsile's "Manifesto" is more restricted, however it takes up Snellings's gesture of extending a Christian framework to a broader sphere by moving from a sacred repertoire of spirituals[106] to the secular, indexed in Kgositsile's final line, "Change is gonna come!" which cites the 1964 Sam Cooke hit song that galvanized listeners involved in the civil rights movement. The contrasting temporal orientations of the two musical references shift

[102] The English version in *Présence Africaine* reads "Where you there," but since the French translation reads "Etais-tu là," it is clear this is an editorial error.

[103] Keorapetse Kgositsile, "Manifesto," trans. Edouard Maunick, in *Présence Africaine* 62:2 (1967): 182.

[104] *Melisma* is a musical term that refers to singing multiple pitches in a musical phrase while using the same vowel sound.

[105] Kgositsile, "Manifesto," trans. Maunick, in *Présence Africaine*, 183.

[106] Kgositsile's reference also reverberates with an earlier articulation of an African American aesthetic. Alain Locke in his 1925 essay "Negro Spirituals" (*New Negro*, 207) discusses a performance by Roland Hayes (1887-1977) of "God's Goin' to Set Dis Worl' on Fire." The trope of a millenarian redemptive fire figures repeatedly in the African American spirituals tradition, and as a vernacular source black writers of several generations turned to. In citing Snellings, Kgositsile also cites a historical African American literary practice of versioning spirituals.

from an orientation toward the past ("Were you there?") toward an orientation toward the future ("Change is gonna come!"). By bringing the sacred and secular repertoires together, Kgositsile casts the lyric present as bearing a specific "ethicopolitical" charge, which, while colored by religious language, is oriented toward political action. Michael Hanchard has argued that

> Religion provides the language for impending confrontation, but the spaces for confrontation were and are plantation societies, tenements, cities, rural areas, and nations—in short, any site where racial prejudice, socioeconomic exploitation, and violence are combined.[107]

For Hanchard, this use of the eschatological is one of the markers of Afro-modernity's specific deployments of time in relation to liberation movements, where the language of transcendence is harnessed in the service of concrete, immanent struggle. Kgositsile's poem uses music to render this millenarian liberation project accessible in the here and now while drawing on the considerable force of spiritually based discourses of freedom in African American tradition. Yet a spiritual orientation toward change is not sufficient, rather the embodied and public spaces of the street and dance floor stand in for the secular, political change Cooke ushers in. It is through his musical citations that Kgositsile collocates a millenarian future orientation and an urgent political investment in the present, enacting a simultaneity, which in the very act of enunciating "Change is gonna come," commits to the embodied present in which change is always coming into being. However significantly Kgostsile's and Senghor's aesthetic and poetic values differ, this notion of a permanent embodied present that is itself the scene of a change coming into being, change *à venir*, is an important note of consonance. Remembering the moments where their paths converged, along with those of the other festival visitors discussed here is important if we are to understand the history of the stereomodern-ist impulses toward solidarity that animated the festival as also perpetually renewed, always summoning change to come.

In a Sentimental Mood

Some fifteen years after the festival, Senghor's composed a poem, "Élégie pour Philippe-Maguilen Senghor," which indicates that the idea of jazz continued to be an important imaginative and affective touchstone for his work. The poem, a tribute to his son who was killed in an automobile accident in 1981, is dedicated to Colette, Philippe-Maguilen's mother, and scored for jazz orchestra and polyphonic choir. Although it treats this most intimate moment of

[107] Michael Hanchard, "Afro Modernity: Temporality, Politics, and the African Diaspora," in *Alternative Modernities*, ed. Dilip Gaonkar (Durham: Duke UP, 2001), 285.

loss, the conflations between his personal life, his son's life as a Senegalese métis, and the historical African American diaspora in this poem are bracing, and, just as in the more public-voiced "Élégie pour Martin Luther King," jazz serves largely as a synecdoche for African American culture in this poem. Take the lines:

> Mais déjà tu le réclamais, cet enfant de l'amour, pour racheter notre peuple insoumis
> Comme si trois cents ans de Traite ne t'avaient pas suffi, ô terrible Dieu d'Abraham![108]

> But you have reclaimed him already,
> This child of love, to redeem your unsubdued people
> As if three hundred years of the slave trade wasn't enough
> For you, O terrifying God of Abraham![109]

These lines indicate the extent to which Senghor's affective imagination allows him to connect his personal grief to that more public and long-standing sorrow occasioned by the slave trade. However, this empathy also raises a significant question as to whether such forms of loss can ever be commensurable. Attending to the second ensemble, the polyphonic choir gives an additional and necessary insight into his intention, for polyphony allows for simultaneity of different registers, rather than implying equivalence. The poet recalls the nick-names he and his wife shared for their son, "mon petit Maure/Mon Bengali, comme nous t'appelions [My little Moor, My Bengali, as we used to call you]"[110] and hints that the capacity for friendship across racial and cultural lines that they treasured in their son also motivate the metaphors of polyphony that run through the poem. Given that the musical references are primarily to the African American spiritual "Steal Away to Jesus," it would appear that the "jazz" referred to in the subtitle is in fact standing in for a much broader repertoire of shared black musics. In other words, "jazz" signifies more as an idea of musical unity forged out of diverse elements, and as a blues-derived form of solace in sorrow than as a specific sonic reference or intertext in this particular poem. Faced with the tragedy of a son's death, the neat borders of Senghor's Négritude musicology dissolve, and music is called upon to do what it does best when "words don't go there"... resonate.[111]

[108] Senghor, *Oeuvre Poétique,* 295.

[109] Dixon, *Collected Poetry,* 208.

[110] Senghor, *Oeuvre Poétique,* 298.

[111] Nathaniel Mackey recalls: "Charles Lloyd once remarked, regarding the source of music, "Words don't go there." Music wants us to know that truths are variable, that one included." The saying has entered a shared musical lingua franca among many interdisciplinary scholars of African American popular music, most especially Charles Rowell and Fred Moten. See Mackey, "Statement for Breaking Ice" in *Callaloo* 23.2. (2000), 717, citing Mackey's piece in *Breaking Ice: An Anthology of Contemporary African-American Fiction,* ed. Terry McMillan (New York: Penguin Books, 1990).

What Women Want

SELLING HI-FI IN CONSUMER MAGAZINES AND FILM

Senghor's poetry and the 1966 festival are remarkable because they reveal how a popular musical form like jazz was inscribed in the high modernist aesthetics of the Senegalese form of Négritude. Yet at the same time that elite Africans sought recognition as cosmopolitan subjects through performance and intellectual gatherings like the Colloquium and Festival of 1966, another cultural current was arising, skirting the conventions of long-form print publishing to offer a new set of experiences geared toward cultivating African consumers. This chapter addresses how women participated in the emergence of a network of new media forms—glossy magazines, films, and musical records—which all placed a high premium on the sheen of the "new." These media forms emphasized an economy of desire that inculcated habits of consumption where "being modern" connoted purchasing (or at least perusing advertisements for) a range of appliances, audio equipment, and print media that referenced one another in an increasingly tight network of mutual advertising. However, these media forms also laid bare the many contradictions of aspirational consumption. I examine how women peeled stereomodernist meanings from these glossy surfaces when the sheen of consumerism wore thin.[1]

Women were featured as magazine covergirls, as starlets in films, and as the target audience for advertising in all these new media formats, and thus were in a prime position to question the claims to African modernity ratified through consumption. While many images in the media forms examined in this chapter referenced African American fashion, hairstyles, music, and more, the notion of shared transnational black cultural currents was undercut in two ways. First, popular media often addressed head-on the debates

[1] For a highly original discussion of shine, surface, and skin in the fetishization of black women's bodies, see Anne Anlin Cheng's *Second Skin: Josephine Baker and the Modern Surface*, (Oxford: Oxford UP, 2011), particularly chapters 7 and 8. While my interest in sheen is focused primarily on the intersection of tactile, visual, and aural registers, my interpretation has been enriched by Cheng's meditations.

over "traditional" versus "modern" beauty ideals. Celebrating African fabrics and natural hairstyles as marks of modern self-confidence, they anticipated the ascendency of such ideas in African American circles. And second, the sheen of advertised commodity surfaces was often rubbed away by the friction of daily life in rapidly developing newly independent nations, opening the opportunity to critique the rhetoric of consumerist promises and to recognize continuities between colonialism's legacies in Africa and the ongoing struggle for civil rights in the U.S. The parallels in media representations between African Americans and Africans facilitated this line of comparative thought but also sometimes occasioned alternative popular instances of transnational black solidarity far from the centers of state power seen in the previous chapter. Lingering over the way that intermedia links were projected among magazines, films, and audio technology, and extending valuable work on popular literacies in Nigeria, and other parts of Africa by scholars such as Emmanuel Obiechina, Karin Barber, Stephanie Newell, Peter Benson, and Sonja Laden, I argue in this chapter that a set of interpretive strategies I call "sheen reading" fostered a degree of skepticism in the face of the rise of advertising, and gave rise to important debates over shifting attitudes toward gender roles at a moment of rapid urbanization. The chapter focuses on two magazines that have received relatively little attention. I analyze *Zonk!*, published in South Africa, at some length, as it captures the relationship between multiple media forms, and then more briefly discuss *Bingo*, published in Senegal and France and distributed across the Francophone world.[2] These magazines are of interest precisely because they appear, on their surface, to downplay the kind of progressive politics that have made *Drum, Itinerario, Transition* and other magazines from the same period so readily appealing to subsequent scholars. The unreflexive celebration of consumption in *Zonk!* and *Bingo* sits less easily with prevailing critical dispositions. Yet, as Karin Barber's scholarship on audiences and popular arts in Africa so richly illustrates, audience responses matter as much as cultural objects per se where popular arts are concerned. Furthermore, audience responses do not necessarily reflect prevailing opinions, but may articulate cultural tensions that lie below the surface.[3] This chapter attempts to attend to such tensions in female audiences' responses to the interlocking media forms around glossy magazines and thus to recover women's voices all too rarely heard when the independence era is read primarily through prestigious elite forms like novels and poetry.

[2] I discuss *Bingo* at greater length in my essay "*Bingo*: Francophone African Women and the Rise of the Glossy Magazine" in *Popular Culture in Africa: The Episteme of the Everyday,* ed. Stephanie Newell and Ono Okome (New York: Routledge, 2013).

[3] Karin Barber, "Notes on Audiences in Africa" in *Africa: Journal of the International African Institute* 63:3 (1997): 347–62.

In August of 1949, a new publication hit the newsstands of South Africa, introducing a glossy, glamorized visual representation of a black African woman for the first time in the nation's media history. Dolly Rathebe, the singing star of South Africa's first film featuring black performers and intended for a black audience, *Jim Comes to Jo'burg* (1949, also called *African Jim*) looked out at her audience with an enigmatic yet confident gaze. Facing on the diagonal, one shoulder exposed, her hair coiffed in an Afro puff and her entire ensemble trimmed with Zulu beadwork, her pursed lips and slightly raised eyebrow called attention to an image of African womanhood that exceeded the familiar images of rural subsistence farmers, domestic workers, shebeen entrepreneurs selling home-brewed beer, and mission-educated petit bourgeois. While newspapers such as *Bantu World* had featured photographs of notable South African and African American women on their front covers before, black South Africans had never before seen one of their own represented with the high sheen of magazine cover paper. Dolly Rathebe had already been a popular singer before her film appearance, but her simultaneous appearance pioneering a black presence in two new media forms won her the faithful "high fidelity" support of an entire generation of South African fans. The climax of the film, which featured Rathebe and her co-star Dan Adnewmah in the studio recording a vinyl record album together, ensured that sound technology and the visual forms of cinema and "pictorial" magazines would be intertwined in black South African imaginaries.

Coming fast on the heels of the Afrikaner-dominated National Party's victory in May 1948 nondemocratic elections, this new magazine, *Zonk!: African People's Pictorial*, would introduce black readers to a set of imaginative possibilities at odds with the increasingly restricted material and political conditions enforced under the new government's policy of apartheid. The cover pushed readers' temporal imagination beyond the immediate concerns of a government brutally instituting racial segregation and projected their attention instead to the imminent release of *Jim Comes to Jo'burg* (premiered October 15, 1949). While *Zonk!* had a staunchly apolitical editorial stance, its imagery was at odds with the drudgery and constrained sphere of aspirations advocated by the state. And when its better-known competitor *The African Drum* began publishing in 1951, the editors tried to distinguish their new magazine by taking a more activist tone, featuring investigative reports on appalling workers' conditions alongside the lighter topics that dominated *Zonk!*'s pages. Nonetheless, Dolly Rathebe's image, confronting readers with her steady gaze on the cover of Volume 1 Number 1 of the *African People's Pictorial,* fundamentally changed the way Africans looked at themselves and out at the world. And it placed women at the center of debates about how domesticity, media consumption, urbanization, modernity, and political identities were lived in post–World War II Africa.

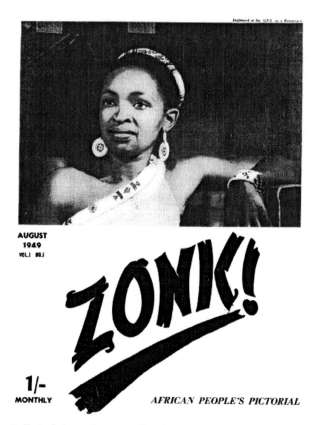

FIGURE 4.1 *Dolly Rathebe on the cover of* Zonk! *Magazine, 1949.*

Zonk! magazine was not the first media production under that name. The publication was established by a Jewish South African entrepreneur, Ike Baruch Brooks, who put together a musical ensemble in 1943 to entertain non-European troops who were conscripted to fight for the Allies in World War II. The all-male group was originally known as the "African Flashes" and they were wildly successful, going on to perform for civilian audiences of all races, under the names "Zonk!" and later, "Nu-Zonk." Following the war, Brooks was convinced by some of his ensemble members to start a magazine that would employ some of the same people, at the same time that *Jim Comes to Jo'burg*'s production team was launching a new black-cast cinema. The advent of the cover girl was one of *Zonk!*'s signature innovations, and the image of the glamorous, confident "new" woman was so central to *Zonk!*'s appeal that when, in 1950, a musical film also known as *Zonk!* was released, its finale featured a life-size mock-up of the cover of a magazine issue complete with a singing "cover girl" belting out the joys of reading the glossy magazine.

Soon after the launch of *Zonk!* and *The African Drum* (later sold as *Drum Magazine* with local editions across the continent), Francophone Africa saw

its equivalent magazine with *Bingo*, a publication edited by writer and dip-lomat Ousmane Socé Diop and distributed from Dakar and Paris, appearing in 1953. While *Bingo* had fewer direct ties to the cinema in its early issues, it borrowed from the pages of other African and African American magazines, including *Drum, Ebony,* and *West African Review*, laying out on the page the kinds of popular lines of affiliation that such everyday literacies facilitated. *Bingo*'s advertising was more extensive than the early versions of *Zonk!* and featured a wide range of products available by mail order from France, in addi-tion to those available at named African stores. Prevalent among these were home audiovisual equipment—radios, hi-fi sets, still and moving cameras—as well as other products promoted for and via listening—musical instruments, pills to take when the music was causing you a headache, and, of course, the latest records. Magazine literacy, then, was concomitant with a network of other media literacies, and one of the functions of the pages of *Bingo, Zonk!,* and similar publications was to train readers in a new set of interarticulated desires for new products and states of mind.

What stands out, then, is the extent to which these magazines charged women with parsing and channeling such desires, both visually and textually. Women were called upon to be discriminating judges of value, and, as a result, despite their limited access to literacy and underrepresentation in urban spaces they were often the ideal viewers addressed in films, the sought-after listeners for popular music, and the target audience of much advertising. This paradox makes answering the question at the heart of this chapter, "What do women want?" in mid-century Africa, rather complex, although early issues of *Zonk!* and *Bingo* and their ties to related media offer some fascinating responses. In *Zonk!*'s case, it is impossible to talk about the first three years of the publica-tion without also considering the set of four black-cast musicals that were fea-tured in the magazine's reporting and advertising: *Jim Comes to Jo'burg, Zonk!, Song of Africa,* and *The Magic Garden.* Each of these pathbreaking magazines has been discussed in an undercirculated academic thesis (by Irwin Manoim and Jacques Bouzerand, respectively)[4] but there are very few published stud-ies of *Zonk!* and *Bingo*, in contrast to the plethora of excellent scholarship on *Drum Magazine,* and thus I will focus my comments on these lesser-known magazines. It is important to note at the outset that none of these magazines were read only, or even primarily, by women, but rather that they presented images and stories that appealed to constructions of femininity and women's experiences that placed women's aspirations and everyday routines at the core of negotiating the changing dynamics of the domestic sphere under apartheid

[4] Jacques Bouzerand, *La Presse écrite à Dakar, sa diffusion, son public* (Dakar: Université de Dakar, Centre de recherches psychosociologiques, 1967) and Irwin Stanley Manoim, "The Black Press 1945–1963: The Growth of the Black Mass Media and Their Role as Ideological Disseminators," M.A. thesis, University of the Witwatersrand, 1983.

and the (de)colonizing process. The interrelated media of film, live musical performance, and popular print culture did much to place the simultaneous consumption of sound and image at the root of a specifically urban(e) stereo-modern black subjectivity that regularly referenced African American music, style, film, and magazines. Throughout this chapter, it is the slippage across different media forms that commands my attention, as this conjunction of magazines, films, and musical recordings inaugurated a new sensibility which I propose to call *sheen reading*, and I begin with an extended discussion of this sensibility.

Sheen Reading

The set of interpretive practices these media demanded blurred textual, visual, and other forms of literacy in the transsensory hermeneutic exercise that I term "sheen reading," in a nod to Africana beauty cultures that place a high aesthetic value on the sheen of glowing skin and glistening hair, as the U.S.-made Johnson company recognized in marketing hair products like Ultra Sheen (1957) and later Afro Sheen. Throughout Southern Africa, in particular, glowing skin was so valued that women adapted traditional self-care routines spreading animal fat to moisturize and add shine to their skin with new colonial products, ranging from margarine to petroleum jelly.[5] In discourses of urban racial uplift (such as Charlotte Maxeke's in our first chapter), women were seen as the first line of defense against the threat to established hierarchies and order posed by urbanization and youth culture. It fell to them not only to maintain hygiene of the body and home, but also in the more broad sense of hygiene, to foster and guide their domestic units toward the health of society and to conserve and enhance "sheen," or the surface of smoothly functioning daily life. I want to think of their engagements with interarticulated forms of media—film, radio, records, and magazines—as acts of reading sheen, interpreting reflective surfaces whose distortions provided generative openings for improvisations of new identities in the face of increasing racialized restrictions on freedom.

The pictorial magazines born around 1950 not only depended on sheen to sell their glossy copy, but also generated sheen for the commodities advertised in their pages. Self-fashioning, in the most literal sense, drove much of the advertising for personal care and hygiene products, and sheen was also marketed in shoe polish (as with a Nugget boot polish advertisement on page 21 of the November 1950 issue of *Zonk!*) or more troublingly with skin lightening creams (like the Bu-Tone complexion cream on page 8 of the July 1950

[5] Timothy Burke, *Lifebuoy Men, Lux Women: Commodification, Consumption, and Cleanliness in Modern Zimbabwe* (Durham: Duke UP, 1996).

issue). Sheen lay at the heart of modernity's stress on the new and consumer capitalism's fetishization of clean, shiny, polished surfaces. Indeed, advertising new technologies was one of the primary functions of the "African pictorial magazine," and the authoritative voice of the consumer advocate that spoke from its pages was constitutive of the popular print form, for, as David Moreley argues, "the dynamic of making technologies consumer-friendly in practice often means inserting them into recognizable forms from previous eras."[6] At the same time, the periodicity of the magazine form betrayed the impossibility of maintaining such fetishized surfaces: in constantly advertising new products, magazines were signs of potential or rather *planned* obsolescence.

Sheen reading, as I am proposing it, is an apt interpretive framework for the contexts in question in part because it is flexible enough to account for the wide range of literacy levels that characterized media audiences. Sheen reading a magazine does not presuppose textual literacy, nor, however does it preclude it. The sheen reader visually assimilates the composition of the page, its spatial configuration juxtaposing a variety of typefaces and font sizes, and a range of illustrations from photographic images to line drawings. As a temporal experience, sheen reading may entail pausing to decipher the text (with highly educated ease, or with the belabored effort gained in places like l'*école populaire*[7] [the people's school]), as well as poring over images of fashion, interior design, and other staged still lifes of consumer goods. Conversely, the magazine page's weight, size, and texture facilitate a wide range of specific uses: flipping rapidly through pages, licking a finger to turn a page, dog-earring durable glossy paper, or pasting selected images with an interior design aesthetic that turns walls into windows of desire. What's more, the tactile experience of fanning through a magazine contrasts sharply with the more hushed sounds of the same flip through a book and the awkward, granular sweep of turning a newspaper page. The choices in how a magazine is temporally experienced are emblematic of a spectrum of multisensory choices that the reader makes. Hilary Radner has noted that these choices are particularly suggestive for a feminist approach to reading:

> the women's magazine...incorporates novelistic discourse but also disperses this discourse through the simultaneous introduction of other texts that evolve out of a number of different positions that might be termed "feminine." The magazine reader must pick and choose among a number

[6] David Moreley, "What's 'Home' Got to Do with It?: Contradictory Dynamics in the Domestication of Technology and the Dislocation of Domesticity," in *European Journal of Cultural Studies* 6:4 (2003): 435–58.

[7] I refer here to the site of work of the public letter writer in Sembene's *La Noire de*... Nightschools and other community adult education centers are, of course, not unique to Africa, but their focus on empowering workers denied the benefit of formal literacy education earlier in life makes them particularly influential in shaping reading practices in rapidly urbanized centers.

of different possible orders, and in its very format, the magazine evokes the possibility of another regime of reading, another way for the reader, herself, to conceive of the reading process, of her role as a reader. One might argue that it is the women's magazine that might serve as the most clearly paradigmatic example of feminine culture as a heteroglossic discourse... that accumulates rather than replaces, that permits contradiction and fragmentation, that offers choice rather than conversion as its message.[8]

Her observations suggest that one of the important differences between reading magazines and viewing films is at the level of choice, for the magazine presents readers with a huge range of choices for possible orderings, durabilities, and uses of the page.

Sheen reading pulls our sensibilities in diverging directions. On the one hand it recalls sacred practices, such as *lectio* (*divina*) and meditation on an image serving as an icon, but on the other, it just as easily unmasks the text's profane and ephemeral nature. By definition the magazine is periodic: it is so disposable that, unlike pulp fiction or trashy novels, its potential to be discarded does not call for an adjective; it is constituted of a decaying aura intended to be regularly replaced. Yet, a page torn from its binding and affixed to a wall becomes a timeless secular icon removed from the temporal bounds of its original serialized appearance. As such, the magazine's interpretive effect, sheen reading, is the mode of print consumption par excellence of the postcolony, for the magazine, itself always already almost out-of-date, reveals that *sheen is precarious,* letting us in on the dirty secret of the very impossibility of maintaining the fetishized surfaces its pages advertise. This makes the magazine a sign of potential obsolescence, failure, and therefore possible points of departure for imagining alternative realities and creative forms of resistance. Here the hyper-exploitable precariousness of the (post-)colonized poor is emblematized in the easily torn textures of the magazine. Black South Africans led lives that were nothing if not precarious: subject to arbitrary arrest, forced removal, exorbitant taxation, and the denial of citizenship, they could count on none of the state apparatuses, ideological or otherwise, that might lend some semblance of order to their daily rhythms. Any health care provided by the state was minimal, schools substandard, and prisons dehumanizing. The magazine, more than any other print medium, mirrored their human condition in potentially disruptive ways for, in the ragged gaps between lived local experience and glossy metropolitan excess, desire and disillusionment easily blurred, feeding critiques and political action. Generalizing this reading, one might claim that the glossy magazine's page, as a media form, presents more than a sleek graphic layout to the disenfranchised reader; it prompts a deep

[8] Hilary Radner, *Shopping Around: Feminine Culture and the Pursuit of Pleasure* (New York: Routledge, 1995), 128, 135.

skepticism of the aspirational fictions upon which the compliance of raced or otherwise marginalized subjects rests.

This critical potential, I would argue, is heightened by the very silence of the print object. If magazine copy, particularly photography, can transmit a visually realist image, the aural dimension (beyond the flip and flap of pages) is essentially mute. And while the pages of *Zonk!* and *Bingo* are filled with images of music, noise, and acoustic exuberance, the page itself withholds sound, heightening the experience of lack and disappointment built into commodity fetishism. Such critical potential, then, hinges on the paradox of magazine copy that transmits seemingly flat visually realist images and shallow text, yet activates a multiplicity of adjunct sensory dimensions.

As a quintessential mode of reading in the postcolony, the cross-referential links between print, audio, and visual communications that define the networked modern media machine are not unique to African settings. The links made legible through sheen reading lie at the core of consumer magazines' success worldwide, but have been felt all the more acutely in those areas excluded from a Eurocentric version of modernity. Arjun Appadurai has reflected on his encounters with intermediality in the global South, writing:

> [i]n my own early life in Bombay, the experience of modernity was notably synaesthetic and largely pretheoretical. I saw and smelled modernity reading *Life* and American college catalogs at the United States Information Service library, seeing B-grade films (and some A-grade ones) from Hollywood at the Eros Theater.[9]

What was, however, distinctive about the South African synesthetic experience of an American-inflected modernity was the significance of proposed racial affinities in determining what images and narratives resonated. In fact, South Africa might be seen as the most extreme (even exceptional) instance of sheen reading's postcolonial anchoring. The case of *Zonk!* reveals how American-style consumer capitalism and leisure culture arguably became as important in Africa as the attenuating ties of colonialism. Just as segregation in the United States made the "American Dream" nightmarish for citizens of color, the racial tensions of not only apartheid but also colonialism in the world of *Zonk!*'s readers brought the limits of capitalist dreams of self-actualization through consumption very close to the surface. Nonetheless, such betrayals also heightened the acute desire for consumerist chimera that might provide imagined respite from the all-too-real consequences of legislated and de facto inequalities. Sheen reading—going to the movies, or fingering the glossy images of aspirational ease—became a crucial way to manage the everyday humiliations of living under domination.

[9] Arjun Appadurai, *Modernity at Large: Cultural Dimensions of Globalization* (Minneapolis: U Minnesota P, 1996), 1.

How did this magic sheen rub off? If Dolly Rathebe's image on the cover of *Zonk!* showed local black women in a new light, American black women had long been ciphers of glamour due to the popularity of going to the cinema, or bioscope, as it was known. Film historian Peter Davis notes that films featuring black heroes such as *Cabin in the Sky* and *Stormy Weather* (both made in 1943) had introduced South African audiences to African American artists such as Lena Horne, Billie Holiday, and the Ink Spots.[10] While some light-skinned performers in these films would have been considered "coloured" under apartheid codes, black South African audiences were already accustomed to making these screened images their "own." In addition to identifying with the actors as Lindiwe Dovey and Angela Impey have argued, audiences found that going to the cinema offered "not only inherent pleasure, but also the transgressive pleasure of *emphatically embracing pleasure* while under siege or occupation."[11] By preserving the time and space of the cinema as an imaginative vista that stretched beyond the windows of opportunity that apartheid was rapidly shuttering, black South Africans used cinematic viewing to assert and revel fully in their humanity. In some respects, spectatorship in the townships paralleled what Jacqueline Stewart describes in her pathbreaking study of cinema spectatorship in black Chicago, *Migrating to the Movies*: residents in the townships were generally first or second generation urban migrants who had left the rural areas seeking employment much as African Americans in the Great Migration did. In the cinema (or bioscope) theaters they encountered far more films featuring white lead characters (Hollywood or British) than black, although some African American films and musical footage did cross the Atlantic. In effect, urban black South Africans watched many of the same movies as African Americans under similar circumstances, and so I would argue it was not just the representations, but also the viewing practices of African Americans that contributed to South African black audiovisual modernities.[12] As Stewart astutely notes, "the movies occupied an important space in the new cultural landscape Black migrants encountered up North"—and, I would add, similarly in South Africa's townships—"not simply by offering an accessible and enjoyable leisure activity but by providing a public context, among many, in which to negotiate a new set of racist power relations."[13] Going to the bioscope was not merely an escape from, but a means of coping with racist apartheid policies.

[10] Peter Davis, *In Darkest Hollywood: Exploring the Jungles of Cinema's South Africa* (Johannesburg: Ravan and Athens, OH: Ohio UP, 1996).

[11] Lindiwe Dovey and Angela Impey, "*African Jim*: Sound, Politics, and Pleasure in Early 'Black' South African Cinema," in *Journal of African Cultural Studies* 22:1 (2010): 60.

[12] Jaqueline Najuma Stewart, *Migrating to the Movies: Cinema and Black Urban Modernity* (Berkeley: U California P, 2005).

[13] Ibid., 7.

The very first issue of *Zonk!* included a full-page advertisement for records by the "Negro Kings of Swing"—"Fats" Waller, Count Basie, Duke Ellington, Louis Armstrong, Dizzie Gillespie, John Kirby, John Hodges—while the "American Letter" section, which ran for several months, regularly introduced notable African Americans.[14] Entertainers were given particular attention: in the third issue, Marian Anderson was featured, and in the fifth issue, a large photograph of Hazel Scott drew more attention than the brief biography and small photograph of her then-husband, Congressman Adam Clayton Powell, appearing below her photograph.[15] Hazel Scott occupies a privileged place in black magazine history, given that the first issue of *Ebony* magazine in 1945 featured a two-page spread entitled "Bye bye boogie" about Scott's move from the Café Society to the concert stage upon her marriage to Powell. One might argue that her negotiation of glamour and a career as a pianist-singer was foundational to defining what kind of woman belonged in the pages of the black glossies. The *Ebony* article quoted multiple references to her figure even as it claimed to foreground the musical gift that led her to debut at Carnegie Hall playing Tchaikovsky's Piano Concerto No. 1 at age thirteen. Thus, *Zonk!*'s article about Scott four years later was a sign of up-to-date, savvy, and cosmopolitan style, as well as a reinscription of the schizoid representation of women as glamorous stars and demure spouses. While African American women were not featured as often as men in advertising and stories, the image of black cover girl, movie star, and torch singer all reproduced diasporic women's iconography, and it is remarkable that most African American women featured in the magazines were accomplished musical entertainers, further reinforcing the intermedia ties between aspirational ideals of sound and image.

By reviewing local records like Josaya Hadebe's Trutone "cowboy" albums, alongside American stars like Duke Ellington and Slim Gaillard, *Zonk!* implied a parallel set of aspirations for South Africans and African Americans.[16] *The African Drum* shared similar preoccupations. In March 1951, the new magazine's first issue opened with Countee Cullen's poem "Heritage," asking "What is Africa to me" from the other side of the Atlantic. The poem was prefaced with a note that betrays the patronizing attitude of the founding editors, Jim Bailey and Bob Crisp:

> We are privileged to begin the first issue of "The African Drum" with a great poem by a great American Negro poet. We have never read anything yet that expresses so brilliantly and so beautifully the bewildering thoughts that

[14] Advertisement, *Zonk!*, 1.1 (August 1949), 46.

[15] "Bye bye Boogie/Hazel's Heart Belongs to Daddy," *Ebony*, 1:1 (November 1945), 31–2.

[16] *Zonk!*, August 1949, 47. Needless to say, not all American music advertised in *Zonk!* was made by African Americans, and soon records by the likes of Stan Kenton and Benny Goodman were also advertised for sale.

beset the 20th Century African—even after 300 years of civilising [sic] away from Africa.[17]

Bailey and Crisp appealed to their prospective readers' interest in African American culture to launch their publication. And the magazines built on a trend already apparent in musical forms. As Christopher Ballantine notes:

> For several decades, urban Africans were held in thrall by American culture—but above all by the activities and achievements of blacks in that society. Where American culture fascinated, *black* American culture infatuated.... Most obviously, the infatuation furnished inspiration: examples for imitation, standards to be striven for and exhortations to achievement.[18]

With the introduction of African "pictorials," readers entered a new set of audiovisual simulacra—no longer only looking toward African American models, but also toward local models who had absorbed jazz aesthetics into *marabi* and later *mbaqanga* music. Aspiring toward African American culture was one point on a continuum that also included a range of local performances of modern black savvy.

The Girl on the Cover of *Zonk!*

The outfit Dorothy Rathebe wore for her shoot for the inaugural cover of *Zonk!* magazine was designed for her performances at the Ngoma Nightclub in *Jim Comes to Jo'burg* by the film's set designer and artistic creator, Gloria Green. While all but two of the actors were black South Africans, the production team was all white, and the film's layered racial and cultural constructions made for a uniquely complex viewing experience, as we shall see. The project was conceived of by Eric Rutherford, who formed the production company, Warrior Films, with his fiancée Green; another Englishman, Donald Swanson, as scriptwriter and director; and Ronald Shears as cameraman.[19] *Jim Comes to Jo'burg* was an immediate box-office success in the townships, presenting viewers with the first opportunity to see themselves projected on screen.[20] However, while recollections of reporters and artists who came of age in the 1940s stress the thrill of seeing "people you recognized on streets that you knew,"[21] black

[17] Jim Bailey and Bob Crisp, *The African Drum*, 1:1 (March 1951), 5.

[18] Christopher Ballantine. *Marabi Nights: Early South African Jazz and Vaudeville* (Johannesburg: Ravan Press, 1994), 13.

[19] See "Diary" by South African film historian, Peter Davis, http://web.uct.ac.za/depts/sarb/X0013_Davis.html (accessed June 17, 2011).

[20] See Gwen Ansell, *Soweto Blues: Jazz, Popular Music, and Politics in South Africa* (New York: Continuum, 2005). Ansell notes "*Jim Comes to Jo'burg* became a scornful metaphor among black intellectuals for all back-to-the-homelands literature," 75.

[21] Peter Davis cites the journalist and musician Arthur Maimane's recollections: "A film shot with people you recognized, on streets that you knew, you know, sometimes it was difficult to hear the

intellectuals were irked by the patronizing image of title character, Jim (played by Dan Adnewmah) and the implicit endorsement of National Party ideology restricting black communities to rural "homelands" or "Bantustans." A naïve country bumpkin, Jim manages to get robbed, rescued by a night watchman, hired as a domestic worker, fired, and introduced to the watchman's alluring daughter, Dolly (played by songstress Dolly Rathebe) within the first twenty-four hours of his arrival in Johannesburg.

Dolly's dress on the August 1949 cover reflected Gloria Green's vision of the counterpoint between tradition and modernity: while the beadwork trim was marked as traditional and African, the form-fitting, one-shoulder design was coded as Western. In stitching the two together, Green sought to fashion a modern seam whose utopian resolutions staged Dolly's performance in a multiracial club that did not and could not exist under the apartheid laws of the time, as we will consider further below. Dolly's oblique gaze focused on a distant horizon well beyond the confines of the densely built Johannesburg townships where *Zonk!* magazine was first sold and the black-cast films first screened. As Jacqueline Maingard has pointed out, *Zonk!* magazine espoused a heavy-handed editorial message of uplift, announcing that it saw "the Bantu...reaching out for the fruits of pride of race, social consciousness, trained abilities, in short, the fruits of development."[22] Rathebe, the first "girl on the cover of Zonk!" was posed gazing toward such fruits, but the obliqueness of her gaze suggested that such a future was not to be confronted head-on. The promised fruits of development were offered with the supplemental glare of a requirement to accommodate the demands of racist capitalist exploitation as domestic and industrial labor. All that glittered was not gold, nor did all sheen shine true.

As already noted, *Zonk!* and its competitors were popular with readers of both genders,[23] but for female readers, the dialectic between the role of "cover girl"—film star, beauty queen, musician—and the domestic mastery encouraged through women's sections on hygiene, child care, and beauty, demanded an ability to sift through contradictory signs to assemble new meanings. Through advertising, photographs, and features, female readers developed not only an eye for design (and its price tag) but also an ear for good music (a category the magazines invested much energy and space in defining). That they

dialogue because people were shouting,...'Hey, that's my street, I live down that street!'...They became like—home movies." *In Darkest Hollywood: Exploring the Jungles of Cinema's South Africa*, 26–27.

[22] *Zonk!* March 1950, 2(3), (inside cover).

[23] Throughout this chapter I use heteronormative terms—including only referring to two genders, male and female—as a placeholder and with awareness of the limitations of this optic. While same-sex relationships and other embodied alternative sexualities make occasional appearances in the magazines, these are rare. An interesting example is the story "Léonard le Jour Léonie La Nuit" featuring a full-length double portrait of transvestite Léonard/Léonie (February 1966, page 11), although its tone is hostile, close to that of a sensationalist tabloid.

were imagined in the new media of film and magazines to be more savvy and discriminating than men is reflected in the plot line of *Jim Comes to Jo'burg.*

After his harrowing introduction to city life, Jim wins Dolly's affections (or pity). Dolly teaches him how to successfully navigate the straits of Egoli (as Johannesburg was affectionately referred to in the film), first getting him a job as a waiter at the Ngoma club where she sings, and then securing him an audition for a record deal and initiating him into the culture industry. In the final scene, Dolly literally leaves her father's side to join Jim as they record a duet about their "wedding day," linking domestic reproduction and commercial productivity. The film's plot underwrites a specific family structure open only to families whose wives, equipped with the government-required passbooks, were allowed to migrate to the urban areas. The state-sanctioned model was the nuclear family whose clean, well-fed male worker headed a household where his wife maintained the domestic space as a satellite support system, neatly contained in the Spartan box-structures of townships that replaced Sophiatown, District 6, and other neighborhoods that were devastated in the wake of the Group Areas Act.

The film ends by cutting from a close-up of the happy couple to an even tighter shot of a vinyl record being inscribed as they sing in the record-making process itself. Audio technology figured large in popular culture all over Africa. Indeed, an early issue of *Bingo* featured a full-length article on the production process of making records with photo spreads on the use of shellac in the 1950s. *Jim Comes to Jo'burg* climaxes in a recording studio when Jim's former boss from his gardening and housekeeping "career" turns out to be a record company A and R man. He fires Jim earlier in the film for listening to the radio too avidly. Jim had been so enthralled by a broadcast of Zulu singers on "Radio Bantu" that he fell into a daydream, transported acoustico-pathically to his home in the rural areas where he joins others in hunting antelope and in the comforts lavished by village women. The domestic order is awry, as we see when Jim spills a bucket of soapy water across the boss's living room floor, startled out of his radio-trance. Where the radio brings waves from a public, government-sponsored broadcaster into the private domestic space of a white bourgeois home, already in dubious condition given the film's lack of a Madam to balance the Boss, the record deal stabilizes and encodes "proper" domestic and conjugal relations in the Boss's world; for it is a white hand that applies the glossy shellac in which the needle's inscribing apparatuses are reflected as if in a mirror.

However, it is Jim and Dolly whose voices distort the surface perfection with grooves of recorded sound. This, I would argue, is a form of sheen, one of those reflective surfaces whose distortions provided generative openings for improvisations of new identities in the face of increasing racialized restrictions on freedom. Here, the tear does not hint at fraying the film's imagined marital bliss, but rather appears in what becomes of the real life Dolly Rathebe after

this. Rathebe's star role facilitated her burgeoning career as a media personality with considerable economic and personal autonomy as compared with her peers. She appeared multiple times in *Zonk!* and *Drum* (in feature stories and in advertisements endorsing photographers, medicine, and more), her musical career flourished, and she starred in *Magic Garden,* Swanson's second film in 1952. Thus while there was a strong impulse in the movie's plot to stabilize women's roles and locate the gendered balance of labor in a split between home and public space, acting and singing in *African Jim* allowed the leading lady to create her own set of possibilities outside of those strictures, demonstrating the very flimsiness of such constraints.

The possibilities Dolly displayed for women had a long genealogy. Charlotte Manye Maxeke's writings in the 1920s explicitly recognized women as the driving force in inculcating a healthy and robust modern black subjectivity through their roles as mothers. By the 1930s, interest in women's accomplishments outside the home was regularly featured in black newspapers. One of the most sustained discussions on this topic appeared under the byline of "Lady Porcupine" in the May 30, 1936, issue of *Bantu World*.

Lady Porcupine was the pen name of the well-known singer, Johanna "Giddy" Phahlane, leader of the Merry Makers vaudevillians of Bloemfontein,[24] and a regular contributor to the paper.

> A modern woman has been educated in the home and school therefore she is better fitted as companion of intelligent men, to bear and train her children rationally and is of greater service as a citizen. She is out on strike; her mood is defiant and [she] insists upon her right to sound education. You will realize that a modern woman refuses to spend her time in dressing only for the captivation of gentlemen, as some may think, but will struggle hard to earn her living in many ways as a nurse, teacher, singer, actress, dancer, cook, dress-maker, housekeeper, laundress etc. and is very much anxious to make men compprehend [sic] that she can do without them.[25]

Lady Porcupine rode the fine line between arguing for education in the interests of companionate and egalitarian marriage on the one hand, and dismissing the desirability of marriage and usefulness of the "captivation of gentlemen." And for her, the professional, rather than the political sphere was the crucial battleground.

Lady Porcupine saw women as already active in three broad categories of work: education, which had long been an accepted profession for women, especially given the prestige and "respectability" that accrued to the mission-schooled; hygiene, in its root sense of "maintaining health," as well as

[24] Ansell, *Soweto Blues,* 56
[25] Lady Porcupine (Johanna Phahlane), "A Modern Woman Struggles for Freedom," *Bantu World,* May 30, 1936, 12.

cleanliness, encompassing nursing, laundering, cooking, housekeeping, and even seamstress work; and entertainment (singing, acting, dancing). Perhaps only an active and popular performer like Phahlane could have made a case for the latter, at odds, in many ways, with the feminized purview of nurturing.

Musicianship was, in fact, a highly prized skill for prospective partners of educated and prominent men, and a number of remarkably talented African American women who married South African elites boasted of biographies that only added to this economy of prestige. These women shaped a somewhat distortedly positive image of African American life, as they often had the advantage of an education unavailable to both their South African and working class African American counterparts. They formed part of the middle class the black press in South Africa regularly featured in biographical stories. A 1936 *Bantu World* article entitled "Young Wife's Brilliant Career: Mrs. Mary Helen Dube: Her Crowded Life of Achievement"[26] outlined her childhood as the daughter of a Virginia preacher, her voice and piano studies at the New England Conservatory, and her activities teaching at the Bantu School of Music, part of Adams College, one of a limited number of institutions for black South Africans.

While these accounts were not strictly concerned with women's access to and control of audio technologies, they did see the auditory as a uniquely apt mode for mediating women's entry into an emerging modern public sphere, a field where the structures of the stage and recording studio could manage any threat to conventional heterosexual domesticity by scoring women's voices primarily for the part of solo torch singer. Such performance roles allowed individual exceptional women to command the gaze and ear of a collective desiring audience, but the desire channeled was implicitly one that a single suitor would realize.

If Dolly Rathebe's headshot gave the first cover of *Zonk!* glamour, the publication's name, *Zonk!*, brought its own zing. It is ironic that a publication that had such consequences for representations of women took its name from a group of male musicians and entertainers recruited by Ike Baruch Brooks to entertain nonwhite conscripted troops in South Africa during World War II. Robert Nixon has noted that the importance of African American urban cultures to black South Africa can be accounted for in parallels between the Great Migration in the U.S. following World War I and the similar influx to cities accelerated by World War II in South Africa. Likewise, David Coplan notes that World War II was a watershed moment in the transformation of black South African performance cultures, providing new forums that would continue to shape postwar cityscapes profoundly and increasing an "international" consciousness among urban African performers.

[26] *Bantu World*, June 20, 1936, 11.

A number of military bands were recruited to entertain troops, and among the most popular were the "African Flashes," whose revue was renamed "Zonk!" by Ike Brooks to memorialize the fallen General Daniel Pienaar. According to Brooks, Pienaar had coined the phrase, meaning very much the same as "oomph." "Zonk!," then, was a phatic statement, a rallying call intended to muster the justly flagging "vim and vigor" of troops constrained to fight on behalf of a nation that offered them little in the way of civil or human rights.

The original cast of the "Zonk!" revue consisted of twenty-one army service-men, selected by Lieutenant Brooks from five thousand auditioning troops, and they performed "expressly for the entertainment of non-European troops" and from May 1943 onward for both black and white civilian audiences. The conditions of labor for these service men can only be described as coercive. A *Cape Times* article describes the rehearsal process thus:

> He had no saxophone player but a Msuto pianist struck Mr. Brooks as having strong lungs. He shut the pianist in a room ten hours a day for three weeks with a saxophone. He reckons now that the Zonks' saxophonist could compete with Duke Ellington's best.[27]

However, the opportunity to make a consistent living performing music, dance, comedy, and theatrical sketches led the "Zonk!" cast to "re-form the party for civilian entertainment" after they were demobilized. Their performance tour between 1943 and 1944 was received positively by both white and black audiences, and by August 1945, a new production, "Nu-Zonk" had opened to rave reviews.

Among the acts which consistently received media coverage were

> the fine singing of Simon in "Wagon Wheels," Sylvester in "September in the Rain," and several other tunes, and Daniel, a little singer with a deep voice of Paul Robeson range, who was encored for his rendering of "That's Why Darkies were Born."[28]

The patronizing tone of this article and others like it is manifested in quasi-ethnographic assertions that "The African is naturally melodious" and in referring to performers only by their first names. The recruiting process, failure to acknowledge the history of local performance Brooks capitalized on, infantilizing attitude toward talent, and lack of meaningful employment options once de-mobilized all remained unstated in the laudatory newspaper accounts of what was one of the first opportunities for large white audiences to see an all-black performance troupe on stage legally. Notably, these first forums for collective cross-racial consumption excluded female performers entirely, since the cast was made up of ex-servicemen.

[27] *Cape Times*, "Zonkers." 15 September, 1944.
[28] *The Star*, 27 March, 1945. Thelma Gutsche Papers, University of Cape Town.

It is unclear how long "Nu-Zonk!" ran, but Brooks soon found a new way to capitalize on and market black creative talent. It was his work as a musical impresario that inspired him to establish *Zonk!* magazine "The African's People's Pictorial," the first monthly magazine of its kind directed at a black readership and featuring largely black writers. As we've seen, the visual, specifically filmic, imagination of African modernity was central to the magazine's appeal, and *Zonk!*'s subject matter contributed to the way reading, writing, film viewing, and music listening—become inextricably interwoven modes of consumption and activating modern/urban subject positions. Through *Zonk!* modern black South African heuristic subjectivity was structured as constitutively multimedia and interdisciplinary.

Adding Sheen to Cellophane: Temporality and the Black Bioscope

While the first cover (August 1949) featured a headshot of Dolly Rathebe, and stories about the making of the film appeared in the next months, it would not be until the fifth issue (December), that an article about the actual bioscope premiere was published. Thus, black South African film was constructed as a peculiar time-object, subject to literal and anticipatory projections, so remarkably new that it was "old news" by the time readers could actually experience what the magazine reported. Furthermore, from its inception, the magazine's representations of women were deeply involved in and indebted to both Hollywood and local cinematic gazes.

Zonk! pioneered the role of the magazine form in shaping an urban self-consciously modern South African *habitus* in which choices about spending leisure time reflected aspirations to middle-class consumer consciousness. Several letters to the editor in the first years of the magazine's publication noted that *Zonk!* had particular appeal because, as one reader wrote in a letter, "it is non-political,"[29] and several decades later it is clear that this apolitical content contributed to its obscurity in later scholarship compared to the more well-known competitor, *Drum.* However, the magazine relied heavily on language emphasizing South Africa's participation in world-historical narratives of progress, and tropes of modern temporality emphasized the "new," the "fashionable," the recent, the latest, and the "potential." The magazine (and soon its competitors) cast an urban habitus as reorienting the reader's subjectivity from the present inhabited moment toward a projected, but imminent future (perfect). This imagined temporal projection operated in close alignment with a geographical projection that was already key to South African

[29] " 'No Politics' Applauded" Letter from Wellington D. Qupe, Cape Town. *Zonk!* October 1951, 6.

investment in African American culture with a monthly featured "Letter from America" and reviews of recently released American jazz recordings (currently or imminently available in Johannesburg and other record stores). Such projective displacements emphasizes the excitement urban South Africans could feel at being able to "participate" in the currents of global modernity through the modalities of fan-culture and identifying with local film stars like "our very own" Dolly Rathebe, and thus affirmed a local alternative modernity. However, the privileged place of black-cast local films in *Zonk!*'s pages served to alienate or distance readers from the essentially inaccessible, fictional cinematic space. Such split subjectivities index the modernist effect of *Zonk!* upon its readers.

Magazine literacy called upon different visual and textual interpretive strategies than more conventionally literary genres such as novels or poetry. Sonja Laden's work is particularly suggestive in this respect. In light of the 1948 National Party election and increasing apartheid legislation, she suggests magazines functioned "as a dislocated version of the [chief's courtyard] *kgoro/ kgotla* facilitating alternative forms of civil sociability, cooperation, and social collectivity."[30] Women were excluded from the rhetorical practices of the actual *kgoro/kgotla*; however, one of the signal innovations that *Zonk!* and other print mediations of public culture was to promote women writers' access to a new forum, where they addressed mixed-gender audiences, regardless of how proscribed the topics of their articles might have been. Admittedly, female writers like Laura Gabashane and Maud Malaka often covered stories of stereotypical topical interest to women for *Zonk!*, however, these pages were no longer segregated in a separate pull-out "Women's Section" as with earlier newspapers. Furthermore, the prominence of advertising ensured that articles by women were likely to be juxtaposed with advertisements that were gender-neutral or male-focused. A short story by Maud Malaka entitled "Nonzizi's Love Affair," for example, was printed alongside ads for Zubes Cough mixture, a horoscope column, and a half-page ad for Nugget Boot Polish, featuring a dapper young man sporting a Stetson hat, a tie, and a pin-striped suit. Magazines presented readers with a set of images, texts, and surfaces that they were free to organize and consume with greater flexibility than other forms of print media available, loosening gendered paradigms of reading.

Less than six months after *Jim Comes to Jo'burg*, the film *Zonk!* premiered on March 29, 1950, reprising Brooks's successful war-time musical revue with the addition of four female singers (and a number of dancers) to the originally all-male theatrical cast. The film presents a stage show from an almost uniformly stationary camera angle (the exceptions breaking conventions of reality and coherence to present a sparkling river during Daniel Lekoape's performance of "Ole Man River" and a series of landscape shots at the close of the

[30] Sonja Laden, " 'Making the Paper Speak Well,' or, the Pace of Change in Consumer Magazines for Black South Africans," *Poetics Today* 22.2 (Summer 2000): 521.

film). Two compeers, managing the potentially unruly space of the stage with the patriarchal authority of masters of ceremonies, introduce each of the acts either entirely in English or in local languages, followed by an English gloss. *Zonk!* was ostensibly produced for an intended audience of black township residents, yet the introductory remarks are markedly ethnographical. Hence, the narration is fragmented along linguistic lines (paralleling the apartheid policies of the period to emphasize ethnic difference and segregate retribalized identities with the Bantustans). It also fractures the black spectator's subject position by presenting her with an anthropological rereading of her ostensible self. The stage show, which eschews any narrative or diegetic progression, recapitulates tropes of American minstrelsy, most starkly with the "darkie impersonating a European impersonating a darkie" in Sylvester Phahlane's Al Jolson act. Such minstrel numbers appeared alongside music and dance performances (in both local and "authentic"—that is, not black-face—African American traditions) in a montage that was unified only by the abstract category of race (hence naturalizing this category, and its very arbitrariness). In African Film Productions' next project, *Song of Africa* (1950), the operative workings of film on shaping spectator subjectivity are even more marked. The theater audience of the staged performances is screened repeatedly. Uniformly dressed in formal evening wear, they applaud every act with indiscriminate enthusiasm, as if their reaction is being codified, dressed, and consolidated. Implicitly, both films convey the message that while the category and mobilization of "race" is incoherent, the savvy, modern consumer response is one of a-critical consent: applause. The role of the compeers here mediates the invisible power funding and scripting the performance, and the still more invisible subvention of African Film Production by the apartheid State.

Three acts in the *Zonk!* film featured female singers: a performance of Brahms's "Cradle Song" by Henriette Segoete, a trio featuring solos by Laura Gabashane and Hessie Kerry in "The Girl on the Cover of Zonk!" and the finale, which stars Hessie Kerry. "Cradle Song" is staged in a space far larger than the homes which average black South Africans inhabited. The scene featured a double bed, a wicker cradle, a table, chairs, a chest and a framed wall hanging—in short, numerous signs of a comfortable urban lifestyle inaccessible to the film's intended audience. The scene is further distanced from the audience by the compeer's introduction:

> There are composers of beautiful music who are well-known to some of us and unknown to the less fortunate. The great artist Brahms was just such a one. It affords us tremendous pleasure, ladies and gentlemen, to present one of his exquisite compositions, "Cradle Song" and it is sung by that very gracious young artist, Henriette Segoete.

It is implied that the majority of the film's audience, to whom Brahms would be unknown, are "the less fortunate," a condition of aesthetic and economic

lack. While Brooks, and the film's white production team intended this scene to display an idealized domesticity, the gap between the scene and the conditions of possibility of such a home life would have been obvious to the audience, opening up a moment of potential critique of the proscribed role envisioned for women in this act, in spite of Henriette Segoete's beautiful rendition of the song. This opportunity for critical spectatorship paralleled what bell hooks describes as the cinema's attraction for black female viewers who, "[i]dentifying with neither the phallocentric gaze nor the construction of white womanhood as lack,... construct a theory of looking relations where cinematic visual delight is the pleasure of interrogation."[31] One of the most obvious differences between the domestic idyll behind the Brahms performance and the daily lives of women in the audience was the arbitrary disruption of spatial practices introduced with the Group Areas Act of 1950 and the long-running campaign to force black men and women to carry passes when moving (with laws passed in 1913, 1923, and 1952 that were increasingly restrictive). Viewers knew that neither the homes they inhabited nor the streets beyond would cradle them in the kind of safety imagined in the lullaby scene. The trope of a backstage musical also made the very constructedness of the scenery and fictional aspect of the scenarios a constitutive dimension of the viewing experience. As Peter Davis points out in discussing *Jim Comes to Jo'burg,* when "Swanson and Rutherford came up with a plot, they placed it in an African nightclub of a kind that never existed."[32] Groups like the African Inkspots and Jazz Maniacs who were featured in the film generally performed in the municipal beer halls where African alcohol consumption was policed by the state, but equally vulnerable to disruption from local *amapantsula* or gangsters.[33] Likewise, the freedom of movement the quick scene changes and editing implied were clearly unavailable to black bodies. During the shooting of *Jim Comes to Jo'burg* the previous year Dolly Rathebe had been arrested for being in a whites-only area after 9:00 P.M. Such gaps between the audience and actor's lived experiences and the scenes in the films invited the audience to ask *why* such freedoms were out of reach as they looked at various spaces from which they were barred.

"The Girl on the Cover of Zonk!" is a delightfully brash example of "product placement," featuring regular columnist Laura Gabashane flanked by Chassa Mako and Henriette Segoete, then April 1950 *Zonk!* cover girl, Hessie Kerry, and finally Gabashane singing the praises of the latest modern pastime:

> "It's a great sensation
> What an education
> Reading Zonk!"

[31] bell hooks, *Reel to Real: Race, Sex, and Class at the Movies* (New York: Routledge, 1996), 208.

[32] Davis, *In Darkest Hollywood,* 23.

[33] Lara Allen, "Music, Film and Gangsters in the Sophiatown Imaginary: Featuring Dolly Rathebe," in *Scrutiny 2: Issues in English Studies in Southern Africa* 9:1 (2004), 19–38.

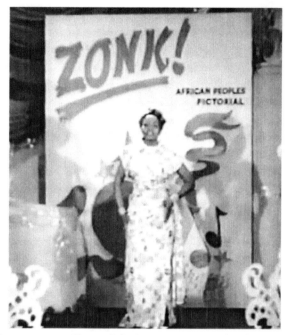

FIGURE 4.2 *Screen capture of Laura Gabashane singing in* Zonk!, *the musical.*

The scene opens with a tight shot of a cut-out mock-up in giant scale of the front cover of the magazine. A cartoon of a heart shot through with ribbon dominates the screen, and Laura Gabashane stands in front of the mock-up. The two-dimensional flatness of the cinematic screen plays into the conceit, as does the staging, which has Laura singing with relatively little movement, but rather "posing on the cover." As the song progresses, she descends a flight of stairs, and Mako and Segoete enter from stage left and right to flank her as they sing in front of the band, now visible on the raised level from which Gabashane has descended. One might read this scene as the working woman, writer Gabashane, coming down from the pedestal to the level of the other women, demonstrating the accessibility of a modern self-determination and control over one's own labor newly available to South African women. However, the next scene, which features Hessie Kerry soloing and jiving with energetic dance moves that won her much positive media coverage, seems to present a different version of emancipated womanhood. Kerry solos in the midst of about fifteen admiring male extras, and her scene also begins with her standing on blocks elevated above the other figures on stage. She seems to embody the reader, rather than the author of *Zonk!* and part of her persona is clearly invested in consuming the latest products, as she is costumed in high style (a circle skirt, a neckerchief, tennis shoes) and has mastered the jive dance moves sweeping the townships at that time. Her segment of music is

much more up-tempo than Gabashane's, and this difference in tempo is exaggerated by a *ritenuto* in the music when the final scene of this act returns to Gabashane reprising the "great sensation" of "reading Zonk!" Again, I would suggest that the contrasting images of idealized femininity embodied by Gabashane and Kerry open to the spectators a gap in which critical agency might come up with a very different interpretation of the scene from the one its production team envisioned.

Evidence of this alternative if not quite "resistant spectatorship" can be found on the pages of the actual *Zonk!* magazine. Along with Laura Gabashane, the other regular female writer was Maud Malaka, who largely wrote short fiction for the magazine, but occasionally also filed news reports. In the May 1950 *Zonk!* issue, Malaka weighed in on the film that had dominated the magazine's pages since the first story about it had appeared in February that year. Malaka's review emphasized the singularity of the premiere, noting the transportation and spatial disruptions evident in Alexandra (one of three townships where the film simultaneously premiered). The anticipatory displacement discussed above was clear in Malaka's declaration:

> I cannot tell you what played before the opening of ZONK!. I am sure that most people who were present do not remember any other short or comic and even the serial part that was played that evening. All were impatiently awaiting ZONK!.[34]

However, there were two points about which Malaka was insistent, even defiant. First, the film, while experienced as an anticipatory disorientation, was significant as a means to enter and participate in *historical time*:

> I and many other Africans are rightfully proud of this picture no matter what the critics and Know-Alls may say about it, but we are glad to have witnessed history in the making. Greater and better pictures may still be made but ZONK! like "Jim Comes to Joh-burg," means one and the same to us Africans. This is history. One day when better pictures are praised we shall still sing the praises of ZONK!.

This access to history overrode and in fact contested other critical authority, in effect, opening up the viewers' own critical agency. Second, while several acts were mentioned, it was Gabashane's performance of "The Girl on the Cover of ZONK!," which, "although not the grand finale," remained "in the hearts of many like me." Notably, attention is drawn to Gabashane, and not Hessie Kerry who actually appeared in both the cover girl act and the finale. Malaka does also mention the "Cradle Song" performance, but her appreciation only serves to underscore how distanced this act was

[34] Maud Malaka, "We Have Witnessed History In the Making," *Zonk!*, May, 1950, 47.

from its audience: "I have never heard a lark sing, I have only heard people praising it, but I am sure I have heard something sweeter from that scene." What seems implicit in the article as a whole is that, while Malaka was very enthusiastic about all of the performances featured, her repeated mention of Laura Gabashane's prowess, suggests that, as a professional writer, Gabashane commanded more of Malaka's attention and respect than Hessie Kerry, whom she did not mention at all. What is more, the local and familiar made a deeper affective impression than the nonetheless compelling foreign elements. Despite Malaka's disavowal of authority—"I am no critic and so I shall not say anything critical"—she clearly responded to the performances of gender on display, arguably offering a feminist interpretation of the film.

The finale from which Malaka regretted Gabashane's exclusion seems to curtail female mobility in two distinct ways. The first part of the of the act features Hessie Kerry, surrounded by most of the rest of the cast, singing:

> It's such a shame, blokes
> To have to leave you
> Such a shame, for we wish we could remain
> It's been the grandest fun
> We found a place in the sun
> And incidentally made you happy
> There's only one little blow
> We have to close up the show
> Because *a dame like me...*
> has to get home at a respectable hour.

Given apartheid curfew laws and their known impact on other film projects, the campy enthusiasm of this farewell has a more sinister edge. Women, particularly women aspiring to the class status of respectability, *should* not, and black bodies in apartheid South Africa *could* not, circulate freely beyond a certain hour. The finale casts this containment of the black female performer in a humorous light, as the lyric goes on to suggest that the real constraint is jealousy on the part of the manager's "dear little wife," and that "soon for alimony, she'll be suing" and then dismisses the situation, singing "we all have squabbles." However, the final scene works strongly against any neat resolution.

At the end of Kerry's song, the entire cast freezes. They turn to face the camera frontally, and all members not already standing, including the band, rise to their feet. They then begin an *a cappella* rendition of Nkosi Sikelel'iAfrika, accompanied by cuts to footage showing landscape and rural life scenes. Peter Davis notes that this one concession to cinematic rather than theatrical possibilities is fraught with incoherence: the footage presents

views of what was then called Basotholand—not even part of South Africa. What most likely happened here is simply that for this footage, the director had recourse to another film, or the out-takes from another film, probably a travelogue.

Whether Hyman Kirstein appreciated the significance of *Nkosi Sikelel'iAfrika* as the black national anthem, or whether (more likely) he simply regarded it as a nice African hymn, cannot be determined. But it is certainly curious in the context of the times.[35]

Earlier in the century, South African governmental policy had limited female migration to the cities by allowing only mine and other urban laborers to move legally and by building all-male dormitories to house them in the Rand and other similar areas. Coupled with tropes of Mother Africa, these policies contributed to a gendering of the landscape and a feminizing of the rural. A careful analysis of the genre and gender distinctions in the final shots reveals how the film's multiple interpretations might give rise to unsettling ambivalence. On the one hand the closing footage employs genre conventions of travelogue (in the shots including horse-riding Sotho men) and ethnographic film (in the river scenes with women and children bathing) and viewed with the soundtrack of resistance, *Nkosi Sikelel'iAfrika,* playing in the background, these shots might encourage urban black South African viewers to interpret this as a broader political critique of governmental policies toward land and (re)settlement. Nonetheless, the fact that the song is sung by a choir standing absolutely still on a stage would seem to convey that, with this stasis, the film endorses the status quo. This ambiguity was apparent elsewhere in the film, too, most especially in its embrace of urban patterns of consumption hardly accessible to most viewers, yet such messaging (as with the fast-paced footage of women jiving in the cover scenes) at least presented viewers with a set of multiple possible embodiments to choose from, mitigating against the stabilizing gesture of the final choral scene. Perhaps the most quintessentially modern experience engendered by the film was a sense of unresolved impulses in multiple directions.

The next African Film Production project, *Song of Africa*, couched its musical numbers in a plot about a band, led by David the son of a chief from a remote village in "Zululand." The band wins a competition to perform in an urban variety show, yet throughout the film they perform in traditional dress. In contrast with *Jim Comes to Jo'burg*, the record player here is seen as a form of audio technology so modern as to be impossible to integrate into the village life. David's fiancée refers to it as a "music box," and his father does not realize that it is caught in the same groove when it starts to repeat. The music in *Song of Africa* is difficult not to enjoy, but the film offers no hints of the

potential of audio recording of live performance; rather, the record player introduces "master" texts to be imitated. Recalling the urban music culture of mid-twentieth-century Johannesburg, trombonist and composer Jonas Gwangwa would remember:

> Our people were listening to American records and seeing from the movies that people were doing out there—the Cab Calloways, the Duke Ellingtons. All those movies came in.... The Merry Blackbirds, the Jazz Maniacs were some of those disciplined bands, reading music, costumed and all that like any other big band in the US at the time.[36]

While the polished swing performances by most of the bands in the film appeared to be sure-footed renderings of an American performance style learned from well-worn and even broken records, by 1951 they were dated, contrasting sharply with the hipper, edgier music of David's prize-winning boogie-woogie. Yet David's band abandons musical innovation as willingly as they embrace a "back-to-the-homelands" itinerary confining them to what appears to be Kwazulu, one of the new apartheid "Bantustans." They return home to present a live swing performance in the village, with the seated women applauding on the beat rather than with syncopated savvy. The movie's plot resolution reestablishes rural and domestic conventions rather than fully exploiting the potential to read the postmodern spectacle of these jazz virtuosos performing in animal skins against the official grain.

The chains of signification in South Africa's media were gummed up with the heavy grease of apartheid propaganda and liberal patronization, and while readers and viewers sometimes interrupted these chains, the surfaces of media texts were often too slick for resistance to gain traction. Sheen reading in West Africa was a different matter, where the most pressing political question was decolonization.

Bingo: Glossy Black in the Age of Optic White

While South Africa's popular print and film cultures were presenting a startlingly clear instance of interreferential media that relied on giving prominent place to jazz and other diaspora music, a related dynamic was unfolding in Francophone Africa, and nowhere more vividly than in *Bingo*, the first African-owned popular illustrated magazine distributed throughout the colonies, which was launched in 1953 by Ousmane Socé Diop (1911–1973). Socé Diop, who had already authored two novels, *Karim* (1935) and *Mirages de Paris* (1937), in addition to poetry and folktales, was also a former mayor of

[36] Ansell, *Soweto Blues*, 47.

Rufisque. With *Bingo,* Socé Diop sought to reach readers from across West Africa, the Congo, the Antilles, and France, and the magazine had offices in both Dakar and Paris. In addition, African American, Brazilian, and Hispanophone Caribbean media personalities were often featured, making it an important vehicle of not only transnational but also translational black cosmopolitanism in print at a time when regionalist self-determination (as at the Brazzaville Conference of 1944) had resulted in only tepid French gestures toward granting independence. This regional political consciousness was implicitly gendered masculine, but *Bingo's* general interest format addressed both women and men as key actors in generating African modernities, making the magazine a treasure trove of historical insights on women's participation in transnational cultural currents of the day. As the work of women shifted from primary roles in farming to a new range of urban waged work, debates unfolded in *Bingo's* pages about how to accommodate new dynamics in the domestic sphere. Urbanization drew women into a market system where consumption of processed goods eclipsed production of raw goods and transformed the meanings of biological reproduction. New forms of literacy—or sheen reading—were required to decipher the advertising and print cultures driving city economies. Such injunctions to feed infants, nurse headaches, and perfume bodies with new commodities promised to render the consumer modern in the mere act of purchasing..

Bingo, like its contemporaries in Anglophone Africa, grew out of a thriving local newspaper culture, where male nationalists in Ghana, Nigeria and South Africa,[37] for example, had started their careers as editors and journalists. *Bingo's* large geographical reach, encompassing all of black Francophonie, set it apart from similar magazines with the sole exception of *Drum,* which eventually expanded to publish West and East African editions. *Bingo's* pages projected the possibility for modern women's rights broadly and in pan-African rather than strictly local or even regional terms. Strikingly, home audio technologies played into these debates about women's roles: *Bingo* heralded the ways that such technologies were enabling women to listen in on political and economic changes that they would increasingly gain access to participate in.

Bingo's arrival coincided with the development of expanding markets for consumer goods and growing the leisure sector. Advertisements for musical instruments were fixtures in every issue—Couesson, for example, reminded readers monthly that "les plus grands artistes noirs jouent sur Couesson" [the

[37] Kwame Nkrumah's insistence in *Towards Colonial Freedom* (1947) that an anticolonial movement "must have its own press" (36) confirms what South African Native National Congress founding president, John Dube, must also have known when he founded *Ilanga Lase Natal* (alongside a number of other vernacular papers operated by other leading South African nationalist). Likewise, Nnamdi Zik Azikiwe returned after completing a masters degree at University of Pennsylvania to become editor of the *African Morning Post* in 1934 and went on to become Nigeria's first president.

greatest black artists play Couessons] in an effort to compete against another of *Bingo*'s instrument advertisers, Paul Beuscher. Radio companies including Teleson, Telefunken, and Technifrance advertised widely. Like *Zonk!* and *Drum, Bingo* also gave ample coverage to films, particularly black involvement in the cinema. There were stories on the first Francophone films shot entirely in Africa, as well as on Dorothy Dandridge, Harry Belafonte, Marpessa Dawn, Nathalie Ewande, and others. As with technologies for music consumption, these stories appeared alongside advertisements for cameras,[38] and most strikingly, cinematic equipment, inviting readers to imagine themselves making and manipulating images despite the tremendous limitations on economic access to such items.

The prominent place of film and popular music made clean sound, the clean image, and the clean home central themes in urban casual reading. In a context where publishing houses were few, literacy limited and book prices high, casual reading was no light matter. The explicit borrowing from and exchange visits to African American publishers like *Ebony*, and the regular reviews and feature articles on African American, Cuban, French Caribbean, and other popular black music reveal that the transnational black cultural flows driving *Bingo* and its sister magazines were anything but incidental. If, as I have argued in my discussion of Rathebe above, the very idea of a black starlet or *vedette* reveling in the gaze of her fans was understood as one of the gifts of the diaspora, participating in star and fan culture was a form of cosmopolitanism accessible to any reader within the confines of one's own home.

A recuperative reading of consumer culture and women's purchasing power (both individually and by proxy through male family members and suitors) has its limits. While I am primarily interested in reading the magazine as popular text, it is important to recall that *Bingo* was also an important distribution outlet for literary and scholarly work. When *Bingo* first appeared, it regularly featured brief pieces by authors from across the Francophone world, including Aimé Césaire, Birago Diop, and Cheikh Anta Diop. In time it came to be seen as primarily a commercial publication, with larger amounts of page space devoted to advertising, particularly in its second incarnation after a hiatus in publishing. Rather than viewing this as a narrative of "decline" from earlier literary heights, the following reading demonstrates the value of attending to the structures of feeling that the mixed layout set in place. *Bingo*'s role in instituting a form of intermedial reading, as well as indications of important afterlives of these reading habits in both popular and "high" culture, thus emerge and parallel the sheen reading discussed above in relation to *Zonk!*

[38] One of many possible examples is the Pathé camera advertisement on page 4 of issue 33 (August 1955). The same advertisement copy ran in multiple other issues of the magazine.

Selling Telefunken Radios: Thoroughly Modern Raky

Bingo aimed at urban readers who saw themselves as cosmopolitan even when limited material resources made this an imaginative rather than material project. And the cosmopolitanism in question appeared to be (consumer-)cultural rather than political in reference. A look at the May 1959 issue makes this clear. In the wake of the momentous events bringing independence to Guinée the year before, and on the eve of *les soleils d'independance* in the rest of the African French colonies, print space was dedicated not to the political sphere but to the unique blend of literary reviews, correspondence, sports, music, career profiles highlighting gender role shifts, and advertisements for consumer products implicated in such shifting roles. One of the most striking advertisements in Issue 76 is the first of a series of spots featuring the attractive, svelte young female persona, "Raky," and her prized possession, a Telefunken radio.

The copy for the advertisement in the May 1959 issue reads:

> Raky est moderne.
> Elle veut tout savoir.
> Elle écoute toujours la radio.
> Son poste marche très bien.
> Il est joli et sonore.
>
> [Raky is modern.
> She wants to know everything.
> She is always listening to the radio.
> Her set works very well.
> It is stylish and sonorous.]

The advertisement features a full-length photograph of Raky in Western dress, but with a white head wrap that casts her look as distinctly African although culturally ambiguous, so as to appeal to readers in diverse geographical and religious contexts across Africa. Her posture is strikingly angular, with perpendiculars playing up the modernity of Raky's tastes. She has one forearm outstretched, and a hand on the radio dial, extending the horizontal line of the radio set, and her muscled biceps are propped parallel with the table's legs. She smiles confidently, gazing frontally into the camera and her head scarf draws visual attention to her single visible ear. Presented here is a modernity in which black women participate fully, whose epistemic mode is *aural*, enacted through a *listening habit* rather than the ocular regimes of reading and viewing, and which is enabled through sonic technologies. On the right of the frame is a small red box with the technical specifications of the radio in smaller print, not least of which that it is "entièrement tropicalisé." While this provides an assurance that the radio is well-equipped to withstand humid climates without

Raky est moderne ...

Raky est moderne.
Elle veut tout savoir.
Elle écoute toujours la radio.
Son poste marche très bien
Il est joli et sonore.

CARACTÉRISTIQUES TECHNIQUES :
• circuits imprimés
• 5 gammes d'ondes
• entièrement tropicalisé
• boîtier plastique couleur

C'est un :

TELEFUNKEN

Elle l'a acheté chez **TECNOA**
SERVICE TECHNIQUE CE LA S.C.O.A.

DAKAR · ABIDJAN · CONAKRY · BAMAKO · COTONOU · DOUALA · NIAMEY · LOMÉ

FIGURE 4.3 Bingo *Telefunken advertisement 1959 "Raky est modern." Used by permission of M. de Breteiul, former publisher of* Bingo.

rust or other technical damage, it also marks the radio's sonic technology as located in space and place. The past participle, *tropicalisé* (tropicalized) suggested a belatedness, the sense that Telefunken's technology had to be innovated, updated in order to project across the Tropic of Cancer where it would be put to distinct regional uses in the salons of Africa's emergent middle class.

The German-based manufacturer's name combined the prefix *tele-* for distant with *funken,* German for sending a radio signal.[39] The name underscored the

[39] Competition for technology business in West Africa was rife in the 1950s and 1960s. In Ghana, Shirley Graham Du Bois, who was in charge of developing television under Nkrumah, visited Japanese manufacturers and later offered Sanyo the contract for supplying equipment, much to the chagrin of Western suppliers, who viewed not only programming but infrastructural decisions as part of a Cold War strategic challenge. For more, see Gerald Horne's biography *Race Woman: The Lives of Shirley Graham Du Bois* (New York: New York UP, 2002).

exchange value of the capacity to transmit signs of the singular black modernity Raky's noncultural specific image projected across borders, oceans, and vast distances. What was on offer was a specifically African mode of aural consumption: stereomodernism for sale. The larger typeface text below Raky's portrait reads: "C'est un: Telefunken/Elle l'a acheté chez TECNOA Service Technique de la S.C.O.A./Dakar-Abidjan-Conakry-Bamako-Cotonou-Douala-Niamey-L omé" [It's a: Telefunken/She bought it at TECHNOA, the Technical Service of the Société Coloniale de l'Ouest Africain/Dakar-Abidjan-Conakry-Bamako -Cotonou-Douala-Niamey-Lomé]. Raky's modernity was mapped as transnational, and routed through a network of West-African markets for high quality radio sound, emphasizing regional identities at the precise moment that national identities were up for grabs. This regionalism bore little in common with concurrent and future political affiliations, such as Pan-Africanism, for the logic that bound these localities was imperial, matching the borders of the French empire almost exactly. Its afterlife, *la Francophonie* and the strange economic intimacies under cover of *la coopération* would linger long into the neocolonial era, clearly proscribing the progressive possibilities of transnationalist political bonds.

Raky's modernity was advertised as equally accessible in Senegal, Ivory Coast, Guinea, Mali, Benin, Cameroon, Niger, and Togo, and the pause inscribed with a colon in the announcement "It's a: Telefunken" introduced a call-and-response structure implying that the brand aspired to a chorus of name recognition throughout the region. Telefunken and its competitors encouraged *Bingo*'s readers to believe that being modern was less about being a sovereign national subject, and more about being a discerning consumer, with a discriminating sensorium and a rationalized relation to the market. In short, one became modern not at the ballot but at the cash register. The predominance of advertising business that depended on distribution networks and products manufactured in the metropole would continue to undercut the celebration of black achievements, both individual and collective, that *Bingo*'s editorial staff clearly valued. *Bingo* reported the news of African nations gaining independence with full covers devoted to maps and detailed articles describing the new governments, but its advertising pages emplotted collectivities that essentially retained and reproduced colonial relations.

In fact, one could argue that the transnational vernacular modernity Telefunken enabled Raky to participate in was determined by the consumption of sound technologies. For Africans intent on accessing global black cultural capital, the most modern organ was the ear. Audio technology processed, reproduced, and distributed the shared aural texts (musical and spoken) that made palpable the political and social simultaneities characteristic of engagement in a *popular* pan-African ethos. Magazines (and to an even greater extent, "formal" literary texts) could reflect on this ethos, but always at a degree of temporal remove, either announcing upcoming events or retrospectively

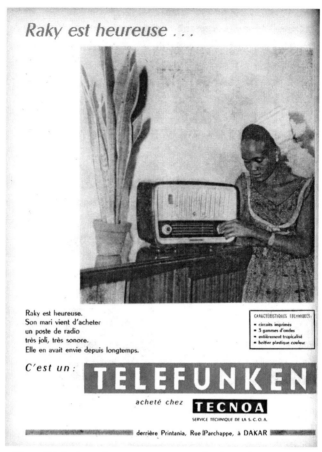

FIGURE 4.4 Bingo *Telefunken advertisement 1959–60 "Raky est heureuse." Used by permission of M. de Breteiul, former publisher of Bingo.*

reviewing recordings or performances. Radio waves on the other hand were, by definition, current.

Radios had been advertised in the magazine since its earliest issues, and the radio as a means of accessing and participating in global affairs was regularly stressed. A June 1956 advertisement for Teleson-Radio, for example, invited readers to "Écoutez le Monde Entier avec le Seul Radio-Portatif tropicalisé à Alimentation Universele...Même en plein brousse" [Listen to the whole world with the only tropicalized portable radio at Alimentation Universele...even in the remote bush]. However, Telefunken's was the first advertisement to make literal the performative function of listening in enacting modernity. Strikingly, our idealized female consumer, Raky, was not only the featured interpreter, innovating the hermeneutics of African stereomodernism, she also appeared to wield her own purchasing power and had a capacious intellectual appetite. The June, 1959 version of the advertisement backed away completely from

this representation of female independence and purchasing power, investing Raky's husband with the sole power to realize desire:

> Raky est heureuse.
> Son mari vient d'acheter
> un poste de radio
> très joli, très sonore.
> Elle en avait envie depuis longtemps.

> [Raky is pleased.
> Her husband has just bought
> a very stylish,
> very sonorous radio set.
> She had been wanting one for a long time.][40]

Not only was Raky no longer plunking down her own francs, she was now verging on the nagging shrew, pestering her husband for the latest in audio technology. The motivation for this desire—an intellectual interest in knowing about the world at large—had also been edited out of view.

The next month's advertisement experimented with yet another twist of Raky's hand on the Telefunken dial. This time, the copy read:

> Raky est sérieuse.
> Elle a réfléchi avant
> d'acheter son poste de radio.
> Elle voulait qu'il soit joli, sonore,
> et qu'il dure très longtemps.
> Ella a choisi un TELEFUNKEN...[41]

> [Raky is sensible.
> She thought hard before
> buying her radio set.
> She wanted one that was stylish and sonorous,
> and that would last a very long time.
> She has chosen a TELEFUNKEN...]

Given that these versions appeared in three consecutive months it is reasonable to speculate that Telefunken's advertising team were busy trying to tune in to the *Bingo* reader's sensibilities as effectively as possible. Tellingly, the version that was adopted for the next year's worth of monthly advertisements was the one that confined Raky and her happiness most narrowly within the walls of the home and the role of wife ("Raky est heureuse"). Telefunken's diglossic

[40] *Bingo* 77, June 1959, 38.
[41] *Bingo* 78, July, 1959, 34.

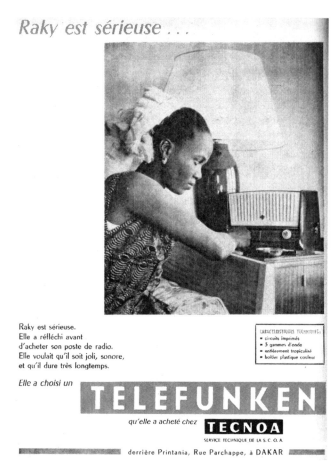

FIGURE 4.5 Bingo *Telefunken advertisement 1959 "Raky est serieuse." Used by permission of M. de Breteiul, former publisher of* Bingo.

message suggested that, within the erotic economy of domestic life, part (but only part) of the answer to the question "What do women want?" was a tropicalized radio set.

Regardless of the ideological apparatus buttressing representations of gender and technology in its pages, women's participation in the aural work of interpreting stereomodernity continued to feature in both *Bingo's* advertising and feature articles. On both the level of signal content (music, spoken word, and noise) and transmission (signal quality, amplification, clean sound, fidelity, and beyond) women's hands were on the dial, their voices emanating from speakers, and their ears attuned to the multi-track modernity emerging in parallel streams across the black world.

Raky's debut issue in May 1959 featured music that neatly mapped the sonic boundaries of pan-Africanism. In the same issue, a woman who was

not merely a listener (however active) but also a singer, instrumentalist, and band leader was featured in the letters section. A reader submitted a photograph of an eleven-piece band (which included *three* women guitarists) with the caption:

> Voici l'orchestre le plus important et le plus dynamique du Cameroun. Il est dirigé par *Mme Kingue-Mbengue, qui est la première femme Camerounaise à chanter en s'accompagnant elle-même.* Cette orchestre prête toujours son concours, chaque fois qu'on fait appel à lui et il a reçu d'innombrables félicitations de personnalités officielles.
>
> [Here is the most important and dynamic orchestra in Cameroon. It is directed by *Mrs. Kingue-Mbengue, who is the first Cameroonian woman to sing while accompanying herself instrumentally.* This orchestra is ready for a gig whenever called upon, and they have won the praises of innumerable prominent personalities.] (my italics)

Madame Kingue-Mbengue was part of a steremodernist scene closely linked to the diaspora. The features section included a photograph of the American jazz saxophonist Lester Young, announcing his death; news of an Ivorian who had adopted the Anglophone name of Joe William (presumably identifying with black diasporic prestige) winning a singing competition in Paris; a feature on Josephine Baker and her international adopted family; and a section titled "Musique Typique avec Benny Bennett," which featured Afro-Cuban hits. While the version of pan-Africa Telefunken radio sets like Raky's most readily tuned into was the continent's sub-Saharan Francophone urban centers, the wider map of transnational black cultural sound *Bingo* plotted was anchored by African American jazz, Afro-Cuban salsa, and Paris cabaret as essential and unique meeting grounds for Francophone and Anglophone black diasporas. The act of performing was marked as exceptional, but all of *Bingo*'s readership was invited, and indeed schooled, by the magazine, to participate in a collective aural project, a shared *listening* that cast the perimeters of the black Atlantic as the acoustic parameters of popular pan-Africanism.

When Gloss Loses Its Sheen

As this chapter has illustrated, sound was at the center of an emerging mediascape that addressed women as key actors in determining the shape of stereomodernism in mid-twentieth-century Africa. Arjun Appadurai's description of mediascapes as interrelated and interreferential media forms is particularly salient here. Mediascapes

> provide *large and complex repertoires of images, narratives, and ethnoscapes to viewers throughout the world, in which the world of commodities and the*

world of news and politics are profoundly mixed. What this means is that many audiences around the world experience the media themselves as a complicated and interconnected repertoire of print, celluloid, electronic screens, and bill-boards. The lines between the realistic and the fictional landscapes they see are blurred, so that the farther away these audiences are from the direct experiences of metropolitan life, the more likely they are to construct imagined worlds that are chimerical, aesthetic, even fantastic objects, particularly if assessed by the criteria of some other perspective, some other imagined world.[42]

The magazines and films discussed here traced the ways that women were represented as interpreters and consumers of cultural texts, primarily as readers and as listeners in an audiotechnological landscape through which a sonic version of popular pan-Africanism was distributed. I have sought to show how attending to the intertwined practices of listening and reading allows us to recognize and attend to female agency in defining a globally aware black modern consciousness, which we have already come to recognize as stereomodernism. Sheen reading is a form of reading that grows from the logic of magazine composition and consumption, and which may be extended to forms of sensory experience, choice, and intermedial association that connect a wide range of texts. Sheen reading as such is neither necessarily productive nor a priori suspect. However, it can facilitate imaginative work, which (if we take Appadurai, Radner, and others seriously) suggests a less severe interpretation than Marx's view of individual consumption as a double-edged sword that "provides, on the one hand, the means for the workers' maintenance and reproduction; on the other hand, by the constant annihilation of the means of subsistence, it provides for their continued re-appearance on the labour-market."[43] Something else, a form of collective consciousness related to Benedict Anderson's "imagined communities" but also less predictable given the range of ludic and leisure choices offered, is produced in these acts of consumption. Comparative black beauty cultures as featured in these magazines that drew on stories from local and global spheres presented a unique form of race solidarity built around sheen reading and other forms of hermeneutic enjoyment. What sheen reading makes clear is that pan-Africanism was not simply a position, but a practice.

[42] Appadurai, *Modernity at Large,* 35, my italics.
[43] Karl Marx, *Capital: Volume 1: A Critique of Political Economy* (New York: Penguin Classics, 1992), 719.

"Soul to Soul"

ECHOLOCATING HISTORIES OF SLAVERY AND FREEDOM FROM GHANA

On March 6, 1971, a group of primarily African American musicians joined their Ghanaian counterparts for an epic fourteen-hour concert held in Accra's Black Star Square on the anniversary of Ghana's independence from Britain. This Soul to Soul concert was both a first in terms of its scale, and, simultaneously, only one iteration in a series of similar occasions echoing tropes of diasporic "return" and a trans-Atlantic reckoning with the history of slavery *in situ* around extant slave dungeons. The numerous such architectural structures still standing have made Ghana a particularly important site for memorializating the Middle Passage.[1] This chapter addresses how diasporic and continental Africans use sites and events to contend with the historical burden of the trans-Atlantic slave trade.

Extending the previous chapter's emphasis on pan-Africanism as a practice rather than simply a position, I shift my attention here from mediated music to the "unplugged" capacity for sound to travel, and specifically to the interactions between sonic content and place, to engage with what Ghanaian musicologist John Collins has called the feedback loop of the diaspora in the intimacies of musical encounters between Ghanaian and African American artists. The acoustic phenomenon of echo, and its resonances in specific places, spaces, and *lieux de mémoire* form the theoretical backbone of this discussion. I consider how the Soul to Soul concert in Accra, and the texts that record it, demonstrate a process of Black Atlantic echolocation where repetitions of specific rituals of commemoration offer a framework for successive generations of diasporans and Ghanaians to stage encounters on the ground of a traumatic

[1] Several important events followed the model of the Soul to Soul concert, notably the Zaire '74 concert coinciding with the Muhammed Ali-George Foreman Rumble in the Jungle in Kinshasa (and recently commemorated in the 2008 *Soul Power* documentary), 1977 FESTAC held in Lagos, and the biennial PANAFEST Pan-African Festival of Theater established in the mid-1980s by Efua Sutherland. For more on PANAFEST's continuing legacy, see the official website, http://www.panafestghana.org (accessed July 27, 2012) For more on *lieux de mémoire* and memorialization see Chapter 3 n79.

history and thus to work out their relation to place, time, and belonging. Displacing that history's traumas onto a performance context, Call-Response, which Samuel Floyd has called the musical trope of tropes, takes on unique significance.[2] Here, music functions as a means to sound out a call and elicit a response from one's acoustic environment (and potentially, one's listeners), to echolocate one's own subject position and orient oneself in the time and place of the stereomodern. My use of echolocation builds on an elegant explanation of the phenomenon by Hans Fründt. He explains:

> Echolocation is an interrogative function, and simultaneously a unilateral function with objects of the world. Every transmitted signal is a question, every reflected signal contains information via its distortion caused by the object and is identified directly with it by the receiver.[3]

For diasporic writers, articulating their own experiences and expectations of Ghana and by extension, Africa, orients them as participants in an imagined community and as citizens with claims against their home nations in the diaspora. Similarly, Ghanaian writers who take up the challenge of local histories of slavery and the need for confronting its moral toll on their own psyches as well as on diasporans may anchor themselves more surely on a global context, what Glissant would call the *Tout-Monde*. Reading these Ghanaian and diasporic writers against the backdrop of the 1971 concert, multiple layers of meaning are woven together.

Echo has been a particularly resonant trope for thinking through diasporic relations in multiple sites. Most recently, Carol Ann Muller and Sathima Bea Benjamin's collaborative work on the significance of Benjamin's career as a jazz singer and composer, *Musical Echoes: South African Women Thinking in Jazz*[4] has explored this metaphor. The book's title evokes Benjamin's 2004 CD of the same name, and Muller notes that echo "conveys qualities of and bears strong resemblance to the diasporic subject. The echo articulates spatial, temporal, and cultural displacement, which is frequently accompanied by a discourse of loss and suffering."[5] Drawing on the work of Collins, Muller, Benjamin, and others, I seek to elucidate how echo figures reiterations of diasporic relation that are always already inflected by histories that may be muted or diminishing, but never fully silenced. The narratives of the trans-Atlantic Middle Passage discussed here grapple with the profound generational rupture of enslavement, but also revisit earlier attempts to represent this history of loss

[2] Samuel A. Floyd, *The Power of Black Music, Interpreting its History from Africa to the United States* (New York: Oxford UP, 1996), 95.

[3] Hans Fründt, "Echolocation: The Prelinguistic Acoustical System," in *Semiotica* 125–1/3 (1999), 85.

[4] Carol A. Muller and Sathima Bea Benjamin. *Musical Echoes: South African Thinking in Jazz* (Duke UP, 2012).

[5] Ibid., *Musical Echoes*, 276.

within diaspora imaginaries and local African memories of slavery. The abyss of the Middle Passage is charged with the sonic and imaginative traces of these earlier attempts, making it a resonant cavern where echoes of multiple generations of artists who have engaged in reparative work overlap.

The form of this chapter places certain demands on the reader, as I oscillate between the 1971 Soul to Soul concert (itself a commemorative event echoing earlier historical instances) and the various layers of repetition and reiteration evoked by the concert. After an opening description of the concert and an exposition of echo's theoretical valences, I alternate in sections between moments in the 1971 concert (Soul to Soul Takes) and "echolocations" that explore selected texts reflecting back on each of these takes. Toggling between the 1971 concert and its echoes is potentially disorienting, and my hope is that my prose performatively initiates for my reader the kinds of intellectual and affective labor involved in echolocating herself within these layered events.

Some additional background will anchor our echolocations. The concert was originally the brainchild of Maya Angelou, who proposed the idea to officials in the Nkrumah government during her residence in Ghana described in *All God's Children Need Traveling Shoes*, although it was years before the idea was realized. Soul to Soul's lineup included Wilson Pickett, Tina Turner, the East Harlem Choir, and Carlos Santana, as well as the Ghana Arts Council resident ensemble Anansekromian Zounds, longtime palm-wine musician Kwaa Mensah, jazz percussion innovator Kofi Ghanaba (Guy Warren), the Psychedelic Aliens, Ishmael Adams and the Damas Choir, and Amoah Azangeo. Denis Sanders directed a film about the venture, borrowing genre conventions from a live concert recording and a "home" video travel narrative.[6] In addition, a poem by Kwadwo Opoku-Agyemang, and a 2004 rerelease of the original documentary with significant edits provide alternative records of the event. In contrast with the 1966 Dakar FESMAN, which was funded primarily by the Senegalese and French states and by UNESCO, the Soul to Soul concert was privately initiated but scheduled to coincide with a national(ist) commemoration rather than internationalist event. Furthermore, while it enjoyed the logistical support of the Ghanaian government, both the concert and the documentary film produced about it were the work of private citizens. The performers' highly personal reflections on the idea of diasporic "return" to Africa are prioritized over a public discourse such as Senghorian Négritude in accounts of the Soul to Soul concert. Thus, these accounts function as an echo chamber of the range of deeply felt, often conflicted, affective responses to encounters between diasporic and continental Africans premised upon a "re-"union of long-separated kin. In sum, while the Soul to Soul concert celebrated the anniversary of Ghanaian independence, it also sought to

[6] *Soul to Soul*, directed by Denis Sanders, 1972 (re-released in edited version in 2004).

make palpable the legacy of ties between continent and diaspora, and more specifically between Ghanaians and African American descendants of the trans-Atlantic slave trade. In commemorating these two layers of history, the concert echoed several relatively modern traditions, and what follows is a consideration of how echolocation as a metaphor for site-specific historical commemoration offers an alternative to the tradition-modernity dichotomy, one that revolves around repetition and difference.

The idea of diasporans returning to rediscover their roots in Africa is a recurring trope in cultural pan-Africanism, particularly compelling for descendants of the trans-Atlantic slave trade, who suffered not only displacement and forced labor, but also the willful erasure of cultural and linguistic ties. While Sierra Leone and Liberia have the most extensive histories of actual return and resettlement, freed slaves from Brazil and other parts of the Americas in the nineteenth century settled further down the coast of Africa, including the Tabom community in Ghana.[7] Kwame Nkrumah's invitation to diasporic blacks to settle in the new nation upon its independence in 1957 made Ghana a key site of return. Ghana was not the first African nation to gain independence from Britain (Egypt and Sudan preceded it), nor was it the only nation where significant numbers of African Americans settled in recent decades (Tanzania and Guinea, for example, famously welcomed prominent political leaders). However, Ghana was an undeniably important symbol of freedom for blacks across the globe and Nkrumah's devotion to pan-African ideals led him to prioritize building transnational relations with other African countries and with blacks in the diaspora. Ghana hosted the first of three All African People's Conferences in Accra in 1958 and welcomed George Padmore, W. E. B. Du Bois and his wife Shirley Graham DuBois, among others, to settle there.[8]

It should go without saying that the historical burden of the slave dungeons belongs to all people. They are UNESCO World Heritage Sites precisely because they speak to people of all nationalities about the human condition. A consideration of what expressions emerge from the uniquely coupled responses of Ghanaian Africans and African American diasporans in these sites should not obscure the fact that slavery is a human tragedy, not the unique burden of the descendants of enslaved people. However, insofar as descendants of enslaved Africans in the diaspora feel the traumas of this history acutely and personally, it is appropriate to look to how the performance arts have long offered a means for peoples of the Black Atlantic to play out alternative histories, and sound

[7] See K. K. Prah's *Back to Africa: Afro-Brazilian returnees and their communities* (Rondebosch: CASAS, 2009) for discussion of nineteenth-century returnees throughout West Africa.

[8] Nkrumah's policies engendered complex reactions among local Ghanaians who sometimes resented the pride of place given to nonnationals. While his suppression of trade unions and other forms of opposition was widely condemned, Shirley Graham Du Bois remained a staunch supporter, visiting him in Guinea after his overthrow in the coup of 1966.

out possible futures without getting locked into repetitive patterns that might choke conversation. To put it frankly, the viability of future pan-Africanist projects depends on the extent to which continental Africans can come to recognize and honor the raw feelings that many from the diaspora bring to the history of complicity of certain Africans in the slave trade, and likewise, on the extent to which diasporans can come to grips with how centuries of colonialism and global capitalism place present day encounters in the context of heritage tourism upon an inherently uneven ground. How, we might ask, does echo offer both a sonic metaphor for diasporic return and a generative creative strategy for negotiating repetition with difference, and new traditions of stereomodern solidarity? How does echo become something more than decaying repetition? Given its influence over both Western and decolonizing imaginaries, the myth of Echo in classical literature is worth recalling before we proceed further with a discussion of Soul to Soul and its echoes.

An Echoing Myth

Ovid's *Metamorphoses* recounts how Echo falls in love with Narcissus but is unable to engage in real dialogue with him. Echo has distracted Juno with idle conversation while Juno's husband Jupiter has affairs with the nymphs and when she discovers the truth, Juno condemns Echo to repeat only the last words of her interlocutor's speech. Ovid recounts Juno's words thusly: " 'From now on you'll not have much use for that voice that tricked me so.' The threat was followed by the fact. And Echo can mime no more than the concluding sounds of any words she's heard."[9] Not only is her ability to initiate speech eliminated, but she is also curtailed to truncated and delayed copies of what she has heard. Soon after, Echo falls for Narcissus, and while the handsome youth is at first intrigued enough to speak to her, he quickly becomes frustrated by her enigmatic responses. However, Gayatri Spivak has pointed out that this punishment goes only so far:

> Echo in Ovid is staged as the instrument of the possibility of a truth not dependent upon intention, a reward uncoupled from, indeed set free from, the recipient. Throughout the reported exchange between Narcissus and Echo, she behaves according to her punishment and gives back the end of each statement. Ovid "quotes" her, except when Narcissus asks, *Quid...me fugis* (Why do you fly from me [M 150, 11. 383–84])? Caught in the discrepancy between second person interrogative (*fugis*) and the imperative (*fugi*), Ovid cannot allow her to be, even Echo, so that Narcissus, flying from her, could have made of the ethical structure of response a fulfilled antiphone.

[9] Allen Mandelbaum, *The Metamorphoses of Ovid*, (New York: Houghton Mifflin, 1993), 92–93.

> He reports her speech in the name of Narcissus: *quot dixit, verba recepit* (M
> 150, l. 384)—he receives back the words he says. The discrepancy is effaced
> in the discrepancy of translation. In English, Echo could have echoed "Fly
> from me" and remained echo. [citing Loeb Classical Library edition][10]

Spivak's comments draw attention to the fact that Echo's curse opens up the
necessity for a narrating voice to supplement and edit their exchange. Thus,
what appears to be an instance where dialogue is precluded by set repetitions
and truncations becomes the occasion for an unforeseen intervention on the
part of the artist's voice. Spivak's reading shows that conversations between
subjects lodged in their own historical and psychic contexts may get jammed,
but narrative and poetry have the potential to decode and retransmit these
signals. The kinds of trans-Atlantic encounters of interest here are also satu-
rated in stereotyped discourses and a repertoire of previous texts ranging from
exoticizing colonial travelogues to postcolonial state propaganda. These ste-
reotyping tropes—avaricious African chief, or abjectly terrified captive—are
rarely unmasked in full, as this would threaten the claims made for implic-
itly racial solidarity. However, like the language of kinship casting Africa as
Mother Africa and blacks as brothers and sisters, and the concept of taproots
rather than the rhizomatic schema Glissant proposes for thinking about iden-
tities, these stereotypes maintain rigid structures of feeling that stunt the
possibility of full Relation with all its necessary exigencies, negotiations, and
ambivalences.

Ovid's Echo, disappointed in love, eventually turned to desiccated bones,
and then to stone, leaving only her reverberating voice to haunt the hills she
had previously inhabited. What I am suggesting here is that pan-Africanism
is, similarly, a mode of identification continually haunted by its prior itera-
tions, which echo in the same spaces that new forms of solidarity elaborate.
However, I propose that literature of the slave dungeons actually functions as
echolocation, an acoustic operation where transmitted signals, when reflected
back as echoes, give an indication of the transmitter's relationship to his or her
surroundings, as in sonar systems.

Soul to Soul Take One: On Returning to Africa

The film *Soul to Soul* casts the 1971 concert as a historical watershed, staging
an archetypal Back-to-Africa with which Afro-diasporic viewers could iden-
tify even if they could not afford to make the journey themselves. The sense
of embarking on unprecedented discovery depends on the relative unfamil-
iarity with Africa of some performers, which the film plays up to dramatic

[10] Gayatri Chakravorty Spivak, "Echo," in *New Literary History* 24:1 (Winter, 1993), 24–25.

effect. The first scenes of the cast in flight feature Pops Staples of the Staples Singers enthusing about how the concert will join African Soul to American Soul, as well as Les McCann and a young woman from Voices of East Harlem discussing the affective pull of Africa. However, the opposite sentiment is also expressed. This is most striking in the statements by twelve-year-old Kevin Griffin, the youngest member of the tour. Griffin, another member of the Voices of East Harlem, responds when asked whether he expects to hear good music in Africa with a blunt "No." On the same flight, Ike Turner declares "I didn't know nothing about Africa, period. Still don't." It is striking that no historical background is provided for either the viewer or the participants in the film, and thus the travelers experienced the journey as inaugurating an entirely new relation between Africa and the diaspora.

> As the plane got close to Accra, the party atmosphere subsided and an eerie silence enveloped the cabin. "That really struck me," states Kevin Griffin. "How everybody shut down because of the fact that it was time for the individuals to take off their professional hats, their egos, and every person on that plane realized that we were about to embark upon something historical."[11]

Yet the "historical" disembarkation was highly constructed, for as the liner notes specify, white participants were asked to wait on board while a film crew captured the African American performers' exit from the plane. The film goes to great lengths to present the *Soul to Soul* journey as unprecedented, but the irony is that by 1971 Ghana already had a long history of welcoming diasporans. The film makes no mention of troops of West Indian soldiers, who had been conscripted into the British army and stationed in Cape Coast in the late nineteenth century, bringing Caribbean brass instruments to enrich local musical cultures; nor are the sojourns of luminary diasporic figures including Padmore, Du Bois, Wright, Angelou, and Brathwaite noted. Most strikingly, there is no reference made to Louis Armstrong's triumphal visit to the Gold Coast in 1956, the most obvious precedent to the Soul to Soul tour. Obscuring the precedent of prior diasporan journeys to Africa allows the film to present the featured musicians as heroes on an individual quest, a narrative more suited for Hollywood, rather than as participants in a long-running cultural dynamic.

Echolocation One: Ghana Emotion(s), before and after 1957

My subtitle is taken from the 2006 song by British neo-soul artist, Omar Lye-Fook, "Ghana Emotion" and this section examines three important

[11] *Soul to Soul* DVD Booklet, 8–9.

musical counterparts for the Soul to Soul concert: Louis Armstrong's first visit in 1956, the use of Afro-pop sensation Osibisa's song "Welcome Home" in the 2007 government-initiated Joseph Project, and finally, Omar's song. The silence about Louis Armstrong's 1956 performance (and subsequent African tour in 1961–62) is particularly remarkable given that Armstrong passed away in July 1971, within months of the concert, and prior to the film's release. The echoes between Armstrong's visit and the *Soul to Soul* film are striking: indeed the choice to film both the performance and visit paralleled the fact that Ed Murrow of CBS initiated Armstrong's visit during the filming for *Satchmo the Great*, while the arrival scene in 1971—the live drumming and Akwaaba ceremony of welcome on the tarmac of Kotoka airport—recalled the jam session that took place when Armstrong first arrived. It may well have been that Satchmo had become reduced to a grinning and overly accommodating media caricature that ignored his often bold statements critiquing U.S. racism,[12] and was seen as reactionary compared to the more exuberant "Black-Is-Beautiful" thrust of the Soul era. However, had the producers of the *Soul to Soul* film and concert turned to press coverage of Armstrong's tour they would have discovered that themes of return, recognition, and reciprocity that occur in the *Soul to Soul* film were also prevalent in the discourses Armstrong's visit launched. A handwritten note in Louis's handwriting was published on the front page of a special newspaper section of Accra's *Daily Graphic* in which he recalled seeing "one of the women dancing in one of the Tribes Yesterday who looked just like my mother Mayann, who died in 1927. I'll just have to return to my home land to blow for the cats at least once a year-Yeah." Furthermore, Armstrong reported recognizing a popular highlife tune "All for You," which was played for him upon his arrival as a Creole folk tune he had grown up hearing in New Orleans (John Collins points out that the tune is based on a popular early calypso tune, "Sly Mongoose" and may well indicate earlier waves of Black Atlantic cultural traffic).[13] Recognizing the familiar tune, he was able to join in immediately on his horn. His response to this recognition was to begin a *collaborative improvisation*. This is the gift that Armstrong and the other musicians in this section offer, and, I would argue, the motive behind literary adoptions of the music. In other words, recognition is not an end in itself, a question of transparency or legibility, but rather the condition upon which new creative elaboration depends. For musicians who enter into such collaborative improvisation, echoing what they hear is only the first step toward establishing a shared acoustic space.

John Collins's account of the visit also highlights how such encounters rely not only upon extemporaneous improvisation but also on intentional

[12] Penny von Eschen details his statements about the Little Rock school integration process, for example, in *Satchmo Blows Up the World*.

[13] John Collins, *Highlife Time* (Accra: Anansesem, 1996).

preparation. Drawing on interviews with leading Ghanaian musicians of the era, including the highlife trumpet star, E. T. Mensah and bongo player Dan Acquaye, Collins reports that before Armstrong's arrival the CBS team and their Ghanaian government liaison, James Moxon, gathered the highlife musicians to rehearse a song that they would later jam on with Armstrong and his All-Stars band. The chosen song, "St. Louis Blues," was not familiar to the group and this was in part because Armstrong belonged to an older generation than the musicians who were popular with Ghanaians in the 1950s. In Mensah's words, "swing was popular but dixieland was not."[14] Interestingly, the Ghanaians, it seems, were too modern for Armstrong. Mensah also recalls that part of the problem Armstrong's band initially had with connecting with the crowd was an acoustic one...their sound was too thin to cut through their audiences expectations. Ghanaians "wanted more rhythm" and they did not "give heavy applause at the end of the music as is done abroad."[15] According to Mensah, it was the All-Stars trombonist Trummy Young who saved the day by introducing a layer of comedic theatricality to the show by laying on his back and playing the slide with his feet. I would argue that Young here actually introduced a performance practice that felt familiar to Ghanaian audiences. Highlife had become popular within the Concert Party tradition where slapstick comedy performed in blackface (a modern variation on West African minstrel, masquerade troubadour traditions as well as griot/djeli praise poetry traditions) was an integral part of highlife evenings. Like the Jaguar Jokers (Messrs. Bampoe, Baidoo, and Hammon), who boasted that a "jaguar is a wild animal—you can't make it laugh—but we can,"[16] Trummy Young won his audience over with total entertainment. The rest of the night's performance went well, and Armstrong's visit paved the way for the Soul to Soul group and many others in years to come.

The involvement of government officials in Armstrong's otherwise private visit (Moxon was head of the Information Service at the time) was also repeated in the Soul to Soul tour, with the Ghana Arts Council, an arm of the government, providing logistical support and organizing the many local music and dance performances that the touring Americans attended. However, the government has, in recent times, taken an even more active role in dialogues with the diaspora.

As we have already seen, Ghana has long held a cherished place as both the first black African nation to gain independence (in 1957) and as a site of pilgrimage where extant slave dungeons provide a scene for personal and public rituals of remembrance. Marking Ghana's fiftieth anniversary as an independent nation, the Joseph Project was launched in July 2007 by the then Minister

[14] Ibid., 152.
[15] Ibid., 154.
[16] Ibid., 22.

of Tourism and Diasporic Relations, Jake Obetsebi-Lamptey,[17] a member of President John A. Kufuor's cabinet. It extended an invitation to diasporans to visit and invest in the modern nation-state of Ghana, in a self-avowed update of Osagyefo Kwame Nkrumah's welcome issued to blacks when the nation first gained independence. However, where Nkrumah's invitation stressed shared ideology and antihegemonic solidarity, the Joseph Project emphasized lines of kinship and heritage. In addition, the religious overtones of the Joseph Project would have been an anathema to the nation's first president, who presented a report to the Pan-African Congress of 1945 declaring, "[t]hat organized Christianity in West Africa is identified with the political and economic exploitation of West African peoples by alien powers."[18]

The Kufuor government (2001–2009) intended to reaffirm links between diasporic Africans and the modern nation-state of Ghana, simultaneously standing in metonymically for the continent, and metaphorically as a Gateway to Africa.[19] The Joseph Project adopted the narrative of Joseph from the book of Genesis in the Bible as a metaphor for the return of descendants of enslaved Africans to the continent of their ancestors. What distinguishes the Joseph Project's invitation from earlier Nkrumahist policies is its foregrounding of the trans-Atlantic slave trade's significance in African history, a recognition first signaled in Ghana by the adoption of "Emancipation Day" as a national holiday in 1998.[20] As the original website elaborated:

> The Joseph Project recognizes that while it is miserably true that there are far too many Africans held down by the legacy of their chains, it is also true that there are many, like the Biblical Joseph, who have risen above their captivity and are shining examples of the best of the human spirit and of what man can achieve in every walk of life.[21]

A soundtrack automatically began when the page was opened, playing a 1977 song entitled "Welcome Back," by the Afro-pop ensemble, Osibisa. "Welcome Back" invites those who have "been gone for so long" to "come on back to the

[17] Obetsebi-Lamptey left his ministerial office in 2007 to seek the National Patriotic Party nomination for president. He lost that contest to Nana Akuffo-Addo, who stood as the NPP candidate in 2009 elections, but was defeated by John Evans Atta Mills in a close runoff. Obetsebi-Lamptey became head of the NPP in 2010.

[18] Kwame Nkrumah, *Toward Colonial Freedom: Africa in the Struggle against World Imperialism* (London: Heinemann, 1962), 42.

[19] Transcript of June 7, 2007 broadcast "Ghana's Joseph Project Says 'Come Home'" posted on http://www.npr.org/templates/story/story.php?storyId=10802304 (accessed 8/3/10).

[20] See Jennifer Hasty, "Rites of Passage, Routes of Redemption: Emancipation Tourism and the Wealth of Culture," in *Africa Today* 49.3 (Fall 2002): 47–76. Hasty traces how Emancipation Day came to be adopted in Ghana after then President Rawlings and his aide, the poet Kofi Awoonor witnessed a celebration in Jamaica.

[21] (www.thejosephproject.com accessed 6/5/08). The domain name appears to have changed hands, but content is archived on the Wayback Machine's Internet Archive (www.web.archive.org).

Promised Land." In spite of the song's minor key, which casts a melancholy tone over the invitation, hinting at the ongoing complexities of such returns, the music is used to promise a resolution of the longing and pain that generations continue to feel about their enslaved ancestors, and to further cast this project in biblical terms. Nonetheless, the very looping of this song provided an aural hint to visitors of the site of the unfinished and infinite nature of efforts to "come back."

Against the grain of Western modernity's separation of secular and sacred, the narrative of "the Biblical Joseph" was invoked by a secular state official to encourage the flow of sentiments, people, and capital from the diaspora to Ghana. This rhetoric blurred the lines between material and human capital in ways that are too close to slavery's logic to go unremarked. While there are sincere desires on the part of both Ghanaians and diasporic blacks to honor those lost in the long-running catastrophe of the slave trade, to come to grips with the history of slavery, and to wrestle with the challenge that representing it continues to pose, the official state framework of this enterprise was haunted from the beginning by its own elisions, contradictions, and ambiguities.

Minister Obetsebi-Lamptey made no acknowledgment of Ghana's religious diversity (which includes a population that is 16 percent Muslim, and close to 10 percent traditional) in his first official statement on the Joseph Project.[22] Later, in an interview with National Public Radio correspondent Michel Martin in 2007, Obetsebi-Lamptey defended the biblical references, saying:

> Joseph comes from the Bible and the Koran—because Joseph is also in the Koran—who was sold into slavery by his brethren, rose in the land of his slavery and then when the brethren reached to him, he reached back...The thing about Joseph being Christian. For me, that's a very simple thing. There's a huge numbers [sic] out there. We can't deal with everybody. We're going to eat this elephant piece by piece.[23]

How the Qur'anic Yusuf, and Judaic interpretations of Joseph (who is, after all, a figure from the Torah first, and Christian by adoption) differ in significant ways from the Minister's "Biblical Joseph" is not elaborated.

If we take the "Biblical Joseph" at face value, this narrative is but the latest in a long line of Jewish scriptures and lore to resonate with the African diasporic imagination in its quest for metaphorical and literal liberation. As scholars such as Joseph Skinner and more recently Paul Gilroy, in *The Black Atlantic,* have pointed out, the very concept of a diaspora derives from Jewish experience and discourse. From the Torah's prophecies of renewal after slavery and oppression to Bob Marley's late-twentieth-century Ras Tafari

[22] According to the 2008 CIA Factbook.
[23] Transcript of June 7, 2007 broadcast "Ghana's Joseph Project Says 'Come Home'" posted on http://www.npr.org/templates/story/story.php?storyId=10802304 (accessed 8/3/10).

celebration of "Exodus, movement of the people!" the biblical narratives of Jewish persecution have provided a rich storehouse of metaphors in black struggles for self-determination. Such an identification is perhaps counter-intuitive: Afro-diasporans in the New World routinely identified with the Hebrews, non-Africans in the narratives of Israel's time in Egypt, while the figures cast as tyrants, slavers, and despots, the Pharaonic Egyptians, were in fact Africans. The power of narrative in providing a conceptual and affective framework for liberation politics clearly overrode such details.

The hope driving the Joseph Project was grounded in a very particular interpretation of the Genesis narrative recounting the tale of a brother whose dreams and ties to his father feed the jealousy of his brothers, who then sell him into slavery. Joseph is reported to be dead rather than enslaved, trig-gering his father's inconsolable mourning. But he is later rediscovered after having risen to acclaim in Egypt while his brothers have fallen into penury in their homeland. As the righthand man of the Pharaoh, Joseph chooses to extend mercy and generosity toward his brothers, but only after an encounter in which he not only reveals his identity but also bears witness to the suffer-ing brought on him by the treachery of his brothers. The reunion encounter between the brothers is a deeply emotional one, as described in Genesis 45:1–4:

> Then Joseph could not refrain himself before all them that stood by him; and he cried, Cause every man to go out from me. And there stood no man with him, while Joseph made himself known unto his brethren. And he wept aloud: and the Egyptians and the house of Pharaoh heard. And Joseph said unto his brethren, I am Joseph; doth my father yet live? And his brethren could not answer him; for they were troubled at his presence. And Joseph said unto his brethren, Come near to me, I pray you. And they came near. And he said, I am Joseph your brother, whom ye sold into Egypt. (KJV)

How apt is this story for the Ghanaian government's project? The prestige and wealth that Joseph attained parallels the highly publicized visits to Africa by celebrities like the Soul to Soul cast. However, working class diasporans for whom a trip to Africa constitutes the most significant and expensive journey they will ever make may well be shocked to find that self-declared brothers and sisters in Africa are better prepared to welcome American dollars than to engage in the kind of fraught affective exchange that so many descendants of enslaved Africans seek upon their first visit to the continent. What is more, the version of the Joseph narrative mobilized in this project truncates an extended episode in which Joseph is falsely accused of seducing the Pharaoh's wife.[24] Its elision shows the complexities of mobilizing a borrowed origin narrative for official purposes, while the state's role in managing affect is called into

[24] This episode has recently been treated at length in Mieke Bal's rich and innovative comparative study, *Loving Yusuf* (Chicago: U Chicago P, 2008).

question in an encounter whose scriptural prototype is described as a violent emotional disruption.

Joseph, as the book of Genesis recounts, "wept aloud: and the Egyptians and the house of Pharaoh heard" through the walls of his chamber, and his brothers become "troubled at his presence." Dumbstruck, they are unable to immediately enter into a conversation with him. While the Joseph Project frames its invitation as a return home, the biblical encounter takes place in the land of *exile*, not on the Midian soil in the brothers' land of origin. The "Joseph Project" version of the narrative in fact does not cite the original text of the "Biblical Joseph" anywhere in its online or print publications, relying, instead, on an abstracted character in the popular imagination (whose characteristics are, nevertheless, clearly based on Judeo-Christian sources). This figure, which I call "iconic-Joseph" to distinguish it from "textual-Joseph" whose story is recounted in Genesis, functions similarly to a brass Akan gold weight. Long used in Akan trading culture as measures for negotiating the worth of gold dust to be exchanged, brass weights are also mnemonic devices, representational objects that evoke any number of proverbs and sayings and thus facilitate a multilayered intercourse through nonverbal gestures that convey complex discursive moves.[25] The iconic-Joseph, a truncated citation of the textual-Joseph of Genesis, becomes a metonym for a departed returnee's generosity, and for the reconciliation and sense of belonging so many diasporic blacks long for upon first visiting Africa. What falls away, in this iconic representation, is the affective density, temporal scale, and cultural specificity of such returns to Africa, and the shifting transnational political agendas which undergirded such journeys. The potential for disappointment and sense of failed connections loom large for both diasporans and Africans in such contexts.

The Joseph Project is the most recent and formalized effort to establish a material diaspora-continental connection based on heritage tourism and immigration, but certainly other formats, from general tourism initiatives to academic exchanges sponsored by a state university, Legon, and the National Commission on Culture are also significant. In these examples, the figuration of echo, or call-and-response is less prominent, while official discourses tend toward naturalizing heritage tourism and minimizing or obscuring the contentious dimensions of such a project. Nevertheless, the limits of such projects emerge: among those scholars who have explored how the expectations of tourists from the diaspora and Ghanaian residents often fail to intersect, giving rise to disappointment and frustration as much as to solidarity are Paulla Ebron and Ann Reed.[26] They describe the sometimes deeply disquieting

[25] Albert Ott, "Akan Gold Weights," in *Transactions of the Historical Society of Ghana*, 9 (1968), 17–42.

[26] The final chapter of Ebron's *Performing Africa* analyzes a tour of Senegal sponsored by McDonalds in terms of Victor Turner's theory of ritual, while Reed's essay "Sankofa Site: Cape Coast Castle and Its Museum as Markers of Memory" analyzes exhibits at Cape Coast Castle museum, and a video produced by Kwaw Ansah, *Crossroads of People, Crossroads of Trade,* which the museum screens. See also

consequences of combining *lieux de mémoire,* such as the slave forts at Cape
Coast and Elmina, with a for-profit tourist industry. In critiques of heritage
tourism, a recurrent theme is that visits to the sites of slave castles are too
scripted. A ritual structure is imposed on visitors' temporal and spatial expe-
rience of the castles, where symbolic acts such as reading memorial plaques
out loud or entering the "Door of No Return" from the opposite direction
are supposed to meet the affective demands that diasporans place upon these
sites. Music is regularly used to consolidate the interpretive meaning in such
exercises. Edward Bruner describes a ceremony at Elmina Castle ending with
songs that effect the symbolic "overcoming" of slavery's losses:

> "Through the Door of No Return—The Return" is a fascinating performance
> [mounted by African American expatriates, the Robinsons' company, One
> Africa Productions]. After a tour of the castle the group assembles in the
> dungeon, where they hold hands, light candles, pray together, usually weep
> together, pour libation as a homage to the ancestors, and then pass through
> the door that the slaves went through to the slave ships that would take them
> to the Americas. After the slaves went through that infamous door, there was
> no return, however, once the tour group gets to the other side they sing "We
> Shall Overcome" and the Negro National Anthem, which are diaspora songs.
> Then they reenter the castle, singing festive African songs and dancing to the
> beat of the drums to celebrate their joyous return to Mother Africa.[27]

In this ceremony, the kinds of collaborative improvisation and reciprocal
exchange seen in the Soul to Soul concert and Armstrong's jam sessions are not
allowed for, but rather diaspora songs are assigned a place *outside* the struc-
ture of the castle while the castle's reentry is accompanied by "festive African
songs" and beating drums. One consequence of such a spatial schematization
is that there is no place imagined for dialogue and reflection between tourists
and resident Ghanaians about the various meanings and interpretations of the
castles, and music is seen as filling in to ratify a reconciliation for which words
are insufficient.

A more flexible approach can be heard in British neo-soul artist Omar
Lye-Fook's 2006 song "Ghana Emotion" from the album *Sing (If You Want
It).* The very genre designation of neo-soul acknowledges a millennial rein-
vocation of the 1960s and 1970s articulations of pride, promise, and pleasure
that lend a nostalgic patina to the Soul Era and its celebration of black per-
formances of freedom. For Omar, that era's influence is most accessible in the
person and music of Stevie Wonder, whom the British artist names regularly

Jemima Pierre's *The Predicament of Blackness: Postcolonial Ghana and the Politics of Race,* (Chicago: U
Chicago P, 2012).
 [27] Edward Bruner, "Slavery and the Return of the Black Diaspora: Tourism in Ghana," in *Culture on
Tour: Ethnographies of Travel* (Chicago: U Chicago P, 2005), 111.

as one of his most important inspirations, and with whom he collaborated in the recording studio for another track on the 2006 album. Omar's compositional style features distinctive keyboard vamp lines and lush instrumentation (often including large hand percussion sections and brass prominently), and his vocal style is partially modeled on Wonder's. The eminently danceable track, "Ghana Emotion," reveals an additional geographical resonance that the two artists share. Stevie Wonder has spoken of his desire to retire to Ghana since the mid-1970s and has performed there on numerous occasions, even coauthoring the lyrics to the song "Moon Blue" with Akosua Busia, daughter of former Prime Minister, Dr. Kofi A. Busia. And Omar states that "Ghana Emotion" was inspired by his visit to his parents' home in Cape Coast, Ghana. The song in fact first came to him as he and his father, Jamaican-born musician Byron Lye-Fook, were jamming in his father's studio on the coast.[28]

The Lye-Fooks' decision to emigrate from the UK to Ghana and establish their guesthouse, Amber Tree, mirrors a choice that numerous diasporic blacks have made since Kwame Nkrumah first encouraged resettlement in the newly independent Ghana. For two generations of Lye Fooks, then, Ghana has been a resonant cipher of diasporic feeling. While their experiences are grounded in an authenticity that relies on individual experience and affect, they are also naming and participating in a modern tradition of ratifying transnational black solidarity through vocal song. This act of sung solidarity is an instance of Black Atlantic echolocating. Invoking a set of tropes that are available to both diasporic and continental voices, "Ghana Emotion" lays claim to a sense of home, comfort, and connection, but also to history, memory, and valorizing the past. Rather than the iconography of the Middle Passage, this song homes in on the mundane physical spaces of the seaside, and the domestic household. Here, everyday acts like eating, walking, and humming are amped up with symbolic potential as acts of return, punctuated by the refrain's declaration, "I'm coming home." By consciously relating the self to these physical spaces, Omar identifies as a Black Atlantic subject, reorienting himself toward places and practices uniquely resonant for transnational black sensibilities.

The lyrics of "Ghana Emotion" vacillate between Omar's autobiographical account of visiting his parents and more general tropes of diasporic return to Africa. The first stanza more or less equates coastal Ghana's with a series of memory sites or *lieux de mémoire* charged with historical resonance:

> Everywhere I look around I see history
> The birth of man in front of me
> There is so much soul going on, yeah

[28] See "FEATURE: Omar Proves Why There Is Nothing Like Him When It Comes to Music," by Bianca Manu, http://urbandevelopment.co.uk/updown/features-reviews/features/feature-omar-proves-why-there-nothing-him-when-it-comes-music_1311 (accessed July 23, 2012).

> I wanna soak it up to the top
> Take in everything[29]

Evoking the "birth of man" effectively conflates Ghana's status as a gateway to Africa (where diasporic identity literally begins at the threshold of the Door of No Return) with a more generalized continental Africa by evoking the Great Rift Valley where paleontologic evidence of Lucy, the *Australopithecus afarensis* ancestor of humanity has only recently been challenged by discoveries of fossils in other parts of the world. The singer expresses his desire to not only encounter the history that surrounds him, but also to fuse with this world in an ecstatic excess of "soul," to "soak it up" and "take in everything." A Freudian reading of this oceanic desire might trace a longing for fusion with the mother figure, and by extension with Mother Africa, but the metaphor of water cannot help but evoke the Middle Passage in this context, even while reclaiming and reimagining it as a passage that can be approached in reverse, soaking rather than sinking in the powerful currents of the Black Atlantic.

Omar describes his parents' decision to emigrate to Ghana by highlighting the fact that *music* is what exerts a pull: drawn to their new homeland, "[t]hey could hear the calling/ of all the drums all around them." Omar does not linger in the symbolism and abstraction of African drums, however, but rather turns to the material conditions of his parents' emigration as adventurous diasporic retirees relocating with British pounds and significant cultural capital at their disposal: they can "liv[e] it up in a big old house" with a sea view and the acoustics of this structure allow them to continue to elaborate particular black musical tropes both figuratively (in the call of the drums) and literally (in Byron Lye-Fook's home studio). The global inequalities that make Western currencies so much stronger than the Ghanaian *cedi* are not lost to Ghanaian policy makers, who have explicitly sought to attract diasporan dollars (whether from Ghanaians living abroad or from other Western black populations in search of a foothold on the continent) when outlining immigration and tourism agendas.

As George Bob-Milliar has noted, since the 1980s local and national governing figures in Ghana have been particularly keen to attract prominent African Americans to take up the honorary position of *Nkosuohene/hemaa,* or chieftaincy/queen-motherhood, and with it the mantle of leadership in development and community service projects.[30] He points out that musicians have been particularly well represented in these numbers. Besides Stevie Wonder, the list includes Isaac Hayes and Rita Marley. As *Nkosuohene* of Ada, Isaac Hayes has led education efforts through the foundation named after him.

[29] Omar Lye Fook, "Ghana Emotion," on *Sing (If You Want It),* Ether (2006).
[30] See "Chieftaincy, Diaspora, and Development: The Institution of *Nkosuohene* in Ghana" by George Bob-Milliar in *African Affairs* 108/433 (2009): 541–58.

Likewise, as *Nkosuohemaa* of Konkonuru, the reggae artist and widow of Bob Nestor Marley, Rita Marley, has brought a clinic, paved roads and street-lights, a music studio and many other services to the town of Aburi, where she resides, and to the Konkonuru district. Thus, Omar's lyric coincides with the official Joseph Project agenda described above. After a paean to Ghanaian cuisine, Omar continues to outline the specific self-orienting functions of Ghana's coast:

> Take a stroll along the beach
> In the beautiful weather
> Perfect place for you
> If you need to get it together

What distinguishes Omar's version of Black Atlantic echolocation from earlier versions is precisely its appeal to the individual. On the one hand his vision might appear to take for granted and even celebrate the economic privilege and consumer standpoint of the global Northern tourist who can extract personal growth from the idyllic beaches of coastal Ghana. However, if we consider that Omar's musical setting clearly references a body of soul, jazz, and R&B conventions, it is clear that he is working within a tradition of Black Atlantic expression. Thus, the beach stroll that he evokes contrasts with more scripted visits within heritage tourism, as well as the journeys of Flack, Soul to Soul, Angelou, and Armstrong. Singing in 2006, Omar suggests that visiting Ghana need not require that one hew closely to the well-worn itineraries of pilgrim-ages to Elmina and Cape Coast Castles and the overdetermined affective sig-nificance of such visits. Rather, "strolling" becomes the context in which this can be the "perfect place" to "get it together." Turning to the soul-inflected vernacular, "get it together" ironically connotes a deeply interior, personal pro-cess by evoking the collective "together." (As it happens, "Get It Together" also reinvokes the 1973 Jackson Five album of the same name, and with it the sonic world of late soul that Omar so heavily draws on musically.)

Finally, the compositional form of "Ghana Emotion" relies heavily on repetition, troping on the idea of echo with an eight-measure instrumental introduction that is an exact repetition of a four-measure keyboard and drum phrase (itself built up of a harmonically static measure-long motif repeated three times with the slight variation of an ascending melodic line on the fourth iteration). This introduction becomes the vamp accompaniment figure for almost the entire song, varied by soaring brass lines layering over the drum, keyboards, bass, and backup vocals and apart from a leading tone in the verses (itself repeated four times within each verse about retirement), the entire song is simply one long groove over a single modal chord progression. The very fact that the verses contrast the slight harmonic tension of the leading tone with a contemplation of maximal social rest only underscores the essential harmonic gesture of the song: the pleasure of return to the tonic key.

Soul to Soul Take Two: The Muted Echoes of Roberta Flack

Returning to the Soul to Soul concert, the 2004 reissue by Reelin' In the Years Productions of the original 1972 version of the documentary film *Soul to Soul* differs significantly from the original film as Roberta Flack's appearances are edited out at her request. Flack's appearance in original film, the enthusiastic embrace she received in the Ghanaian press, and a poem by the Ghanaian poet Kwadwo Opoku-Agyemang commemorating her visit all serve to complicate the trope of "returns" to Africa as resolutions and celebrations of healing. The "texts" generated by a live performance are exemplary of the poetics of echo in a material sense, a dynamic determined by interplays of space and sound, place and song. In Hannah Arendt's *The Human Condition* she makes a claim that resonates strongly in our current examination. Her proposal that "a life without speech and *without action* ... is literally dead to the world"[31] by virtue of its refusal of or exclusion from human communion is provocative. If this is so, what are the consequences of Flack's erasure of her performance, and its dogged survivals in other media formats? How do they bring us closer to thinking about enslavement as literal and social death? Asking such questions highlights her withdrawal from the film as figuring a radical rejection of comfort and peace that, I would argue, recovers a place for skepticism among the possible responses to the diaspora-continental node.

Tropes of uncanny recognition, particularly of maternal and sisterly female figures, and of song as resolution run through the accounts Louis Armstrong and Maya Angelou write of their travels in Ghana. The trope of song recurs in narratives set in other West African countries. The documentary film, *The Language You Cry In* (1992), traces a song African American linguist Lorenzo Turner transcribed in the Gullah Islands in the 1930s to the village in Sierra Leone where those lyrics are still sung. In the film, a contemporary Gullah family whose women elders still sing the song journey to Sierra Leone where they are introduced to ("reunited" with) the descendants of the song's composers. Although its tempo, tonality, and rhythms suggest a celebration in the Gullah version, the song's durability (as the film would have it) lies in the fact that it is a *sorrow song*, a song of mourning in the Mende community from which it originates.

In fact, song (a conjunction of music and speech) as a means of situating the diasporic in relation to the continental can be read as one of the most literal versions of echolocation, where the singer's transmitted signals, when reflected back as echoes, give an indication of her relationship to her surroundings, as in the sonar communication of dolphins and other vocalizing beings. Recalling Fründt's explanation that "every reflected signal contains information via its

[31] Hannah Arendt, *The Human Condition* (New York: Doubleday, 1959), 157 (my italics).

distortion caused by the object and is identified directly with it by the receiver," we begin to see here that the distortion, in this metaphor, is caused by the obdurate impossibility of assimilating or working through the traumas of slavery that exhaust representation.

This trope of reorienting toward Africa through the essential genre or form of song is certainly at the heart of Roberta Flack's performances of presence and absence in the multiple representations of *Soul to Soul*. But this is mirrored in desire on the part of Ghanaian audiences for an up close experience of African American popular culture. This desire exceeds mere fandom in search of a particular (one might even say peculiar) intimacy. Although Flack had only recently risen to prominence with the 1969 release of her first album, *First Take*, from Atlantic Records, advance press ensured that her reputation only grew in her absence. We can think of this as not unlike poring over the photographs of distant cousins before a family reunion, a means of heightening enthusiasm for the coming encounter. Accra's *Daily Mirror* announced that "critics now rate[d Flack] as greater than Aretha Franklin, the official soul sister No. 1" (Feb. 20, 1971 p.1); *The Ghanaian Times* called her "America's newest soul sister singing sensation" (Feb. 27, p. 4); and her photograph appeared in a full-page advertisement in the *Daily Graphic* (March 3). Although "soul sister" was a commonplace in global black popular culture of the time, this moniker resonated more fully when predicated by the sign of *Mother* Africa, a recurring trope of kinship in pan-African discourses.

The following week, Stella Addo, one of the few female reporters on the *Daily Graphic* staff, reported on both the performance and a preshow interview. Detailing everything from Flack's breakfast menu choices (as specific as her preference for fruit juice with ice cubes) to the color and cut of her leather boots, Stella Addo enabled her readers to embrace Flack in imagined intimacy, and Addo's article also stressed Flack's personal traits of sincerity and honest "expression of one's own experience." After such an enthusiastic introduction in the press, it is no surprise that Ghanaian audiences thrilled at seeing her perform up close.

Contrary to Rob Bowman's liner notes for the 2004 rerelease, the original 1972 film release featured Roberta Flack performing the song, "Gone Away" by Curtis Mayfield and Donny Hathaway, not the more obvious message song, "Tryin' Times." The lyrics are strikingly ambivalent, and the refrain lingers in psychic limbo, unable to resolve either the narrative or the emotional response to it—does she or does she not believe that she has lost her lover, and when?

> You are gone away, I keep telling my mind
> You're not gonna stay
> Yet I believe sometimes I've lost you, baby
> I've lost you, baby, and you are gone.[32]

[32] Lyrics from Roberta Flack and Donny Hathaway, "Gone Away" on *You've Got a Friend/Gone Away*, Atlantic (1971).

This temporally fluctuating acknowledgment of presence and absence is echoed throughout Flack's involvement with the Soul to Soul project. As the press coverage shows, clearly Flack's live *presence* mattered a great deal to both audiences and producers, perhaps even beyond her live *performance*.

The most poignant sequence in the original film follows Flack and Les McCann (who was a great champion of her musical career) walking into the Cape Coast Castle, one of two forts whose slave dungeons have become major sites of pilgrimage for diasporic visitors. The sequence begins with telescoping shots of the architectural details of the castle, evoking for the viewer the experience of being overwhelmed by the space itself. As the two enter the courtyard, Flack makes a comment whose simplicity verges on the banal, but the lowered tone and pitch of her voice indicate the gravity of their encounter with history. "This is a very depressing place and it's oppressive...and just all sorts of unhappy sorrowful things." Clearly, speech is insufficient to express the excessive affective charge of this place. But I would argue that the very plainness of her speech is a truer (if one can say such a thing) representation of the illegibility of such traumatic history than the sentimentalism in Mavis Staples's voice-over, which Dennis Sanders dubbed over footage of the dungeons in the 2004 rerelease. As McCann and Flack walk into the dungeon, the screen darkens to almost complete blackness, except for a window, which, shot facing the sun, glows in preternatural blue, and unseen, Flack is moved to sing the spiritual "Oh Freedom." The film captures her voice singing off-screen, "And before I'll be a slave, I'll be buried in my grave," figuring the thanatic resonances of this space while obscuring Flack's body. The crucial question arises: can Flack's singing here be considered a performance? The very concept of performance presupposes an audience, a dimension of spectacle and display that is abjured in the moment. And does the form of a documentary film disrupt the form, the poetics, of performance to such an extent that this question is unanswerable?

The reasons for Flack's request that all footage featuring her be excised in the 2004 version remain a puzzle. Kevin Gaines reports a conversation with "Mike Eghan, a Ghanaian media celebrity and businessman who served as master of ceremonies for the concert [in which he was told] that Flack was so shaken by her visit to Cape Coast that she was almost unable to perform that evening";[33] but a documentary film is its own integral text, and in this case what is edited out is lost footage that stands outside of the text, so that all that remains of Flack's involvement is her absence. We can only know the reasons for Flack's request through hearsay—overheard conversation. Perhaps Flack's refusal to be included was driven by an aversion to the idea of putting her experience at Cape Coast back into circulation, open to repetition ad nauseum, until this

[33] Kevin Gaines, *American Africans in Ghana: Black Expatriates in the Civil Rights Era* (Chapel Hill: U North Carolina P, 2006), 281.

spectral encounter would become banal after multiple viewings. Perhaps it was the fact that the grand piano on which she performed in the concert itself was horrendously out of tune, affected by the humid outdoor conditions in the stadium overlooking the ocean. Perhaps it was her determination to interrupt the market relations of what another musician has called "a slavery business [where] record owners are slave owners."[34]

Flack might be seen here as a new incarnation of Herman Melville's *Bartleby the Scrivener* as she declares, "I prefer not to" be seen and heard. I am fascinated by her gesture of refusal, an immovable insistence that functions as a kind of guerilla act against the conditions of labor, especially because Flack has earned a reputation for astutely retaining control over how her work is manipulated and sold.[35] Today, the original video is available in fewer than a dozen academic libraries and Amazon advertises a handful of other copies. Thus, one could argue that the public audiovisual documents of Flack's visit to Ghana are so rare that they have effectively been recorded over. Here, another parallel with Mr. Bartleby emerges: just as Bartleby has handled Dead Letters in Washington before adopting recalcitrance as a tactic to efface his presence, Flack dampens her address to the unknown resisting dead, those buried "before [they'd] be a slave" with an equally inscrutable yet powerful refusal to have her performance appear. Recall once more Arendt's notion that action, speech, and performance are necessarily corequisites, and her argument that action requires disclosure, "appearance in the human world."[36] If we accept Arendt's proposition that inaction is effectively death, Flack's non-performance constitutes an echoing and unsettling response to the enduring tomblike structures that seal the slave trade's sentence of social death.

Echolocation Two: The Power of Remembering

Her journey is, nonetheless, reinscribed in the Black Atlantic through Kwadwo Opoku-Agyemang's poem "An Air," which recalls Flack improvising a sorrow song in the "castle's" dungeon. Flack's music is an essential link in a poem cycle where Opoku-Agyemang meditates on resonances in Ghana of the trans-Atlantic slave trade's horrific past. However, Kwadwo Opoku-Agyemang's 1996 collection, *Cape Coast Castle*, in which "An Air" appears, is by far the most sustained local meditation on slavery's toll.[37] I will return to the collection's structure and thematic concerns in more detail below, but turning here to "An Air," we can see how Opoku-Agyemang's privileging of

[34] As Eugene McDaniels put it, as quoted in Michael Anthony Neal's *Songs in the Key of Life*, 12.

[35] Herman Melville, *Bartleby, the Scrivener* (1853) http://www.bartleby.com/129/ (accessed 6/25/11).

[36] Arendt, *The Human Condition*, 159.

[37] Kwadwo Opoku-Agyemang, *Cape Coast Castle* (Accra: Afram Publications, 1996).

song as a means of remembering the Middle Passage resonates with episodes from Maya Angelou's *All God's Children Need Traveling Shoes* and Saidiya Hartman's *Lose Your Mother* when read in tandem.

Throughout the *Cape Coast Castle* collection, diaspora is understood as *Relation*, that is, a cultural fluency rather than a historical or geographical framework. Opoku-Agyemang is acutely aware of the ways that Ghana comes to stand in for the entire continent of Africa, absorbing both the ambivalent longing and the alienation of those diasporans in search of a ground on which to grapple with the ramifications of the slave trade. Thus, the hallways of Cape Coast and Elmina Castles display unique diaspora acoustics, functioning like whispering galleries, where what is said and heard in their dark chambers resonates with disproportionate clarity and amplitude. The physical, architectural, and psychic remnants of the slave trade in Eastern Ghana haunt the poem, "An Air". It begins by posing a quandary. Below the title, which bears an asterisk, a line reads: "*(For Roberta, who sang crying in the dungeons)*." The asterisk directs the reader to a note: "*'An Air: In 1971, Robert Flack descended the closed mustiness of the dungeons and sang enough to cry.*" The title's asterisk—a nod to academic conventions—asks the reader to choose between leaping to the footnote at the bottom of the page for the fine print providing historical context[38] or deferring such disorderly reading until the full poem has been read. And then the parenthetical "For Roberta" opens up an uncertainty about the lyric voice. Is "An Air" offered as a dedication prefacing a poem to memorialize the occasion of her song in an unidentified lyric first-person voice, an imitator paying tribute by identifying with her? Or is it offered as a song composed for her to perform? Resolution of these uncertainties is held at bay, and the punctuation similarly forestalls any sense of easy conclusion. There is not a single period in the entire poem, and what punctuation is used (colons and commas) suggests continuation, something yet to come. Thus, throughout the poem, phrases spill into each other incontinently, like sound overheard, or rather, heard over again, producing an echo effect.

The beginning and end of the poem give its form an echo-effect, which is also apparent on the level of stanzas, lines, and even phonemes. It begins:

I PITCH my ambition
No higher than recitation
My voice: go below and slow
Pay your way as you go (lines 1–4)

and concludes:

I rest my ambition, my voice
A simple air, my tune of choice (lines 33–34)

[38] The note reads, "An Air: In 1971 Roberta Flack descended the closed mustiness of the dungeons and sang enough to cry" (Opoku-Agyemang, 56).

Perhaps coincidentally, the number of lines from start to finish, thirty-four, is the minimum number of meters a sound wave must travel (seventeen meters in each direction) in order to be considered a true echo, with enough distance to create the uncanny effect of hearing the voice of a responding Other, which is in fact a decaying repetition. Setting aside such numerical arcana, what resonates most strongly here with the myth of Echo is the haunting sound of decaying repetition and the denial of a possible reply. The slightly distorted repetitions of phrases and syllables is one strategy used throughout, particularly "my voice," "no higher," "recitation/recital," and "ambition." The difference between the opening quatrain and the final couplet, where the sense does not change much, but the length of the stanza is attenuated, suggests a repeated but decaying sound. The slant rhymes and parechesis in "pitch/ambition/recitation" again create an echo.

It is common, upon discovering a particular spot that echoes, to shout as loud as possible and wait for a "reply." Yet the lyric speaker in "An Air" paradoxically projects not into the open space of performance—auditorium, amphitheater, stadium—but into low, dark, dampened depths: repeatedly urging "my voice: go below." And rather than anchoring to a single place, this speaker calls upon a collectivity to make a journey that almost parallels the Stations of the Cross, reconstructing events in a distant past pausing where "two braves slipped and fell," where the founder of the Asante nation, "Anokye planted his sword of war," where chains "bared their teeth," and yet acknowledging there are "miles and miles to go." In contrasting the castle (equated to resonance) with the counterintuitive "ambition…voice…tune" of *rest*, listening for "the sound of seed going to seed," Opoku-Agyemang echoes Flack's decision to suppress her performance. Or rather, unsettlingly, anticipates her, eight years before the rereleased film appears.

The uncanny, as is so regularly recalled, is the *unheimlich*, the unsettling, that which makes us feel out of place and out of sync. If *Soul to Soul* staged a great and festive homecoming party, the hushed tones with which Kwadwo Opoku-Agyemang and Roberta Flack approached the threshold, "The Door of No Return" hold open the possible disjunctures between origins and returns. Performances end. Audiences cheer. Or jeer. But the unperformed lingers.

An alternate scene of reckoning at Cape Coast Castle unfolds in Maya Angelou's moving meditation in her 1986 memoir, *All God's Children Need Traveling Shoes*. Angelou extended her stay in Ghana by several months following her son's injury in a car accident in 1962, during which period she conceived of and shared her dream of a large-scale concert of diasporic and Ghanaian performers. She closes her account of her sojourn with a vivid window onto the ongoing work of mourning in the coastal Ghanaian communities near the slave castles. She describes how in spite of having "not consciously come to Ghana to find the roots of [her] beginnings" she had been "recognized" as looking Bambara, Ahanta, and Ewe on different occasions. Although these

"recognitions" do not constitute definitive resolution of where her roots lie, they attest to an active memory of the slave trade that motivates the Ghanaians she meets to identify with her. Angelou travels to Eastern Ghana with her host, Mr. Adadevo, who translates during the following exchange with a market woman who mistakes Angelou for a long-lost relative:

> the woman reached out and touched my shoulder hesitantly. She softly patted my cheek a few times. Her face had changed. Outrage had given way to melancholia. After a few seconds of studying me, the woman lifted both arms and lacing her fingers together clasped her hands and put them on the top of her head. She rocked a little from side to side and issued a pitiful little moan....
>
> Mr. Adadevo spoke to me quietly, "That's the way we mourn."[39]

Adadevo goes on to explain to Angelou how the slave trade impacted the residents of Keta village, with several generations witnessing waves of kidnappings, and concludes that "What they saw they remembered and all that they remembered they told over and over."

The market woman recognizes in Angelou a reminder of the traumatic losses her community sustained. For Angelou, discovering that these losses continue to be deeply felt is "simultaneously somber and wonderful." Mourning and exaltation commingle in her reflections:

> Although separated from our languages, our families and customs, we had dared to continue to live. We had crossed the unknowable oceans in chains and had written its mystery into "Deep River, my home is over Jordan." Through the centuries of despair and dislocation, we had been creative, because we faced down death by daring to hope.[40]

Angelou turns to the registers of sentimentality and music to come to grips with her experiences in Ghana, and offers a narrative of overcoming. The vision of solidarity she clings to depends on creating a temporal continuity between her own relationships with Ghanaians and African Americans living in Ghana, on the one hand, and her ancestors who were taken from the continent, on the other. To do this she imagines herself in the place of that ancestor, writing "Many years earlier I, or rather someone very like me and certainly related to me, had been taken from Africa by force" and closes, in the final sentence, by turning yet again to the acoustic: "I could nearly hear the old ones chuckling."[41] It is this imagined acoustic scene where generations are bridged that forms the ground of Angelou's solidarity, and suggests that it may, in fact,

[39] Maya Angelou, *All God's Children Need Traveling Shoes* (New York: Random House, 1986), 204.
[40] Ibid., 207.
[41] Ibid., 208.

only and necessarily be in the imagination that these echoes can be registered, since this is a scene of leave-taking, and a return to black America.

Saidiya Hartman's *Lose Your Mother* (2007) offers a more pessimistic vision of return.[42] She presents a sustained and nuanced consideration of the expectations diasporic blacks bring upon "returning" to Africa, reflecting on her own journeys to Ghana in search of historical traces of the slave trade. While her journeys were in the framework of research rather than tourism, they are informed by similar expectations. She notes that

> [i]f slavery persists as an issue in the political life of black America, it is not because of an antiquarian obsession with bygone days or the burden of a too-long memory, but because black lives are still imperiled and devalued by a racial calculus and a political arithmetic that were entrenched centuries ago.[43]

Her insight here shows that the motivation for African Americans to seek the traces of slavery sometimes have more to do with political and material inequalities in the U.S. than with an interest in establishing or elaborating an ongoing relationship with Ghanaians. This insight is beautifully expanded upon in Salamishah Tillet's book *Sites of Slavery*.[44] Tillet and Hartman's work helps us account for why the emphasis in contemporary diasporan heritage tourism is rarely on pan-Africanism of the sort that Nkrumah's earlier projects took for granted. What does recur is the role that music is imagined to play in what is cast as an otherwise frustrated quest. At the close of her journey, Hartman emphasizes how empty the category "African people" seems in light of the history of slavery, given the fact that warring communities delivered one another into captivity. Having all but given up on finding "any stories or songs or tales about the millions who had been unable to experience flight, evade terror, and taste victory,"[45] Hartman happens across a group of girls playing jump rope. Watching the girls sing and play to the following song:

> Gwolu is a town of gold
> When you enter the circle
> You will be protected
> You will be safe

[42] One leading advocate of Afro-pessimism as a critical stance, Frank B. Wilderson, III, considers Hartman's work to be in the same vein. For more on Wilderson's approach to Afro-pessimism see the bibliography on www.incognegro.org/afro_pessimism.html (accessed 7/14/13).

[43] Saidiya Hartman, *Lose Your Mother: A Journey Along the Atlantic Slave Route* (New York: Farrar Strauss and Giroux, 2007), 6.

[44] Salamishah Tillet, *Sites of Slavery: Citizenship and Racial Democracy in the Post–Civil Rights Imagination* (Durham: Duke UP, 2012).

[45] Ibid., 237.

finally ends her quest, if not satisfying it fully. A young man in the crowd assuages her doubts about the limits of identification when he asserts, "The girls are singing about those taken form Gwolu and sold into slavery in the Americas. They are singing about the diaspora."[46] In this sense, where discourse and historiography have failed to present the traces she is seeking, music offers them up: "Here it was—my song, the song of the lost tribe, I closed my eyes and I listened."[47] It is striking how similar this closing gesture is to Maya Angelou's in *All God's Children Need Traveling Shoes*, suggesting that music bears a unique burden in the diaspora imagination for securing a connection that might otherwise dissolve in contentious discourse.

Soul to Soul Take Three: Repeat After Me

Throughout the *Soul to Soul* film, echo serves as a crucial pedagogical tool for training performers and audience alike how to navigate the cultural gulf between the U.S. and Ghana. The footage of travels in Ghana presents a rich record of how numerous interpersonal exchanges allowed the celebrities to break out of abstractions about "returning to African roots" outlined by one of the concert organizers during the trans-Atlantic flight. A more concrete sense of reconnection emerges in a brief but telling scene in Kumasi where a Ghanaian woman teaches Tina Turner a song by having her echo short musical phrases as they are sung to her. It is precisely the same technology of stereomodernist transmission, echo, that Turner uses to open her set in the Accra concert, inviting the audience to sing back to her *a cappella* in the first lines of her song. As if emphasizing the significance of this form of musical signifyin[g], Turner raises echo to the level of virtuosic performance when she ends her set with a duet with then-husband Ike Turner. Having abandoned lyrics in favor of vocalise, she sings phrase after phrase followed by a pause in which Ike closely or exactly echoes what she has just sung. Blurring the differences and limits between instrumental and vocal performance, the Turners riff on a core shared musical aesthetic of black music on both sides of the Atlantic, what Oliver Wilson has called the heterogeneous sound ideal, or the value placed on keeping different timbres audibly distinct. The audience thrills to their performance. When Wilson Pickett takes the stage for the climax act of the night, he too relies on echo as a technology to secure his audience's enthusiasm, holding the mike to the crowd and leading them in echoing him on the chorus of "nahnahnahnah." Like Tina Turner, Pickett abandons language and its potential for mistranslation in favor of vocalise and a form of musicking that is both familiar and pleasurable to his audience. Echo worked

[46] Ibid., 235.
[47] Ibid.

as a profoundly hopeful and generative musical strategy for the Soul to Soul participants and their audience in 1971.

Echolocation Three: An Acoustic Dilemma

Only a few years earlier, the young playwright Ama Ata Aidoo had struck a different note. As we have already seen in the reading of Ovid's *Metamorphoses,* echo can be a double-edged sword, generating a plethora of new sounds by reflecting an original signal, yet also potentially trapping sound in loops of incommunicative repetition—mimicry at its worst. The risk that African Americans and continental Africans might discover themselves mutually unintelligible is one that haunts the romance of "return" in multiple texts, but perhaps most starkly in Ama Ata Aidoo's precocious play, *Dilemma of a Ghost.* First staged by the Students' Theater at University of Ghana in Legon in 1964 (when Aidoo was but twenty-one), the play traces the unraveling of a romance between a Ghanaian student named Ato and his African American bride, Eulalie, when they move to Ghana and face the challenges of an intercultural marriage. As the play opens, Ato and Eulalie are locked in a heated argument about nothing less than acoustics:

> EU: Don't shout at me, if you please.
> ATO: Do keep your mouth shut, if you please.
> EU: I suppose African women don't talk?
> ATO: How often do you want to drag in about African women? Leave them alone, will you…. Ah yes they talk. But Christ, they don't run on in this way. This running-tap drawl gets on my nerves.[48]

The poetically named Eulalie (née Rush) indeed embodies the meaning of her name, "well-spoken" as she and her husband argue who gets to speak, how loudly, and when. Their marital difficulties are compounded by their perceptions of differing, or more bluntly, competing codes of proper vocal comportment in their respective cultures. In other words, their struggles revolve around the right to speak and the duty to listen, and over whether the voice is an instrument of connection and consonance or of distraction and dissonance. The notion that Eulalie's alienation from her new Ghanaian community turns on the sonic is reinforced by the difficulties Esi, Ato's mother, and her friends have in pronouncing her name, eventually mangling "Eulalie" into "Hurere":

> ESI: Ato my son, who is your wife?
> ATO: [*Quite embarrassed*] Eulalie.
> ALL: Eh!

[48] Ama Ata Aidoo, *Dilemma of a Ghost* (London: Longman's, 1965), 35.

ATO: I said "Eulalie." [*By now all the women are standing.*]
MONKA [ATO'S SISTER]: Hurere!
ESI: Petu! Akyere! What does he say?
THE WOMEN: Hurere![49]

Eulalie, too, finds her new home to be sonically threatening, reacting with fear and bewilderment when she hears drums being played. She notes that unlike the "Spanish mambo" she expected to recognize, these unfamiliar sounds fill her with dread. However, as the play unfolds, Ato's family's reactions to Eulalie's strange-sounding name, and even their initial disdain for a daughter-in-law whose "grandfathers and...grandmothers were slaves" dissipate, and their concern shifts to the fact that the couple remains childless after over a year of marriage. When Ato finally confesses what he has hitherto been mute about, namely their explicit decision to delay starting a family, his parents' opprobrium shifts from Eulalie to Ato. His silence is seen as the failure to create an acoustic of hospitality and mutual understanding. His mother reprimands him by stating a proverb, "No stranger ever breaks the law... [*Another long pause.*] Hmm...my son. You have not dealt with us well. And you have not dealt with your wife well in this."[50] Her judgment implies that as a subject who has chosen to inhabit the contact zone between two cultures, Ato has a responsibility to translate and interpret differences fully enough to ensure that both parties can hear the nuances in each other's voices. A timid voice is not enough, such a cross-cultural trans-Atlantic encounter requires full stereo sound quality. The acoustic pressures of cross-cultural scenes of encounter, and specifically the strains on the human voice of speaking across the divide between Ghana and African America so apparent in Aidoo's 1965 play presciently anticipated similar challenges in productions such as the *Soul to Soul* project.

Soul to Soul Take Four: Freeing Jazz

One highlight of the Soul to Soul concert was a collaboration between soul jazz musicians Les McCann and Eddie Harris and northern Ghanaian percussionist and herbal healer, Amoah Azangeo. McCann had specified before the tour that he would only be interested in participating if he had an opportunity to meet and perform with local musicians. As a result he and his ensemble had a rare chance to improvise with a new musical partner in front of a huge live audience. Placing their faith in collaborative improvisatory aesthetics, the performers risked what was almost a failed moment in the concert (DVD

[49] Ibid., 46.
[50] Ibid., 192.

chapter 14), a moment of not just (mis)recognition, but lack of recognition.[51] Earlier in the film, Les McCann mentions that, like a number of progressive jazz musicians in the late 1960s, he had conducted personal research in order to become well informed about African history and culture. In addition, one might say that jazz performers specialize in the art of recognition, in listening to their ensemble mates closely enough to recognize what chord quality, groove, harmonic language, and even formal innovations they are favoring in order to improvise in a stylistically consistent and convincing manner. But the pleasure of jazz also depends on the audience recognizing the familiar, and thus the innovative departures from that familiar. The film shows Ghanaian audience members shifting uncomfortably as saxophonist Eddie Harris plays unfamiliar avant-garde reed noise after having won the audience over in a funk blues performance. As sophisticates of Accra, this audience seems unprepared to see Azangeo, a Northern Ghanaian from the far less industrially developed region of Bolgatanga, perform alongside the international guests to such acclaim. The audience reaction shifts when the musicians begin not only collaborating but also trading fours.[52] What the audience hears and recognizes is a conversation producing something entirely new. The musicians on stage, and on another level, the audience members, are all engaged in an acoustic exercise in sustained openness to the Other, a call-and-response that requires recognizing not only their points of unison but also their dissonances, allowing a compelling performance on stage to connect with listeners who have already sat through several hours of music.

This scene is worth lingering over. As chapter 14 of the DVD begins, Les McCann introduces the new piece, saying: "We have a new song, and on this we'd like to feature a great friend and a great musician, from Ghana, he's fantastic, and you must, as we have to do at home, learn to honor our black heroes, right on. You have one right here in Ghana, his name is Amoah." The piece opens with a hand-drumming solo by one of Harris and McCann's American band mates, and then the startling sonorities of Harris's solo distorted tenor saxophone reed outline a minor melody whose contours are equally strange. Not only does the drummer squint as he looks on, but the camera cuts to two elegantly dressed young Ghanaian women, who point and whisper, evidently trying to make sense of the odd sounds they are hearing (chapter 14: 2.15). The audience is awkwardly quiet, with no sign of recognition, and only an

[51] I am borrowing the concept of "(mis)recognition" here from Kenneth Warren. He elaborates on both the hazards and the productive potential of (mis)recognition in an influential essay, "Appeals for (Mis)recognition: Theorizing the Diaspora," in *Cultures of U.S. Imperialism*, edited by Donald Pease and Amy Kaplan, (Durham: Duke UP, 1993), 392–406.

[52] "Trading fours" is technique in which jazz musicians consistently alternate brief solos of preset length (for trading fours, four bars; musicians may also trade twos, eights, and so forth). Trading fours usually occurs after each musician has had a chance to play a solo, and often involves alternating four-bar segments with the drummer.)

occasional chuckle or shout of amazement. This is especially ironic given that Harris was a member of a generation of musicians, including John Coltrane, Pharoah Sanders, and Randy Weston, who took a keen interest in African and other non-Western musics and saw their approach to timbre as reflecting African musical aesthetics.

When Harris ends his phrase, Azangeo begins with a dramatic solo riff on the *shekere* (a percussion instrument made from a gourd filled with sound-producing grains), and the audience instantly comes alive, cheering and applauding as the rhythmic energy builds. He sings a few lines in a local vernacular, and then begins to mimic the saxophone's timbre by singing sotto voce, halfway between humming and his full voice. In fact, he distorts Harris's musical message in order to recognize it, respond to it, and return it to Harris and the audience in a form made available to the reinterpretive energies of improvisation. As jazz scholar Ingrid Monson would put it, these instrumentalists are "saying something," extending rhetorical gestures from competitive, largely homosocial speech acts, such as playing the dozens, to a new and highly charged musical context. It is the logic of the interaction, the call-and-response, the give and take, the collaboration among ensemble members that wins over the audience, and allows them to make the connection, Soul to Soul. The collaboration was an important moment in the trajectory of Azangeo's career, as he went on to join Faisal Helwani's group, Basa-Basa. John Collins has noted that while the group's name means "pandemonium" in Ga, the "fusion of the Ewe Agbadza beat with Fra-Fra music was one of the most exciting features" of the group.[53] Clearly, Azangeo's experiences improvising with the soul jazz idiom of Harris and McCann informed his ensuing musical experiments.

Echolocation Four: Brathwaite's West African Jazz

It is tempting to read this performance as an affirmation of the utopian potential of jazz in live performance. However, I would argue that the gifts, risks, and even limitations of jazz displayed at the Soul to Soul concert were already apparent in the early work of Bajan-born poet, Kamau Brathwaite. While *Africa in Stereo* has focused thus far on African American and African figures, I include Brathwaite here because his poetry and poetics theorize a way to think tidalectically around the entire Black Atlantic, and because it is precisely his sojourn in Ghana that informs his own turn, first to oral literary tradition, and then to jazz, as steps on the way to "nation language." In turning to the Caribbean, it is also worth noting that by far the most influential of the musical acts in the Soul to Soul concert, Santana, was warmly received precisely

[53] Collins, *Highlife Time*, 264.

because his Afro-Cuban and Latin rhythms struck a chord with the historic links between West Indian and highlife music.[54] In 1955, (then Edward) Kamau Brathwaite left England for the Gold Coast, where he would spend the next seven years, witnessing its metamorphosis to the independent state of Ghana, which he left in 1962.[55] His stay followed close on the heels of Richard Wright's visit to Ghana, which Wright chronicled in his book *Black Power* (1954), and anticipated the arrival of other prominent diasporans, as we have already seen. Upon returning to the Caribbean, he published three long poems in short succession: *Rights of Passage* (1967), *Masks* (1968), and *Islands* (1969). They were later published as a trilogy, *The Arrivants* (1973).[56] During these same years, he composed his influential essay "Jazz and the West Indian novel" (1967–68). The very structure of the trilogy, which traces an arc from the blues and jazz references that dominate the first, to the African focus of the second, to a distinctly West Indian set of references in the third, maps the itinerary of a pilgrimage. However, by making the Caribbean *Islands* rather than Africa the final resting point, the arc challenges the idea of Africa as a site of return, and the journey to Africa as an end in itself; rather than imagining such a journey as bridging the gaps of the Black Atlantic, Brathwaite's collection demonstrates how his sustained engagements with Ghanaian (particularly Akan) oral and musical culture enriched his own poetics of voice, grounding his search for "nation language" and a more durable vision of solidarity. The practice of mining oral literature, which *The Arrivants* initiated, would become a recurring and central aspect of his approach to writing, and his chosen metaphor of tidalectics a model for the tactic of drawing from fluid waveforms (oceanic or sonic) to theorize repetition and difference in the Black Atlantic. Significantly, his sojourn in Ghana did not represent a failed return, but rather a turning point where borrowing liberally from a range of African and Afro-diasporic sources—Akan poetry, jazz, blues, calypso—was generative of a new pan-African poetics, one that continues to influence global black writers as evident in Ngugi waThiong'o's use of the closing words of *The Arrivants* as the title of his 2009 monograph *Something Torn and New: An African Renaissance*.

The sonic world was summoned through references to both music and oral literature. In the first book in the trilogy, *Rights of Passage*, the titles of individual sections make clear Brathwaite's interest in diasporic musical form as a conceptual template. The first section, "Work Song and Blues" begins with

[54] See Collins, *Highlife Time* and "The Impact of African-American Performance on West Africa from 1800" http://www.bapmaf.com/wp-content/uploads/2011/10/African_American_Performance_Impact_on_West_Africa_From_1800.pdf (accessed 7/28/12).

[55] Brathwaite is, of course, an exception to my focus on African American writers. His extended career in the United States and the need for a more hemispheric approach to American studies inform the inclusion of his work.

[56] Kamau Brathwaite, *The Arrivants: A New World Trilogy—Rights of Passage/Islands/Masks* (Oxford: Oxford UP, 1973).

a "Prelude" whose first line, "Drum skin whip" is soon followed by the manifesto: "I sing/I shout/I groan/I dream" (lines 6–9). These lines literally prioritize song before speech, and suggest that the sonic precedes the oneiric; in this poetry sound initiates poetic vision and it is only by sounding out one's position that one can gain the "right of passage" to arrive at a new poetic language. The vernacular of African American spirituals echoes in the names of other poems in this first section even when this music is not referenced explicitly, in titles like "New World A-Comin'" and "All God's Chillun," while the blues and roots music are evoked in references to drums, "the slow guitar," violin, and "cotton blues."[57] The poems increasingly blend African American and Caribbean English usages, as in the poem "Folkways" where Louis Armstrong gets a West Indian dressing down:

> To rass
> o' this work-song singin' you singin'
> the chant o' this work chain
>
> gang, an' the blue bell
>
> o' this horn that is blowin' the Lou-
> ee Armstrong blues; keep them
> for Alan Lomax, man, for them
>
> swell
>
> folkways records, man,
> that does sell for two pounds ten. But get
> me out' a this place, you hear....[58]

Echo enters as an important compositional device in the final stanza, which poses a question in "Folkways:" "Ever seen/a man/travel more/seen more/lands/than this poor/land-/less, harbour-/less spade?"[59] which is answered in the final stanza of the next poem, "Journey:" "Never seen/a man/travel more/seen more/lands than this poor/path-/less harbour-/less spade."[60] In search of music that will resonate rather than repel him, the lyric speaker adopts Echo for the larger structure of this first book, closing *Rights of Passage* with a similar gesture in "Epilogue," which repeats a slightly altered version of the opening stanza "So drum skin whip....I sing/I shout/I grown/I dream"[61] However, where flame and fire imagery dominated the opening poem "Prelude," the dominant imagery here is of water, "old negro Noah"[62] the rivers "Pra,/Volta, Tano"[63] and rain. The reference to water cannot help but conjure up a threat

[57] Brathwaite, *The Arrivants*, 12, 23–24.
[58] Ibid., 32.
[59] Ibid., 32.
[60] Ibid., 40.
[61] Ibid., 81.
[62] Ibid., 82.
[63] Ibid., 84.

worse that flames for the diasporic voice here; evoking the Middle Passage, the final lines of *Rights of Passage* warn that at the threshold of The Door of No Return, "There is no/turning back."[64] One could read this as an *ars poetica* statement claiming for echo a purpose that exceeds the seeming limitations behind the *Metamorphoses* story.

In a diasporic context, echo can also be seen as a sonic version of *Sankofa,* the bird in Akan lore. As a cultural principle, *Sankofa* is regularly translated as "go back and fetch it" and associated with the Akan aphorism: *Se wo were fi na wosankofa a, yenkyi.* [Literal translation: There is nothing wrong with learning from hindsight]. It is symbolized by the Adinkra symbol of a mythical bird that flies forward with its head turned backward. While originally indicating the Akan belief in past tradition as a necessary resource for present decision making, it has become a powerful symbol for diasporans conceptualizing a relation to Africa, particularly since the release of Haile Gerima's film *Sankofa* (which I discuss further below) in 1993. For Brathwaite, echoing stanzas that he has used earlier in his poetry collection allows him to perform the act of returning to past forms in new contexts, a poetics of repetition with a difference closely aligned with *Sankofa's* meanings for the diaspora.

The second book of the *Arrivants* trilogy, *Masks,* provides the clearest indication of Brathwaite's interest in adapting Akan oral literature to the written page. Maureen Warner-Lewis has traced Brathwaites many citations of Akan poetry transcribed and analyzed in musicologist J. H. Nketia's *Voices of Ghana* and anthropologist R. S. Rattray's *Ashanti.*[65] She notes similarities, for example, in Rattray's transcription of a work prayer: "when I work let a fruitful year come upon me, do not let the knife cut me, do not let a tree break and fall upon me, do not let a snake bite me"[66] and Brathwaite's version in "Prelude" in *Masks*:

> And may the year
> this year of all years
> be fruitful
> beyond the fruit of your labour
> shoots faithful to tip
> juice to stem
> leaves to green;
>
> and may the knife
> or the cut-
> lass not cut
>
> me.[67]

[64] Ibid., 85.
[65] Maureen Warner-Lewis, "Odomankoma Kyerema Se" in *Caribbean Quarterly* 19.2 (June 1973): 51–99.
[66] Brathwaite, *The Arrivants,* 215.
[67] Ibid., 92.

Warner-Lewis states that "[T]here are enough verbal echoes between these two extracts to conclude that Brathwaite fashioned poetry out of Rattray's anthropological data."[68] She illustrates how sections of "The Making of the Drum" transcribes Nketia's "Awakening, or Anyaneanyane" a prayer with which a drummer begins to play in an Adae festival and how Brathwaite's "Atumpan" begins with a word-for-word citation in Akan of Rattray's "Drum History of Mampon." The second portion of "Atumpan" is a free translation including more repetition than the original, which Warner-Lewis suggests slows the pace of the poem, connoting the hard work, patience, and dignity of work. I would add that Brathwaite's translation also weaves a more permeable connection between the Akan and English version.

Interspersing Akan and English conjures a stereophonic space where both languages sound in the presence of each other, portraying the multilingual metamorphoses of tradition in decolonizing Ghana via stereomodernist rehearsal of durable oral cultural forms. Rattray's transcription "Odomankoma 'Kyerema se/Odomankoma 'Kyerema se/" becomes Brathwaite's "Odomankoma 'Kyerema says/Odomankoma 'Kyerema says// The Great Drummer of Odomankoma says/The Great Drummer of Odomankoma says" and his final lines intersperse Akan and English: "we are addressing you/ye re kyere wo/we are addressing you/ye re keyere wo."[69] In other words, like an echo, where the original signal enters the same acoustic field as its reflections and the sounds become intermingled in a single sonic field, Brathwaite's poetic intervention creates a space where Akan and English resonate and intersect freely and repeatedly. Thus, the poem figures the poetic strategy of echoing as form of stereomodernism, drawing from and reconfiguring the boundaries of oral culture in print.

The final part of the trilogy, *Islands*, also takes up the problem of origins. The last section called "Beginning" starts with a poem entitled "Jou'vert,"[70] taking its title from the day before the Christian calendar's Mardi Gras, which is, itself, the day before Ash Wednesday and the first of Lent's forty days before Easter. In other words, "Jou'vert" is by definition an opening gesture, the ultimate anacrusis, a move that preempts closure for this long cycle of poems and suggests that the recurring and recursive act of soliciting answers from invisible shores (to recall Warren's phrase) replaces the possibility of completing both the journey back to (or back from Africa), and the work of diasporic mourning. The poem employs repetition and the material sounds of percussive /ba/ and /bu/ syllables in the phrase "bambalula bambulai" to achieve an incantatory effect. The *Dictionary of Caribbean Usages of English* explains that "Bambalula bambulai" is not from a Ghanaian language, but rather describes the phrase as an example of "echoic language," and glosses it as evoking

[68] Warner-Lewis, "Odomankoma Kyerema Se," 63.
[69] Brathwaite, *The Arrivants*, 98–99.
[70] Ibid., 267–70.

drumming. Brathwaite's introductory lines convey this very sense, even as they make present the gruesome tortures of slavery, perhaps inviting the possessing spirits of the enslaved through repetition:

> *bambalula bambulai*
> *bambalula bambalulai*
>
> stretch the drum
> tight hips will sway
>
> stretch the back
> whips will flay[71]

It is the material sound itself, whether in the striking of the drum and other percussion or in the stinging articulation of whip-hide against taut skin that renders present the spirits of human beings and gods. Evoking, in the person of Christ and the recurring indicators of a Lenten temporality, an interstitial mode of existence that hovers between personhood and godhead, the poem pushes away from this imagined incarnation into a field of symbols and metaphors where not only human bodies but also nature's objects—boulders, lightning, pools, and flowers—are all open to the mysterious and enlivening beat of a divine rhythm:

> kink the gong gong
> loop and play
>
> ashes come
> and Christ will pray
>
> Christ will pray
> to Odomankoma
>
> Nyame God
> and Nyankopon (lines 10–17)

On the one hand, in Brathwaite's terms, these elements of nature represent a pristine world infused with godlike power and presence, a landscape that bears enough similarity in its primordial purity to evoke an implicit continuity linking the Africa of Nyame God to the wider reach of Christendom. Yet on the other hand, this landscape is not entirely divorced from the man-made interventions of agriculture and construction called forth in the last section of the poem, suggesting that the elemental power accessed through nature serves to infuse the everyday with a divine beat, rather than to mark its banality as separate from the sacred. Note that it is material sound, and specifically rhythm, that is the vector of this power in Brathwaite's poem:

[71] Ibid., 267.

flowers bloom
their tom tom sun
heads raising
little steel pan

petals to the music's
doom

as the ping pong
dawn comes

riding
over shattered homes

and furrows
over fields
and musty ghettos
over men now . . .

making
with their

rhythms some-
thing torn

and new (lines 47–60; 73–77)

What is important (in the context of African diaspora-continental relations) is that the site of rupture is not a place of failure or unintelligibility, a terrifying void, but rather an intentional opening, something *made* with rhythm (*poesis*), "torn/and new." This is an exhilarating place to leave the reader at the end of this final poem in the collection. I would propose that this moment of openness to the other is the site and instant where diaspora logic can be activated. Subjects of African heritage—whether on the continent or abroad—are not "bound/to black and bitter/ashes in the ground" (lines 68–70), the deadening traces of essentialized identities, rather, they can be startled by the recognition of both the familiar and the utterly unknown in the (black) Other and invited to respond with the act of "making/with their rhythms some-/thing torn/and new."

Brathwaite's resonance in Africa is apparent in Ghanaian authors who share his interest in jazz as generative of poetics, particularly Kwadwo Opoku-Agyemang, whose poem "An Air" we have already analyzed. Opoku-Agyemang demonstrates his encyclopedic knowledge of the jazz musical tradition in poetic tributes to musicians Cecil Taylor, Abbey Lincoln, and Thelonious Monk, among others. In addition, the fact that he has written extensively about the slave trade's impact on Africa, both in essay and poetic forms, places his work in dialogue with the scholarly-creative dynamic

in historian-poet Brathwaite's work. Excavating an African perspective on the slave trade and diasporic music are the two most dominant themes in his 1996 collection, *Cape Coast Castle*. Some of Opoku-Agyemang's awareness and sensitivity to diasporic cultures developed during years as a graduate student at York University[72] in Toronto, Canada, and he regularly teaches courses on African American literature as a professor of English at the University of Cape Coast in Ghana. An essay that appears both in journal format and as the introduction to *Cape Coast Castle* investigates the castle as both edifice and metaphor, stating:

> Slavery is the living wound under the patchwork of scars. A lot of time has passed, yet whole nations cry, sometimes softly, sometimes harshly, often without knowing why.... The slave trade persists in its effects: pain without form, drilling, alone, without kin; thus the persistence of the lament even in our happiest love-song; love, the common Akan saying goes, is death.[73]

The imaginative work of Opoku-Agyemang's poetry makes palpable the continuing effects of the slave trade, which he believes are exacerbated by the rarity with which they are discussed publicly.

In the final poem, "Dancing with Dizzy or Manteca by Mr. Birks," the Afro-Cuban infused jazz of Dizzy Gillespie connotes the power to raise energy, foster movement, and even occupy space. The poem's choice of "Manteca," meaning butter or lard, and associated with the production and export of lard from the eponymous Jamaican Montego Bay, further inscribes the Caribbean in Opoku-Agyemang's field of reference. A dually gendered singer in the second stanza, for example "steps all over the chorus/And swallows a stanza in double time," while "the dancers shake every step with glee/Men and women startled by their own bodies" are, in a sense, also startled by the power of music to dissociate bodily and psychic experience, creating openings for other forms of identification and solidarity. The final lines are even more startling in light of the foregoing discussion. Not only does "the trumpet [crowd] the floor/ [Slashing] back and forth," the music opens up a crucial gap in the sense of an articulation Brent Edwards has theorized. The final lines of Opoku-Agyemang's poem are worth examining more closely:

> His cheeks in a dizzy bulge
> He blows, clutching fire in his teeth
> His faith is fluid and off known keys
> Diz diz diz and dat . . .
> Between tunes silence enough
> To waken a sleeping river

[72] In an interview I conducted with Opoku-Agyemang on March 9, 2007, he stated that time spent in the diaspora (particularly Canada) exposed him to the wide range of musicians he mentions in his poetry.

[73] Opoku-Agyemang, *Cape Coast Castle*, 23.

> And command it march forth
> Singing like the flood.[74]

The fissure that opens with the transition from "diz" to "dat" is in fact a silence, a gap in the moving music, which allows a body of water perhaps not unlike Angelou's "Deep River" to sing forth its truth, a unity which, as Brathwaite has put it elsewhere, is "submarine."[75]

While Brathwaite imagines a submarine unity, the poetry of his longtime friend and colleague, Kofi Anyidoho traces paths for such solidarity along air routes and itineraries of black urban centers. In the process Anyidoho critiques the ways that, long after independence, colonial powers continue to shape trade possibilities and force dependencies that follow these same routes. Anyidoho, too, combined scholarly pursuits as an English professor and director of the Institute for African Humanities at the University of Ghana, Legon with a long career as a poet, and the diaspora has figured in his poetry for at least twenty years. While his graduate studies in the U.S. may have been the genesis of his interest in the diaspora, Anyidoho has continued to deepen these ties, culminating in 1998 when he led an international group of scholars (including Saidiya Hartman) on the African Humanities Institute project, "Memory & vision: Africa and the legacy of slavery," involving African and American faculty. The project resulted in a fifteen-segment television documentary and also inspired Hartman's *Lose Your Mother*. The experience that leaves the deepest diasporic trace on his poetry, however, is a trip made to Cuba and the Dominican Republic in 1990, which he reflects upon in *AncestralLogic & CaribbeanBlues,* completed during his residency as a Rockefeller Visiting Faculty Fellow at Cornell University's Africana Studies and Research Center. One of Anyidoho's signature poetic practices is the republication of selected poems from earlier collections in subsequent works, staging an ongoing conversation with himself, a form of echo-writing, and this collection is no exception.

In his introduction to *AncestralLogic and CaribbeanBlues,* Anyidoho describes a encounter with Father Tujibikile, a Zairean priest serving in the Dominican Republic, who described the vexed diaspora-Africa relation as a "logica ancestral":

> How do our people, trapped as they are in this 20th century sugar planta-
> tion colony, how do they celebrate life in a land where all people of African
> decent [sic] are mislabeled *Indios,* and you could not call yourself a Negro no
> matter how far you insist on journeying into Soul Time.[76]

In many ways, Anyidoho's entire collection which takes its title from this *logica ancestral* is an attempt to come to terms with the paradoxes of African heritage

[74] Kwadwo Opoku-Agyemang, *Cape Coast Castle* (Accra: Afram, 1996)

[75] Kamau Brathwaite, *Contradictory Omens: Cultural Diversity and Integration in the Caribbean* (Kingston: Savacou, 1974), 64.

[76] Kofi Anyidoho, *AncestralLogic & CaribbeanBlues* (Trenton: Africa World Press, 1993), xiii.

in the Caribbean, to make sense of this ancestral logic, and to make a journey into the Soul Time that joins Africa and its diaspora.

One example of Anyidoho's linking his books by echoing selected poems is "Earthchild," the title poem in the 1985 collection, which appears in a slightly reworked version in *AncestralLogic & CaribbeanBlues*.[77] "Earthchild" thematizes diasporic music with references to the jazz of Miles Davis and the soul music of Donny Hathaway. During a 2006 interview with Anyidoho in Accra, I asked about the genesis of the poem and what jazz meant to Anyidoho. He responded:

> That poem came out of, I was in Austin at the time and I was invited to give a talk in Dallas, TX and after the presentation there was a small gathering. Not the usually excited, slightly rowdy kind of party, but a very quiet, reflective kind of situation where they played music, jazz, and for me perhaps it may have been the first time I really just listened. Yes, I had heard jazz often, but I wasn't sure that I really ever truly listened to jazz the way I did that night. And some particular numbers by Miles Davis, the *Kind of Blue* album, and then a Donny Hathaway album, it sort of just sank in. And I think I went back to Austin, and literally on the way back or soon after I went back it came. So there was a very clear, very definite connection there. And the meaning of jazz then took on all kinds of significance for me. Because there is the sense in which we talk of jazz as noise, some kind of noisy reaction. Well, there are different kinds of jazz, but on the whole we begin to understand how jazz came into being, and what it means to individual artists and the individual listener, and above all the community as a whole, whose experience is being refracted through the prism of this musical structure. So that's basically it. I can't remember the year, but this would have been sometime in 1981, 1982, thereabouts, perhaps '83, but the early 80s.[78]

In the interview, Anyidoho makes clear that the gathering emphasized the "community as a whole," among diverse black folk from the diaspora and from continental Africa. The "musical structure" of that evening became the "prism" through which Anyidoho could think and imagine the potential of the unique historic relationship between diaspora and continent.

"Earthchild" begins with an italicized chorus that recurs six times throughout the poem, framing all that follows in an almost cinematic frame of heroic resistance against unnamed risks:

> *And still we stand so tall among the cannonades*
> *We smell of mists and of powdered memories....* (lines 1–2)

Throughout the poem, repetition of block quotes or individual words serves to emphasize its potential as an oral and aural medium, creating the effect of

[77] Kofi Anyidoho, "Earthchild" in *AncestralLogic & CaribbeanBlues*, 19–23.
[78] Kofi Anyidoho, personal interview, June 7, 2006.

a ritual through formal strategies borrowed from song and evoking the structure of echo so prevalent in Black Atlantic expression. The poem continues in regular typeface in the same quasi-mythic tone, with no time markers, heavy use of definite articles, and capitalization for the nouns "Earth" and "Locust Clan," raising both to the status of proper nouns. The language evokes a scene of origin:

> Born to Earth and of the Earth
> we grew like infant corn among the Locust Clan
> we gathered our dawn in armfuls of dust
> we blew brainstorms in the night of our birth. (lines 3–6)

The threats against which the "we" in the poem must stand strike primarily at memory and the voice, as in the vivid line "Termites came and ate away our Voice" (line 7). The Voice, in particular, is bound up with authenticity, since it is replaced by howls, screams, and "the rancid breaths of priests." This betrayal (implicit in the word "rancid") is followed by the only variation on the refrain: where the line has begun with "and" in the previous two iterations, this time the aspect of opposition is emphasized by changing the line to *But still we stand so tall among the cannonades.* Even repetition turns out to be untrustworthy with this false copy. This version of the refrain is followed by the first appearance of a purely incantatory stanza:

> EarthChild EarthChild EarthChild
> SeyamSinaj SinajSeyam SeyamSinaj
> EarthChild EarthChild EarthChild (lines 18–20)

It is hardly a coincidence that reversing the letters in the second line of this stanza spells out the name of the noted expert in Francophone literature of the African diaspora, Janis Mayes, who is a friend and colleague of Anyidoho's.

Shifting back to free verse, the lyric speaker addresses in the second person a figure animated by Song, and significantly it is jazz that provides the common ground for the lyric speaker and his addressee to meet:

> You sought my Soul I sought your Soul so long
> in cross rhythms of Jazz in polyrhythmic miles of Jazz
> till Miles our Davis led us through the rumbling weight of
> Drums
> I found I lost you again to wails of Saxophones
> lost found you again in booming hopes of God's
> Trombones (lines 29–35)[79]

[79] Anyidoho, like Senghor in chapter 2, taps not only the musical tradition of jazz, but also the African American literary tradition of privileging music in text, citing the very same James Weldon Johnson's poem cycle, "God's Trombones."

In spite of the contingency of the connection, the poem celebrates the metaphor of "our history braided on you[r] head/all woven into cross rhythms of hair" (lines 45–46). The image evokes a magnificent weave of musical and visual images, and the connection also proves to be global, encompassing

> …all alleyways of old London and Paris and
> Lisbon
> And in all harlemways of New York Chicago New
> Orleans
> in Kingston-Jamaica Havana in Cuba Atlanta in
> Georgia (lines 50–55).

and most crucially Haiti (whose name is repeated nine times, honoring its vanguard role as the first independent black republic). After another stanza of EarthChild incantation, there is a stanza that closely resembles the stanza about Miles Davis and jazz; however, rather than simply echoing the same lines, Anyidoho signifies by using repetition with a difference, introducing several subtle deviations. The most notable is the addition of a reference to "Donny Hathaway checking out so soon so young/so good" (lines 70–71). *Soul* makes a signal appearance, here introduced metonymically through the reference to Hathaway's soul music. Three stanzas later, souls make a second, more literal, appearance:

> Some swear there will be mountains washed to sea
> seagulls flying through our whispered dreams
> pains so deep in granite walls of Souls
> corncobs left half-burnt from blazes in our mind (lines 82–85).

In the context of Ghana and the diaspora, the granite walls cannot but evoke the haunting walls of slave dungeons like Elmina and Cape Coast. Yet Anyidoho strikes a note of hope in his closing lines:

> *And those who took away our Voice*
> *Are now surprised*
> *They couldn't take away our Song* (lines 99–101).

It is remarkable that while the embodied grain of the voice falls prey to the risks evoked in the opening lines, Anyidoho assigns staying power to "our Song," the composition, the platonic musical object that exists as what Oliver Sachs might call an "earworm," a trace of aural memory. Here, the acoustic imagination is able to forge an enduring connection that exceeds the losses of history, and the traumas of the slave trade.

Yet, Anyidoho insists that such connections do not expiate so much as overcome the always palpable differences of cultures, histories, nationalities, geographies. The closing lines of "Havana Soul," a poem in the same collection, closes not by predicting a coherence or ease of association, but in

acknowledging that "all our journeys must always take us/away from destinations into disLocations" whose end is a project of renavigating, or, redefining diaspora.[80] In this project, the only route linking Africa, the Caribbean, South and North America, and the many other regions through which black folk and their allies wander, is one that must reckon with the Middle Passage, that historical landmark of the triangular slave trade that is the Atlantic Ocean.

Anyidoho uses the term *Africana* to identify a "structure of feeling" (as Raymond Williams might put it) that grounds political and intellectual solidarity among diverse black populations. Steering through troubled waters, Anyidoho writes "With AfricanaAirways, we can renavigate the Middle Passage, clear the old debris and freshen the waters with iodine and soul-clorine [sic]." He calls not for a papering over of difference, some kind of hastily constructed bridge over troubled waters, but rather for a clearing of old debris, a freshening of waters, a searing chemical treatment, even. In more prosaic terms, his metaphors describe a kind of truth and reconciliation process, which leads to a fundamental reevaluation of the meaning of history's "debris." Earlier in the poem he notes that the Middle Passage as an air route is haunted by continuing colonial relations that restrict access to technology and mobility:

> CubanaAir must take me first to Gander of the intemperate North.
> Then South to Madrid of the arid lands.
> And AirFrance into Paris.
> And SwissAir into Zurich. And on and on
> to the GoldCoast via the IvoryCoast,
> those sometime treasure lands where now
> we must embrace the orphan life in small measures of foreign aid.[81]

Rather than allowing the geopolitical distribution of capital and power to determine the kinds of intellectual and artistic connections possible, Anyidoho suggests that AfricanaAirways is essentially a creative project, mapping physically impossible routes that nevertheless mark solidarity, reconnecting "the only straight route from Ghana to Havana to Guyana/and and[sic] on and on to Savannah in Georgia of the deep deep South." It is a process that must be undertaken as the work of the imagination. He closes his poem with the lines:

> And our journey into SoulTime
> will be
> The distance between the Eye and the Ear.[82]

In much of Africa the "vernacular" has long been the local language that is not recorded, or at least belatedly recorded, in print. This has been generally

[80] Kofi Anyidoho, "Havana Soul" in *AncestralLogic & CaribbeanBlues*, 14–17.
[81] Ibid., 17, lines 63-69.
[82] Ibid, 17, lines 81-83.

taken to be the case, even in situations like Ghana, where the tradition of Adinkra symbols are obvious evidence of ideographic repertoires. Thus, when the poet Anyidoho evokes the distance between the Eye and the Ear, he is referencing in part the tension between written and oral poetry. However, rather than resolving this tension by privileging one over the other, this poem invites us to a journey whose time scale is something other than what we have known, a journey inside our minds to where our imaginations can take us, whose circulatory boundaries are the Eye and Ear, the visual and the auditory.

Soul to Soul Take Five: When the State Listens In

The *Soul to Soul* film is certainly a celebration of the unity (whether submarine, aerial, or sonic) that binds communities of African heritage together especially powerfully through music. However, it is also a remarkable document of some of the contradictions between local, national, and transnational forms of collectivity. One of the clearest signs of this tension is visible in the numerous scenes of police control throughout the film, and particularly during the concert itself. From the very first arrival scene on the airport tarmac, with individual policemen standing by in their khaki uniforms to the black-uniformed officers at the stadium's opening libation ceremony, these shots serve as a reminder of the state's presence and ambivalent role as facilitator (through the Ghana Arts Council's support) and surveillance. The exuberant energy of the live performances reaches a climax in Wilson Pickett's final number, and as he repeats the lyric "One more time" over a full-band vamp, the mounting musical tension is visually mirrored by the footage increasingly focused on the audience dancing as close to the stage as possible with a line of black- and khaki-uniformed police trying to keep the audience from mounting the stage. Eventually, these efforts at police control fail, and the scene ends with shots of three young Ghanaian fans dancing on stage, one having removed his shoes the better to get down. While my discussion of the Joseph Project explored how state policy tried to adopt and manipulate the music and narrative of transnational black solidarity for its own ends, these scenes show the subversive potential that live performance can release to complicate top-down efforts to control and channel such energies. This potential for almost manic defiance and creative chaos is a dimension of live performance that differs fundamentally from the more mediated forms of cultural exchange seen in the South African transcriptions, Senghor's musical rapportage, and the magazines and films discussed in the foregoing chapters.

Echolocation Five: *Sankofa* Standing Guard at the Slave Dungeons

If the *Soul to Soul* film shows the police as controlling movement and use of public space, the opening and closing scenes of Ethiopian-born filmmaker, Haile Gerima's, 1993 film *Sankofa,* capture a contest over who should be the rightful caretakers of Ghana's *lieux de mémoire* associated with the slave trade. A ululating male voice and drums beating at rapid tempo break the silence, as the credits begin at the start of the film. As Robin D. G. Kelley reminds us in his study of diasporic-continental ties in jazz, *Africa Speaks, America Answers*, the drummer who plays the spiritual guardian of the unnamed slave dungeons behind him (a composite of Cape Coast and Elmina castles) is the Ghanaian-born jazz innovator, Kofi Ghanaba (formerly Guy Warren).[83] We hear him call "Sankofa!" naming a defining structure of feeling that binds diaspora and continent. The first image seen is of a statue of a mother and child, and a close shot reveals the macabre detail of chains around the mother's neck. As the credits roll on, we immediately sense the pan-African scope of this project, as the names of Ghanaian, Nigerian, Caribbean, and North American participants scroll by. A sculpture of the backward facing bird associated with the expression "Sankofa!" comes into focus as the music is overlaid by an urgent whispered off-screen voice:

> Spirit of the Dead, Rise Up! Lingering spirit of the dead, rise up and possess your bird of passage. Those stolen Africans, step out of the ocean, from the wombs of the ships and claim your story. Spirit of the dead, rise up. Lingering spirit of the dead rise up and possess your vessel. Those Africans shackled in leg irons and enslaved, step out of the acres of the cane fields and cotton fields and tell your story.... Those lynched in the magnolias, swinging on the limbs of the weeping willows, rotting food for the vultures, step down and claim your story. Spirit of the dead, rise up. Lingering spirit of the dead, rise up and possess your bird of passage. From Alabama to Suriname, up to the cays of Louisiana, come out you African spirits, step out and claim your story...you African spirits, spirit of the dead, rise up, lingering spirit of the dead, rise up and possess your bird of passage.[84]

As the action begins, Ghanaba, clad in white, along with ceremonial white body-paint, calls out, "Wute! [Listen]" and declares that "the Almighty created the Divine Drummer."[85] Clearly the drum, and the act of listening are foundational to the origin narrative worked out here, and we also see music playing

[83] Robin D. G. Kelley, *Africa Speaks, America Answers: Modern Jazz in Revolutionary Times* (Cambridge: Harvard UP, 2012).

[84] *Sankofa*, directed by Haile Gerima, 1993.

[85] Ghanaian musicologist, J. H. Nketia, in *Drumming in Akan Communities of Ghana* (1963) cites a classic Akan drum call: "When the Creator created things/ When the Manifold Creator created things/ What did he create?/He created the Court Crier/ He created the Drummer./ He created the Principal State Executioner" (154).

the role of a sonic agent that lays claim to the space. The action soon switches to the lead protagonist, an African American woman named Mona (later renamed Shola), posing for a white photographer on the grounds of the dungeon, and with the new subject, the music switches to a soundtrack dominated by drum set, bell-like keyboard, and horns in close harmony vamping with increasing tension. Both Mona/Shola and the photographer are startled when the elderly Ghanaba, clutching a linguist's staff with the Sankofa bird at its head, confronts Mona/Shola. They seem to lose him and continue the photo shoot, moving within earshot of an official tour of the slave fort. The elder returns, however, shouting, "Sankofa!" The subtitles translate this as "Get back to your past. Return to your source." The pho-tographer, the tourists, and Mona/Shola are all left speechless. The elder declares the land sacred because of the blood of those shed on it, and the suffering of those launched into slavery from this spot, but he is confronted by an armed policeman, clearly an agent of the nation-state. The official tour guide, also dressed in uni-form, explains that the elder, who goes by the name Sankofa, is a self-appointed spiritual guardian and drummer at the castle. When he confronts the group a second time, two armed police escort him out of the building. It appears that Sankofa's call for remembrance and reverence is incompatible with the plans for tourism and order embodied by the nation-state's policemen. Pan-Africanism, it seems, is at loggerheads with nationalism here. A more vivid dramatization of the struggle over control of memory and meaning is hard to imagine.

The closing scene of the film projects a poetic vision of the irreducible diversity of peoples of African descent, and Gerima presents this diversity as a visual chal-lenge to the statist controls embodied by the police earlier. As the modern-day Mona/Shola emerges from the dungeons, having traveled back in time to a slave plantation and now making a spiritual and physical return back to Africa, she joins a gathering of black people, all seated on the ramparts of the slave castle, facing the ocean and gazing intently toward the sea. Each one is dressed indi-vidually, and no words pass between them. In their shared silence, what binds them together, beyond their orientation seaward, is their shared act of listening. The drummer who opens the film plays and cries out words of welcome, and the camera focuses in on individual faces. The look of intense concentration and inner reflection on each unknown face (for, except for Nunu and Shola, most of the people ranged on the beach have not previously appeared in the film) seems to capture the opacity of each individual. We do not know what they are thinking, who they are, where they are from, and yet the soundtrack and close-ups draw us into that magical space between Eye and Ear that Anyidoho's poetry points to, where each of these black folk seems to be Soul-journeying to whatever moment of solidarity allows them to confront the yawning void of the Atlantic, the Middle Passage, in plurality, *The Human Condition*[86] of action, rather than in a frozen singularity. The closing shot captures birds silhouetted against a sun setting

[86] Arendt consistently maintains that plurality is fundamental to making us human in the sense of biopolitical subjects. See Arendt, *The Human Condition* (9–10; 155) in particular.

into the horizon. A horizon is, by definition, unreachable, but it can motivate a vision, drive an orientation, tantalize and inspire with its unknown possibilities. Listening together may be the work that enables listening to one another, and looking together in the same direction a sign of love, the truest form of solidarity.[87]

[87] Antoine de Saint-Exupéry's oft-cited definition of love—"Aimer, ce n'est pas se regarder l'un l'autre, c'est regarder dans la même direction"—speaks to the more aural dimensions cited in two compelling expositions of love as a grounds for politics, Fred Moten's discussion of Duke Ellington's ensemble in *In the Break: The Aesthetics of the Black Radical Tradition* (Minneapolis: U Minnesota P, 2003) and Paul Gilroy's essay "Between the Blues and the Blues Dance: Some Soundscapes of the Black Atlantic" in Michael Bull and Les Back's edited volume *The Auditory Culture Reader* (Oxford: Berg, 2003).

Pirates Choice

HACKING INTO (POST-)PAN-AFRICAN FUTURES

Just as the Sankofa principle that one cannot move forward without know-ing one's past has come to be recognized across the African diaspora, so too, in this chapter, that same principle informs the investigation of how future-oriented discourses of transnational solidarity necessarily involve debates over how history is made and told. I propose that a number of recent African expressive texts reveal a pirate logic at work. In these texts, pirating the past undoes the authorizing function of official archives that otherwise monopolize the narration and documentation of history. If state archives, privilege the national and inherently de-emphasize activities at the supra-, trans-, and subnational levels, these pirate texts propose alternative futures by archiving counter-histories. Pirating is, at its most basic, a practice of unauthorized copying and alternative distribution networks thriving in informal economies, and as such, may be not merely illegible but also dis-ruptive and unpredictable to centralized systems. In the era of clear collu-sion between national governments and multinational capitalism, piracy, as trope or as practice, becomes a mode for artists to critique the simultaneous commodification of artistic production (particularly music) and the nadir of revolutionary, redistributive politics committed to the interests of the work-ing class and unemployed people. By figuring pirates, thieves, vigilantes, and other extrastate actors as crucial cultural agents who produce, reproduce, and distribute alternative archives of solidarity, the works in this chapter turn to the terrain of the everyday, to the scrappier scale of local social movements grounded in intimate interpersonal encounters as the ground of urgent contemporary political action.

The novel, films and website discussed in this chapter were produced after 1985, in an increasingly digitized media environment. After a consideration of the theoretical implications of piracy and the archive, I trace the ways that analog forms embraced a proto-pirate logic, analyzing Ousmane Sembene's film, *Camp de Thiaroye*, and Moussa Sene Absa's film, *Ça Twiste à Popenguine* alongside each other. Following this, I take up the more direct thematic treatments of piracy in

three later works: the Ghanaian-British filmmaker John Akomfrah's *The Last Angel of History*, the Senegalese-born Gambian-based writer Ken Bugul's *Rue Félix-Faure*, and the ongoing web-based platform curated by South African-born Neo Muyanga and Cameroonian-born, South African-based Ntone Edjabe, the *Pan African Space Station*. The hyphenated identities of these artists speak to the ways in which diaspora is an increasingly multiply iterated and generalized condition, making distinctions between diaspora and continent more relative and fluid, and suggesting that the immediacy of the new media era is also a function of the increasingly diverse class positions, motivations, and national origins of subjects who circulate among different geographical locations.

What do archival processes have to do with the insurgent energies of pirated media? As Arjun Appadurai has cogently argued, a post-Foucauldian conception of "the archive as a collective tool" must recognize that

> the archive is not just a way to preserve accidental, but also precious traces of collective memory, we need to see that perhaps Foucault had too dark a vision of the panoptical functions of the archive, of its roles as an accessory to policing, surveillance, and governmentality. The creation of documents and their aggregation into archives is also a part of everyday life outside the purview of the state...we should begin to see all documentation as intervention, and all archiving as part of some sort of collective project...the product of the anticipation of collective memory. Thus the archive is itself an aspiration rather than a recollection.[1]

While earlier chapters have shown the ways that the state has historically emphasized particular forms of pan-Africanism and (to return to George Shepperson's formulation) state-sponsored big "P" Pan-Africanism, here we uncover the legacies of transnational black solidarities that take a detour from official archives by pirating the authorizing functions of archives. This shift in focus traces how pan-African feeling and practice lives on beyond the days of high nationalism and its statist-internationalist inflections. In fact, attending to the insurgent informal registers of pirate logics may also help to make sense of texts and practices that seem at first to be anomalous, idiosyncratic departures from a canonical African corpus. In other words, pirate logics help us understand the afterlives of pan-Africanism *and* African experimental artistic practices that critics have too often ignored. By taking piracy seriously as a cultural logic, this chapter performs its own echolocation, reorienting our thinking about the practices and tactics of piracy by returning to an oft-forgotten historical root of modern musical copyright law and antipiracy. Adrian Johns, in his magnum opus *Piracy: The Intellectual Property Wars from*

[1] Arjun Appadurai, "Archive and Aspiration," in *Information is Alive*, ed. Joke Brouwer, Arjen Mulder, and Susan Charlton (Rotterdam: V2/NAi Publishers; New York: Distributed Art Publishers, 2003), 16.

Gutenberg to Gates, notes that it was the unlicensed reproduction of sheet music for British jingoistic ditties in support of the troops in the Anglo-Boer War in South Africa that drove music publisher David Day to first seize and confiscate copies of the songs and later found the Musical Copyright Association in 1902.[2] Thus, piracy and copyright protection are not merely imported concerns in Africa, but rather grounds on which struggles over free expression and fair trade have long been waged. The great irony is that, the failure of music publishers to protect the rights of composers and performers of African heritage is, by now, a familiar and shameful story. It is in the shadow of the way both the innovations and the betrayals of copyright have played out with particular piquancy in the Black Atlantic that this chapter's discussion of piracy as an insurgent cultural logic unfolds.[3]

My interest throughout this book has been to analyze the dialectical relationship between music making and the media forms that brought African Americans and Africans into contact, where these forms became part of the creative grist for local iterations of stereomodernist expression. With the advance of new communications technologies at the end of the twentieth century, transnational black intimacies are more readily accessible than ever before. Each of the chapters thus far has considered how black music functioned essentially as an *archive* of pan-African feeling, practice, and imagination. My attention to specific media is animated by questions concerning how that archive became accessible, and the uses to which it could be put in particular locations. The question of accessibility has, of course, been pertinent throughout the twentieth century, given that music by African Americans circulated primarily in the commodity form of audio recorded performance and the adjunct media of print, and film. However, with a shift from primarily analog and live formats to digital formats over the last three decades, a new logic is shaping what had once been forms of circulation inescapably grounded in tangible commodities.

Recent scholarship by Brian Larkin and Ravi Sundaram has compellingly traced the intersections between new media formats, informal economies, decentralized distribution and reproduction circuits in Nigeria and in India as examples of "pirate modernity."[4] For Larkin, as for Sundaram, pirate modernity is "a mode of incorporation into the economy that is

[2] Adrian Johns, *Piracy: The Intellectual Property Wars from Gutenberg to Gates* (Chicago: U Chicago P, 2010), 333.

[3] One powerful example of the way black artists around the globe have often received outrageously little acknowledgment for their creative and musical labor is the case of Solomon Linda, the original performer of "Mbube" or "The Lion Sleeps Tonight," which reached the peak of its fame after the Disney movie *The Lion King* used it as a theme song. A 2002 documentary by François Verster about the royalties controversy, *A Lion's Trail,* was instrumental in raising awareness and enabling the Linda family to bring legal suit. For more on this example see Veit Erlman's *African Stars: Studies in Black South African Performance* (Chicago: U Chicago P, 1991).

[4] Brian Larkin, *Signal and Noise: Media, Infrastructure, and Urban Culture in Nigeria* (Durham: Duke UP, 2008) and Ravi Sundaram *Pirate Modernity: Delhi's Media Urbanism* (New York: Routledge, 2011).

disorganized, nonideological, and marked by mobility and innovation."[5] While remaining circumspect about the oppositional potential of piracy, their analyses offer a rich account of the cultural and symbolic work piracy does while forestalling too hasty a utopian vision of new media. Larkin notes that while "the mobility, innovation, and provisionality of piracy" are important to attend to, we also need to understand how the material conditions of production give rise to specific *pirate aesthetics*. Formal concerns must encompass both the highly organized alternative infrastructures and the artifacts of buzz, fuzz, noise, glare, and inaudibility often seen in pirated media. Larkin astutely suggests that rather than considering frequent technological breakdowns as simply moments of failure, we should recognize that these experiences—common and ubiquitous in the global South—are in fact generative of a whole range of shared values, experiences, and aesthetic qualities. As he puts it:

> Piracy imposes particular conditions on recording, transmitting, and retrieving data. Constant copying erodes data storage, degrading image and sound, overwhelming the signal of media content with the noise produced by the means of reproduction. Pirate videos are marked by blurred images and distorted sound, creating a material screen that filters audiences' engagement with media technologies and the new senses of time, speed, space, and contemporaneity. *In this way, piracy creates an aesthetic, a set of formal qualities that generate a particular sensorial experience of media marked by poor transmission, interference, and noise.*[6]

The texts in this chapter reward attention to the particular aesthetic qualities of pirated media (both as material artifacts in new media and as referents in older media that thematize informal modes of access) by bringing into view a broader pirate logic operating in a range of recent African cultural productions. As throughout the book, Ghana, Senegal, and South Africa are the focal points of this chapter, although making the comparative move from Larkin and Sundaram's work to these contexts should illustrate ways in which this pirate logic might apply more broadly.

The chapter's title, "Pirates Choice," borrows from a now-legendary double compact disc album by Orchestra Baobab, the longtime house band at Dakar's Baobab Club, released in 2001 on the World Circuit/Nonesuch label.[7] The set comprised of twelve songs, six from earlier releases in Senegal (1982) and Europe (1987) as well as six tracks from previously unpublished sessions. While the double album's name refers to how difficult it was to obtain

[5] Larkin, *Signal and Noise,* 226.

[6] Ibid., 218, my italics.

[7] Orchestra Baobab, *Pirates Choice* (1989 & 2001) World Circuit/Nonesuch Records WCB014 and WCDO63. I follow the album title, rather than using a possessive form e.g. Pirates'.

recordings of the group after they disbanded, having been eclipsed by Youssou N'Dour's rising Star Etoile, it also shows how piracy is now celebrated as an insurgent cultural strategy. The marketing category of "world music" has been thoroughly critiqued elsewhere[8] and certainly, the codes of scarcity and eso-teric fan knowledge recur in reviews hailing the album as the "Holy Grail" of Afro-pop music collectors. Moving beyond such critiques, how might we account for the paradox of a commercially released album circulating under the name *Pirates Choice*. For many of the works discussed in this chapter, the allure of an unregulated, if not illegal, circuit of production, reproduction, and distribution figures large in the value assigned these works despite the fact that they are often much closer to standard infrastructures than their thematic troping on piracy would suggest. Building upon the excellent work of media scholars on the materiality of pirated media, I am interested in what the meta-phor of piracy enables Africans to say and do with authorized texts or posi-tions, rather than literal instances of piracy, whether in media or on the seas.

Pirate logics are not new to contemporary Africans. It is difficult to imagine how one might navigate traffic without the *taxis clandos* (short for *clandestines*) in Dakar, trotros in Accra, or pirate taxis in Cape Town, given the rapid sprawl of urban areas. Nor could one do much shopping without the endless stretches of pirated CDs and DVDs available in the markets of Sandaga, Makola, and the environs of the Cape Town train station. African entrepreneurs and infor-mal traders constantly find ways to work around regulations, copyright laws, (often corrupt) licensing bodies, and unreliable infrastructures. Where media are concerned, the rise in use of small mp3 players and mobile telephones that double as media storage devices has shrunk the distance that any form of mediation presupposes between maker and listener, making such media a potential site of simultaneous, coeval contestation, facilitated by piracy.

It is worth recalling that although these "new media" offer a speed of con-nection and facility in distribution that seems game-changing, African artists and audiences have a long history of accessing, deploying, manipulating, and pirating the newest technologies of their day. As Karin Barber reminds us:

> media in much of Africa are not experienced as a recent and external force, but as a constitutive element in the formation of African popular culture from the early twentieth century onwards. What we think of as live, local popular culture in Africa was often inspired by new media technologies. Examples include popular print fiction which combines conventions of the thriller, the romance and the folktale; music shaped by the possibilities of electronic amplification; popular art shaped by film posters and book or

[8] For a fine study, see Mai Palmberg and Annemette Kirkegaard's edited collection *Playing with Identities in Contemporary Music in Africa* (Uppsala: Nordic Africa Institute, 2002)

magazine illustrations; new forms of popular theater which were stimulated by a two-way relationship with radio, television, film and video.[9]

New electronic media and the experimental forms they inspire are only the most contemporary continuations of the kinds of cultural strategies historicized throughout *Africa in Stereo*.

While the possibilities of new media, and of new uses of old media, can seem heady, there is good reason for skepticism. Despite the rise of a range of potentially liberating technologies (seen most vividly in the way the Internet and mobile phones have enabled momentous political action across North Africa in the past few years), the precarity of life is felt today with renewed acuteness on the heels of a wave of fiftieth anniversaries of independence whose promises are as yet unfulfilled. Similarly, in the midst of the proliferation of new media forms, the archive of pan-Africanist stereomodernism encoded in black music is both at its most accessible and, paradoxically, at its most vulnerable. The very material conditions that make for the easy reproduction, storage, and transmission of music as data also make for easy erasure, corruption, and crashes, as Jonathan Sterne illustrates in *MP3: The Meaning of a Format*.[10] The coinciding potential and precarity of this archive makes it a compelling sign of the conditions of life in the time of postapartheid and the postcolony.

Nowhere is the vulnerability of global black archives more searing than in the ongoing crisis in the wake of the spring 2012 coup in Mali at Timbuktu, the site of sub-Saharan Africa's oldest university and home to thousands of priceless manuscripts. A power vacuum in Northern Mali after the coup enabled a coalition of hard-line Islamists to introduce sharia law, and to desecrate the graves of saints they do not recognize, destroying the treasured cultural inheritance of Sufi Islam in Timbuktu, the city of 333 saints. A pall of anxiety settled over the fate of the thousands of priceless manuscripts covering topics as diverse as Sufi theology, medicine, and aesthetics reaching back to Timbuktu's days as a center of learning in the medieval world. Faced with such a crisis, pan-Africanism. On the one hand, the Malian situation was eventually addressed by one of pan-Africanism's most concrete outgrowths, a military intervention mounted by ECOWAS (Economic Community of West African States). On the other hand, the transnational religious community that brings together ultraconservative Islamists from Nigeria, Algeria, the Touareg independence movement, and beyond indicates a robust transnational solidarity grounded in politicized religion rather than pan-Africanism. What then, is the relevance of enduring archives of transnational black solidarity in the new media age? Why and how does the type of stereomodernism analyzed

[9] Karin Barber, "Orality, the Media and New Popular Cultures in Africa," in *Media and Identity in Africa*, ed. Kimani Njogu and John Middleton (Bloomington: Indiana UP, 2009), 4.
[10] Jonathan Sterne, *MP3: The Meaning of a Format* (Durham: Duke UP, 2012).

throughout the foregoing chapters persist? And what, if anything, does it have to say to the very real local experiences of precarity that give pause to the utopian impulses of cultural pan-Africanism? Grappling with these questions, it is helpful, following Barber, to consider the ways narratives of technological advance presented in "old" media prefigure contemporary challenges.

A final caveat: any discussion of new media must recognize the continuing inequalities in technological access that affect black subjects on the continent and in the diaspora. According to 2012 figures from Internet World Statistics, Internet penetration in Africa is at only 15.6 percent of the total population, however this represents a rapid expansion of access over the last decade.[11] Likewise, in the U.S., the last decade has seen a shrinking digital divide across racial lines. A 2012 Pew Foundation study reports that, while in 2000, African Americans used the Internet at substantially lower rates than white Americans (35 percent compared to 49 percent), that disparity had significantly narrowed by 2011 to a nine-point difference (71 percent of African Americans compared to 80 percent of white Americans). Where differences remained stark in the U.S. were in the kinds of devices and ways the Internet was accessed, and here there are clear grounds for comparison with Africa. Important parallels in new media use by Africans and African Americans include the significance of mobile phones as a predominant form of technology usage, and the embrace of highly digitized music forms, such as hip-hop, jungle, and techno.

African youth, who access digitized media more widely than their elders, live in a mediascape where black music associated with African American performers is a deeply influential cipher of local aspiration.[12] If, in earlier chapters, I have emphasized how music facilitated enactments of pan-African solidarity, here we see how it may also privilege consumption over comradeship, and the popular over the properly political, hence the note of caution over the ideological potential of such technologies in the context of a pirate cultural logic. Furthermore, where digital downloading and other new media uses are concerned, material constraints are multiple, and affect youth more acutely than those with greater economic and/or social capital. Personal computers and Internet access remain prohibitively expensive for the vast majority of Africans, while sporadic electricity supplies and load-shedding practices make a generator an additional prerequisite in many locations. *Télécenters* or Internet cafés are a key mode of accessing the Internet, given the low rates of personal

[11] Statistics available at http://www.internetworldstats.com/stats1.htm (accessed 1/11/11).

[12] The study of African youth has received increasing scholarly attention in African humanities given their demographic significance. How to define the category of youth is a contentious issue, given the difficulty in finding full-time employment in many parts of the continent, but with 44 percent of the continents' population under the age of fifteen, youth culture will continue to be of significant interest for the foreseeable future. See Lori S. Ashford, "Africa's Youthful Population: Risk or Opportunity" (Washington DC: Population Reference Bureau, 2007).

computer ownership,[13] and thus much Internet usage is still best conceived of within a social context. That said, youth are more likely to use small digital technologies, particularly cell phones with popular music ringtones, mp3 players, and pirated discs.[14] The relatively inexpensive virtual media through which sonic files are stored, transferred, and consumed allow a growing number of young Africans to participate in diasporic flows. Their means of access also mirror findings in how African Americans access the Internet:

> Today, as mobile technology puts computers in our pockets, [U.S.] Latinos and blacks are more likely than the general population to access the Web by cellular phones, and they use their phones more often to do more things....some see a new "digital divide" emerging—with Latinos and blacks being challenged by more, not less, access to technology. It's tough to fill out a job application on a cell phone, for example.[15]

Internet access by phone is rarer in Africa, but the challenge of how to create content rather than merely access and consume it remains. The study of virtual content creation in such communities is pressing because the rise of new media presents itself as a pivotal moment. As traditional media apparatuses gives way to new forms, the hierarchal orders they maintained are uniquely open to interruption and change, a moment of opportunity for the marginalized. How have African subjects inserted themselves into a pirate logic to seize, adapt, and detour emerging technologies to articulate timely critiques of the postcolonies they inhabit and to render new possible trajectories of pan-Africanism and transnational solidarity?

Analog Pirates: Gramophones in Senegal

The two Senegalese films I want to discuss here feature scenes of listening that encapsulate the way analog mediums in the mid–twentieth century signified on popular African American music as a fetish object whose value was proportionate to its scarcity and precarity. Both films date from the early stages of the shift from analog to digital media (*Camp de Thiaroye* appeared in 1987 and *Ça Twiste à Popenguine* in 1993), and thus present a form of technonostalgia, which also inflects works that emerge later, more clearly in the digital age, as we will see. However, despite similarities in the technonostalgic patina of these films, I would contrast the analog playback technologies central to each

[13] Olivier Sagna, "Les télécentres privés du Sénégal: La fin d'une 'success story,'" *Revue NETSUDS* 4 (August 2009), 27–43.

[14] All of these media technology formats I observed were common in African urban marketplaces during fieldwork between 2006 and 2007 in Dakar, Accra, and Cape Town.

[15] Jesse Washington, "For minorities, new 'digital divide' seen," AP January 9, 2011, http://www.washingtonpost.com/wp-dyn/content/article/2011/01/09/AR2011010900043.html (accessed 1/11/11).

film's portrayal of transnational black connections with what appears to be a more insurgent pirate logic at work in the more recent cultural texts. As stories about an analog world dominated by record players, the Sembene and Sene Absa films also demonstrate the capacities of the gramophone to both make and play back a recording, and by extension, the possibility of an archiving *machine* to not only maintain but change the way the past is narrated for its future. This double function of the archive has fascinated thinkers as different as Derrida and Kittler.

Early in his essay *Mal d'Archive,* Derrida points to the double function of the archive as that which both gathers evidence of the past and determines the structure of what can enter the archive. As he writes:

> L'archive, comme impression, écriture, prothèse ou technique hypomné-sique en général, ce n'est pas seulement le lieu de stockage et de conserva-tion d'un contenu archivable *passé* qui existerait de toute façon, tel que, sans elle on croit encore qu'il fut ou qu'il aura été. Non, la structure technique de l'archive *archivante* détermine aussi la structure du contenu *archivable* dans son surgissement même et dans son rapport à l'avenir. L'archivation produit autant qu'elle enregistre l'événement. C'est aussi notre expérience politique des media dits d'information.[16]

> This is another way of saying that the archive, as printing, writing, pros-thesis, or hypomnesic technique in general is not only the place for stocking and for conserving an archivable content *of the past* which would exist in any case, such as, without the archive, one still believes it was or will have been. No, the technical structure of the *archiving* archive also determines the structure of the *archivable* content even in its very coming into existence and in its relationship to the future. The archivation produces as much as it records the event. This is also our political experience of the so-called news media.[17]

Derrida's claim that the archival process produces the event just as much as it records it is not all that far removed from Marshall McLuhan's truism that the medium is the message. However, as we think beyond the archive as a reser-voir of state power, deriving its name, as Derrida reminds us, from the ancient Greek, *arkheîon* or seat of power, the act of representing other archives destabi-lizes the colonial monopoly on state power in an act of pirating by legitimating competing archival impulses. In the films discussed here, local subjects turn to the transnational archive of black music as an alternative to the authorized discourses of state, religious, and traditional power to facilitate counterpublics

[16] Jacques Derrida, *Mal d'Archive* (Paris, Éditions Galilée, 1995), 34.
[17] Jacques Derrida, *Archive Fever: A Freudian Impression*, trans. Eric Prenowitz (Chicago: U Chicago P, 1998), 16–17.

that incorporate transnational affinities outside the fixed hierarchical relationships reified by official archives.

In Sembene's *Camp de Thiaroye* (1987), the point of contention between a Senegalese *évolué* sergeant returning from service in Europe in the Second World War and an African American military policeman from Detroit is, initially, a failure to meet each other's expectations of what a black man's street conduct should be.[18] Meeting after exchanging blows to engage in both official (diplomatic) and private (racial) reconciliation, it is Diatta's LP player, and a Charlie Parker album, that facilitates the rewriting of their initial confrontation as a moment where class complicates racial solidarity to challenge the complicities of both men in fighting for polities that still deny full human rights to their comrades. In Sene Absa's *Ça Twiste à Popenguine* (1993), African American soul music is but one of multiple pulls from the global North, but along with French *variété* it commands the attention of 1960s youth in Senegal as an alternative to the religious music and school poetry recitations that fill their sonic world.[19] How the aspirations of a group of friends, whose nicknames include Otis (Redding) and Jimi (Hendrix) find expression in a remote fishing village, has everything to do with how they access and reimagine audiovisual technologies, from a Teppaz record player, to a homemade shadow puppet "pitchoss" show, to a live concert organized for the entire village. Here, the ways that subjects detour media objects to serve their own ends shows stereo-modernism at work. Both of these films expose the power of pirate archiving to produce new versions of the past, and more fundamentally even, new pasts. They present the possibility to rewrite the past afresh by representing the phonograph record as a transnational black archive above and beyond the state, and in imagining ways to use, reuse, and abuse the gramophone to play back alternative versions of the past.

Yet, how might we consider the vinyl record player, that analog technology par excellence, as a protovirtual medium, appearing in films made in the shadow of emerging digital recording technologies that quickly became widely available in Senegal? As the German media theorist, Friedrich Kittler has observed, the phonograph

> alone can combine the two actions indispensable to any universal machine, discrete or not: writing and reading, storing and scanning, recording and replaying. In principle, even though Edison, for practical reasons, later separated recording units from replaying ones, it is one and the same stylus that engraves and later traces the phonographic groove.[20]

[18] *Campe de Thiaroye,* directed by Ousmane Sembene, 1987.

[19] *Ça Twiste à Popenguine,* directed by Moussa Sene Absa, 1993.

[20] Friedrich A. Kittler, *Gramophone, Film, Typewriter,* trans. G. Winthrop-Young and Michael Wutz (Stanford: Stanford UP, 1999), 33. Originally published in German as *Grammophon Film Typewriter* (Berlin: Brinkmann & Bose, 1986).

It is this capacity to both play and record, to wield that most elemental of writing implements, the stylus, to play, to play back, to play backward, to render the prerecorded in new acoustic arrangements that makes this technology such a powerful metaphor (and indeed, material instrument) for the virtual links in these films by Sembene and Sene Absa. Playing the record of a Charlie Parker solo in Thiaroye rewrites the record of Senegalese-African American relations. Spinning James Brown in Popenguine puts a new spin on being black and proud.

Ousmane Sembene's 1987 film, *Camp de Thiaroye* Sembene's sixth feature film, is set in the hot dusty November days of 1944, on the outskirts of Dakar, Senegal. A company of *tirailleurs sénégalais,* recently disembarked from a French ship are marooned in a Spartan military camp at Thiaroye, waiting to be demobilized. Based on a tragic moment in Senegal's history, the film presents the fate of this returning regiment of demobilized *tirailleurs sénégalais* Having been cheated by the French government of fair pensions for service under the French flag upon their return to Africa, they fell victim to a shameful colonial massacre. On December 1, 1944, after protesting the insulting rates at which they were to be compensated, the *tirailleurs* were attacked by French troops who stormed their transit camp, leaving dozens dead and countless others wounded.[21] However, even before the appalling murders with which the film ends, it is clear how race, colonialism, and an increasingly powerful American global presence circumscribe the possible futures of this generation of Francophone Africans. Nevertheless, Diatta's adventure proves important for tracing the possible axes of solidarity in mid-century Senegal.

Historically, the *tirailleurs sénégalais* were troops drawn from all of France's African colonies (not just Senegal), and while the forces were first constituted in the 1850s, universal conscription in peace and war was instituted throughout French West Africa after 1919. During World War II, close to 10 percent of French troops were *tiralleurs sénégalais.*[22] Sembene's film reveals one unintentional result of the French recruitment policies. National and religious diversity among the troops occasions a rehearsal of the mutual aid and affective support that the French term *solidarité* connotes (in contrast to the more public and abstractly political notion of a shared cause implied by the English, "solidarity"). In *Camp de Thiaroye, solidarité* is figured by the lingua franca the troops use, *petit-nègre*—which facilitates communication across difference in a pidginized version of French. (As the shared language of a collectivity of men aligned by a shared, marginal class position and by itinerant soldiering one might even argue that *petit-nègre* should be considered a parallel to the maritime pidgins of the nautical pirates from which the terms for media

[21] The precise number of men murdered remains a matter of contestation, with estimates ranging from twenty-five to sixty or more, while it is believed hundreds more were injured.

[22] See Myron Echenberg, *Colonial Conscripts: The Tirailleurs Sénégalais in French West Africa, 1857–1960* (Portsmouth: Heinemann, 1991).

piracy emerge.) *Solidarité* motivates religious tolerance in the camp, seen
when Muslim soldiers are accorded a designated space and time for prayers,
while soldiers of other faiths proceed with their daily routines. And *solidarité*
motivates the troops' communal care for a shell-shocked former P.O.W. who
has survived Buchenwald, named *Pays* (meaning country) as a kind of anti-
dote for his profound alienation and disorientation. Nevertheless, confined to
their demobilization camp, the memory of the festive portside welcome where
they were hailed as heroes by family, military bands, and colonial dignitaries is
fading fast. The film implies that the African troops' communitarian *solidarité*
shifts to a political solidarity around both their class position and their sub-
jugated colonial condition (they are, after all, waiting to be paid by that most
exploitative of employers, the colonizer). This politicized solidarity enables
the *tirailleurs* to organize a unified mutiny against the duplicitous French, one
which, although unsuccessful in its time, left a lasting blemish of shame on
the Hexagon, only partially expiated in 2006 when President Jacques Chirac
finally ordered that African veterans be paid equal pensions to their European
colleagues, and in 2012 when President François Hollande offered to hand over
all French archival records of the massacre during his first visit to Senegal after
taking office.

The most fascinating episode in the film from the standpoint of my discus-
sion on piracy, however, concerns an altercation between a group of American
military policemen and Sergeant Diatta, the only African officer among the
troops. The arrest of Diatta, an *évolué* who has interrupted his law studies in
France to fight, leaving behind his French wife and a young *métisse* daughter,
paradoxically opens up the possibility of a pan-African solidarity that reaches
beyond the continent. When Diatta obtains his leave pass to visit the Plateau
district, he is caught wearing a U.S. military uniform. The military police
assume that he is wearing the uniform without permission, despite the fact
that in Europe the American forces presented the *tirailleurs* with U.S. kit in
recognition of their bravery when their French kit had worn out. Diatta is
not only arrested, but also assaulted by a group of American military police,
among whom is a vocal, aggressive African American. Once Diatta is released,
this MP, a native of Detroit named Tom, comes to visit Diatta, hoping to apolo-
gize and ensure that he has recovered fully. The two immediately seek to estab-
lish a bond, addressing each other in English as "brother."

The visit itself takes place in Diatta's barracks, with the door pointedly
closed as if to shut out the French military authorities who would take a dim
view of the private encounter. Among Diatta's most treasured possessions is
a record player from which classical Western art music is occasionally heard
drifting through the barracks walls, projecting his exceptional class and edu-
cation status to both his troops and his commanders, who are discomfited
when it becomes clear they are unfamiliar with the French literature lining his
shelves. Diatta puts on a record of Charlie Parker playing "Honeysuckle Rose,"

which Tom recognizes.[23] Ousmane Sembene plays on the trope of music as a connecting link between diaspora and continent, but he also uses the moment as a critique of the class dynamics that shape this encounter. Diatta mentions the writers Langston Hughes, Paul Laurence Dunbar, and Marcus Garvey in an effort to find common ground with Tom, and for Diatta, his acquaintance with Parker is part of an urbane cosmopolitanism that means he could just have easily have chosen an orchestra or opera recording from his collection. Tom, however, recognizes only Garvey's name, the one writer who is better known as a populist political figure than a man of letters, and he reflects that he has never been outside of the U.S. before the war. Stating that Diatta has "a big head and a lot of luck," Tom reminds him that "in Detroit all the Negroes are in car factories." Tom shares a class position with the other *tirailleurs,* whose lack of educational and work opportunities limit them to speaking *petit-nègre*; however, just as their pidgin language impedes effective negotiations with their monolingual French army supervisors, it also stands in the way of their being able to truly engage in a more meaningful anti-capitalist solidarity with their Detroit brother. And while the cultural affinity that Diatta and Tom grasp as they listen to Parker together certainly gestures toward a celebration of aesthetic experience as a vector of more sturdy political bonds, the limitations and tenuousness of those bonds are painfully obvious.

A more generative politics emerges if we consider that for Diatta, the phonograph player is a sign of a cosmopolitanism contingent upon the adoption of bourgeois values of connoisseurship and conservative, nuclear familial structures. The phonograph is, after all, displayed alongside portraits of Diatta's French wife and daughter, and accompanies his letter-writing sessions. I would argue that the symbolic consequences of Diatta's turn to Bird's music are considerable. By taking hold of this technology, which has come to him with the prerecorded tracks of European art music as a sign of *évolué* status, and playing the bebop sounds of virtuosity, conscious self-making through art, speed, and horsepower, Diatta shares in the joy of this music with Tom; a newly emerging trans-Atlantic listening community enters the cinematically projected historical imaginary. In this act of listening, Diatta amplifies a connection with Tom that had nearly been drowned out by the static of national pride by playing the record. Reading catachrestically, this is an act of proto-pirate archiving, of seizing the sound, of keeping records, of playing back records, of keeping Bird's album in heavy rotation as a record of black solidarity. And this act of proto-piracy determines what is archivable—an encounter with an American

[23] The song is identified as "Honeysuckle Rose" in the film's credits, although no specific recording is cited. Given that Parker only recorded this song twice early in his career (http://www.jazzdisco.org/charlie-parker/discography/ lists two recording dates in 1940, one solo and with Jay McShann and His Orchestra), it is difficult to know whether listeners in Paris like the fictional Sergeant Diatta would have had access to this particular recording, or whether Sembene simply chose a recording that evoked the historical period.

FIGURE 6.1 *Screen capture of Sergent Diatta and Tom listening in* Camp de Thiaroye*.

MP that becomes a moment of solidarity and affinity rather than a confrontation between occupying powers and their proxies. The record, played back this way, produces the event of black music resonating as a form of pan-African stereomodernism. Away from the anxious eyes and ears of the colonial commanders, Diatta and Tom effectively pirate Bird's music to circulate it in a transnationational interior of insurgent solidarity.

If, for Sembene, bebop is the essential data file for the pan-African imaginary, Moussa Sene Absa's *Ça Twiste à Popenguine* draws on a different repertoire, 1960s dance music. The film's drama turns on the struggle over control of audio-(visual) technology between two groups of friends, fans of variété stars Johnny Halladay and Sylvie Vartan on the one hand, and the Kings, whose nicknames reflect their admiration of "Jimi Hendrix, Ray Charles, Otis Redding, [and] James Brown" on the other. The film is a seemingly lighthearted romantic comedy about the two teenage boys' clubs vying for the attention of the girls in their seaside village. However, their wooing strategies rely heavily on their ability to obtain, maintain, and manipulate a variety of technological media. Radio, record players, makeshift shadow puppet "pitchoss" (as homemade protocinema), pirated electricity, and television provide props for the drama of crossgenerational relationships strained by competing versions of modernity in Popenguine, 1964.

Although released in 1993, during the tenure of Senghor's hand-chosen successor, Abdou Diouf, the nostalgic patina of Sene Absa's film looks back to 1964, portrayed as an era of almost magical possibility and freedom for youth

culture. Sene Absa, born in 1958, creates a complex film that is more than simply a set of fond reminiscences. The child-narrator, Bacc, captures some of the temporal discontinuities between memory, oral history, and archival research, while Bacc's adult narratorial voice's use of the past tense creates a documentary effect. The year 1964 is a significant choice, since this was the year the Festival Mondial des Arts Nègres (FESMAN) was originally scheduled for. Its delays exposed the inefficiency of the Senghor government. Thus, the date and displacement of the film's action from Dakar to a provincial beach offers a critique of Senghor's out-of-date swing-Négritude, and his cumbersome centralized governing style. *Ça Twiste à Popenguine* posits an alternative to the legacy of Négritude's "âme nègre" (black soul) by celebrating the transnational black energy of a new musical movement: *soul* power. Recall that, as discussed in the third chapter, Langston Hughes had been among the first to announce "soul" to Senegal's intellectual community as the most pressing new artistic impulse among young Americans in 1966. However, if Hughes was content to state a trans-Atlantic equivalency, that "*Soul* is contemporary Harlem's *Négritude,*" thirty years later, Sene Absa saw soul as a grassroots alternative to the state power encapsulated in Négritude, or even as a form of pirated Négritude, one best understood within the mediascapes and ideoscapes of globalized black life.

Soul music was indeed a crucial shared reference point for youth aspiring to hipness, whether African or American. Manthia Diawara's essay "The 1960s in Bamako: Malick Sidibé and James Brown" gives a vivid sense of soul's *international* black appeal. Diawara recalls how the *grins,* as teenage posses who gathered to chat and listen to music were known in urban Mali, allowed youth to express their chafing at both traditional Islamic and nationalist disciplinarian rhetoric by identifying with artists such as James Brown, Jimi Hendrix, and Aretha Franklin. Diawara states:

> Looking back at the period between the mid-sixties and the early seventies in Bamako, it is clear that the single most important factor, after independence, that introduced change into youth's habitus was their exposure to diaspora aesthetics through rock and roll and the black power movement.[24]

The aptness of Diawara's claim is confirmed by the fact that in 1967 the Centre Culturel Français in Dakar, a highly influential social and organizational center in the years immediately following independence, sponsored a *Festival du Jerk* in 1967. The festival celebrated the new bodily comportments that soul music inspired—dances like the Jerk, the Monkey, the Mashed Potato, and the Funky Chicken—barely a few months after FESMAN's more staid stagings.

[24] Manthia Diawara, "The 1960s in Bamako: Malick Sidibé and James Brown," in *Black Cultural Traffic: Crossroads in Global Performance and Popular Culture,* eds. Harry J. Elam and Kennell Jackson (Ann Arbor: U Michigan P, 2005), 252.

FIGURE 6.2 *Screen capture of the Kings' clubhouse in* Ça Twiste à Popenguine.

What becomes clear when considering the historical record through national archives, memoirs such as Diawara's, oral history interviews with musicians from this period, and the nostalgic tinge of Sene Absa's film, is that the soul music of the 1960s and 1970s constituted a chronotopia in which multiple layers of African affinity for African American musical culture were sedimented. Soul music effectively created an archive of expressive memories that can still be accessed through the citation of songs, fashion, and dance moves. Thus, James Brown's "Get On Up!" in the opening scenes, bell bottoms and shades throughout the film, and the Twist as a dance that finally unmoors Blackness from black bodies when a French musician performs the hit song live for the village of Popenguine, all represent objects that can be borrowed at will to evoke a popular cultural affinity that made it Beautiful to be Black. One could even argue that, in demonstrating the reproducibility of key iconic elements of the soul power aesthetics, the teenagers of Popenguine propose pirating as an ideal and flexible mode of fandom for soul-lovers living at geographical remove from their idols.

Bacc is a highly sympathetic protagonist and narrator. His mother has departed—for "the city," perhaps for France, but certainly for good—and his father appears to have been always absent. Bacc is a *de facto* orphan who seems to belong to the entire village. As he comments more than once, everyone in Popenguine engages in commerce, and Bacc's major enterprise is to run

errands on commission for his older friends in both the Ins(eparables) and the Kings clubs. The opposing posses have two main preoccupations: trying to listen to as much of their preferred music as possible, and jostling with the rival club to win the affections of two teenage girls in Popenguine, Sheila and Sylvie/Mariétou. The Ins hold an advantage as the film begins, due not only to their looks but also to an already established romance between the member who goes by Eddy (Mitchell), and Tina, who has emigrated to France but supplies them with a steady stream of variété records mailed directly from Paris. While the cachet of these records is precisely the fact that they are "the genuine article," not an elicit reproduction, the fact that they are trafficked privately through the mail rather than commercially distributed draws attention to a pirate logic undermining the official channels of the media market. In fact, the entire film is haunted by the absence of Senegalese emigrants to France, and the extent to which *solidarité*, as a practice of material remittance, is the necessary but contingent condition upon which other forms of musical solidarity rely. Even though the Ins have access to records, the Kings possess the only "electrophone" record player, and thus wield a technological advantage in the pursuit of love. In an effort to level the playing ground, and purchase their own record player, the Ins undertake a fundraising campaign. They mount a "pitchoss" (shadow puppet show) version of Ivanhoe, charging the younger residents of Popenguine admission.

The film cuts from this scene to a scene of Bacc's "grandmother" telling a folktale to a circle of young children at night, and so establishes a clear line of continuity between local oral storytelling traditions and the low-tech evening puppet show the Ins offer. The film suggests that the technological trajectory of African storytelling extends to the cinema itself, and proposes that within this genealogy, all forms of screen technology might be understood as pirating the voice of oral storytellers in order to reproduce and distribute their stories more widely, with all the inevitable distortions implied in pirate aesthetics. Bacc supports this innovation by providing word-of-mouth publicity and message delivery, standing in for the functions of print advertising and personal ads. The common thread of creative enterprises that foster self-sufficiency and improvisatory interpretations of rules runs through the schemes of both the Ins and the Kings, and it is these adaptive uses of media, rather than the reliance on specific material technologies that the film celebrates.[25]

Sene Absa does not shy away from confronting the material scarcity of technology necessary for this utopian cosmopolitan consumption of soul music, however, and the record player remains central to his representation. When the Ins decide to put on a party as part of their efforts to buy a record player, they

[25] Other forms of audiovisual technology also figure large, most noticeably the arrival of the first television set, which, on its inaugural broadcast draws the entire village together for an outdoor viewing.

are forced to bargain with their archrivals to rent both the sound equipment and the records. The Kings are only too happy to name their price. Pirating electricity from the mosque, the boys rig a wire to power the borrowed "electrophone" record player. However, this only earns them an ear-boxing from El Hadj, one of the elders, as too few of the party guests actually pay the door fee. When the Kings discover they have been cheated, they set light to the Ins clubhouse, destroying the Teppaz record player in the process. If the broad range of cultural signifiers that carry "soul power" have made it appear a uniquely sturdy vector of international black affinity, this scene highlights the fragile contingency of such ties, and the inescapably material barriers between the global South and its others that can quickly unravel such affinities, particularly when based upon pleasure unlinked to ideological projects.

With the embers of the clubhouse still glowing, the elders of Popenguine intervene, and mete out collective corporal punishment. When the resident metropolitan, a French teacher named M. Benoît, happens upon the group and calls for an end to their whipping, he is contradicted by Jabbel:

> JABBEL: M. Benoît, ils doivent être comme leur pères, comme les pères de leurs pères, c'est à dire comme il y a dix mille ans, comme le baobab millénaire.
>
> BENOÎT: Même le baobab se meurt. Et là sera ainsi votre culture, si vous oubliez l'autre. La civilisation de l'universel se fera par le donner et le recevoir.
>
> JABBEL: M. Benoît, avec toute l'amitié que je te porte, je dis que tu parles comme notre président Senghor. C'est bien, c'est même très très très bien, mais c'est trop compliqué pour moi. Les enfants ont fait une bêtise, ils seront punis.

> [JABBEL: M. Benoît, they ought to be like their fathers, like their father's fathers, that is, like we've been for the last ten thousand years, like the millenarian baobab tree.
>
> BENOÎT: Even baobabs die. And so will your culture, if you forget the other. Universal civilization depends on give and take.
>
> JABBEL: M. Benoît, with all due respect, I'd say you talk like our president Senghor. It's good, it's even very very very good, but it is too complicated for me. The children misbehaved, they will be punished.]

In comparing M. Benoît's discourse to Senghor's, Jabbel critiques how a fine-sounding concept such as the Négritude maxim of "enracinement et ouverture [rootedness and openness]" fails to translate to the context of a provincial beach town like Popenguine, far from the glittering Plateau district of the capital, Dakar. In other words, Senghorian Négritude does not play back well on the channels available to Popenguine listeners. However, Benoît's point that even baobab trees die hints at the fragility of living beings as archives, implying the necessity of

supplementary technologies of memory. The film ends with the generic conceit describing what each of the Inséparables grew up and went on to do with their lives. The Kings, however, are not mentioned. Their future remains in the most radical form of futurity, one of unforeseen, which is to say not foreclosed, speculative possibility: as archivists of the black musical repertoire linking 1964 soul to the film's present they stand as an alternative to the model of the baobab as a storage medium. For in using (up) their cultural and embodied memories as a reservoir of nostalgic affect that sustains Sene Absa's film, they render international popular black musical affinities a vibrant part of Senegal's history, anticipating such hybrid genres as mbalax and hip hop in Wolof.

The local political context in which *Ça Twiste à Popenguine* was made also shapes its meaning. After Senghor's retirement in 1980, the role of the state in determining cultural politics began to shift noticeably. As Souleymane Bachir Diagne points out, Senghor's successor, Abdou Diouf, not only saw himself as a technocrat where Senghor was a visionary, but he also inherited a troubled state faced with the challenges of structural adjustment and increasing economic pressures. Under Diouf's rule, the redeployment of the Musée dynamique, which Senghor had built to house the FESMAN art exhibition, as the seat of the Supreme Court came to be seen as emblematic of a shift away from the literal theatricalization of the state, and toward a more managerial approach. During the 1988 electoral campaign, a new slogan, *Sopi* (meaning "change" in Wolof) gained popularity, and found material expression in the *Set Setal* (meaning "purify oneself" in Wolof) movement.[26] As historian Mamadou Diouf has noted, the movement was dominated by youth who led in neighborhood cleanups and community-based actions, claiming a greater role for ordinary citizens in democracy.[27]

Like Sene Absa's film, the *Set Setal* movement emphasized the local as a site of self-determination distinct from the theater and theories of Négritude and closer to the popular and populist aspirations of those remote from the centralized state. Even more important, the movement, like Sene Absa's film, drew attention to the creativity and potential for change that youth engaging the technologies of their own global inclusion and exclusion brought forth. This impulse toward improvising with available resources, whether in mounting a "pitchoss" production or in creating small-scale neighborhood murals as beautification projects, also found its parallel in the world of Senegalese beaux arts. As Elizabeth Harney notes, numerous Senegalese artists, particularly members of the Laboratoire Agit-Art, which first became active

[26] Youssou N'Dour composed a song of the same name, *Set*, which spelled out in the clearest terms his sense that artistic expression had real consequences: "One day all the world's musicians will meet/ Music has no frontiers." However, as debates about world music bear out, how music circulates as a cultural commodity is largely determined by the globalized market for non-Western music.

[27] Mamadou Diouf, "Des cultures urbaines entre traditions et mondialisation," in *Le Senegal Contemporain*, ed. Momar Coumba Diop (Paris: Karthala, 2002), 261–88.

in the mid-1970s, have been committed to an aesthetic of bricolage, taking found objects otherwise considered trash—"chiffon, bottles and caps, cans, and discarded metal parts, found readily available in the large city markets and streets"—and turning them into expressions of a "poetics of poverty" that places particular emphasis on recuperating and transforming lack and disrepair for a defiant celebration of invention.[28] Harney sees in the aesthetics of *récupération* a parallel to what Ousmane Sembene has called "*mégotage.*" For Sembene, mégotage describes African filmmakers' ability to transform the limited technological and material resources available to them—the *mégots* or cigarette butts—and the often constricting conditions imposed by Western production partners, and to turn these meager remnants into compelling artistic statements. The very nature of this archive as an instrument cobbled together in the absence of power alters its function and pirates the role of culture in a post-Négritude state to render the processes of musical listening, dance, painting, into objects of curation, care, and preservation. In both of the films we have analyzed, the gramophone is no longer simply the player of records, but the writer of the record, determining what is archivable. What, then, becomes of this determining function of the gramophone as material technology and dominant cultural metaphor when we move from the analog era to the digital-mediated present?

Hacking into Afro-Futures

Whereas pirating most broadly encompasses unauthorized uses of proprietary material, hacking applies more specifically to unauthorized accessing and altering of codes that reprogram new possible outcomes. The three works discussed in this section elicit not only attention to experimental writing, but also experimental reading and viewing, and so extend the discussion of the phonograph as both player and writer of records. I stress the status of these works as aesthetic experiments for pointed reasons.

Very few popular media (Western or otherwise) regularly present images of innovation, progress, technological advance, experiment, or invention emerging from Africa. A skeptic has only to do a Google search coupling the terms "African" and "experimental" and an art form of her own choosing to grasp how deeply these limited notions also suffuse the critical terms in which aesthetic production is conceived. "African Experimental" expression is arguably a category that eludes recognition.[29] This situation is not unlike the difficulties

[28] Elizabeth Harney, *In Senghor's Shadow: Art, Politics, and the Avant-Garde in Senegal, 1960–1995* (Durham: Duke UP, 2004), 121.

[29] Searching on Google in August 2012, I discovered twenty-seven unique "hits" for "African Experimental Writing" (although almost all referred to a single South African publication of Lesego Rampolokeng's poetry), twenty-one unique hits for "African Experimental Music" and thirteen unique hits for "African Experimental Film." Certainly the works of literary scholars like Phyllis Taoua and Chantal Zabus draw particular attention to innovative writing and avant-gardes, however the category

facing black experimental writers in the U.S., with a critical establishment too often unprepared to recognize their work. Reflecting on this dilemma, Nathaniel Mackey describes the practice of innovative experimental writing as "centrifugal," exploring the outer reaches of the imagination. Outlining the challenges facing black experimental authors in the U.S., he writes:

> [T]here's a general tendency to think of innovation, especially where it's taken to be related to or synonymous with experimentation, as having to do with method, as having, more specifically, to do with the pursuit of greater complexity and sophistication in technical and formal matters, greater self-consciousness and complication with regard to questions of media-tion.... The innovation that's granted African American writing, where there's any granted at all, tends to be one of content, perspective, or attitude. The newness African American writing is most likely to be recognized and valorized for...is the provision of an otherwise absent or underrepresented (thus new) perspective, conveniently known as the black perspective, its report on the one thing African Americans are regarded as experts on— racial victimization. Along with this tendency go canons of accessibility and disclosure that are viewed as diametrically opposed to the difficulty attrib-uted to formally innovative or experimental work.[30]

Of course, African and African American writing occupy very different posi-tions in the global Northern academy, however the paradoxes of multicultural-ism described by Mackey also apply to postcolonial literature canons in which African literature features. One condition that African and African American experimental writers share is that of marked marginalization exacerbated by the very categories that allow more formally transparent authors admission into the canon. If, as the OED defines it, to hack is to "gain unauthorized access to (computer files, etc.)" it would be fair to call the creative labor of these inno-vative writers "hacking" to the extent that the critical establishment seems unready to recognize (and thus authorize) the various forms of Afro-futurism they make palpable in their work.

Placing Akomfrah, Bugul, and the Heliocentrics in conversation constitutes an act of experimental reading that highlights a common concern with pirat-ing, coding, hacking, and other tropes of our technologically mediated present moment that might otherwise remain buried beneath the surface of these texts. This convergence of recording and writing draws attention to hacking as a par-ticular form of piracy, a useful entry point into the detoured discourses of tech-nology lying just below the surface of these works. Technological insurgency

of experimental forms is not widely recognized in African criticism or valorized as a stylistic classifica-tion for publishers.

[30] Nathaniel Mackey, "Expanding the Repertoire," in *Paracritical Hinge, Essays, Talks, Notes, Interviews* (Madison: U Wisconsin P, 2005), 240.

is a prominent theme in John Akomfrah and the Black Audio Collective's 1995 film *The Last Angel of History,* and thus the film serves as a sort of instructional video, a collection of procedures that can profitably be used to decode the more recent Ken Bugul's *Rue Félix-Faure* (2005) and the Internet site *Pan African Space Station* (2008 to present). A willfully experimental reading matters particularly for Ken Bugul's novel, which makes no reference to electronic technology, computers or the Internet at all. I will argue that the way the silent protagonist, Muñ, deciphers a typefaced manuscript screenplay in an effort to solve the mystery at the center of the novel bears many of the hallmarks of more explicitly Afro-futurist writing. Furthermore, the music that suffuses the novel—the blues and Cape Verdean *morna*—serve as an essential code for Muñ and others trying to come to grips with a chaotic situation that the state, symbolized by police agents, is singularly ineffective in addressing. My reading (or rather navigation) of the *Pan African Space Station* website may appear to be a return to conventional interpretive practices, but I attend particularly to the ways in which hypertext, radio listening, and social networking sites all offer ways of engaging with the site that invite experimental reading practices.

Cyberspace Is the Place: The Last Angel of History

Like all of the Black Audio Film Collective's productions, *The Last Angel of History* is a collaborative project, and was directed by John Akomfrah, produced by Lina Gopaul and Avril Johnson, written by Edward George with research by Kodwo Eshun and Floyd Webb, and with original music and sound by Trevor Mathison. Although Eshun and Webb joined later, the group has worked together since 1982. *The Last Angel of History,* like its related shorter version, *Mothership Connection,* bears some of the signature techniques of the collective: extensive use of archival footage, ambient sound design as an integral part of creating continuity, highly poetic and abstract narration, and a thematic interest in pan-African lines of connection coupled with a deep suspicion of identity politics and explicit black nationalism. The first of these techniques, extensive use of archival footage, is almost literally piracy, for they generate new and unexpected aesthetic objects out of a reproduction of often minimally credited found footage to propose transnational black counterhistories to national(ist) British media sources. In so doing, they hack into other lines of affiliation, forging, in *Seven Songs for Malcolm, Handsworth Songs,* and *The Last Angel of History,* among others, an archive of transnational black solidarity. For Akomfrah and Eshun, participating in the collective is but one of multiple identities they inhabit as part of the Ghanaian diaspora in Britain. Given how common migrancy has become in the contemporary world, their status as both British and Ghanaian subjects is emblematic of an increasingly shared experience of multiply inflected and mobile forms of belonging. Recognizing

this, the film offers an opportunity to read its diasporic surface for its *African* valences. Such a reading is arguably catachrestic, given the preponderance of American and British voices in the film, but constitutes yet another layer of the experimental reading this chapter espouses.

The film's title is the only direct evocation of Walter Benjamin's *Angelus Novus,* the angel of history described in the ninth of his *Theses on the Philosophy of History.* Benjamin's angel flies with his back toward the future and his face toward the past. Akomfrah's film revolves not around an angel, but a Data Thief, a pirate figure par excellence. The conceit of the film plays with both the literal and metaphorical senses of pirating as data thieving, bringing a wry sense of humor to discussions of technology usage, sampling, actual space exploration, experimental music, and science fiction that blur distinctions between the real and the imagined. The film's narrator announces that in the film's framing chronotope of the year 2057, the Data Thief has been commissioned to dig for the "technofossils" of the blues, an *ur*-black music characterized as a "black secret technology.... The blues begat jazz, the blues begat soul, the blues begat hip hop, the blues begat R&B." In Harry Zohn's poetic translation of Benjamin's essay, the angel sees all of history folded in upon itself: "[w]here we perceive a chain of events, he sees one single catastrophe which keeps piling wreckage upon wreckage and hurls it in front of his feet."[31] The Black Audio Film Collective's versioning transforms the eschatological vision of Benjamin's angel into a black audio culture parallel: sampling, which Kodwo Eshun calls "a way of collapsing all eras of black music onto a chip" in his on-screen interview. If Benjamin sees the angel propelled into the future by a storm blowing from Paradise, leaving mounting piles of debris in its wake, what does the storm of progress sound like in the Black Audio Film Collective's dub versions?[32]

One version of the angel's flight follows it through its fall, its paradise lost,[33] as it becomes instead a Lucifer figure whose pact with Robert Johnson delivers the gift of blues at the crossroads. Another version is projected as the human explorations of outer space in interviews with one of NASA's first black astronauts, Dr. Bernard Harris, Jr., and with Nichelle Norris, the actress who played Uhura on *Star Trek* for decades. A third version most explicitly indexes the cybernetic as a pan-African cultural strategy, making the bold claim that black folk have lived a history of such traumatic ruptures that survival itself has depended upon "the integration of living organisms and ... technological

[31] Walter Benjamin, "Theses on the Philsophy of History," in *Illuminations: Essays and Refelctions,* trans. Harry Zohn (New York: Schoken Books, 1968), 257.

[32] For a fuller exposition of Kodwo Eshun's musical thought, see his magnificent collection of essays, *More Brilliant than the Sun* (London: Quartet Books, 1998).

[33] Like Kofi Anyidoho, Akomfrah is a great enthusiast of John Milton's *Paradise Lost,* using a citation from it as one of the key texts in his 2010 film *Mnemosyne.* (Anyidoho interview, Accra, Ghana, June 2006; Akomfrah screening and lecture, Haverford, PA, March 20, 2011).

devices," as one entry defines "cybernetic."[34] While the camera focuses the entire frame on an image of multiple computer monitors (a recurring leitmotif throughout the film), the narrator declares:

> the Data Thief knows that the first touch with science fiction came when Africans began playing drums to cover distance. Water carried the sound of the drums and Sound covered the distance between the old world and the new world. This was the Data Thief's first visit, his first clue. It took him back to the new world.

However, *The Last Angel of History* is not content to trace the roots of human-technological and human-astral interfaces to Africa. Late twentieth-century black music itself is a technofossil, a miraculous weapon for the radical rear-rangements of time and space the Data Thief must uncover.

His mission is to "steal fragments from cyber culture, technoculture, narra-tive culture," an elegant summation of the cultural logic of piracy. This version of stereomodernism is characterized by a bricolage aesthetic, composed of sto-len and repurposed fragments, and by a disavowal of grand, statist, or monu-mentalizing gestures in favor of more granular-level cultural action. As Kodwo Eshun insists in his on-screen interview, the music *The Last Angel of History* digs (up)—George Clinton's funk, Sun Ra's Arkestrations, Lee "Scratch" Perry's dub, Derek May's techno, A Guy Named Gerald's jungle—is quintessentially electronically mediated. Far from the street or stage that Eshun considers hackneyed stereotypes of black sound, these forms are "studio music…impos-sible, imaginary musics…they imagine a future"—they are, in a word, cyber-netic musics.

The term *cybernetic* is deeply embedded in our current media environment. Terms like "virtual," "digital," and even simply "new," threaten to bury all but a fragment of the *cybernetic*. The term is most likely to be unearthed as a broken shard, as in *cyber*space, *cyb*org, and in the age of the generalized and perma-nent war, *cyber*terrorism. Its ancient Greek roots in navigation are buried even deeper in forgetfulness. A specimen of this older use is preserved carefully in the pages of the OED, which traces its etymology to "κυβερνήτης" meaning steersman and also "κυβερνητικός," good at steering. In the Black Audio Film Collective's work, the metaphors of steering and navigation tap into a signifi-cant current in Black Atlantic musical experimentation, while accruing depth to the conceptual rhymes with piracy's nautical referents. The film begins with a cryptic assignment for the Data Thief: to locate the blues crossroads and crack the blues code, armed with only one clue: "it's a phrase: 'mothership connection.'" An extended meditation on P-Funk's 1975 hit album, *Mothership Connection,* follows, fundamentally resetting the orientation of citizenship to

[34] See OED, entry 1.b.

universal rather than national terms in a parliament of dipping hips and glid-
ing strides, seizing the archive of Sorrow Songs to take a joyride on the sweet
chariot hailed in the album's title song.[35]

The cover image of George Clinton emerging in go-go boots, a diaper, and
shades from an unidentified flying object is surreal enough, but this recurrent
visual becomes especially "out" (as jazz musicians would put it) when juxta-
posed with the documentary footage of NASA astronaut Harris's flights and
the three-dimensional animated graphics representing space travel. Only a few
years before the film's release, Frederic Jameson critiqued pastiche as a form
of "blank parody" in late capitalist postmodern cultural expression as risking
a descent into a depoliticized world of simulacra precisely because it effaced
a connection to history.[36] By contrast, Akomfrah and his collaborators used
juxtapositions of real and imagined space travel to underscore the very exclu-
sions of black subjects from Eurocentric history that made Afro-futurist and
speculative artistic projects so politically charged. The film cuts to an inter-
view with techno musician Derrick May as he recalls his first experience at a
live concert, where he saw Clinton emerge dressed as on the cover of the 1975
album and heard music that continues to inform his own art. May declares
"George Clinton, I think, is a fucking maniac." The *out*ness of Clinton's music
extrudes beyond the shared expectations of collective listening, the bounded
arena of concerted pleasure to such an extent that it calls forth *ex*pletive, and
places Clinton outside of the space of reason, in a unique geography of Black
Sonic UnReason. While Clinton himself claims to have heard nothing more
of Lee "Scratch" Perry than his name, *The Last Angel of History* proposes that
Perry and Sun Ra share a language anchored in imagery of navigation, travel,
and Afro-futurism. Lee Perry's spinning Black Ark and Sun Ra's Arkestra are
vehicles fueled by a musical imagination that propels players and listeners
alike into that strangest of temporalities and topologies: here, we are already
"after the end of the world," where "Space is the Place." Clinton's temporal
framework is similarly complex, as he states "Space for black people is not
something new...we've been there...[we're] striving to return to the essence
of where we come from." The metaphors of space exploration that suffuse the
music of Clinton, Perry, and Sun Ra situate them at the very core of cybernet-
ics, both as master steersmen and as artists working at the interface of human
and technological expression, creating shockingly new aural experience out of
studio and extended-instrument techniques.

The African American writers interviewed in the film—Ishmael Reed,
Greg Tate, Octavia Butler, Samuel Delaney, DJ Spooky—stress that the his-
torical experience of African Americans has been one that parallels many of

[35] Here, of course, I am comping on the lyrics of "Mothership Connection."
[36] Frederic Jameson, *Postmodernism, or, the Cultural Logic of Late Capitalism* (Durham: Duke UP, 1991), 17.

the plotlines of science fiction. Reed observes: "we are not *believed*. We're like aliens trying to tell our experience to earthlings…living in this country for African Americans is a far out experience." And similarly, Greg Tate speaks over footage of Detroit's abandoned inner core and June Tyson's voice on the audio track exclaiming "It's after the end of the world! Don't you know that yet?" Tate recalls that he has long "contended that black experience and science fiction are one and the same. The form of science fiction [portrays] someone at odds with the apparatus of power in society…[experiencing] cultural dislocation, alienation, estrangement." If the Black Audio Film Collective is taken as a strictly British entity, a collaboration of black British subjects circumscribed by a single shared identity born of coming of age in the shadow of the British Empire's perplexing responses to an increasingly diverse population swelled by the descendants of the Caribbean Windrush Generation and related waves of immigration from other Commonwealth countries, *The Last Angel of History* might be read as a meditation of comparative diasporas. However, returning to the invitation that artists navigating hyphenated identities like Eshun and Akomfrah seem to issue as they demonstrate that they are both fully British and fully Ghanaian, how might *The Last Angel of History* be read as an *African* film?

The key, I would argue, is in the invocation of an origin tale that insists on fabrication as the very locus of its authenticity. The sound of the drum, as we have seen, is taken as the Data Thief's first brush with science fiction, and Kodwo Eshun argues that "black producers release the entelechy of an instrument, release the potential energy that lies inert in any technology," suggesting an a priori given-ness. For Akomfrah, his family's exilic departure from Ghana in the wake of the coup that deposed Kwame Nkrumah in 1966 introduced an irrecoverable error into the relation to Africa as a source file, and much of his most creative work has to do with representing actual and imagined returns to his homeland as part of the larger catastrophic history of the Black Atlantic. The *cybernetic*, in Eshun's view, has been a constitutive element of black subjectivity since the eighteenth century, when "slaves like Phyllis Wheatley wrote poetry to prove that they were human," and since then technologies of expression have always driven black creativity toward a form of chiasmic cyborg-being, "to get out of this time here, this space now." Donna Haraway's seminal diagnosis of "the line between social reality and science fiction" as "an optical illusion" takes on a new inflection in the *Last Angel of History*'s narration when juxtaposed with black-and-white footage of unidentified mass protests in Accra and contemporary shots of Ghanaian urban crowds and slave heritage sites.[37]

[37] Donna Haraway, "A Cyborg Manifesto: Science, Technology, and Socialist-Feminism in the Late Twentieth Century," in *Simians, Cyborgs and Women: The Reinvention of Nature* (New York: Routledge, 1991), 149.

[the Data Thief]'s in a land of African memory. Every entrance into these vaults brings new information of victories and defeat, dreams and catastrophe, new words: alien, slave...Africa, the Data Thief's last visit. He would like to return home, but cannot. No escaping from this time, this space, he continues collecting information wandering the boundaries between science fiction and social reality. This is the Data Thief's new home, the zone of optical illusions.[38]

Reflecting on making the first of his films that grappled with returning to his homeland, *Testament,* Akmofrah recalls:

We went to Ghana to try to make a film about Kwame Nkrumah, but also about a movement and a body of ideas that simply don't exist any more.... They'd been swept away not just by the force of historical events but also by attempts on the part of successive governments after Nkrumah's to basically bury the man and all that he stood for. There is something metaphorically significant in that act because so much of diasporic history rests precisely in that gap between history and myth.[39]

The parallels between the violence of the postcolony's commandment and its antecedent violences of slavery and colonialism give rise to a common archival crisis. And rather than searching for records that simply do not exist, or mourning the material conditions—weather, fires, intentional destruction, underfunding[40]– that threaten the limited records that do exist, Akomfrah and the Black Audio Film Collective have come to an aesthetic of disjuncture. Collecting discrete found objects, they reinsert them in a poetically spare film-essay form made intelligible by the ambient sound design of Trevor Mathison and the referencing of shared texts of black music. This music is *the mother-ship connection,* a means of understanding together one's exilic and diasporic African-ness, both on the continent and in black communities abroad. This form of solidarity is not necessarily "political" in the sense of being tied to particular social movements and legal outcomes, but rather recuperates more open-ended futures. It works out of a differently assembled archive, one that is from its very beginnings disorderly, uncatalogued, unreasonable, unavailable, *out.* Out music is the call of such outer reaches, the out-er space where black solidarity exceeds and absorbs historical rifts.

[38] *Last Angel of History,* directed by John Akomfrah, 1987.
[39] Kobena Mercer, "Post-colonial Trauerspeil," in *The Ghosts of Songs: The Film Art of the Black Audio Film Collective,* ed. Kodwo Eshun and Anjalika Sagar (Liverpool: Liverpool UP, 2007) 44–45.
[40] Maxwell Agyei Addo, "Audiovisual Archives in Ghana," in *Archives for the Future: Global Perspectives on Audiovisual Archives in the 21st Century,* ed. Anthony Seeger and Shubha Chaudhuri (Calcutta: Seagull Books, 2004), 118–129.

Pirating the Blues on Dakar's *Rue Felix-Faure*

Where *The Last Angel of History* literalizes its emphasis on "outness" through a meditation on the outer reaches of space, Ken Bugul's novel *Rue Félix-Faure* seems to unfold primarily in the interiors of back rooms, alleyways, and privies. However, in these private spaces, it explores how gendered subjects adopt surrealism and media pirate methods to respond to violence in the face of insufficient judicial structures in Dakar, a postcolonial city in the throes of globalization, corruption, and contested religious authority. I want to push, even force the point of emphasizing the connections between this text and the more explicitly technologically oriented themes in Akomfrah's film and the Heliocentric's website because African women continue to be excluded from scholarly as well as popular imaginings of electronic futures. As the founder of *JENdA: A Journal of Culture and African Women Studies* and Nigerian internet innovator Nkiru Nzegwu has observed:

> The bottom line is that in [prospective funders eyes] an over-the-hill immigrant African woman of the wrong color with an unpronounceable name, doctoral degree in the humanities, and teaching in some lackluster public university does not fit the bill. Everyone *knows* that such people are not Internet savvy, imaginative and resourceful.[41]

My effort to link the language and metaphors of data files and digital media with the novel's concerns will, I trust, seem less forced as the complex forms of memory, writing and rewriting in Bugul's work emerge below.

The novel's women circulate through urban spaces, exposed to forms of violence enabled by the city's anonymity, perpetrated with an impunity that would seem impossible in more intimately interconnected rural settings. Yet, for the protagonists (a blues singer named Drianké, her domestic worker Muñ, their Cape Verdean neighbors, and sex workers operating in the neighborhood), just as urban anonymity renders them vulnerable to sexual violence, an anonymity assumed behind veils, in the dawn's halflight, in the city's alleyways and outhouses allows these women to deliver vengeance to the serial rapist, a false *moqadem*[42] or spiritual teacher responsible for their suffering, where state and religious authorities have proved inept or unconcerned. Behind veils, in speakeasies down hidden allies, and through louvered windows, subjects to whom Dakar's state apparatuses are least accessible—unaccompanied women,

[41] Azuka Nzegwu, "Redefining 'Africa' in the Diaspora with New Media Technologies," in *The New African Diaspora*, ed. Isidore Okpewho and Nkiru Nzegwu (Bloomington: Indiana UP, 2009), 364.

[42] Littéralement "celui qui est promu." Titre attribué au représentant des autorités civiles, au niveau du voisinage, mais aussi à celui d'un maître sprituel, autorisé à dispenser un enseignement et à initier des disciples. (N.d.E.), p. 20 [Literally, "the promised one." Title attributed to a neiborhood representative of the civil authorities, but who is also a spiritual master, authorized to dispense teachings and initiate disciples (Editor's Note).]

but also immigrants, the indigent, and the artistic—navigate the city, imagining their own justice in the wake of the betrayals of what Derrida names the *arkheîon,* or seat of power. Their tactic of strategic anonymity recalls masking traditions among secret societies throughout West and Central Africa, but it also parallels the phenomenon of unidentified hacktivist collectives such as Anonymous, who have been active in antiglobalization social movements and who sport Guy Fawkes masks as a way to claim both visibility and invisibility in the public sphere.

In the shared sufferings of these characters, a form of solidarity through what one could call an out-of-body experience is instituted, an oft-overlooked form of synesthesia. The OED's second definition for synesthesia, derived from its use in psychology, is "agreement of the feelings or emotions of different individuals, as a stage in the development of sympathy" and the dictionary's etymological note reminds readers that the terms *synesthesia* and *anesthesia* share a root. This clinical sense of synesthesia moves away from the aesthetic, and into the realm of feeling, and especially feeling pain; in so doing it conceives of a way to escape the isolation of individual pain and move into a form of radical empathy.[43] Bugul speaks to the significance of moving from the isolation and shame of sexual assault into an aggregated gathering of shared feeling and testimonies, heard in private domestic space but addressed in collective street justice.

Rue Félix-Faure is a slippery text that encompasses multiple genre conventions. On one level, the novel is a murder mystery, but it is the identity of the corpse rather than that of his killer that occupies the novel. As successive characters encounter the dismembered and mutilated body of a leper who has been sleeping in an alcove, several recognize him as they have crossed paths with him earlier in their lives. The leprous *moqadem* is a serial con man and sexual predator who returns to Dakar after studies in the metropole. Unsatisfied by his life as an obscure civil servant, he declares himself a spiritual teacher with a sinister calling to "minister" to a succession of seemingly self-sufficient women. His modus operandi is to promise marriage while fleecing their finances, to perform "cleansing" rituals, which are in fact sadistic or incestuous sex acts, and to then disappear. His victims keep their experiences secret, and it is only a subsequent chance encounter with the *moqadem,* seemingly unrecognizable in his new condition as a leper cloaked in a towel, that triggers each of their traumatic memories.

[43] While the body of scholarship on "affect" might well apply here, particularly the work of Eve Kosofsky Sedgwick, Brian Massumi, Félix Guattari, and Gilles Deleuze, I want to work through these ideas via a close reading of *Rue Félix-Faure* because the novel has yet to be translated and deserves new readers. I also find Ruth Leys critique of the affective turn in literary studies, particularly the ways it undercuts ideological critique, highly compelling. For a full version of Ruth Leys's critique see: "The Turn to Affect: A Critique" in *Critical Inquiry* 37:3 (Spring 2011), 437–72.

On another level, this novel is a domestic fiction concerned with what home and belonging mean in contemporary Senegal. In fact, the novel's title is a home address of sorts. The novel's address resuscitates the French premier who presided over the Dreyfus affair, Félix Faure, and so the title evokes a France in crisis. Furthermore, President Faure died in office in farcical conditions, reputedly collapsing in an apoplectic fit while receiving fellatio from a woman many years his junior. Thus, the colonial past is skewered each time the novel's setting is named. However, contemporary Dakar's Rue Félix-Faure is also inscribed within a postindependence nationalist geography. It branches off from the Rue de la République to the west, skirting the ministry of the interior and crossing the Avenue du Président Léopold Sédar Senghor to the east. Proximate to, but outside the seat of present and past power, it is home to successive waves of migrants and nonconformist subjects. Their "home" address is linked throughout the novel with spaces the postcolonial state cannot acknowledge, detouring the state's responsibility to administer the law to the street.

The novel is also a tribute album of sorts, dedicated to three West African artists—the Cape Verdean singer Cesária Évora (1941–2011), the Senegalese filmmaker Djibril Diop Mambety (1945–1998), and the Senegalese singer and actress Aminata Fall (1942–2002, who appeared famously in Mambety's *Touki Bouki*).[44] These dedications evoke a regional, even Afro-cosmopolitan, rather than national vision, celebrating a synesthetic melding of visual and aural senses. Mambety is abstracted into the character Djib (a filmmaker), while the character Drianké seems to be a composite abstract portrait of Évora and Fall. Drianké, one of the main characters of the novel, is the blues singer who owns the speakeasy on whose doorsteps the corpse is discovered. Her name identifies a Senegalese female archetype (and, as with several other characters substitutes a social role for a typical proper name). Francis Nyamnjoh sums up the archetype of the *diriyanke* (also spelled *drianké*) as a

> bulkier, often heavily perfumed and incensed, jeweled (with earrings, chain necklaces, bracelets and rings on fingers and toes) and richly traditionally dressed [woman...] in the popular imagination the word reflects the dignified, slow and gracious gait and middle-aged elegance of the Senegalese lady at her best.[45]

Drianké, we learn, moved to the Plateau district many years earlier and set up her speakeasy in order to escape the traumas of her encounter with the *moqadem*. She brings with her the tactics of vernacular expression, for while

[44] Aminata Fall, the singer and actress, is not to be confused with Aminata Sow Fall, the grande dame of Senegalese letters.

[45] Francis Nyamnjoh, "Fishing in Troubled Waters: Disquettes and Thiofs in Dakar," in *Africa* (Summer 2000), 300.

she does not read or write, she is described as an expert listener who wields "an empirical logic stripped of all flourishes," as Bugul puts it. And the fact that she sings the blues recalls Akomfrah's sense of the blues as a matrix of black musical creativity. However, for Bugul it is the social and aesthetic *function* of the blues, and specifically its *timbre* that is emphasized, rather than specific musical repertoire or genre conventions:

> Elle avait une voix de blues. De par ses origines berbères, negro-berbères et kabyles, elle avait hérité une intonation dans la voix qui partait des monts de l'Atlas dans le désert. Elle avait éte surnommée Billie Holiday, Bessie Smith, Sarah Vaughan, Mahalia Jackson, Nina Simone, Ella Fitzgerald, des femmes qu'elle ne connaissait pas. Elle n'avait jamais été à l'école, et n'avait que sa voix. Elle chantait sa ville natale avec la langeur de cette ville, d'une voix plus que blues. Une espèce de plainte, complainte amoureuse, sanglotante. [She had a blues voice. From her Berber, black Berber and Kabyl roots she had inherited a vocal intonation that came from the Atlas mountains in the desert. She had been nicknamed Billie Holiday, Bessie Smith, Sarah Vaughan, Mahalia Jackson, Nina Simone, Ella Fitzgerald, women she did not know. She had never been to school, and all she had was her voice. She sang of her village with the languor of that village, with a voice full of more than the blues. A sort of lament, a lover's sobbing complaint.][46]

The blues have the power to enact a continuity in subject position between Drianké and the iconic musicians with whom she is compared. Although they do not know of one another, and arguably sing in different musical idioms, the plaintive function of the blues highlights a parallel struggle; indeed, the blues function as a device for activating transnational black female solidarity.

Drianké's home is the principal interior space of the novel. At once a drop-in speakeasy and the residence she shares with her mysteriously silent domestic employee, Muñ, Drianké's place functions as a Foucauldian heterotopia. Ken Bugul describes it as a "garde-fou," an alternative to the mental asylum and a place where the solace of talk and laughter among friends may be found. It is not marked by any signage, but rather is hidden at the end of long, potholed corridors in a courtyard along with several other cottages behind the façade and entrance that opens onto Rue Félix-Faure. Thus, it exemplifies Foucault's notion that "heterotopias always presuppose a system of opening and closing that both isolates them and makes them penetrable."[47] While they host a wide range of guests, Drianké and her domestic worker Muñ model a family without patriarchal or heteronormative foundations.

[46] Bugul, *Rue Félix-Faure*, 238.
[47] Michel Foucault, "Of Other Spaces" in *Diacritics* 16 (Spring 1986), 22–27.

Rue Félix-Faure is also an immigration narrative, as the street is home to Dakar's significant Cape-Verdean diaspora. Ken Bugul evokes the easy accommodation of this diaspora in central Dakar's breezy tolerance with her description:

> Tous ces bureaux chics et précieux jouxtaient les salons de coiffure des Cap-Verdiens, d'où filtrait à chaque moment de la journée de la musique. Morna, biguine. Une musique lancinante, prenante, envoûtante, nostalgique, une musique des îles, non loin. [All these chic and trendy offices were adjacent to Cape-Verdean hair salons, from which music filtered at every moment of the day. Morna, Beguine. An insistent, captivating, bewitching, nostalgic music, a music of the nearby isles].[48]

The novel's Cape Verdean community is defined as much by this music as by their bodies, dress, and language. However, in contrast with the blues' function as a sign of female black solidarity, despite the fact that their music filters into the city's public spaces to intricately weave them into the local landscape, their diasporic presence in Dakar remains apolitical, a proximity without intimacy. The ubiquity of Cape Verdean presence through music and fashion focalizes their exclusion from the polis as envisaged by the mythologies of postcolonial nationalism. A similar exclusion in fact applies to the entire Rue Félix-Faure community, comprised of single and divorced women, actresses, singers, sex workers, and others whose professions do not serve such nationalist mythologies. The *moqadem*, capitalizing on such exclusions, does violence to the narrative voice of each of his victims, and uses isolation and shame to bar them from a public forum so there can be no collective action unless this silence is broken.

The hair salons and fashion boutiques operated by the Cape Verdean community maintain bodily surfaces just as this diaspora hovers on the surface of Senegalese society. Ken Bugul describes the Cape Verdean community as reserved:

> "Ils n'avaient pas pu aller plus loin qu'en face de leurs îles. Ils auraient voulu partir beaucoup plus loin, en Amérique comme les autres. Hélas! Leur bateau avait échoué juste en face de leurs îles!...Les Cap-Verdiens faisaient seulement partie du décor./Comme la musique de violon!/Comme les filles aux dos nus, couleur caramel!/Comme les salons de coiffure!/Comme la couture!" [They had not succeeded in going any further than across from their islands. They would have liked to go farther, to America like the others! Alas! Their boat had given out just across from their islands!...The Cape-Verdeans were just part of the décor./Like the violin music!/Like the

girls with their caramel colored bare backs!/Like the hair salons!/Like the dressmakers!][49]

While their community seems insular, the one dimension of their presence that suffuses the neighborhood is music. This music seems to do more to anchor the Cape Verdeans within Dakar's sonic landscape than to effect the kind of transnational solidarity the blues activate. As the novel opens, Rue Félix-Faure is just waking, and the only sounds drift from the not-yet-open hair salon, *Chez Tonio,* where a violin's rendition of a Cape Verdean morna drifts through the louvered windows. The music *makes* this Tonio's home, but just as crucially it is the sign of leaking cultures, crossing thresholds, and coexistence. The morna enunciates and frays this diaspora's edges, and insists that local diversity be acknowledged. The Cape Verdean community of the Plateau is at once constitutive of Dakar's locality (the specificity of this neighborhood in this city) and its globality (a mode of diasporic being that is by definition urban, since this is where the necessary resources, transportation, and communication networks converge to support transient populations).

Dakar's diversity is not limited to international migration. All of the residents of Rue Félix-Faure are transplants of one form or another. Drianké hails from the northern city of Saint-Louis, Muñ comes from a remote town named Hogbo, and so on. Because the neighborhood is defined by a conviviality confined to the present, Muñ's past remains hidden to Drianké. Muñ, in fact, holds a degree from a French university, but upon returning to discover that her mother has fallen gravely ill, she resolves to seek out the man who has infected her mother with leprosy and to see justice done. Taking a position as Drianké's domestic worker gives her a home address in Dakar as she seeks redress for her mother's suffering. Muñ is a silent figure, whose name is simply the Wolof word for patience, and her strategy contrasts with Drianké's way of sifting through experience by singing the blues.

In fact, Muñ's silent act of reading constitutes perhaps the most literal version of piracy in the novel. Muñ first discovers a manuscript hidden in a yellow envelope near where the leper sleeps outside Drianké's home. For inexplicable reasons she is consumed with curiosity, and hides the manuscript in the most private space available to her, above the toilet tank in Drianké's bathroom, to continue reading it on her own time. Soon afterward, Djib the filmmaker announces, distraught: "J'ai perdu mon histoire! [I have lost my story]"[50] and explains that he means the scenario for his next film, which is based on a firsthand account told by the leper. As the novel continues, it becomes clear that Muñ's manuscript is in fact this scenario, and her long private reading sessions appear to magically reactivate the memories of the leprous *moqadem*'s abuses

in his victims, eventually leading them to the collective act of "Vengeance" alluded to in the manuscript's title. By seizing the manuscript and subjecting it to her own act of counterreading, Muñ pirates the original text and distributes it to a wide, diverse, and unidentifiable community of women who eventually take concerted action in response.

Drianké is one of those women. When Drianké learns that the corpse is "mon lépreux" (her leper) she breaks into a song, perhaps of mourning, perhaps of something more complex:

> De la gorge de Driankée était sorti l'un des plus beaux blues qu'on n'avait jamais entendu depuis le *Cotton Club*. Un chant sorti des dunes du désert, emporté par les vents de sable, vers l'océan lointain et proche! [From Drianké's throat rose one of the most beautiful blues that had ever been heard since the Cotton Club. A song rising out of the desert dunes, carried on the sand winds, towards oceans far and near].[51]

Drianké had earlier granted the leper permission to sleep in the passageways to her courtyard. However, there is something uncanny about his presence. She asks him where he has lived before, but represses what seems to be recognition:

> Même sous sa grosse serviette, Drianké pensait reconnaître quelqu'un. Mais ce quelqu'un, elle ne voulait pas y penser, elle ne voulait plus s'en rappeler. Elle pensait à ce quelqu'un parfois, malgré elle, et à chaque fois, elle sifflait un blues pour passer sur ce souvenir. [Even under his huge towel, Drianké thought she recognized someone. But that someone was someone she did not want to think about nor remember. She thought about this person occasionally, in spite of herself, and each time she would whistle the blues to herself to get over this memory.][52]

Singing the blues allows Drianké to work through the trauma of a memory she is not yet able to assimilate. It also allows her to turn her grievance into a public plaint, literalized by the fact that Drianké's voice grows louder whenever she contemplates the *moqadem*'s predations, and Drianké's singing prompts other victims of the *moqadem* to break their silence. For Djib's unnamed female companion, this takes the form of a piercing scream the first time she encounters the leper at Drianké's, and she subsequently narrates her experiences to Djib, who responds by planning a film about the *moqadem*. The silent Muñ eventually adds her voice, singing a loud blues when she finishes reading the "Vengeance" manuscript.

The form that vengeance upon the *moqadem* takes is as graphic as his serial molestation of women: he is dumped on a doorstep, *"découpé en gros morceaux avec les petites parties sexuelles enfoncés dans la bouche"* [cut into chunks

[51] Ibid., 69.
[52] Ibid., 127–28.

with his genitals stuffed deep into his mouth]. This description is, in fact, a leit-motif repeated throughout the novel, and the textual repetition of the *moqadem*'s castration punishes him not only by the vigilante justice of strangers in his death, but also through the narrative reiterations of this violence. Achille Mbembe has written of the link between what he calls the aesthetics of vulgarity and postcolonial abuses of power, noting how its "symbolism focus[es], above all, on the mouth, the belly, and the phallus."[53] In Ken Bugul's text, the convergence of these three dimensions is literal and hyperbolic. The *moqadem* adopts his persona as a spiritual teacher to feed an obscene hunger for power frustrated by his position as a petty bureaucrat. Ready to turn any relation into a financially and sexually exploitative one, the *moqadem*'s approach is strikingly congruent with Mbembe's diagnosis of the exercise of power in the postcolony as an extension of colonial economies of extraction and maximized exploitation.

> *To exercise authority is, above all, to tire out the bodies of those under it,* to disempower them not so much to increase their productivity as to ensure the maximum docility.... The male ruler's pride in possessing an active penis has to be dramatized through sexual rights over subordinates, the keeping of concubines, and so on. *The unconditional subordination of women to the principle of male pleasure remains one pillar upholding the reproduction of the phallocratic system.*[54]

While this system enacts its power upon *female* bodies, Ken Bugul suggests that interrupting and bearing adequate witness to its violence requires the action of both men and women.

The arts (music and film) play a primary role in the novel's vision of male solidarity with female suffering. Tonio the barber responds to the discovery of the leper's corpse by playing a dramatic morna on his violin, playing with passion and intensity despite the indifference around him. With no particular audience in mind, this is not a performance so much as Tonio giving voice to his family's grievance against the *moqadem*, who has preyed upon both Tonio's daughter and his wife, and forcing the *moqadem*'s eyes (which are, uncannily, still living) to recognize the suffering he has caused. Tonio, as well as Drianké's brother Amoul and Djib, name the oppressive suffering that the women appear to express in more limited terms. Nevertheless, a quartet of veiled female figures are the final harbingers of the *moqadem*'s death. Their collaboration with a number of veiled and shadowy figures delivers a decisive act of vigilante justice that transforms the city's anonymity from a curse to a gift. Taking cover in the very silence that has oppressed them, "Les quatre formes voilées qui semblaient se multiplier reculèrent un peu vers le grand portail, comme pour

[53] Achille Mbembe, *On the Postcolony* (Berkeley: U California P, 2001), 106–7.
[54] Ibid., 110, my italics.

ne pas se faire voir par cette ombre qui marchait d'un pas vigoureux" [The four veiled forms which seemed to multiply recoiled slightly toward the large doorframe, as if to keep from being seen by this shadow which was walking with a vigorous gait].[55] If citizenship and mobility are bounded by technologies of the individuated self, these figures elide and overcome those bounds through an uncanny dispersal of projected identities onto their spectral bodies. The anaphoric repetition creates an incantatory spell that allows for individual unspeakable traumas to be aired, but does not demand the humiliating unveiling of each one's private suffering:

En l'une des ombres voilées, Muñ avait reconnu sa mère.
En l'une des formes voilées, le Philosophe de la rue Félix-Faure avait reconnu Drianké.
En l'une des formes voilées, Tonio, des persiennes de la fenêtre de son salon de coiffure, avait reconnu sa fille....
En l'une des formes voilées, on pouvait reconnaître une femme abusée....
En l'une des formes voilés on pouvait reconnaître la fille aînée de Muezzin.
En l'une des formes voilées, on pouvait reconnaître toutes les femmes.

[In one of the veiled shadows, Muñ recognized her mother.
In one of the veiled forms, the Philosopher of Rue Félix-Faure recognized Drianké.
In one of the veiled forms, Tonio, from the window shutters of his salon, recognized his daughter....
In one of the veiled forms one could recognize an exploited woman.
In one of the veiled forms one could recognize an abused woman
In one of the veiled forms one could recognize the eldest daughter of the Muezzin.
In one of the veiled forms, one could recognize all women].[56]

The *moqadem*'s body is finally boxed in a coffin by "l'employé de la morgue," a civil servant at the morgue, and the time (5.30) and date (November 29) of his death are translated into the language of official archives, a legal record of the state's power over death. The *moqadem*'s ultimate punishment is to be delivered into the hands of the state, boxed into the limits of time and space by the fluid strategy the residents of *Rue Félix-Faure* employ to gain resolution of grievances the state fails to acknowledge, let alone redress. *Rue Félix-Faure*'s community assembles overlapping veiled and public identities, grounded in a flexible feminist alliance that reaches across gender, nationality, and genre, to suborn the stiff limits of citizenship, at least for as long as it takes to end the *moqadem*'s reign of terror.

[55] Bugul, *Rue Félix-Faure,* 273.
[56] Ibid., 273.

In light of the appalling acts of xenophobic mob violence all too common on the continent in recent years, Ken Bugul's vision of a *local* transnational solidarity offers an urgently necessary vision. The examples are far too many to allow for a triumphalist celebration of pan-African unity—the Mauritanian-Senegalese conflict of 1989–91; the nightmare of Rwanda in 1994 and the parallel ongoing turmoil in the Eastern Congo; the shocking brutalities in Liberia, Sierra Leone, Uganda, and the Sudan; the struggles between supporters of Gbagbo and Ouattara in the Ivory Coast; the attacks on Zimbabweans, Somalis, and other immigrants in South Africa since 2008; and too many more. What this litany of human tragedies demonstrates, however, is the ongoing and acute need for other imagined models of ethical coexistence. Ken Bugul's avenging quartet differs from these current and historical examples of xenophobic mob violence in two key respects. First, the women create an archive of oral, sung, and written testimony before taking any action. In private conversations, they discover the similar details in their experiences of intimate violence. In singing the blues, Drianké is able to access traces of memories of a different abjection, born in the Middle Passage, and it is in working through this sonic archive of black survival that her own repressed trauma finally becomes clear to her. And in reading the "Vengeance" manuscript in the privacy of a locked bathroom, Muñ finds a full account of the *moqadem*'s depravities. As I have argued, Muñ's reading seems most explicitly to publish the unofficial, private text through alternative channels as a form of piracy, but one could argue that the generalization of all three of these forms of testimony and their use in vigilante justice are examples of pirating the functions of the state. These three forms of testimony create a corroborating body of evidence, and it is only in the wake of the state's failures that collective action is taken. Nonetheless, Ken Bugul's proffered vision remains disturbing. The haunting dimension of her narrative lies in its ambiguities and veiled truths that appear to give up hope that the state might fulfill its function as arbiter of justice, but as we see in the Afro-futurist language of the Pan African Space Station in the final section, haunting in the form of *The Last Angel*'s techno-fossils becomes a metaphor for the possibility of inhabiting a future, scrambling the grand narratives of history by archiving what is yet to come, the free, the "out (there)."

A Heliocentric Launchpad: The Pan-African Space Station Goes Live

The byline on the Cape Town-based Pan African Space Station's website signposts just such a flight to out*er* space: "There are other worlds out there they never told you about," indicating how metaphors of cyber*space* continue to hold particular appeal, some fifteen years after *The Last Angel of History*'s

release.[57] Against the backdrop of apartheid's extreme restrictions on movement and the gravitational pull of such a burdened history, the idea of projecting oneself virtually across time and space comes to stand in for a degree of freedom defined as much by its celebrated realization as by its constantly reinvoked aspiration. The Pan African Space Station is curated by a duo working under the name "Heliocentrics." The Heliocentrics are two of the most visible artistic innovators in postapartheid South Africa: the Soweto-born composer and performer, Neo Muyanga, and the Cameroonian-born editor of the international literary journal *Chimurenga,* Ntone Edjabe. Together they have harnessed the language of exploration and discovery to sustain a coupling of virtual and material space for collaborative performance and digital archiving that redefines the relationship between presence and aura[58] in constituting a pan-African listening community and, by extension, the possible historical and political resonances of "pan-Africanism" itself.

Muyanga and Edjabe's pseudonym, the Heliocentrics, makes a clear nod to the African American bandleader and pianist Sun Ra's music and philosophy, as well as to South African pianist Abdullah Ibrahim. Graham Lock notes that veneration for the sun is a key dimension of the late Sun Ra's fascination with ancient Egypt, as well as with outer space, with song titles including "The Sun Myth" and "Sun Song"; albums such as *The Heliocentric Worlds of Sun Ra, Secrets of the Sun,* and *When Sun Comes Out*; and performances on sun-shaped instruments.[59] Similarly, Abdullah Ibrahim named the South African label As-Shams (Arabic for "the sun"), a division of Gallo Records, on which he recorded numerous albums under the name Dollar Brand (prior to changing his name); and his 1974 record, "African Space Program" (Enja) is not only a conceptual inspiration for the Pan African Space Station, but also lent its name to an event in the project's first year, when DJ Spooky, That Subliminal Kid (Paul D. Miller) spun a set in Cape Town in December 2008.[60]

On September 12, 2008, the thirty-first anniversary of antiapartheid martyr Steve Biko's death, the Pan African Space Station launched off for the first time from Cape Town, South Africa. A "30-day music intervention on the internet and in venues across greater Cape Town from September 12–October 12,"[61] it has grown since then to include live performers from what they pointedly call "global Africa," and an Internet site that has featured live streaming digital radio, sound archives, blogs, audience-participant comments, images, an

[57] Available at www.panafricanspacestation.org.za (accessed 1/11/11).

[58] See Benjamin on aura and authenticity in "The Work of Art in the Age of Mechanical Reproduction," in *Illuminations: Essays and Reflections* (New York: Schocken, 1969), 217–252.

[59] Graham Lock, *Blutopia: Visions of the Future and Revisions of the Past in the Work of Sun Ra, Duke Ellington, and Anthony Braxton* (Durham: Duke UP, 1999), 18.

[60] See http://panafricanspacestation.org.za/?p=97 for an archive of Noncedo Mathibela's photographs of the December 15, 2008 session (accessed 11/13/12).

[61] See www.panafricanspacestation.org.za (accessed 1/8/10).

associated Facebook page, and more. Although exuberantly pan-African in its reach (expanding to sites in Cameroon, the Democratic Republic of Congo, Kenya, and Ghana by 2012), it began and remains committed to building a local music scene anchored by Tagore's Jazz Bar in the Observatory neighborhood of Cape Town, which hosts most of the live events broadcast over the Internet. The website's design aesthetic, with 10-point Courier font and images incorporating musical manuscript paper, line-drawn sketches of satellites and skylines, and the dotted lines of possible orbits, slyly underscores the chiasmic promise that "there are other worlds they never told you about," worlds of "ancient techno" and "future roots."[62] These aesthetic elements emphasize smallness, the trace of the body in hand-drawings, and a rejection of commercial radio's emphasis on advertising and slickness. And by calling itself a *freeform* radio station, despite how the specifics of Internet radio contrast with earlier forms, I would argue that Pan African Space Station presents itself and operates in many respects as a pirate radio station.

Recognizing the project as a riff on pirate radio helps to account for one of the challenges in studying the Space Station's contributions, since its format and particularly its archive of previous Internet broadcasts, or PASScasts as they are called, is perpetually changing, thus avoiding possible charges of copyright infringement where commercial recordings are used. In fact, the choice to call the Internet broadcasts PASScasts, rather than podcasts, in the first three years of the website challenged the proprietary commercialism of Apple's iPod embedded in the term "podcast." This is a significant act of linguistic resistance, for, as Jonathan Sterne, Jeremy Morris, Michael Brendan Baker, and Ariana Moscote Freire have pointed out, while

> The [New Oxford American Dictionary's] definition for the neologism [podcasting] was simple: "a digital recording of a radio broadcast or similar programme made available on the internet for downloading to a personal audio player" (McKean, 2005);...podcasting is a considerably more vexed term. A colloquial hybrid of "broadcasting" and Apple's trademarked "iPod," it contains a reference to a well-known and heavily branded product, while simultaneously conjuring notions of personal freedom and escape from the vice-grip of commercial broadcasting.[63]

They go on to argue that podcasting should be understood not so much as a new media format, but as a renewal of an old media format, broadcast

[62] The imagery of satellites recurs in references to the project's expansion to sites in West and East Africa. And interestingly, another web-based project in Accra has also adopted similar language, an apparent pirate satellite. ACCRA[dot]ALT Radio includes the byline "Live from the Ghana Space Station" on its blog of Afro-hipster events in Accra, http://accradotalttours.wordpress.com/ (accessed 11/20/12).

[63] Jonathan Sterne, et al., "The Politics of Podcasting" in *Fibreculture Journal* 13 (2005). See http://thirteen.fibreculturejournal.org/fcj-087-the-politics-of-podcasting/ (accessed 11/12/12).

radio (and television). I would concur with this point and specify that the Pan African Space Station shows many similarities to pirate radio broadcasting. Many of the early iterations of the website in 2008 included detailed instructions for how to listen to audio files using a variety of newly available applications. Beyond the practical need to reach visitors to the website, these instructions made explicit the aim to equip visitors with new technological knowledge, opening up cultural practices of listening to and producing media for a wider set of actors than would otherwise have access.

Throughout its existence, PASS has featured a mix of live musical events and DJ'ed broadcasts of commercially recorded music streaming over the Internet. A sample playlist from one of the co-curators, Ntone Edjabe, gives a representative sense of the scope of recordings. The Passcast "Ntone—Interstella breakfast show Pt 3 for the late wakers (Sept 20, 2009)" included tunes by Ranglin, The Light of Saba, Tribe, Marcus Belgrave, Archie Shepp, Johnny Dyani, Gary Bartz, Vincent Geminiani, Cassandra Wilson, Nina Simone, Miriam Makeba, Hugh Masekela, Malagasy (featuring Jef Gilson), Mabi Thobejane, and Louis Moholo.[64]

As in this example, reggae, soul, jazz, and Afro-pop predominate in PASScasts, drawing on music of the Black Atlantic from Africa, the Americas, and Europe. Although the PASS website does not currently host audio files for these PASScasts, the Internet Archive allows curious Afronauts to access the playlists by consulting captures of the site from 2008–2010, and to use other sites, such as YouTube, to reconstruct the playlists proposed as a pan-African listening curriculum. The additional navigation required may presume a degree of Internet access unavailable to many, but it also places the onus for navigating a range of largely pirated recordings on readers, generalizing the seizure of contraband content it so elegantly espouses. Furthermore, the move from calling the streaming audio PASScasts to the current form, PASS Radio, emphasizes the continuity with early broadcast conceptions, even as it challenges them. Taken as a whole, The Pan African Space Station project brings a set of local happenings within the reach of users who are unlikely to afford the recordings the DJs play, expanding the repertoire of common musical texts that global Africans tap as they compose and perform.

While the website makes no direct reference to the apartheid era's media policies, its launch on the thirty-first anniversary of Steve Biko's death speaks volumes. Biko founded the South African Students Organization (SASO) in 1968 after abandoning the National Union of South African Students in protest of its failure to address racism in its membership. With SASO he articulated the doctrine of Black Consciousness, countering the crude denigrations of apartheid discourse by affirming African cultures and preparing the oppressed for

[64] See http://liveweb.archive.org/http://panafricanspacestation.org.za/?p=214 (accessed 11/13/12).

FIGURE 6.3 *Screen capture of Pan African Space Station* ⋆ *September 16, 2010*[65].

[65] Used by permission of Neo Muyanga for Pan African Space Station.

action. Students from the Black Consciousness movement organized strikes against the Bantu Education policy of delivering all instruction in Afrikaans, and the Soweto massacre of striking students in 1976 stunned the globe, exposing the lengths to which the National Party government would go to enforce apartheid order. Biko was arrested and spent the next year in police custody. On September 12, 1977, he died in detention after sustaining a fatal brain injury from a security police truncheon blow. By launching the Pan African Space Station on Steve Biko Day, the curators sync the "sound of 21st century Afroglobalism"[66] with the memory of the antiapartheid struggle. In fact, the third volume of *Chimurenga*, the literary journal of the Africa Center, which sponsors PASS and which is edited by Ntone Edjabe, also focused on Biko (*Biko in Parliament*, 2002), demonstrating that the Black Consciousness leader and his ideals have long been formative for the Heliocentrics.

As a communication form, broadcast radio was a key arm of the apartheid propaganda machine, and the Pan African Space Station's use of streaming podcasts (both live and archived) to make its music freely accessible in any time and place where an Internet connection is available counters the rigid controls over content and distribution maintained before 1994. During apartheid, particularly in the 1960s and 1970s phase of "Separate Development," the government cynically exaggerated linguistic and ethnic differences, extending the expropriations of land and restrictions on movement that had been introduced with the Native Lands Act of 1913 to a new set of invented "homelands" or Bantustans. Apartheid, it was claimed, would simply allow all of the peoples of Southern Africa to develop their separate identities. *Radio Bantu* was introduced as the need for propaganda in support of the forced resettlement grew. It broadcast in nine languages, and featured traditional music and other signs of "authenticity." As Tomaselli and Tomaselli point out:

> Radio Bantu [set] itself the task of inducing the majority of black South Africans to accept their "homeland" status and to view it as independence and development, while at the same time socializing a smaller cadre of the urban population into a work ethic.[67]

Not only was the linguistic and editorial content of radio broadcasting intended to cement the status of these "nations" in relation to the Republic of

[66] While the official homepage, www.panafricanspacestation.org.za, does not use the term, both Neo Muyanga's blog (http://neomuyanga.wordpress.com/) and the Facebook group (http://www.facebook.com/group.php?gid=19510419251) use the tag "Pan African Space Station—The Sound of 21st Century Afriglobalism." While the Heliocentrics are not the first to coin the term "Afriglobalism," their strategic use of the term both supplements and distinguishes it from pan-Africanism.

[67] Keyan Tomaselli and Ruth Tomaselli, "Between Policy and Practice in the SABC, 1970–1981," in *Currents of Power: State Broadcasting in South Africa* (Belleville: International Academic Publishers, 1989), 100–1. Cited in Charles Hamm, *Putting Popular Music in its Place* (Cambridge: Cambridge UP, 2006), 228.

South Africa, but even music itself was to be used to mold ethnic identifica-
tion. Whether it was put in condescending or cynical terms, the intention was
the same, to channel an appetite for music in socially expedient directions.
Charles Hamm cites Huskisson's 1969 study:

> Guiding, inspiring, encouraging the Bantu musical potential, developing
> all around it in South Africa, Radio Bantu has virtually become the focal
> point round which much of Bantu music evolves. Radio Bantu continues to
> encourage both professional and amateur Bantu musician alike. The solo-
> ist,—the group—the vocalists—the bandsmen are recorded week after week
> in Radio Bantu studios throughout the country.[68]

The Pan African Space Station's accompanying texts emphasize the genres
with which an artist has affinities or, indeed, the ways "genre-busting musical
outfits" frustrate categorization. Using this focus, rather than ethnicity, race, or
nationality to conceive of "global Africa" marks a shrewdly imagined antithesis
to the abuses of music in Radio Bantu's propaganda machine.

As I have already noted, the website has been distinguished by its dynamic
shifts in content and, to a lesser degree, visual layout. Snapshots of the site in
2008, 2009, and 2010 by the Wayback Machine Internet archiving project make
it possible to revisit earlier iterations and track changes in the format despite
periodic hiatuses in the year-round activities complementing performances
around Biko Day. I will focus my comments on 2010. PASS 2010 featured live
shows from September 28 to October 2 in performance spaces that crossed the
economic and (still) racial boundaries of Cape Town's neighborhoods, from
the historic Slave Church on trendy Long Street in downtown Cape Town to
the Langa Township in the Cape Flats. The choice of this range of locations
reflected the project's creative activism in facilitating access to cultural events.
In addition to the live events, which were recorded and archived on the web-
site, PASSradio streamed digital DJ sets on the Internet throughout the month
and archived the podcasts (or, as they called them, PASScasts) on the web-
site. The year 2010 also saw a new component, with additional PASScasting
from Limbe, Cameroon, as well as the "mothership" in Cape Town.[69] In a sign
of the refreshing whimsy the curators bring to their project, this mothership
was complemented by a literal spaceship installation: "Bianca the othaship,"
was an approximately three-meter long rocket (or, as they quipped, "rockit")
launched from St. George Mall.[70] The website describes it as Space III:

[68] Charles Hamm, "'The Constant Companion of Man': Separate Development, Radio Bantu and
Music," in *Popular Music*, 10:2 (May 1991), 160, citing Yvonne Huskisson, *Die Bantoe-Komponiste van
Suider-Afrika*, Johannesburg, 1974.

[69] Cape Town's national nickname as the "Mother City" marks its status as the first official European
capital in Southern Africa.

[70] Video footage of building the rocket can be seen on Neo Muyanga's blog entry for September 11,
2010 at http://neomuyanga.wordpress.com/ (accessed 6/1/2011).

No Space Station is complete without the advanced technology to transport audiences to the furthest realms. With that in mind PASS is launching its own sonic rocket outta here—some othaship, to quote Declaime. Situated on St George Mall, it's an audio-visual public art installation by artist Douglas Gimberg and architect Greer Valley which we hope will travel farther/further than Mobutu Sese Seko's notorious 'Nzwamba fusée.'

In a satiric dig at the exaggerations of the former Zaire's ex-president, a leader whose official policy of *authenticité* served as thin cover for an astonishing kleptocracy, PASS recalls the space program Mobutu Sese Seko orchestrated, even as millions of his people went without basic services. The PASS "othaship" disavows the armature of top-heavy state programs for prestige projects, and instead points to the delights of the imagination, and the limitless orbits it can access, propelled by virtual media, viral processes, and vital inventiveness.

While PASS has many parallels with pirate radio, it has also, inevitably, adopted a more standardized approach as it has expanded, both in personnel and in geographical and temporal scope. By 2012, it had added a Facebook page with over 2,400 friends, which served most effectively as a publicity tool for upcoming live performances to be streamed on the Internet, and as a networking space where PASS friends shared related news on its wall about concerts, activist workshops, new albums, and book launches, in addition to a lively discussion of past performances, including audience photographs and other documentation. The primary website also now features a link to a site adapted for mobile devices, and, given the increasing distribution of cell phones in Africa, this suggests a commitment to reaching a wider range of listeners that parallels the *Chimurenga* journal's *Chimurenganyana* initiative, "a pavement literature project consisting of low cost serialized monographs culled from the print journal."[71] The most striking innovation in 2012, however, was perhaps the presentation of a performance explicitly billed as an act of archiving musical memory, The Thath'i Cover Okestra's November 4, 2012 performance in a "collaborative re-exploration of kwaito music" led by young jazz lion, Bokani Dyer.[72] The Okestra's name evokes both the Sun Ra *Arkestra* and another iconic all-African ensemble, the Congo-based Tout Puissant O.K. Jazz Band led by guitar wizard, Franco Luambo Makiadi. The Pan African Space Station's website text makes clear that the performance was an important occasion for reflecting on the burden and potential of nostalgia for the postapartheid generation, and thus I quote it at length:

"Waar was Jy?" asked kwaito crew Skeem in their 1996 pumping house, ragga and rap hit with the same title. "Where were you?" they asked, back

[71] See http://www.chimurenga.co.za/publications/chimurenganyana (accessed 11/12/12).
[72] See http://panafricanspacestation.org.za/?p=3733.

in the 80s; in the days when Brenda Fassie was running things; the days of Jomo Sono's Pirates and Spiderman; of Chaklas Chaklas, Skoro-Skoro, Chicco's Soldier; of perms, pantsulas and breakdance?

For many of the young members of Thath'i Cover Okestra the answer is simple: I was still a kid or I wasn't even born yet. But that hasn't stopped the 11-piece ensemble from creating its own rendition of Skeem's classic. The track is just one of the many kwaito classics recorded between 1994 and 2004 that they have revisioned for the project.... The project is more than just a nostalgic throwback to the heydays of post-apartheid euphoria. Rather than merely cover tracks such as Thebe's "Sokoloko," Thandiswa Mazwai's "Zabalaza," TKZee's "Izinja Zam," Bongo Maffin's "Amadlozi," Lebo's "Ntozabantu" and more, Thath'i create new renditions.

Channelling kwaito's urban syncretic electronic energy through swinging big band choirs of horn and vocal harmonies, and audacious rhythmic eruptions, the crew challenges the concept of kwaito music as an abstract entity—singular, insular and removed from community.

The result is a joyous mix of free jazz with wry 50s Sophiatown quotes, Marabi, rhythm and blues, sexy soul and edgy beats that situates kwaito within a long tradition of black music, giving voice to the pains and pleasures of history while also celebrating contemporary urbanity.... Dyer, the 2011 Standard Bank Young Artist Award winner for Jazz, hopes to channel the okestra's free-wheeling energy and spontaneous creativity into a "new super nostalgic African futuristic spiritual chant non-genre."

The compulsion to remember, to recall where one was when yesterday's hits were new but also when the struggle for "freedom" was being waged, may be felt acutely in postapartheid South Africa, but it is also a compulsion that has haunted postcolonies confronting the contradictions and unmet promises of independence for decades, and thus it is this question that throws into relief the ways Thath'i Cover Okestra plays for the continent.

The interest Dyer expresses in coupling futurism and spirituality resonates strongly not only with the Sun Ra influences on the Pan African Space Station, but also with the whole range of musical traditions featured in Akomfrah's film *The Last Angel of History,* and the impulse toward a blending of genres and emphasis on spirituality rather than religion strongly recalls the liberating shape-shifting and flexibility celebrated in Ken Bugul's *Rue Félix-Faure.* Taken together, these three projects extend the pirate logic seen in the Senegalese films with which this chapter began, undergirding the move away from official, state-level instantiations of solidarity and toward small-scale, interpersonal deployments of a stereomodern black musical archive in response to local challenges while seizing new channels to preserve and broadcast that archive.

{Epilogue}

Singing Stones

I began this book with a question that still presses: how might the insights gar-
nered in thinking about transnational black solidarity, modernism, and medi-
ated music help to conceive of the future(s) of pan-Africanism? One of the few
arenas in which pan-Africanism is regularly invoked today is at the African
Union (AU). Formed in 2002, this body continues the work of its predeces-
sor, the Organization for African Unity (OAU), which was founded on May
25, 1963. In some respects, the African Union seems to offer a viable frame-
work for continental and diasporic Africans to build formal ties. In May 2011,
the first meeting of an official AU body to be held in the disapora, a meeting
of the Economic, Social, and Cultural Council, was hosted by Trinidad and
Tobago, and the Union has made working with persons of African descent
regardless of citizenship a priority. However, the AU is primarily an organiza-
tion of nation-states, and even, some might argue, of heads of state. Only a
month after the Trinidad and Tobago gathering, the summit of AU heads of
state held in June 2011 sent a far less positive signal. The summit was hosted by
the longest "serving" head of state, Equatorial Guinea's Teodoro Obiang. The
venue threw into sharp relief one of the ongoing weaknesses of the organiza-
tion, its failure to censure member nations for human rights abuses. The AU
made no comment on the harassment, arbitrary arrests, police violence, and
the detention of an estimated one hundred people during preparations for the
summit. Nor were the exorbitant costs (an estimated $830 million) for infra-
structure, luxury housing, an artificial beach, and a golf course the subject of
any queries or censure. Such cases suggest that the AU has yet to rise to the
challenge of articulating a form of pan-African solidarity relevant in the era
of globalization.[1] The AU's credibility was also damaged by the prominent role
of Muammar Al-Qaddafi (elected chairman in 2009), who was a vocal advo-
cate of integrating the entire continent into a single body, the United States of

[1] "Amidst Poverty and Human Rights Abuses, Equatorial Guinea Builds Lavish City to Host
African Union" *Democracy Now*, Amy Goodman interview with Equatorial Guinean activist Tutu
Alicante, 6/23/2011; http://www.democracynow.org/2011/6/23/amidst_poverty_and_human_rights_
abuses (accessed 11/17/12).

Africa, but whose human rights abuses and megalomania led to his eventual demise.

Setting aside the current structures of the African Union, pan-Africanism's most clear mission in the twentieth century was to hasten the end of colonialism, apartheid, and other forms of racism in order for people of African descent on the continent and beyond to be able to realize full self-determination. South Africa's democratic election in 1994 was, therefore, a significant teleological point of arrival. Yet the profound economic inequalities that continue to characterize contemporary South Africa (tragically on display during the Marikana mine massacres of August 2012) also contribute to one of that nation's greatest challenges and the obverse of pan-Africanism: xenophobia toward immigrants from the across the continent. In fact, such repeated episodes of xenophobic violence are the strongest argument against a triumphalist account of pan-Africanism. Within weeks of the 1994 elections, Rwanda disintegrated into genocidal violence dominated by armed Hutu citizens slaying their Tutsi countrymen and suspected sympathizers. The scale and rapidity of the violence was shattering, with over eight hundred thousand people killed in a matter of weeks. As cataclysmic as that violence was, the Rwandan genocide is, tragically, only the most spectacular example of internecine battles that sustain many small and not so small conflicts on the continent.

In the face of such tragedies, what can be gained from this book's excercises in thinking about pan-African solidarity as stereomodernism? Just as music has been a crucial conduit of black transnational feeling, one of the most paradoxical dimensions of imagining Africa in stereo is the quantum leap from thinking of music as sound, a wave, to doing the material work of constituting a solid "bloc" of black transnational allegiances. As a literary critic, I have always believed that it is my responsibility to mine my critical insights from a text itself rather than imposing my own perspective, and so I want to end *Africa in Stereo* with a final close reading. Writing the book has convinced me that the most durable pan-African solidarity has always come from creative collaborations rather than diplomatic bodies, and this is compellingly demonstrated in the work of South Africa's poet-laureate, Keorapetse Kgositsile.

As already stated, the achievement of democracy in South Africa was an important telos that had driven pan-Africanist movements since their very beginnings, and after 1994 their raison d'être was less clear. In the "new dispensation," the Rainbow Nation's public rhetoric perhaps seemed to point to a postdiluvian moment where everything was made radically new, renamed in celebration of having survived the entropic decades of apartheid. While celebrating the victory over legislated apartheid was and remains important—as is marking all moments when collective struggle proves that, indeed, another world is possible—reading Keorapetse Kgositsile's work nearly twenty years after that moment, it is the consistencies in his aesthetic and political commitments that have allowed him to recognize and critique injustices

regardless of who the perpetrators were. One of the first ANC cadres to go into exile in the 1960s, Kgositsile continues to write today with the stridency, tight diction, and oratorical cadences that made his early work such effective consciousness-raising poetry and a natural kin to the Black Arts Movement's core voices. His recent contributions to the four-person volume, *Beyond Words: South African Poetics,*[2] show an enduring voice of conscience rooted in dialectic, advancing a recovery of local languages and worldviews as resources for contemporary globalization's challenges. These poetic commitments have lent unique authority to his condemnation of one of South Africa's greatest contemporary shames, xenophobic violence toward immigrants from other parts of the continent. And it is his forthrightness in addressing this grave challenge to pan-African ideals that serves as a sign of the renewal of solidarity.

A close reading of "No Serenity Here," one of three of his poems included in *Beyond Words* (2009) makes this clear. Kgositsile has always viewed memory in very expansive terms, coining the phrase "future memory" to evoke a kind of prophetic work that poetry alone can do. In a 1973 interview with Charles Rowell he stated:

> In English, *memory* is something static. It is something you remember in terms of looking back at another period. In my usage, *memory* is more an assimilated aspect of your every day living and thinking. In that sense, *memory* can be, or it is, all time—i.e., it is past, it is present, it is future, too.[3]

Kgositsile uses this temporally elastic conceptualization of memory to rethink contemporary borders that have made land (re)distribution and intra-African migration such volatile problems for postapartheid and postindependence nations in terms that remain engaged with indigenous ethics and processes of justice.

The title "No Serenity Here" recalls two poems from the 1970s, "No Sanctuary" and "Notes for No Sanctuary." The poem uses scatological imagery to critique xenophobia in the strongest terms, and the multiple languages and idioms here add another form of disruption to hail the reader. From the very opening image—a flatulence-inducing egg omelette—to the final exclamation, "Daar is kak in die land!" Kgositsile is concerned with naming and expelling the excreta that besmear the nation.

The poem begins with a play on words, turning a familiar phrase, the Scramble for Africa, into a prosaic breakfast omelette. In defamiliarizing this phrase, Kgositsile opens a set of metaphors for the entropic chaos that colonial borders and definitions unleashed on the continent, flagging the importance

[2] Keorapetse Kgositsile, Don Mattera, Lebogang Mashile, and Philippa Yaa de Villiers, *Beyond Words: South African Poetics* (London: Flipped Eye, 2009).

[3] Charles Rowell, " 'With Bloodstains to Testify': An Interview with Keorapetse Kgositsile," *Callaloo* 2 (Feb, 1978), 31.

of linguistic devices throughout the poem. The poem's form is binary: it opens with three prose stanzas, each longer than the one preceding it; these three blocks of prose are followed by an eight-stanza section in more standard verse form. The prose blocks recall an essay Kgositsile published in 2004 in a collection commemorating ten years of democracy in South Africa.[4] In both the essay and the poem, Kgositsile turns to his mother tongue to call into question the very validity of the concept of "citizenship" and the exclusionary logics that have fueled waves of shocking xenophobic violence in South Africa all too often, particularly in the past five years. In the essay, he is able to articulate his linguistic argument fully, stating:

> In Setswana, as in other African languages, there is no word for *citizen*. We speak of *moagi*, resident. '*Go agisana/agisanya*,' from *aga*, from which moagi is derived, means, 'in the same breath,' 'building together' and/or 'living together in harmony or peace.' But we carry passports, those badges of our participation in the world of those who plundered our world and established boundaries to demarcate their property. I am not trying to advocate any anarchy here…I am not trying to advocate any return to some preimperialist, or precapitalist, precolonial border post or boundary, pristine African time.[5]

Grounding his critique of an alienated emerging urban petit bourgeois class in South Africa in a reading of Ama Ata Aidoo's *Our Sister Killjoy,* Kgositsile continues in stark terms:

> This is the dog in *Our Sister Killjoy* that you might find yourself face to face with instead of the master of the house with whom you thought you were going to play chess. So, not only do they hold on tenaciously to those crumbs, they are resentful of anyone they perceive as a threat to their crumbs and they can become more dangerous, much more ruthless, than their masters because they are insecure. Once this sentiment spreads, it turns into Nigerians this; Zaireans that; Makwerewere the next; and on and on *ad nauseum*. Stereotypes are created; hostilities develop; explosions of violence follow.[6]

In the poem, "No Serenity Here," Kgositsile similarly gestures toward the disjunctures between national and linguistic boundaries that serve to underscore his critique of jingoistic nationalism. In the poem's exposition, Kgositsile revisits an argument he first presented in the essay form in 2004 in three prose stanzas. This is followed by a transition to lyric verse underscored by

[4] Keorapetse Kgositsile, "Race: What Time Is It?," in *Democracy X (Imagined South Africa)*, eds. Andries Oliphant, Peter Delius, and Lalou Melzer (Amsterdam: Brill, 2004), 145–49.

[5] Ibid., 149.

[6] Ibid..

diction that twice emphasizes the double meaning of lyric as poem and as song: "*Poem*, I know you are reluctant to *sing*." Lest we miss the turn to lyric poetry, Kgositsile continues, naming and citing Langston Hughes. What the poem achieves (and the essay cannot) is to performatively foreground the many ways that language does things with words—through mode, genre, line break, caesura, citation, repetition, anaphora, acronym, references to accent, and, quite starkly, switching between languages. Like the essay, the poem's opening argument turns on the fact that the word "citizen" has no equivalent in Kgositsile's mother tongue, but presents "moagi" as an alternative theory of relation to place and belonging, and "resident" as an alternative ethical-political imaginary to the language of citizenship and right. The need to embrace an already extant ethical turn in local languages is emphasized in the fourth stanza's citation of an African proverb that Kgositsile pointedly aligns with the continent rather than the nation-state.

> somewhere on this continent
> the voice of the ancients warns
> that those who shit on the road
> will meet flies on their way back

Kgositsile's sharp wit here is, of course, also laying a clever trap for us: dropping this scatological proverb on us some four stanzas before the close of the poem warns us of the explosive ending to come. Having invoked the continent as a large-scale geographic abstraction, he excoriates the limits of regionalist and pan-African diplomatic rhetoric that masks problematic governance practices, demanding "do not tell me of NEPAD, or AU,/do not tell me of SADC." He is equally suspicious of too easy an adoption of indigenous African discourses into the language of corrupt statecraft: "please do not try to say shit about/ubuntu or any other such neurosis of history." Actions must be aligned with rhetoric to resonate. As the poem draws to a close, Kgositsile takes up the theme of memory so central to much of his writing.

> remember, always
> remember that you are what you do,
> past any saying of it
>
> our memories of struggle
> refuse to be erased
> our memories of struggle
> refuse to die.

Rather than closing with trite reassurances that the answers to the present's impasse lie in recalling the antiapartheid struggle from the vantage point of a finished project, however, the poetic form suggests that the work of memory, and indeed the work of the struggle itself, must always necessarily be ongoing,

a path rather than a destination, a means rather than an end. Refusing rest, the struggle's legacy pushes the poet to an interrogative stance, one that begins each line asking how, when, whose.

> My mothers, fathers of my father and me,
> how shall I sing to celebrate life
> when every space in my heart is surrounded by corpses?
> whose thousand thundering voices shall I borrow to shout
> once more: *Daar is kak in die land*?

In boldly broadcasting that there is shit in the land in italicized Afrikaans rather than English, Kgositsile draws this language so vexedly, but undeniably, South African into his project of inventing a local English. Given that the 1976 Soweto uprising was inspired by the Black Consciousness Movement-led protests at apartheid education delivered entirely in Afrikaans, this turn emphasizes the parallels in discrimination and biologized discourses of ethnic purity between apartheid-era racism and postapartheid era xenophobia.

The ethics of writing in a multilingual situation have long concerned Kgositsile, as is evident in an interview he gave soon after returning to South Africa from exile in 1991. When asked about his choice to write in English, Kgositsile responded:

> to be articulate in a language means internalizing, whether you like it or not, some aspects of the culture that gave birth to that language. So we are still in the process of creating a South African English. We have to tame this, which we inherited from the British, to carry our cultural weight, so to speak.[7]

This project of taming English is by no means a new, or even a local problematic in Kgositsile's work, and given the predominance of fiction and novel forms in various iterations of postcolonial studies, his insistence that this work can be, must be, and is being accomplished in poetry is, I think, one reason Kgositsile's voice continues to be so necessary, urgent, and compelling. His proposed proofs for this theorem have been varied, and reflect his trans-Atlantic role as a connecting figure between the African American aesthetics of the Black Arts Movement and continental African letters. What he is after is not a flattening act of reconciliation, or, as he wrote in his 1974 poem "Notes from No Sanctuary": "All the obscene black&whitetogether kosher/Shit of mystified apes." But rather, as the lines of that poem continue, a radically and permanently interrogative stance, a commitment to the existential question, the pursuit of, rather than the arrival at, truth.

[7] Kevin Goddard and Charles Wessels, eds., *Out of Exile: Interviews with Albie Sachs, Lewis Nkosi, Mbulelo Mzamane, Breyten Breytenbach, Dennis Brutus, Keorapetse Kgositsile* (Grahmstown: National English Literary Museum, 1992), 83.

> Where then is
> the authentic song? The determined
> upagainstthewallmothafucka act?

Kgositsile's questions are the answer to his own invitation, and counterintuitively, they are questions that open a field for other possible poetries that may not read as being as classically *engagé*. For in closing "Notes from No Sanctuary," he does not simply condemn writing that "floats above" the human rights crises of his moment, but rather claims for all poetry an impotence, a remove from the seat of power that makes of poetry an antiarchive, a counterarchive for imagining projects of justice that might move beyond mere transactions of reconciliation to an ongoing project of reparation. Such a project of reparation might look like models that Deb Thomas, following Glenn Loury, has outlined. In her recent book *Exceptional Violence,* Thomas takes up Loury's proposal of an "interpretive approach" to reparations, calling for

> a complexly cyclical engagement with history that can help "establish a common baseline of historical memory—a common narrative, if you like— through which the past injury and its continuing significance can enter into current policy discourse."[8]

As Thomas points out, by advocating an interpretive approach to racial inequality, Loury rejects the compensatory model of reparations activism. Instead he argues that the ontological basis of race thinking that permeates the Enlightenment's legacy perpetuates racial stigma, not as the result of one or another individual's prejudice or ignorance, but because of commonsense systems of value that reproduce notions of black inferiority:

> "What is required…is a commitment on the part of the public, the political elite, the opinion-shaping media, and so on to take responsibility for such situations as the contemporary plight of the urban black poor, and to understand them in a general way as a consequence of an ethnically indefensible past. Such a commitment would, on this view, be open-ended and not contingent on demonstrating any specific lines of causality"[9]

Perhaps then the "upagainstthewallmothafucka act," the authentic song that Kgositsile calls forth, emerges *most clearly* at language's limits, at the join where English, Setswana, and Afrikaans slam up against one another. In this juxtaposition, languages are made present to one another on the page, and such unmediated abuttals model an ethical witness to the other rather than

[8] Deborah Thomas, *Exceptional Violence: Embodied Citizenship in Transnational Jamaica* (Durham: Duke UP, 2011), 238, citing Glenn Loury, "Transgenerational Justice – Compensatory versus Interpretative Approaches" in *Reparations: Interdisciplinary Inquiries*, ed. Johan Miller and Rahul Kumar (New York: Oxford UP, 2007), 104.

[9] Ibid., 238 (Loury, 104).

blurring over difference in some bad faith version of neoliberal multicultural-ism. This modernist montage forestalls a hasty reconciliation without truth that would smell too much like the "obscene black&whitetogether kosher/shit of mystified apes."

As Kgositsile's sharp language makes abundantly clear, a solidarity worth hanging onto is not, and cannot be, merely a loose notion of "grooving" together to a shared circulating body of musical texts and celebratory impulses. The authentic song that this book has reached toward is one that attends to difference but also eschews an Afro-pessimist dismissal of the potential for collaboration.

In conclusion, I want to revisit the three thematic threads of stereomodern-ism laid out in the introduction—solidarity, modernity, media. My reading of Kgositsile's recent poetry listens for the continuities between solidarity's past expressions and its future possibilities. In the spirit of the Pan African Space Station's imaginative span from "ancient techno to future roots," I close by recalling a very old fable of solidarity, modernity, and media. Callistratus, an all-but-forgotten master of Greek rhetoric, tells of a pair of monumental stat-ues in Aethiopia, the Colossi of Memnon, that caused wonder in the ancient world. This portrait of Memnon, the son of Io, the Dawn, was not only of tow-ering proportions, but was also known to "sing" when the winds blew around it. As Callistratus writes:

> at one time it saluted the rising Day, by its voice giving token of its joy and expressing delight at the arrival of its mother; and again, as day declined to night, it uttered piteous and mournful groans in grief at her departure. [Astonishingly,] the hands of Aethiopans discovered means to accomplish the impossible, and *they overcame the inability of stone to speak.*[10]

Callistratus may have been embellishing things a little. A century or so before, Pausias tells the story slightly differently. Here, the statue is in Egypt, and he notes that it was broken in two by Cambyses, but the portion intact "makes a noise, and the sound one could best liken to that of a harp or lyre when a string has been broken." According to V. Y. Mudimbe, "Aethiops, the proper name of Vulcan's son in Greek mythology, is the generic qualification of any dark-skinned person." Citing texts by Homer, Herodotus, Strabo, Isidorus, and others, Mudimbe states that "by the first century A.D. the continent as a whole has been divided into three main parts by geographers: Egypt, Libya, and Aethiopia, the last corresponding more or less to sub-Saharan Africa."[11] Now, the praises of Callistratus and Pausias begin to resonate anew. These accounts

[10] Callistratus, *Elder Philostratus, Younger Philostratus, Callistratus, (Loeb Classical Library Volume 256)* trans. Arthur Fairbanks. (London: William Heinemann, 1931) (my italics). The Colossi of Memnon are not far from the Ramesseum, which inspired Percy Bysshe Shelley's sonnet, "Ozymandias."

[11] V. Y. Mudimbe, *The Idea of Africa* (Bloomington, IN: Indiana UP, 1994), 26, 27.

tell of a statue in a place whose location is vague, but which is understood as standing in for Africa writ large. And when we read of hands "that discovered means to accomplish the impossible, and thus overcame the inability of stone to speak," we are reading of ancient pan-African sound technologies, the first instances of stereomodernism.

Returning to where this book began, Callistratus's story reminds me of a parallel phenomenon in Zimbabwe. The modern nation-state of Zimbabwe is named for the "houses of stone," *dzimba bwe* that dot the country as evidence of medieval African expertise in stone masonry and construction without cement or other mortar. The most impressive structures still standing are at Masvingo (The Great Zimbabwe) and outside Bulawayo at Khami. These cities were at their height during the eleventh through the fourteenth centuries when the Munhumutapa Empire was flourishing, and among the many objects remaining from that civilization are a number of lithophones, stone gongs referred to in Shona as *mujejeje*. As Kurt Huwiler notes, the use of "stonebells for the veneration of the ancestors was so strong that the practice of 'ringing the stones' can still be found today."[12] If the modern is always, on some level, concerned with distinguishing itself from the ancient, it is at the same time always bound by an anxiety of influence, a desire to live up to the past. In this sense, another set of naturally occurring *mujejeje* offer to me an example of sounding solid(ar)ity that lingers in its potential. Huwiler describes stonebells found not only near the Great Zimbabwe ruins, but also wherever granite slabs eroded by the wind are located at nodal resonating points. "If they are shifted 'just right,' so tradition has it, then the ancestors will speak. Hence any place where the 'stones sounded' were used to communicate with the ancestors to venerate them."[13]

Africa in Stereo has told a set of histories of pan-Africanism, in the hopes that in understanding these particular pasts better, we can do the work of Relation more confidently and honestly in the present. Recalling, for example, the ties between Charlotte Manye Maxeke and her sisters in Xenia, Ohio makes the fact that in 2006 Johannesburg Jay-Z's concert elicited at least as much if not more buzz than J. Z. the politician (Jacob Zuma) looks less like a recent phenomenon of commercial hip-hop's publicity machine (which it may well be) and more like an extension of a long, multidirectional cultural current linking the two nations.

The word "venerate" grows from the Latin root *venus*, to love, and solidarity is most essentially a politics of love. Occasionally, things shift into place, and for a moment stones sing. In that moment, we come together in the name of ancestors held dear—artists and thinkers with whom we may share no genetic links, but whose work connects us to the heritage of human solidarity.

[12] Kurt Huwiler, *Musical Instruments of Africa* (Harare: Mambo Press, 1995), 37.
[13] Ibid., 39.

Pan-Africanism is, after all, only as valuable as the human ties it allows us to feel more strongly, ties that motivate a continuing commitment to ending the intersecting oppressions of people on the grounds of race, but also of class, gender, sexuality, nationality, ethnicity, party affiliation, HIV-AIDS status, and incarceration history.

I want to imagine stereomodernism as those places where stones sound, where solidarity resonates. I want to imagine marvelous African stones that defy reality. I want to imagine ancient technological wonders and catachrestic modernities that astonish even the wind with their innovation, their sonorousness, their reverberation effects. I want to imagine rhythm—the dawn and dusk of Day—confronted and confused by vocal decoys drumming out of dead matter, singing out of silence, speaking out of stillness. I want to imagine the hills reflecting these modulated voices and echoing fragments of waves as they ricochet in unpredictable directions and decay in serendipitous distortions. I want to hear one sound turn into an infinity of sound effects, a unison diffracted into countless intervals. I want to imagine sound waves coming in and out of phase with each other, interfering, amplifying and canceling each other out as they slip in and out of sync. I want to orient myself according to the echoes of this song. I want to locate myself among these sounds. I want to relate to this acoustic. Come, listen with me. Can you hear *Africa in Stereo?*

{BIBLIOGRAPHY}

Addo, Maxwell Agyei. "Audiovisual Archives in Ghana." In *Archives for the Future: Global Perspectives on Audiovisual Archives in the 21st Century*, edited by Anthony Seeger and Shubha Chaudhuri, 118–29. Calcutta: Seagull Books, 2004.

Adotevi, Stanislav. *Négritude et Négrologues*. Paris: Union Génerale d'Éditions, 1972.

African Rhythmus. Archival footage, Senegal/USSR, 1966.

Aidoo, Ama Ata. *Dilemma of a Ghost*. London: Longman's, 1965.

Allen, Lara. "Music, Film and Gangsters in the Sophiatown Imaginary: Featuring Dolly Rathebe." *Scrutiny2: Issues in English Studies in Southern Africa* 9:1 (2004): 19–38.

Andrews, William. *Sisters of the Spirit: Three Black Women's Autobiographies of the Nineteenth Century*. Bloomington: Indiana UP, 1986.

Angelou, Maya. *All God's Children Need Traveling Shoes*. New York: Random House, 1986.

Ansell, Gwen. *Soweto Blues: Jazz, Popular Music and Politics in South Africa*. New York: Continuum Books, 2005.

Anyidoho, Kofi. *Ancestral Logic and Caribbean Blues*. Trenton: Africa World Press, 1993.

——. *Earthchild*. Accra: Woeli Publishing Service, 1985.

——. Personal Interview. June 7, 2006.

Appadurai, Arjun. *Modernity at Large: Cultural Dimensions of Globalization*. Minneapolis: U Minnesota P, 1996.

——. "Archive and Aspiration." In *Information Is Alive*, edited by Joke Brouwer, Arjen Mulder, Susan Charlton, 14–25. Rotterdam: V2/NAi Publishers; New York: Distributed Art Publishers, 2003.

Appiah, Anthony. *In My Father's House: Africa in the Philosophy of Culture*. New York: Oxford UP, 1992.

Archer-Straw, Petrine. *Negrophilia: Avant-garde Paris and Black Culture in 1920s*. London: Thames & Hudson, 2000.

Arendt, Hannah. *The Human Condition*. New York: Doubleday, 1959.

Aschenbrenner, Joyce. *Katherine Dunham: Dancing a Life*. Urbana: U Illinois P, 2002.

Ashford, Lori S. *Africa's Youthful Population: Risk or Opportunity*. Washington, DC: Population Reference Bureau, 2007.

Attali, Jacques. *Noise: The Political Economy of Music*. Translated by Brian Massumi. Minneapolis: U Minnesota P, 1985.

Awoonor, Kofi. *Latin American and Caribbean Notebook*. Trenton: Africa World Press, 1992.

Ballantine, Christopher. *Marabi Nights: Early South African Jazz and Vaudeville*. Johannesburg: Ravan, 1994.

Barber, Karin. "Notes on Audiences in Africa." *Africa: Journal of the International African Institute* 63.3 (1997): 347–62.

———. "Orality, the Media and New Popular Cultures in Africa." In *Media and Identity in Africa*, edited by Kimani Njogu and John Middleton, 3–18. Bloomington: Indiana UP, 2009.

Benjamin, Walter. "Theses on the Philosophy of History." In *Illuminations: Essays and Reflections.* Translated by Harry Zohn. New York: Schocken Books, 1968.

Berliner, Paul. *Thinking in Jazz: The Infinite Art of Improvisation.* Chicago: U Chicago P, 1994.

Berry, Llewelyn. L. *A Century of Missions of the African Methodist Episcopal Church 1840-1940.* New York: Gutenberg, 1942.

Bhabha, Homi K. *The Location of Culture.* New York: Routledge, 1994.

Bourdieu, Pierre. *Esquisse d'une théorie de la pratique précédé de trois études d'ethnologie kabile.* Paris: Librairie Droz, 1972.

Bouzerand, Jacques. *La Presse écrite à Dakar, sa diffusion, son public.* Dakar: Université de Dakar, Centre de recherches psychosociologiques, 1967.

Brathwaite, Kamau. *The Arrivants: A New World Trilogy—Rights of Passage/Islands/Masks.* Oxford: Oxford UP, 1973.

———. *Contradictory Omens: Cultural Diversity and Integration in the Caribbean.* Kingston: Savacou, 1974.

Breaux, Quo Vadix Gex. "Tom Dent's Role in the Organizational Mentoring of Black Southern Writers." *African American Review* 40.2 (Summer 2006): 339–43.

Brown, Jacqueline Nassy. "Black Liverpool, Black American and the Gendering of Diasporic Space." *Cultural Anthropology* 13.3 (1998): 291–325.

Brown, Jayna Jennifer. *Babylon Girls: Black Women Performers and the Shaping of the Modern.* Durham: Duke UP, 2008.

Bruner, Edward. "Slavery and the Return of the Black Diaspora: Tourism in Ghana." In *Culture on Tour: Ethnographies of Travel.* Chicago: U Chicago P, 2005.

Bugul, Ken. *The Abandoned Baobab.* Translated by Marolijn de Jaeger. Charlottesville: U Virginia P, 2008.

Bugul, Ken. *Rue Félix-Faure.* Paris: Hoëbke, 2005.

Burke, Timothy. *Lifebuoy Men, Lux Women: Commodification, Consumption, and Cleanliness in Modern Zimbabwe.* Durham: Duke UP, 1996.

Ça Twiste à Poponguine. Directed by Moussa Sene Absa. 1993.

Callistratus. *Elder Philostratus, Younger Philostratus, Callistratus.* Translated by Fairbanks, Arthur. Loeb Classical Library Volume 256. London: William Heinemann, 1931.

Campbell, James. *Songs of Zion: The African Methodist Episcopal Church in the United States and in South Africa.* Chapel Hill: U North Carolina P, 1998.

Campe de Thiaroye. Directed by Ousmane Sembene. 1987.

Carpentier, Alejo. *La Música en Cuba* (2nd edition). Madrid: Fondo de Cultura Económica, 1984. (Orig. pub. 1946).

Castaldi, Francesca. *Choreographies of African Identities: Négritude, Dance, and the National Ballet of Senegal.* Champaign, IL: U Illinois P, 2006.

Chandler, Nahum. "Originary Displacement." *boundary 2* 27.3 (Fall 2000): 249–86.

Cheng, Anne Anlin. *Second Skin: Josephine Baker and the Modern Surface.* New York: Oxford UP, 2011.

Chirenje, J. Mutero. *Ethiopianism and Afro-Americans in Southern Africa, 1883-1916.* Baton Rouge and London: Louisiana State UP, 1987.

Chrisman, Laura. *Rereading the Imperial Romance: British Imperialism and South African Resistance in Haggard, Schreiner, and Plaatje.* Oxford: Clarendon Press, 2000.

Clark, VèVè, and Sarah E. Johnson. *Kaiso! Writings by and about Katherine Dunham.* Madison: U Wisconsin P, 2005.

Clarke, Kamari M., and Deborah A. Thomas, eds. *Globalization and Race.* Durham: Duke UP, 2006.

Connor, Steven. "The Modern Auditory I." In *Rewriting the Self: Histories from the Renaissance to the Present,* edited by Porter Roy, 203–23. New York: Routledge, 1997.

Cook, Mercer. "Afro-Americans in Senghor's Poetry." In *Critical Perspectives on Léopold Senghor,* edited by Janice Spleth. Washington, DC: Three Continents Press, 1990.

Coplan, David. *In Township Tonight!: South Africa's Black City Music and Theater.* (2nd Ed.) Chicago: U Chicago P, 2008.

Coppin, Bishop Levi. *Unwritten History.* Philadelphia: A.M.E. Book Concern, 1919.

Coursil, Jacques. *La fonction muette du langage: Essai de linguistique générale contemporaine.* Pétit-Bourg, Guadeloupe: Ibis Rouge, 2000.

Couzens, Tim. "Moralizing Leisure Time: The Transatlantic Connection and Black Johannesburg 1918-1936." In *Industrialisation and Social Change in South Africa: African Class Formation and Consciousness, 1870–1930,* edited by Shula Marks and Richard Rathbone. London: Longman, 1982.

Crawford, Richard. *America's Musical Life.* New York: Norton, 2001.

Cullen, Countee. "Heritage." First published in *Survey Graphic*: Harlem Number, 1925.

Davis, Peter. *Diary.* See http://web.uct.ac.za/depts/sarb/X0013_Davis.html (accessed June 17, 2011).

———. *In Darkest Hollywood: Exploring the Jungles of Cinema's South Africa.* Johannesburg: Ravan and Athens, OH: Ohio UP, 1996.

Daymond, Margaret J., Dorothy Driver, Sheila Meintjes, and Gloria Naylor, eds. *Women Writing Africa: The Southern Region.* New York: Feminist Press, 2003.

Derrida, Jacques. *Mal d'Archive.* Paris: Éditions Galilée, 1995.

Derrida, Jacques, tr. Eric Prenowitz. *Archive Fever: A Freudian Impression.* Chicago: U Chicago P, 1998.

Diagne, Souleymane Bachir. "Le leçon de musique. Réflexions sur une politique de la culture." In *Le Senegal Contemporain,* edited by Momar Coumba Diop, 243–260. Paris: Karthala 2002.

Diakhaté, Lamine. "Artistes du monde noir." In *Programme Officielle: Festival Mondial des Arts Nègres,* 74–85. Dakar: UNESCO et al, 1966.

Diawara, Manthia. "The 1960s in Bamako: Malick Sidibé and James Brown." In *Black Cultural Traffic: Crossroads in Global Performance and Popular Culture,* edited by Harry J. Elam and Kennell Jackson, 242–65. Ann Arbor: U Michigan P, 2005.

———. *In Search of Africa.* Cambridge, MA: Harvard UP, 1998.

Diop, Alioune, ed. *1er Festival mondial des Arts nègres: Dakar, 1-24 avril 1966: Colloque. I, Fonction et signification de l'Art nègre dans la vie du peuple et pour le peuple (30 mars-8 avril),* Festival mondial des Arts nègres (1966; Dakar), *Présence africaine,* 1967.

Diouf, Mamadou. "Des cultures urbaines entre traditions et mondialisation." In *Le Senegal Contemporain,* edited by Momar Coumba Diop, 261–88. Paris: Karthala, 2002.

Dovey, Lindiwe, and Angela Impey, "*African Jim*: Sound, Politics, and Pleasure in Early 'Black' South African Cinema." *Journal of African Cultural Studies* 22.1 (2010): 57–73.

Du Bois, W. E. B. *The Souls of Black Folk*. New York: Bantam Classic, 1996, 4.

——. *The World and Africa*. New York: International Publishers, 1976.

Dube, John. *Insila kaShaka*. Durban: Marianhill Mission Press, 1930.

——. *Jeqe, The Bodyservant of King Shaka* (Penguin, 2008, based on 1951 trans. by J. Boxwell, Lovedale Press).

Dube, John, and Nokutela Dube. *A Zulu Song Book/; Facsimile Reprint of Amagama Abantu with Modernised Version Edited, Translated, and Transcribed to Staff Notation by David Rycroft*. Durban: Killie Campbell Africana Library; Pietermaritzburg: U Natal P, 1996.

Dube, Nokutela. "Africa: The Story of My Life." *Life and Light for Woman*, 110 Volume 28, Women's Board of Missions (1898).

Dussel, Enrique. "Europe, Modernity, and Eurocentrism." *Nepantla: Views from South* 1.3 (2000): 465–78.

Ebron, Paulla A. *Performing Africa*. Princeton: Princeton UP, 2002.

Echenberg, Myron. *Colonial Conscripts: The Tirailleurs Sénégalais in French West Africa, 1857-1960*. Portsmouth: Heinemann, 1991.

Edwards, Brent Hayes. *The Practice of Diaspora: Literature, Translation, and the Rise of Black Internationalism*. Cambridge, MA: Harvard UP, 2003.

——. "The Uses of Diaspora." *Social Text* 19.1 (Spring 2001), 45–73.

Elam, Harry, and Kennell Jackson, ed. *Black Cultural Traffic: Crossroads in Global Performance and Popular Culture*. Ann Arbor: U Michigan P, 2005.

Ellington, Edward Kennedy. *Music Is My Mistress*. Garden City, NY: Doubleday, 1973.

Erlmann, Veit. *African Stars: Studies in Black South African Performance*. Chicago: U Chicago P, 1991.

——. *Music, Modernity and the Global Imagination*. Cambridge: Cambridge UP, 1999.

——. "'Spectatorial Lust': The African Choir in England, 1891-1893." In *Africans on Stage: Studies in Ethnological Show Business*, edited by Bernth Lindfors, 107–134. Bloomington: Indiana UP, 2000.

Fabian, Johannes. *Time and Its Other: How Anthropology Makes Its Object*. New York: Columbia UP, 1983.

Fabre, Geneviève, and Robert G. O'Meally, eds. *History and Memory in African-American Culture*. New York: Oxford UP, 1994.

Fanon, Frantz. *Black Skin White Mask*. New York: Grove Press, 1967.

Farred, Grant. *What's My Name?: Black Vernacular Intellectuals*. Minneapolis: U Minnesota P, 2003.

Floyd, Samuel A. *The Power of Black Music: Interpreting its History from Africa to the United States*. New York: Oxford UP, 1996.

Foucault, Michel. *The Archaeology of Knowledge*. Translated by A. M. Sheridan Smith. New York Pantheon, 1972.

——. "Of Other Spaces." *Diacritics* 16 (Spring 1986), 22–27.

Friedman, Susan Stanford. "Definitional Excursions: The Meanings of Modern/Modernity/ Modernism." *Modernism/modernity* (2001) 8:3, 493–513.

Fründt, Hans. "Echolocation: The Prelinguistic Acoustical System." *Semiotica* 125-1/3 (1999).

Fuller, Hoyt W. "World Festival of Negro Arts: Senegal Fete Illustrates Philosophy of 'Negritude.'" *Ebony* 21.9 (July 1966): 96–102.

——. *Journey to Africa*. Chicago: Third World Press, 1971.

Fuze, Magema. *Abantu Abamnyama Lapa Bavela Ngakona* [1922]. Translated by H. C. Lugg as *The Black People and Whence They Came*. Edited by A. T. Cope. Pietermaritzburg: U Natal P; Durban: Killie Campbell African Library, 1979.

Gaines, Kevin. *American Africans in Ghana: Black Expatriates in the Civil Rights Era*. Chapel Hill: U North Carolina P, 2006.

Gaonkar, Dilip Parameshwar, ed. *Alternative Modernities*. Durham: Duke UP, 2001.

Gates, Henry Louis. *The Signifying Monkey*. New York: Oxford UP, 1988.

Gates, Henry Louis, Jr. *Wonders of the African World*. New York: Knopf, 1999.

Gikandi, Simon. "Africa and the Epiphany of Modernism." In *Geomodernisms: Race, Modernism, Modernity*, edited by Laura Doyle and Laura Winkiel, 31–50. Bloomington: Indiana UP, 2006.

Gilroy, Paul. "Between the Blues and the Blues Dance: Some Soundscapes of the Black Atlantic." In *The Auditory Culture Reader*, edited by Michael Bull and Les Back, 381–95. Oxford: Berg, 2003.

———. *The Black Atlantic: Modernity and Double Consciousness*. Cambridge, MA: Harvard UP, 1993.

———. *Small Acts*. London/New York: Serpent's Tail, 1993.

Glissant, Édouard. *Le Discours Antillais*. Paris: Seuil, 1981.

———. *Une nouvelle région du monde (Esthétique I)*. Paris: Gallimard, 2006.

———. *The Poetics of Relation*. Translated by Betsy Wing. Ann Arbor: U Michigan P, 1997.

———. *Soleil de la Conscience*. Paris: Gallimard, 1997. (First pub. Editions Seuil, 1956).

———. *Traité du Tout-Monde (Poétique IV)*. Paris: Gallimard, 1997.

Greaves, Williams. "The First World Festival of Negro Arts: An Afro-American View." *The Crisis* 73:6 (June-July 1966): 309–14.

Guillory, John. "Genesis of the Media Concept." *Critical Inquiry*, 36.2 (Winter 2010): 321–62.

Hamm, Charles. "'The Constant Companion of Man': Separate Development, Radio Bantu and Music." *Popular Music* 10.2 (May 1991): 147–73.

Hamilton, Ruth Simms. *Routes of Passage: Rethinking the African Diaspora. Volume 1 Part 1*. Lansing, MI: Michigan State UP, 2006.

Hanchard, Michael. "Afro Modernity: Temporality, Politics, and the African Diaspora." In *Alternative Modernities*, edited by Dilip Parameshwar Gaonkar, 272–98. Durham: Duke UP, 2001.

Harney, Elizabeth. *In Senghor's Shadow: Art, Politics and the Avant-garde in Senegal, 1960-1995*, Durham: Duke UP, 2004.

Haraway, Donna. "A Cyborg Manifesto: Science, Technology, and Socialist-Feminism in the Late Twentieth Century." In *Simians, Cyborgs and Women: The Reinvention of Nature*, 149–86. New York: Routledge, 1991.

Hartman, Saidiya V. *Scenes of Subjection: Terror, Slavery, and Self-Making in Nineteenth-Century America*. New York: Oxford UP, 1997.

———. *Lose Your Mother: A Journey Along the Atlantic Slave Route*. New York: Farrar, Strauss and Giroux, 2007.

Hasty, Jennifer. "Rites of Passage. Routes of Redemption: Emancipation Tourism and the Wealth of Culture." *Africa Today* 49.3 (2002), 47–76.

Henderson, Stephen. *Understanding the New Black Poetry: Black Speech and Black Poetry as References*. New York: Morrow, 1972.

Hooker, J. R. "The Pan-African Conference 1900." *Transition* 46 (1974), 20–24.

hooks, bell. *Reel to Real: Race, Sex, and Class at the Movies*. New York: Routledge, 1996.

Hughes, Heather. *The First President: A Life of John Dube*. Johannesburg: Jacana Press, 2011.

Huwiler, Kurt. *Musical Instruments of Africa*. Harare: Mambo Press, 1995.

Irele, F. Abiola. *The Négritude Moment: Explorations in Francophone African and Caribbean Literature and Thought*. Trenton: Africa World Press, 2011.

Jabavu, D. D. T. *The Black Problem: Papers and Addresses on Various Native Problems*. Lovedale: Lovedale Press, 1920.

———. *The Life of John Tengo Jabavu*. Lovedale, SA: Lovedale Press, 1922.

Jameson, Frederic. *A Singular Modernity: Essay on the Ontology of the Present*. New York: Verso, 2002.

———. *Postmodernism, or, The Cultural Logic of Late Capitalism*. Durham: Duke UP, 1991.

Johns, Adrian. *Piracy: The Intellectual Property Wars from Gutenberg to Gates*. Chicago: U Chicago P, 2010.

Johnson, James Weldon. *God's Trombones: Seven Negro Sermons In Verse*. New York: Penguin Books, 1955.

Jones, Meta Du Ewa. "Jazz Prosdies: Orality and Textuality." *Callaloo* 25.1 (Winter 2002): 66–91.

Kandé, Sylvie. "Jazz et Littérature francophone" *Mots Pluriels* 13 (April, 2000). http://www.arts.uwa.edu.au/MotsPluriels/MP1300syk.html (accessed 6/24/11).

Kant, Immanuel. *Critique of Judgment*. Translated by Werner S. Pluhar. Indianapolis and Cambridge: Hackett, 1987.

Keil, Charles. "Motion and Feeling through Music." In *Music Grooves*, by Steven Feld and Charles Keil, 53–76. Chicago: U Chicago P, 1994.

Kelley, Robin D.G. *Africa Speaks, America Listens: Modern Jazz in Revolutionary Times*. Cambridge, MA: Harvard UP, 2012.

Kgositsile, Keorapetse. *Approaches to Poetry Writing*. Chicago: Third World Press, 1994.

———. *Beyond Words: South African Poetics*. Defeye Series (No. 3). Apples and London: Snakes, 2009.

———. *My Name Is Afrika*. Garden City, NY: Doubleday and Co., 1971.

———. *The Present Is a DANGEROUS Place to Live*. Chicago: Third World Press, 1974. 2nd edition, 1993.

———. *This Way I Salute You*. Cape Town and Plumstead: Kwela and Snailpress, 2004.

———. *To the Bitter End*. Chicago: Third World Press, 1995.

———. *When the Clouds Clear*. Cape Town: Congress of South African Writers, 1990.

Khanna, Ranjana. *Dark Continents: Psychoanalysis and Colonialism*. Durham: Duke UP, 2003.

Kittler, Friedrich A. *Gramophone, Film, Typewriter*. Translated by G. Winthrop-Young and Michael Wutz. Stanford: Stanford UP, 1999.

Knee, Adam, and Charles Musser. "William Greaves: Documentary Film-making, and the African American Experience." *Film Quarterly* 4.3 (Spring 1992): 13–25.

Kotchy, Barthélemy. *La Correspondance des Arts dans la Poésie de Senghor*. Abidjian: Nouvelles Editions Ivoiriennes, 2001.

Laden, Sonja. "'Making the Paper Speak Well,' or, the Pace of Change in Consumer Magazines for Black South Africans." *Poetics Today* 22.2 (Summer 2000): 515–48.

Larkin, Brian. *Signal and Noise: Media, Infrastructure, and Urban Culture in Nigeria*. Durham: Duke UP, 2008.

Last Angel of History. Directed by John Akomfrah. 1997.

Levine, Mark. *Jazz Piano*. Petaluma, CA: Sher Music, 1989.

Leete, Frederick Deland. *Christian Brotherhoods*. Cincinnati: Jennings and Graham, 1912.

Leys, Ruth. "The Turn to Affect: A Critique." *Critical Inquiry*, 37.3 (Spring 2011): 437–72.

Lindfors, Bernth. "The Early Writings of Wole Soyinka." *Journal of African Studies* 2, (1975): 64–86.

Lock, Graham. *Blutopia: Visions of the Future and Revisions of the Past in the Work of Sun Ra, Duke Ellington, and Anthony Braxton*. Durham: Duke UP, 1999.

Locke, Alain. *The New Negro: An Anthology*. New York: Albert and Charles Boni, 1925.

Loury, Glenn. "Transgenerational Justice—Compensatory versus Interpretative Approaches." In *Reparations: Interdisciplinary Inquiries*, edited by Johan Miller and Rahul Kumar, 87–113. New York: Oxford UP, 2007.

Mackey, Nathaniel. *Paracritical Hinge: Essays, Talks, Notes, Interviews*. Madison: U Wisconsin P, 2005.

———. "Statement for Breaking Ice." *Callaloo* 23.2 (2000), 717.

Maduakor, Obiajuru. "Wole Soyinka as Literary Critic." In *Research on Wole Soyinka*, edited by Bernd Lindfors and James Gibbs, 265–98. Trenton and Asmara: Africa World Press, 1993.

Malraux, André. "Discours de M. Andre Malraux à l'Ouverture du Colloque." *L'Unité africaine* 196 (7 April 1966).

Mandelbaum, Allen. *The Metamorphoses of Ovid*. New York: Houghton Mifflin, 1993.

Manoim, Irwin Stanley. "The Black Press 1945–1963: The Growth of the Black Mass Media and Their Role as Ideological Disseminators." M.A. thesis, University of the Witwatersrand, 1983.

Marable, Manning. "African Nationalist: the Life of John Langalibalele Dube." Ph. D. Dissertation, University of Maryland, 1976.

Marley, Bob, and the Wailers. *Confrontation*. Tuff Gong/Island Records, 1983.

Masilela, Ntongela. *Database on New African Movement*. http://pzacad.pitzer.edu/NAM/ (accessed 7/2/11).

Karl Marx. *Capital: Volume 1: A Critique of Political Economy*. New York: Penguin Classics, 1992.

Mathurin, Owen. *Henry Sylvester Williams and the Origins of the Pan-African Movement, 1896-1911*. Westport, CT: Greenwood Press, 1976.

Maunick, Edouard J. "Une voix vivante de l'Afrique du sud: William Kgositsile." *Présence Africaine* 62:2 (1967): 177–81.

Maxeke, Charlotte. "Social Women Among Bantu Women and Girls (1930)." In *Women Writing Southern Africa*, edited by Mary Daymond, et al., 195–99. New York: Feminist Press, 2003.

Mbembe, J.-A. *De la postcolonie: essai sur l'imagination politique dans l'Afrique contemporain*. Paris: Karthala, 2000. (Trans. *On the Postcolony*. Berkeley: California UP, 2001).

Melville, Herman. "Bartleby, the Scrivener" (1853).

Memmi, Albert. *The Colonizer and The Colonized*. Translated by Howard Greenfeld. Boston: Beacon, 1965.

Mercer, Kobena. "Post-colonial Trauerspeil." In *The Ghosts of Songs: The Film Art of the Black Audio Film Collective*, edited by Kodwo Eshun and Anjalika Sagar, 43–73. Liverpool: Liverpool UP, 2007.

Moreley, David. "What's 'Home' Got to Do with It?: Contradictory Dynamics in the Domestication of Technology and the Dislocation of Domesticity." *European Journal of Cultural Studies* 6.4 (2003): 435–58.

Morrison, Toni. *Playing In the Dark: Whiteness in the Literary Imagination*. Cambridge, MA: Harvard UP, 1992.

Moten, Fred. *In the Break: The Aesthetics of the Black Radical Tradition*. Minneapolis: U Minnesota P, 2003.

Mudimbe, V. Y. *The Idea of Africa*. Bloomington: Indiana UP, 1994.

Muller, Carol. *Focus: Music of South Africa, 2nd ed*. New York: Routledge, 2008.

Muller, Carol, and Sathima Bea Benjamin. *Musical Echoes: South African Women Thinking in Jazz*. Durham: Duke UP, 2011.

Muyanga, Neo. Weblog. http://neomuyanga.wordpress.com/ (accessed 7/2/2011).

N'dour, Youssou. *Set*. Virgin Records, 1992.

Ndiaye, Amadou Racine. "Communication du secrétaire d'état à l'éducation nationale chargé des affaires culturelle à Monsieur Lamine Diakhaté, Ministre de l'Information et des Télécommunications" Dakar (February 1963).

Nketia, J. H. *Drumming in Akan Communities of Ghana*. Lagos: Thomas Nelson, 1963.

Nkrumah, Kwame. *Toward Colonial Freedom: Africa in the Struggle Against World Imperialism*. London: Heinemann, 1962.

La Noire de... Dir. Ousmane Sembene, 1966.

Nyamnjoh, Francis. "Fishing in Troubled Waters: Disquettes and Thiofs in Dakar." *Africa* 75:3 (Summer 2000), 295–324.

Nzegwu, Azuka. "Redefining 'Africa' in the Diaspora with New Media Technologies." In *The New African Diaspora*, edited by Isidore Okpewho and Nkiru Nzegwu, 358–83. Bloomington: Indiana UP, 2009.

Opoku-Agyemang, Kwadwo. *Cape Coast Castle*. Accra: Afram Publications, 1996.

———. Personal Interview. 9 March, 2007.

Orchestra Baobab, *Pirates Choice* (1989 & 2001) World Circuit/Nonesuch Records WCB014 and WCDO63. Sound.

Palmberg, Mai, and Annemette Kirkegaard, eds. *Playing with Identities in Contemporary Music in Africa*. Uppsala: Nordiska Afrikainstitutet, 2002.

Pan African Space Station. http:// www.panafricanspacestation.org.za (accessed 7/2/2011).

———. Facebook page. http://www.facebook.com/group.php?gid=19510419251 (accessed 7/2/2011).

Peterson, Bhekizizwe. *Monarchs, Missionaries and African Intellectuals: African Theatre and the Unmaking of Colonial Marginality*. Trenton: Africa World Press, 2000.

Pierre, Jemima. *The Predicament of Blackness: Postcolonial Ghana and the Politics of Race*. Chicago: U Chicago P, 2012.

Plaatje, Solomon. *Mafeking Diary: A Black Man's View of a White Man's War*. Edited by John Comaroff. London: James Currey and Athens: Ohio UP, 1973.

———. *Native Life in South Africa*. Essex, UK: Longmann, 1987.

———. *Solomon Plaatje: Selected Writings*. Edited by Brian Willan. Athens, OH: Ohio UP, 1997.

Plaatje, Solomon, and Daniel Jones. *Sechuana Reader in International Orthography (with English Translations)*. London: U London P: 1916.

Prah, K. K. *Back to Africa: Afro-Brazilian Returnees and Their Communities*. Rondebosch: CASAS, 2009.

Pratt, Mary Louise. *Imperial Eyes: Travel Writing and Transculturation*. 2nd Ed. New York: Routledge, 2008.

Price, Sally. *Primitive Art in Civilized Places*. Chicago: U Chicago P, 1989.

Ramsey, Jr., Guthrie. "Secrets, Lies and Transcriptions: Revisions on Race, Black Music and Culture." In *Western Music and Race*, edited by Julie Brown, 24–36. Cambridge: Cambridge UP, 2007.

Radner, Hilary. *Shopping Around: Feminine Culture and the Pursuit of Pleasure*. New York: Routledge, 1995.

Rampersad, Arnold. *The Life of Langston Hughes: Volume II: 1941-1967: I Dream a World*. New York: Oxford UP, 1988.

Ratcliff, Anthony J. *Liberation at the End of a Pen: Writing Pan-African Politics of Struggle*, diss. University of Massachusetts, Amherst, 2009.

Richards, Paul. "A Pan-African Composer? Coleridge-Taylor and Africa." *Black Music Research Journal*, 21.2 (Autumn, 2001): 235–60.

Rive, Richard, and Tim Couzens. *Seme: The Founder of the ANC*. Trenton: Africa World Press, 1993.

Roberts, Brian Russell. "Lost Theaters of African American Internationalism: Diplomacy and Henry Francis Downing in Luanda and London." *African American Review* 42.2 (2008): 269–86.

Rohlehr, Gordon. *Pathfinder: Black Awakening in The Arrivants of Edward Kamau Brathwaite*. Port of Spain: College Press, 1981.

———. "Blues and Rebellion: Edward Brathwaite's *Rights of Passage*" Review. *Caribbean Studies* 10.4 (1971): 173–202.

Rowell, Charles. "With Bloodstains to Testify': An Interview with Keorapetse Kgositsile." *Callaloo* 2 (Feb. 1978): 23–42.

———. "Words Don't Go There: An Interview with Fred Moten." *Callaloo* 27:4 (2004): 954–66.

Rowley, Hazel. "Richard Wright's Africa." *The Antioch Review* 58:4 (Fall 2000): 406–21.

Sadie, Julie Anne and Rhian Samuel, eds. *The New Grove Dictionary of Women Composers*. London: MacMillan, 1994.

Sagna, Olivier. "Les télécentres privés du Sénégal: La fin d'une 'success story'" *Revue NETSUDS*, 4 (2009): 27–43.

Sankofa. Directed by Haile Gerima. Myphedud Films, 1993.

Saunders, Christopher. "F.Z.S. Peregrino and *The South African Spectator*." *Quarterly Bulletin of the South African Library* 32 (1978): 81–90.

Sembene, Ousman. *Voltaïque: La Noire de...(nouvelles)*. Paris, Présence Africaine: 1962. (*Tribal Scars and Other stories* by Ousmane Sembene, translated by Len Ortzen. Washington D.C.: Black Orpheus Press 1974).

Senghor, Léopold S. *Oeuvre Poétique*. Paris: Seuil, 1964, 1973, 1979, 1984, and 1990.

———. "L'Humanisme d'Alioune Diop." *Éthiopiques: Spécial centenaire: Contributions de Léopold Sédar Senghor à la revue 76* (numéro spécial 2006): 249–54.

———. *Liberté I: Négritude et Humanisme*. Paris: Seuil, 1964.

———. "Message From President Senghor to the Senegalese People [First World Festival of Negro Arts]." Bilingual official government publication. Dakar, 1963.

———. *The Collected Poetry.* Translated by Melvin Dixon. Charlottesville: U Virginia P, 1991.

Sharpley-Whiting, T. Denean. *Negritude Women.* Minneaopolis: U Minnesota P: 2002.

Shepperson, George. "African Diaspora: Concept and Context." In *Global Dimensions of the African Diaspora,* 2nd ed., edited by Joseph E. Harris, 48–62. Washington, D.C: Howard UP, 1993.

———. "Pan-Africanism and 'Pan-Africanism': Some Historical Notes." *Phylon* 23.4 (1962): 346–58.

Sherwood, Marika. *Origins of Pan-Africanism: Henry Sylvester Williams, Africa and the African Diaspora.* New York: Routledge, 2011.

Skota, Mweli T. D. *The African Yearly Register: Being An Illustrated National Biographical Dictionary (Who's Who) of Black Folk in Africa.* Johannesburg: R. L. Esson and Co., 1930.

Smith, Charles Spenser. *A History of the African Methodist Episcopal Church: Being a Volume Supplemental to a History of the African Methodist Episcopal Church by Daniel Alexander Payne, D.D., L.L.D.* Philadelphia: A.M.E. Book Concern, 1922.

Snipe, Tracy D. *Arts and Politics in Senegal: 1960-1996,* Trenton: Africa World Press: 1998.

Soul to Soul. Directed by Denis Sanders. Grammy Foundation, 2004 (originally released in 1972).

Soyinka, Wole. "The Future of West African Writing." *The Horn* 4.1 (1960): 10–16.

Spectacle féérique de Gorée: opéra populaire en huit tableaux créé à l'occasion du Premier Festival mondial des arts nègres, 1/24 avril 1966, Dakar. Program notes. Paris: A. Rousseau, 1966. (Text for show by Jean Brierre).

Spivak, Gayatri Chakravorty. "Echo." *New Literary History* 24.1 (Winter, 1993): 17–43.

Stephens, Michelle. *Black Empire: The Masculine Global Imaginary of Caribbean Intellectuals in the United States, 1914-1962.* Durham: Duke UP, 2005.

Sterne, Jonathan. *MP3: The Meaning of a Format.* Durham: Duke UP, 2012.

Sterne, Jonathan, et al. "The Politics of Podcasting." *Fibreculture Journal* 13 (2005). See http://thirteen.fibreculturejournal.org/fcj-087-the-politics-of-podcasting/ (accessed 11/12/12).

Stewart, Jacqueline Najuma. *Migrating to the Movies: Cinema and Black Urban Modernity.* Berkeley: U California P, 2005.

Stewart, Gary. *Rumba on the River A History of the Popular Music of the Two Congos.* New York: Verso, 2003.

Stoler, Ann Laura. *Along the Archival Grain: Epistemic Anxieties and Colonial Common Sense.* Princeton: Princeton UP, 2010.

Sundaram, Ravi. *Pirate Modernity: Delhi's Media Urbanism.* New York: Routledge, 2011.

Switzer, Les. *South Africa's Alternative Press: Voices of Protest and Resistance, 1880s-1960s.* Cambridge: Cambridge UP, 1997.

Szendy, Peter. *Listen: A History of Our Ears.* New York: Fordham UP, 2008.

Titlestad, Michael. *Making the Changes: Jazz in South African Literature and Reportage.* Amsterdam: Brill, 2005.

Tomaselli, Keyan, and Ruth Tomaselli, "Between Policy and Practice in the SABC, 1970-1981." In *Currents of Power: State Broadcasting in South Africa,* edited by Ruth Tomaselli, Keyan Tomaselli, and Johan Muller, 84–152. Denver: iAcademic, 2001.

Towa, Marcien. *Léopold Sédar Sénghor, Négritude ou servitude?* Yaounde: Éditions CLE, 1971.

Tucker, Mark. *The Duke Ellington Reader.* New York: Oxford UP, 1993.

Vaillant, Janet. *Black, French and African: A Life of Léopold Sédar Senghor*. Cambridge, MA: Harvard UP, 1990.

Vaneigem, Raoul. *A Declaration of the Rights of Human Beings: On the Sovereignty of Life as Surpassing the Rights of Man*. Translated by Liz Heron. London: Pluto Press, 2003.

Von Eschen, Penny M. *Satchmo Blows The World: Jazz Ambassadors Play the Cold War*. Cambridge, MA: Harvard UP, 2004.

Warner-Lewis, Maureen. "Odomankoma Kyerema Se." *Caribbean Quarterly* 19.2 (June 1973): 51–99.

Warren, Kenneth. "Appeals for (Mis)recognition: Theorizing the Diaspora." In *Cultures of U.S. Imperialism*, edited by Donald Pease and Amy Kaplan, 392–406. Durham: Duke UP, 1993.

Washington, Jesse. "For Minorities, New 'Digital Divide' Seen," AP January 9, 2011. http://www.washingtonpost.com/wp-dyn/content/article/2011/01/09/AR2011010900043.html (accessed 1/11/11).

Weheliye, Alex G. *Phonographies: Grooves in Sonic Afro-Modernity*. Durham: Duke UP, 2005.

Weinbaum, Alys Eve, et al. *The Modern Girl Around the World: Consumption, Modernity, and Globalization*. Durham: Duke UP, 2008.

Wilks, Jennifer. *Race, Gender and Comparative Black Modernism: Suzanne Lacascade, Marita Bonner, Suzanne Césaire, Dorothy West*. Baton Rouge: Louisiana State UP: 2008.

Woman's Mite Missionary Society. "Minutes of the Seventh Annual Convention, Cincinnati," 1903. See http://dbs.ohiohistory.org/africanam/page.cfm?ID=1097 (accessed 11/17/12).

World Festival of Negro Arts. Directed by William Greaves. USIA, 1966.

Wright, Richard. *Black Power: A Record of Reactions in a Land of Pathos*. New York: Harper, 1954.

Xuma, A. B. *Charlotte Manye (Maxeke) Or What An Educated African Girl Can Do*. Johannesburg: Women's Parent Mite Missionary Society of the AME Church, 1930.

Zeleza, Paul Tiyambe. *Rethinking Africa's Globalization: Vol. I: The Intellectual Challenges*. Trenton: Africa World Press, 2003.

Zimmerman, Andrew. *Alabama in Africa: Booker T. Washington, the German Empire and the Globalization of the New South*. Princeton: Princeton UP, 2010.

{ INDEX }

CPSIA information can be obtained at www.ICGtesting.com
Printed in the USA
BVOW04s2056221114

376327BV00001B/5/P